Sister Wendy's
AMERICAN
COLLECTION

Sister Wendy's
AMERICAN
COLLECTION

SISTER WENDY BECKETT

HarperCollins*Publishers*

HarperCollins books may be purchased for educational, business, or sales promotional use.
For information please write: Special Markets Department, HarperCollins Publishers, Inc.,
10 East 53rd Street, New York, NY 10022.

FIRST EDITION

Editor: Michelle Pickering
Designer: Kathryn Gammon
Assistant editor: Mary Senechal
Indexer: Dorothy Frame

Cataloging-in-Publication data is available in the United States from the Library of Congress
and in the United Kingdom from the British Library.

HarperCollins*Publishers* Inc. HarperCollins*Publishers* UK
10 East 53rd Street 77-85 Fulham Palace Road
New York London
NY 10022 W6 8JB

ISBN 0-06-019556-8 ISBN 0-00-710127-9

Color reproduction by Colourscan, Singapore
Printed and bound in the United States by R. R. Donnelley & Sons

00 01 02 03 04
R.R.D.
10 9 8 7 6 5 4 3 2 1

Contents

INTRODUCTION | 6

METROPOLITAN MUSEUM OF ART, NEW YORK | 10

MUSEUM OF FINE ARTS, BOSTON | 60

ART INSTITUTE OF CHICAGO | 104

CLEVELAND MUSEUM OF ART | 152

KIMBELL ART MUSEUM, FORT WORTH | 198

LOS ANGELES COUNTY MUSEUM OF ART | 238

PICTURE CREDITS | 280

INDEX | 287

Introduction

A country that has few museums is both materially poor and spiritually poor. Poverty, whether spiritual or economic, leaves us enslaved to work—having it or wanting it—and in either case, without time or energy to look beyond the immediate. Museums, like theaters and libraries, are a means to freedom. Here, we can move out of our personal anxieties and disappointments into the vast and stable world of human creativity. Here are displayed for us—to delight and enlighten us—the most beautiful objects that our race ever fashioned: objects from all cultures and all centuries. We can touch on the essence of our human potential, and come to understand what we are and what we could become—but, of course, we must make a choice. Self-determining creatures that we are, do we whiz around a museum, intellectually absorbing a few facts? Or have we the courage and intelligence to encounter the extraordinary beauty that is displayed for us? To look—as opposed to merely seeing—takes time and concentration. It is most richly rewarded.

Nowhere in the world are the rewards as great, or the opportunities as many, as in the United States: it is a very rich country, and dense with museums. What makes this even more impressive is that these museums were created from the ground up, so to speak. Nearly all of the major European museums are fashioned around the remnants of princely magnificence: the Hermitage in St. Petersburg was the collection of the czar; the Louvre in Paris, that of the French royal family (and Napoleon); the Kunsthistorisches in Vienna, that of the emperor of Austria. In the United States, however, cities started from scratch. Granted, there was our modern equivalent of royalty—the millionaire citizen—but the very rich were inspired to their acts of generosity by a genuine belief in the importance of culture. Cities actively desired their museums; they were prepared to make sacrifices to get them; and where there was no prominent single donor of land, or art works, or money, they set to work to raise these things among themselves. Fourteen men and eleven women banded together in Minneapolis, for example, "to advance the knowledge and love of art": it took them thirty years, but the city received a fine museum. Sometimes we can tell from the museum's name that there was one preeminent benefactor: the Frick, the Guggenheim, the Whitney in New York, the High in Atlanta, the Getty in Los Angeles and Malibu, the Norton Simon in Pasadena. More often, though, museums resulted from a concerted civic effort, drawing in countless donors, large and small—and still drawing them, people still deeply involved with what is seen as an essential good for the community.

If no country is richer in museums than the United States, it is because no country is more aware of what they can mean, more eager to enter into its human inheritance, more sensitive to the enthralments of the beautiful and the historic. If America's history is relatively brief in comparison, say, to that of China or Egypt, it fully compensates by taking on board the gamut of racial history, from every continent, and recognizing that everyone has a claim to every history. We are what we are today because of "the past"—not our own private or personal past alone, but also the generic past. It is this enrapturing past that we encounter in a museum (and in a museum of contemporary art, it is the equally enrapturing present, and even future).

I must now confess that I wrote all this to enlist your sympathy. From so many great museums, how was I to choose six, since choosing more would spread the book too thin? I had to begin by setting some arbitrary limits. To begin with, I decided I would only consider encyclopedic museums: those that cast their nets widest. I wanted to look at "everything": from medals to monuments, from dresses to musical instruments; and from "everywhere": Africa, Indonesia, the Far East, Polynesia, South America. I wanted to be free to contemplate all times: from the very dawn of civilization to the present. This entailed, of course, giving up the glories of the National Gallery in Washington and the Museum of Modern Art in New York, two of the best known museums in the country; and it also meant that I could not get to see special interests of mine, such as the Corning Museum of Glass.

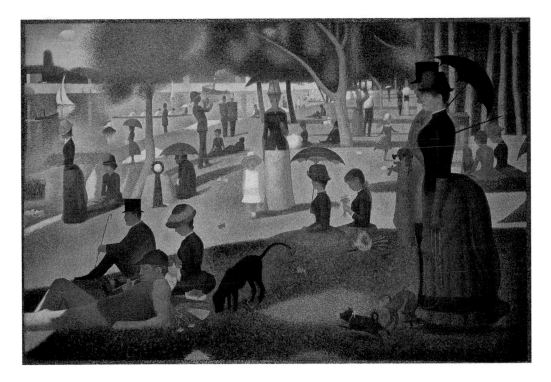

◁ **A Sunday on La Grande Jatte—1884**; 1884–86; Georges Seurat, French (1859–91); Art Institute of Chicago

▽ **Sons of Liberty Bowl**; 1768; Paul Revere, American (1735–1818); Museum of Fine Arts, Boston

▽▽ **Fragmentary Head of a Queen**; 1352–1336 B.C.; Egyptian; Metropolitan Museum of Art, New York

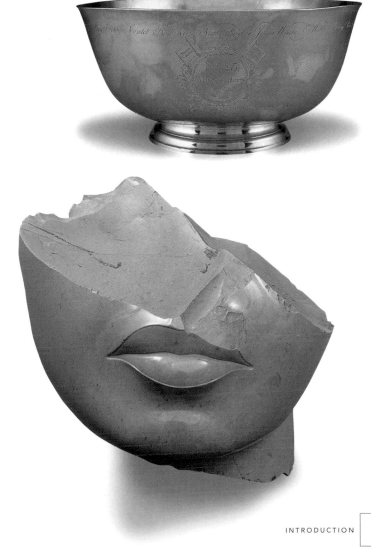

Encyclopedic museums abound, however, in this civilized land, and I needed another limiting factor. It came from the constraints of geography, especially since I knew that there was to be a television series of the book on PBS. (In fact, the entire idea originated with the Boston branch, WGBH.) I needed to cover the country. Some museums chose themselves: nobody could omit the Metropolitan in New York, or the Museum of Fine Arts in Boston, or the Art Institute of Chicago, or the Los Angeles County Museum of Art. These are among the greatest museums in the world. There was, sadly, a downside to this. New York and Boston represented the East, but this part of the country has other great museums that now could not be included. If I went to the Metropolitan, I could not go to the Brooklyn Museum, with its immense holdings of Egyptian art and—a particular love of mine—exquisite masterpieces of late medieval painting. If I chose the M.F.A. at Boston, that ruled out the Fogg, the Sackler, the Isabella Stewart Gardner—the last being one that I dearly love.

The Midwest, which I hazily thought of as "all that land around the Lakes, and down," is also teeming with museums. Several museum directors altruistically recommended Toledo, and I suppose the museum there encapsulates perfectly what I find so praiseworthy in this

▷ **Portrait of the Zen Master Hotto Kokushi;** c. 1286; Japanese; Cleveland Museum of Art

country. Toledo is not one of the great cities, yet it raised for itself a great museum. There is also Kansas City, Missouri: the Nelson-Atkins Museum of Fine Art. If Mrs. Mary Atkins and Mr. William Rockhill Nelson provided the wherewithal, it was the museum's own inspired direction that raised this relatively small city in a relatively poor state to its present status. I always wanted to visit the Nelson-Atkins, but I also always wanted to visit the Cleveland Museum—and the geographical constraints meant that it was one or the other. I admire the Cleveland Museum so deeply that I cannot now afford to think of what I missed in Kansas City, or Detroit, or St. Louis, or Cincinnati, or Pittsburgh.

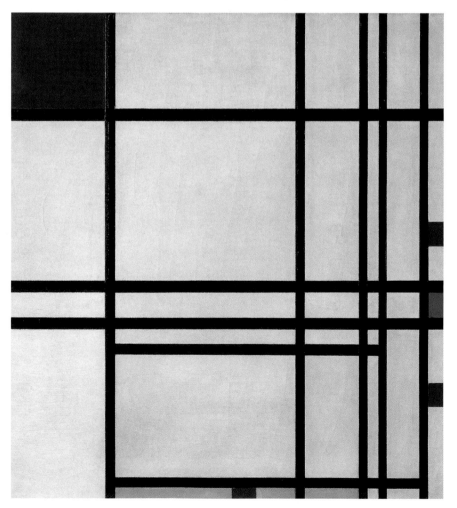

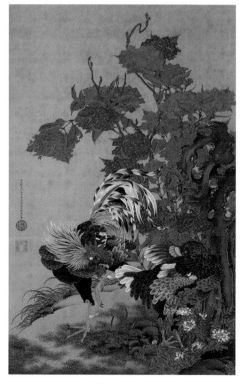

△ **Rooster, Hen, and Hydrangeas;** 18th century; Ito Jakuchu, Japanese (1716–1800); Los Angeles County Museum of Art

◁ **Composition No. 8;** 1939–42; Piet Mondrian, Dutch (1872–1944); Kimbell Art Museum, Fort Worth

All quarters of the compass were now covered except the South, and there my choice was made for me: the Kimbell at Fort Worth, a very small museum in comparison with the others, is probably the nearest such an institution can come to perfection. It is small by design, and one of the greatest achievements in the world.

Here, then, were my six museums. Now the truly daunting business began. Except for the Kimbell—and even that has over three hundred objects—each of these museums had over half a million works (slightly less at Cleveland, slightly more at the Metropolitan), either on view or in storage. Each has produced books of its "treasures," described by Philippe de Montebello, in the latest publication from the Met, as "one tenth of one percent"—and his book has over three hundred pages. I was able to talk about less than one tenth of one tenth of one percent, and around every work illustrated here there glimmer the faint ghosts of the others for which there was no space, no time—not even, in the end, enough energy. (Looking at art is exhausting.)

I have striven to the utmost to share with you the works that most moved me, that made me understand anew what it meant to be a human being living at the turn of this millennial century. We know great art by its effect on us. If we are prepared to look without preconceptions, without defenses, without haste, then art will change us. It will draw us into the vision of some master craftsman: some man or woman, known or unknown, who was exceptionally gifted and who worked with those gifts. We may know a good deal about them, as we do with Rembrandt, for example, or with Georgia O'Keeffe. We may know nothing: who were the potters of these Zuni bowls, or the sculptors who chiseled striding gods out of Mesopotamian stone, or the painters who decorated a wall in the doomed Roman city of Pompeii?

Jewelers, goldsmiths, weavers, carpenters, carvers: as far back as records go, we have been blessed with men and women of genius, who made beautiful things. The intention, until recent times, was not to make "art," but to provide contemporary necessities. Most of the works in our museums were made for worship; they are religious objects. Some were for community ceremonies about which we are often almost entirely ignorant. (African masks, for example—those wonderful creations whose rediscovery galvanized the artists of the early 20th century, and which are now hidden away in ethnological collections—how ignorant we are of their true function; we sense it dimly; we look on in awe, but in darkness.) Other works adorned the home. It seems impossible for our species, thank God, to live happily with the functional and not seek to make it shapely. Chairs, pots, clothes: whatever we need for normal living is susceptible of becoming art—and always will be. There is a measure of unreality in removing objects from their function— whether religious, or ceremonial, or domestic—and setting them reverently on stands in museums, but it is an unreality we can accept. How else?

So then: museums chosen, works chosen; nothing left except to prepare my heart to encounter them, and hope for words with which to speak of them. The essential preliminary is research: a grand word for hours of reading. Then must come hours of looking. Then must come the leap into words, conscious all the time that these words will be inadequate. I would like to hide behind the impossibility of ever finding words to parallel a nonverbal experience, but that is precisely what the good writer does: he or she can conjure up for you exactly what was seen and the impression it made. Here I can only admit to a wretched lack of skill. I have never once felt that I conveyed the wonder of what I was privileged to contemplate—not just for my own benefit, but so that I might share it with you.

I began this introduction thinking about the poverty of a society that does not value museums, but I am ending it thinking of the poverty of words: my own poverty. The consolation is that this book is supremely well illustrated, and I entrust all my deficiencies to the efficiencies of the reproductions. They will bowl you over with joy and pain, and you will long to get yourself together to make your own pilgrimage to the great museums of the United States.

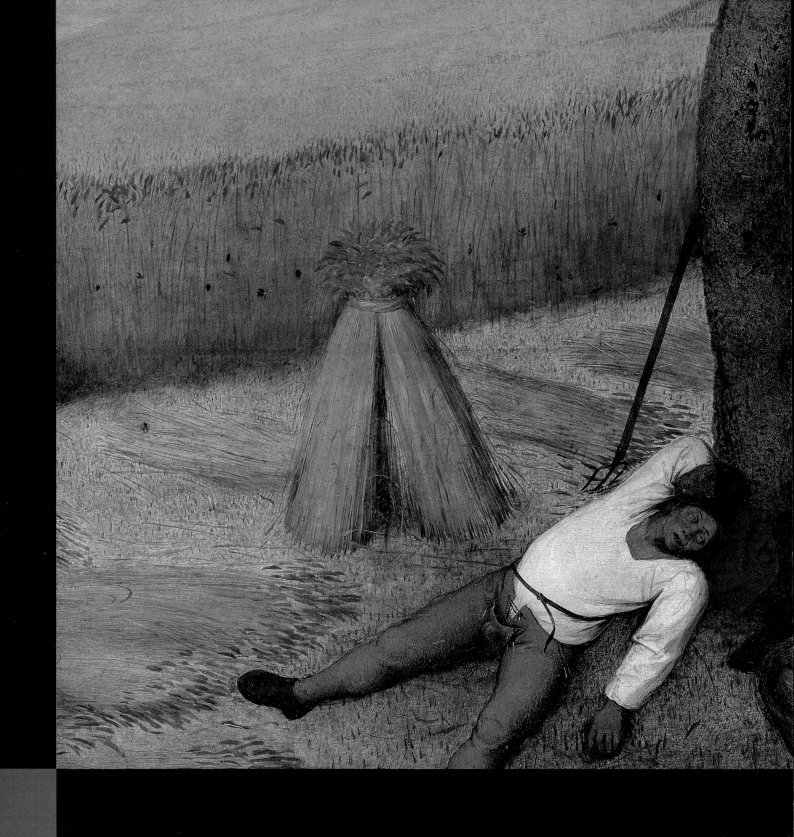

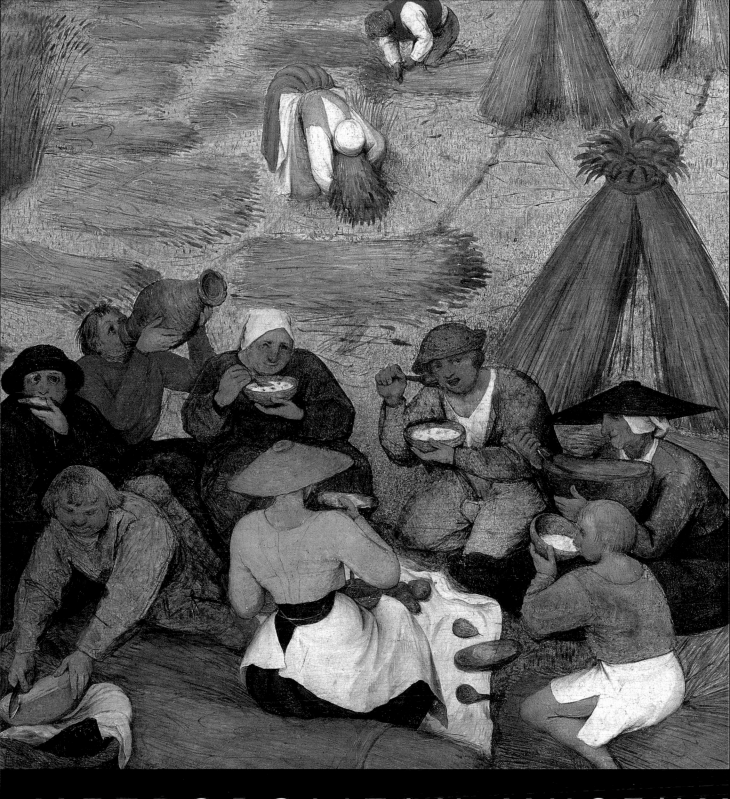

METROPOLITAN MUSEUM

Introduction

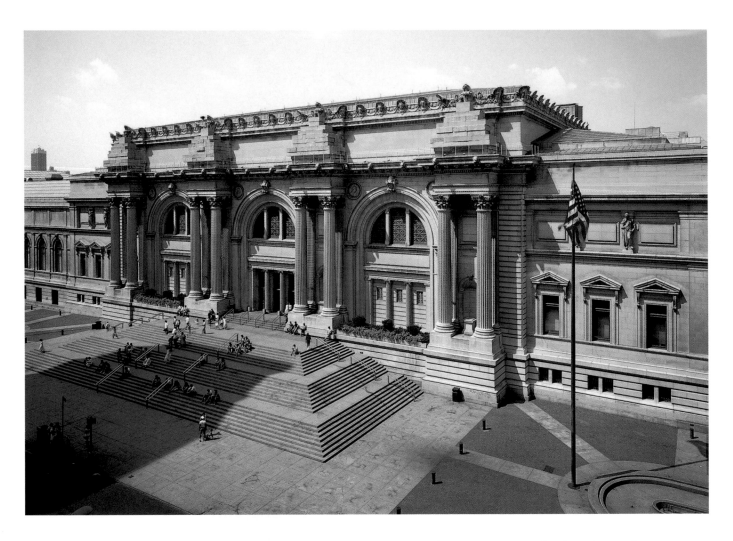

A very large museum can be daunting. In fact, some European museums, such as the Louvre and the Hermitage, which are former palaces, were specifically built to overawe. The eager visitor struggles with the weight of their magnificence, but the Metropolitan—one of the biggest museums in the world—does not daunt, and though its exterior is imposing, it is also welcoming.

It can be approached by a lofty flight of stone steps, but they are usually crammed with people, sitting, talking, eating, or just recalling with pleasure their visit within. The fact that this two million square foot colossus is almost invariably called "the Met" seems to me significant. (Can you imagine Parisians speaking of "the Lou," or St. Petersburgers of "the Herm"?) The space is needed for over two million works of art, covering more

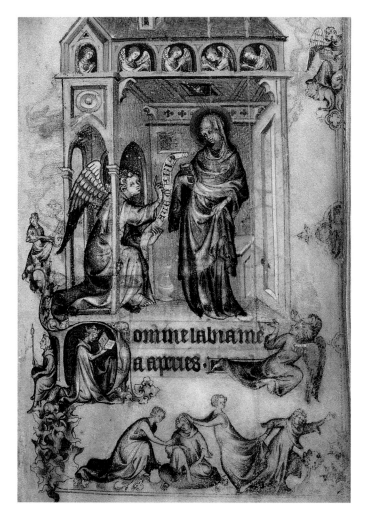

than 5,000 years of human history. To study these masterworks, to care for them, to display them, the Met needs some 1,700 employees, and can call upon another 500 voluntary workers. That last statistic alone indicates how greatly the museum is valued. It is loved, used, and much visited. It would have been easy to write this chapter about any one department—especially, of course, the Cloisters. So rich is the Met's collection of medieval art that there is an auxiliary museum in northern Manhattan, overlooking the Hudson, where entire cloisters and chapels were transported from France and Spain to serve as a silent and contemplative setting for altarpieces, tapestries, murals, sculptures, and sacred vessels.

I think of the Met with great affection, but also with a pang, as so many wonderful exhibits had to be omitted.

▽ **The Book of Hours of Jeanne d'Evreux, Folio 16r: The Annunciation**; 1325–28; Jean Pucelle, French (c. 1300– c. 1355); grisaille and color on vellum; 3½ x 2½ in. (8.9 x 6.4 cm)

△ **Mary and Michael Jaharis Gallery for Greek Art of the 6th–4th centuries** B.C.

Juan de Pareja

VELÁZQUEZ

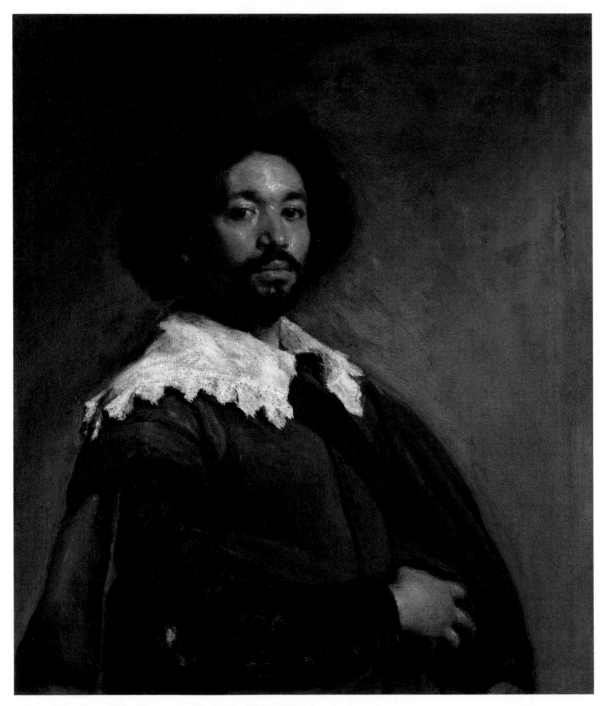

△ **Juan de Pareja**; c. 1650; oil on canvas; 32 x 27½ in. (81.3 x 69.9 cm)

Nearly thirty years ago, when a British earl offered the family's Velázquez for sale, protestors marched from many parts of England and Scotland, pleading with the government to save the piece for Britain, but governments, as we know, are penny-pinching creatures, and so this portrait of a man of North African descent, painted by a Spaniard while residing in Italy, finally came to rest in New York.

The Metropolitan is probably the greatest museum in the world, and I think—daring claim—that this is its greatest painting. Velázquez was only in Italy because the king of Spain wanted him to buy pictures there, and also to paint the Pope. In Madrid, Velázquez was a major figure: the court painter, the king's friend, and a recognized genius. He came to Rome and found himself unknown. It seems to me that, in his well-bred way, Velázquez was a little miffed at this. He was not vain, but he had a good and deserved sense of his own gifts.

Velázquez evidently decided to paint a portrait that would show the Romans what he could do. He chose as his subject his assistant and friend, Juan de Pareja (c. 1610–70). Amazingly, this man was technically a slave; we still have the document of manumission with which Velázquez formally set him free. However, we can see from Velázquez' painting that the two were undeniably equals. That steady look of self-controlled power can even make us wonder which of the two held a higher opinion of himself. It is a daring picture in that it almost eschews the use of color. This is a dark man, with wonderful coppery skin, set against an indeterminate background, where even the rich velvets of the sleeves appear dim.

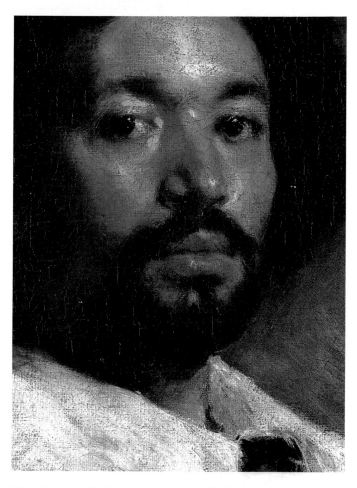

The only marks of color in the painting are the glorious white-lace collar, and the face itself—glowing from within with vitality and strength.

A WONDERFUL SALESMAN

Both Velázquez and de Pareja had a fine sense of public relations, because they agreed that de Pareja would carry his portrait around to every artist in Rome. When the door opened, he would hold it in front of his face before lowering it to let the astonished recipient encounter de Pareja alive. The reaction was unanimous. The saying sped around the city that "All other paintings are art. But this, this is Truth."

BIOGRAPHY

Diego Velázquez
Spanish, 1599–1660

• One of the greatest painters of the 17th century, Velázquez specialized in religious paintings and everyday subjects before turning his hand chiefly to portraiture when he was appointed court painter to Philip IV in 1623.

• Influenced by the realism of Caravaggio and the brushwork of Titian, Velázquez combined acute powers of observation with a mastery of light and shade.

• In later years, Velázquez' brushwork became looser and more impressionistic. He was admired by the impressionists of the 19th century more than any other painter.

> " The Metropolitan is probably the greatest museum in the world, and I think—daring claim—that this is its greatest painting. "

Aristotle with a Bust of Homer

REMBRANDT

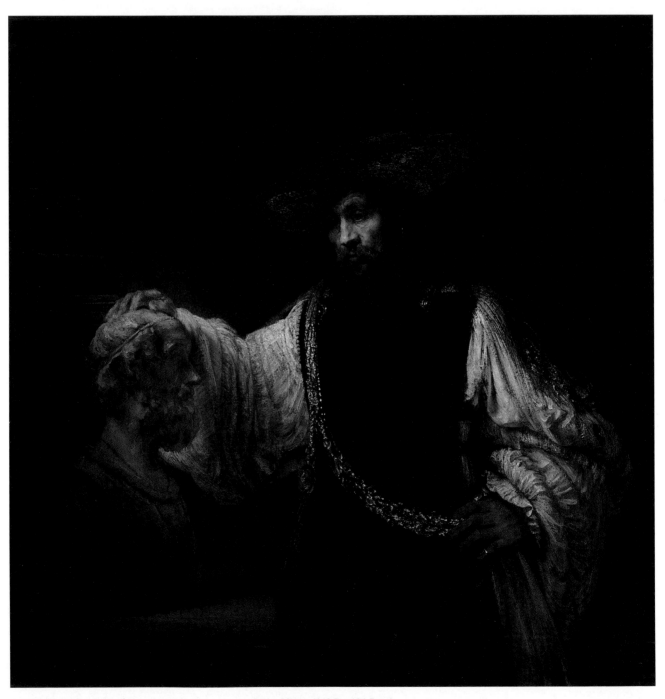

△ **Aristotle with a Bust of Homer;** 1653; oil on canvas; 56½ x 53¾ in. (143.5 x 136.5 cm)

Aristotle's fingers resting on the bust of the blind poet Homer eloquently portray the philosopher's deep contemplation.

Rembrandt had one foreign patron, a Sicilian nobleman, who asked him to paint a philosopher. The request came at a time when Rembrandt had become embroiled in serious financial trouble, and this commission seems to have sparked off some deep inner response. The combination of his personal anxieties and the idea of philosophy drew from Rembrandt one of his greatest masterpieces, in which he contrasts two ways of being a genius.

He ponders visually the importance in life of material success, fame, and power, compared with being true to art. He does so by confronting the greatest Greek philosopher, Aristotle, with the greatest Greek poet, Homer. In the 4th century B.C., philosophy included the whole of science, and Aristotle understood it, integrated and systemized it. He was dazzlingly successful. We see his rich, wide, silken sleeves—those of a man who does not need to work—and, above all, his thick gold chain. The chain was a gift from Aristotle's most prestigious pupil, Alexander the Great, who had left

Aristotle an enormous fortune, but whom the philosopher had failed to influence spiritually.

Rembrandt imagines Aristotle in all his fame and wealth, looking at a bust of the great blind poet Homer. From the meagerness of the bust, we can see that Homer was poor. He wandered around Greece with his harp, playing at evening parties, and earning a pittance. Homer was true to his genius: he made no money from his art, and he did not care. With the medallion, representing both his great material success and his great teaching failure, swinging between them, Aristotle ponders—and Rembrandt with him: What matters most? How can one be certain that one is not selling out? Of course, I can say nothing about Aristotle, but I am certain that Rembrandt never sold out. Perhaps it was precisely these moments of profound self-questioning that kept him pure.

ALEXANDER THE GREAT

Aristotle's gold chain was a gift from his most prestigious pupil, the son of a king of Macedonia, whose medallion is shown dangling from the chain—a quiet third portrait in the painting. The pupil, who came to Aristotle to learn philosophical principles, was Alexander the Great: the man who conquered Greece and disrupted the civilized world, only to die raving because he had no more worlds to conquer. He left Aristotle an enormous fortune, despite his tutor's spectacular failure to exert any spiritual influence over him.

BIOGRAPHY

Rembrandt van Rijn
Dutch, 1606–69

• One of the great painters of the Dutch school, Rembrandt was a master of portraiture. Although his subjects have a real sense of physicality, he was primarily concerned with depicting their inner character. His series of self-portraits, which span 40 years from 1629–69, show Rembrandt's remarkable ability to reveal the person within.

• His paintings use primarily dark tones, and rely on his superb use of light and shade for their dramatic impact.

• As well as painting portraits, Rembrandt excelled as a landscapist and etcher, and produced an enormous number of works, including around 600 paintings, 300 etchings, and 2,000 drawings.

> **"**They set up in the temples small clay images, with big staring eyes and hands tightly clasped: mute witnesses to their human helplessness and their longing for divine intervention.**"**

Gudea

SUMERIAN

Gudea is relatively without secrets. He lived at the end of the 22nd century B.C. in a remote corner of Macedonia, and was the ruling governor of a small city-state named Lagash. Gudea filled his little state with temples containing statues of himself, and there are at least twenty still in existence (this is the only complete statue of Gudea

Gudea's hands, with their very long fingers, are tightly clasped in a gesture that testifies to the anxiety he feels on behalf of his people.

△ **Seated Gudea;** c. 2150–2100 B.C., Neo-Sumerian period; diorite; height 17⅜ in. (44.1 cm)

The seated Gudea is part of a long tradition in Sumerian sculpture. This standing male figure, with its staring eyes and clasped hands, was created around 500–600 years earlier.

△ **Standing Male Figure;** c. 2750–2600 B.C., Early Dynastic II period; white gypsum; height 11⅝ in. (29.5 cm)

in the United States). He did not do this because he was bigheaded; though literally, as you can see, bigheaded is a fair description of him. His head is depicted disproportionately large for a serious religious reason— as governor, it is his responsibility to be ever in the temple, pleading with the gods for his city.

This was a time of great anxiety for Lagash, which felt itself under threat. All Mesopotamians seem to have experienced an intense need to propitiate their divinities. They set up in the temples small clay images, with big staring eyes and hands tightly clasped: mute witnesses to their human helplessness and their longing for divine intervention. Gudea had himself set before the altars, not for himself, but for the people. He was not a king; he wears the woolen hat of a governor. We hardly notice his garments, however, so intense is the impression of strain. He is rigid, his body coiled into a knot of passionate prayer. His face is calm and he demonstrates his faith to his city, but his hands are locked in a clasp that is impossible to duplicate. This is a symbolic gesture, testifying to his anxiety.

The happy outcome is that when this worried pastor died in 2124 B.C., he was able to hand Lagash over to his son (who also put up statues of himself). Amid all the tempests and turmoils taking place in the ancient Mesopotamian world, he had kept his little city safe. Those anxieties and that relief are still real—even though they were experienced 4,000 years ago.

Hatshepsut

EGYPTIAN

Hatshepsut's story starts conventionally. She was the eldest daughter of Tuthmosis I, whom she revered, and she married (as was the custom) her half-brother Tuthmosis II. When he died—apparently unlamented—she became regent to his child by another wife: a son who would become Tuthmosis III. To be queen regent was not unusual, but for her, it was not enough. For whatever reason, she suddenly decided to "go for gold": to be king and not queen. What makes her action so astonishing is that the Egyptian pharaoh was not just the ruler of the country; in some mystical way, the pharaoh was the country. No other Egyptian could speak to the gods, because the pharaoh alone possessed a seed of divinity. If there was a bad or even an eccentric pharaoh, of whom the gods disapproved, things went ill with Egypt; there would be famines, military defeat, public unhappiness. So it was crucial for Hatshepsut to show that she was a perfectly acceptable—in fact, a superior—pharaoh.

Hatshepsut wrote: "The King Hatshepsut, she lives, she lasts, she is full of joy, she will live forever, eternal as the sun god." Of course, she did not last, nor did she live forever. After about twenty years of power, she seems to have died naturally; and out of the shadows came Ramses III, who became one of the greatest of the pharaohs. As soon as he ascended the throne, there began a concentrated effort to expunge Hatshepsut from history. She was wiped from the list of pharaohs; her temples were given over to another; her statues were smashed and thrown into a pit.

The delicate, girlish, and yet regal figure of Hatshepsut enthroned is one of the few that remain—

◁ **Hatshepsut Enthroned**; c. 1503–1482 B.C., 18th dynasty; painted indurated limestone; height 76¾ in. (194.9 cm)

> **"I cannot help thinking, as I look at these noble fragments, how furious Hatshepsut would be if she knew the fate of her legacy!"**

though even this is not intact. All around the room where she stands are fragments: great heads that once topped pillars in her temples; and a splendid sphinx—half-lion, half-pharaoh. Some of the faces are so damaged that we can barely make out who she is. Pathetically, she left an inscription in which she says: "I cast my mind here and there, wondering what people will say in the years to come when they see my monuments." Battered though many of them are—or almost whole, as the beautiful enthroned statue is—we can still see Hatshepsut's monuments. Here at the Met, in fact, is her true monument, lovingly excavated and restored. Everything here is magnificent, but I cannot help thinking, as I look at these noble fragments, how furious Hatshepsut would be if she knew the fate of her legacy!

Queen Hatshepsut was portrayed in many forms: in traditional male pharaonic garb (far left); as a sphinx, the protector of sacred places (below); and as Osiris, god of the underworld and divine judgment (right).

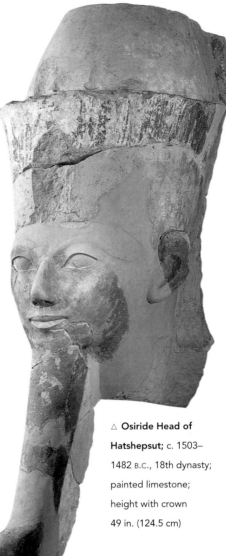

△ **Osiride Head of Hatshepsut;** c. 1503–1482 B.C., 18th dynasty; painted limestone; height with crown 49 in. (124.5 cm)

◁ **Sphinx of Hatshepsut;** c. 1503–1482 B.C., 18th dynasty; red granite; height 64½ in. (164 cm), length as restored 135 in. (343 cm)

HATSHEPSUT'S GLORY

Hatshepsut invented the story that her mother had received a divine annunciation that her daughter was the child of a god. She showed herself to her people in traditional pharaonic garb: the little beard (artificial even for a male), the kilt, and the symbolic headdress. Yet she never pretended to be a man. She was a female pharaoh—and she was very good at it. She filled the country with wonderful works of art. To make up for not fighting any battles, she sent an enormously successful expedition to Punt in Somalia. Egypt reveled in the goods that the expedition brought back: gold, ivory, silver, jewels, ebony, frankincense, and myrrh—not to mention the Somalian monkeys, which were a triumph in themselves.

Aquamanile: Aristotle and Phyllis

FRENCH

This delightful exercise in *lèse-majesté*, in all its polished irreverence, is typical of the Middle Ages. Whenever I find myself lamenting that I did not live in those days, I remind myself that the sanitary arrangements were unspeakable. There were at least two occasions, however, when hands were ceremoniously washed. One was religious: by the priest at Mass. The other was social: by guests at dinner. For this, an elaborate pitcher, known as an aquamanile, was used. Around 1400, a sculptor in France had enormous fun decorating a superb aquamanile with the story of Aristotle and Phyllis.

In this tale of pure invention, Alexander the Great was said to have fallen passionately in love with an Indian woman named Phyllis. Aristotle, who was Alexander's tutor, pointed out that the conqueror was neglecting his army for his lady love, and persuaded him to

end the relationship. The aquamanile shows how Phyllis took revenge against Aristotle. However, Aristotle used the event as proof that even he—wise, old, and experienced—was helpless against the power of a determined woman; how much more, then, a handsome young hero like Alexander? Sadly, it was the chauvinism of the story that made it popular. Nevertheless, I defy any feminist not to smile at Phyllis the dominatrix, tugging at Aristotle's beard and patting him condescendingly on the rump. It is politically incorrect—but a superb work of art.

> **" I defy any feminist not to smile at Phyllis the dominatrix, tugging at Aristotle's beard and patting him condescendingly on the rump. "**

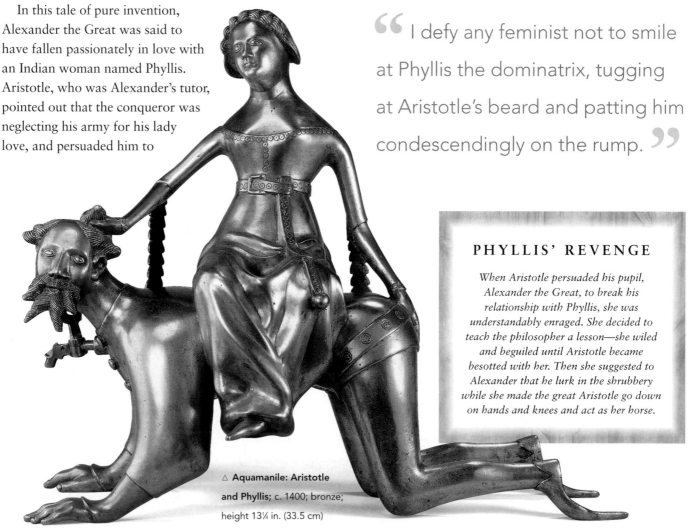

△ **Aquamanile: Aristotle and Phyllis**; c. 1400; bronze; height 13¼ in. (33.5 cm)

PHYLLIS' REVENGE

When Aristotle persuaded his pupil, Alexander the Great, to break his relationship with Phyllis, she was understandably enraged. She decided to teach the philosopher a lesson—she wiled and beguiled until Aristotle became besotted with her. Then she suggested to Alexander that he lurk in the shrubbery while she made the great Aristotle go down on hands and knees and act as her horse.

Kneeling Bull Holding Vessel

IRANIAN

We have probably all had the experience of being in the street or the supermarket, and overhearing a snatch of conversation somewhere behind us. It can be an intriguing fragment, reminding us of the lives going on all around us. We would love to know what those unknowns were talking about, and we realize that we never will; theirs will remain a private world into which we briefly intruded. That is how I feel about this exquisite little silver bull. He comes from the third millennium B.C. in the Near East: a small but stately figure that seems to know exactly what he is doing—but we do not. Does he represent a myth, in which animals acted as humans? Is he an animal god? Or does the long vase with its spout serve a liturgical purpose that is the real focus of the piece, and is the bull merely an elaborate handle? For us, it does not really matter. The piece is self-contained; the bull is tranquil and controlled. He seems wrapped in an awareness of his own significance, from which we are forever excluded—but then, what right have we to know everybody's secrets?

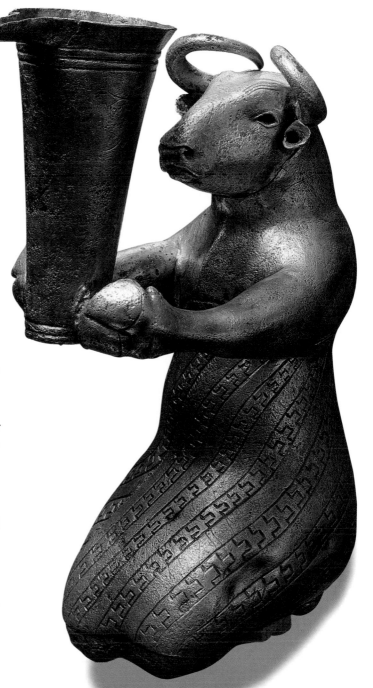

△ **Kneeling Bull Holding Vessel**; c. 2900 B.C., Proto-Elamite period; silver; height 6⅜ in. (16.3 cm), width 2½ in. (6.3 cm)

Ugolino and His Sons

CARPEAUX

Perhaps if Carpeaux had made a painting of Ugolino, we would walk past it, unaffected, because it would be distanced from us, on a wall. Instead, however, he made a sculpture, and it invades our space, forcing our attention. Sculpture is physically present—and in a way, this huge work is all about physicality. It is a meditation on what it means to have a body. It is a courageous work, created by a young and ambitious artist, who took on that great sculptural challenge: narrative.

The story of Ugolino is a terrible one. Even without knowing it, you might guess that it concerns a father and his children. Furthermore, the way those bodies are huddled together might suggest that they are in prison. Ugolino is a man suffering emotionally, because he is a father—a strong, protective father—who cannot save his children. The son who is still conscious looks at his father with a heart-rending expression of reproach and bewilderment. There is bodily suffering also, because he

is dying from the cramps of starvation. Worst of all, there is moral suffering; we can tell, from the way Ugolino gnaws at his fingers, that he has already thought of that last, appalling temptation. There are cultures where cannibalism has an honored place. For us, it is the final taboo. Carpeaux spares us the sight of those last animal-like moments, but he compresses all of the horror into this one anguished scene.

This entire story is told only through the body: the beautiful bodies of the sons—one dead and three dying; and the ugly, extravagant, tortured body of the father. He has an enormous back, hunched and convulsed with strain; all of his muscles stand out like knotted cords; and his face is so hideous with emotion that one hardly dares to look at it. Guilt, remorse, temptation: each is here in an extreme form—but sadly none of them is unfamiliar to any of us. This could be one of the ultimate sculptures: a work that we cannot like, yet must respect and remember.

THE STORY OF UGOLINO

The story comes from Dante's Inferno. *Count Ugolino of Pisa was suspected of treachery, and his enemies imprisoned him and his sons in a tower, where they left them to die of starvation. The most horrifying part comes at the end. For two days after the last son died, says Dante, Ugolino mourned; and then, "Grief was less strong than hunger."*

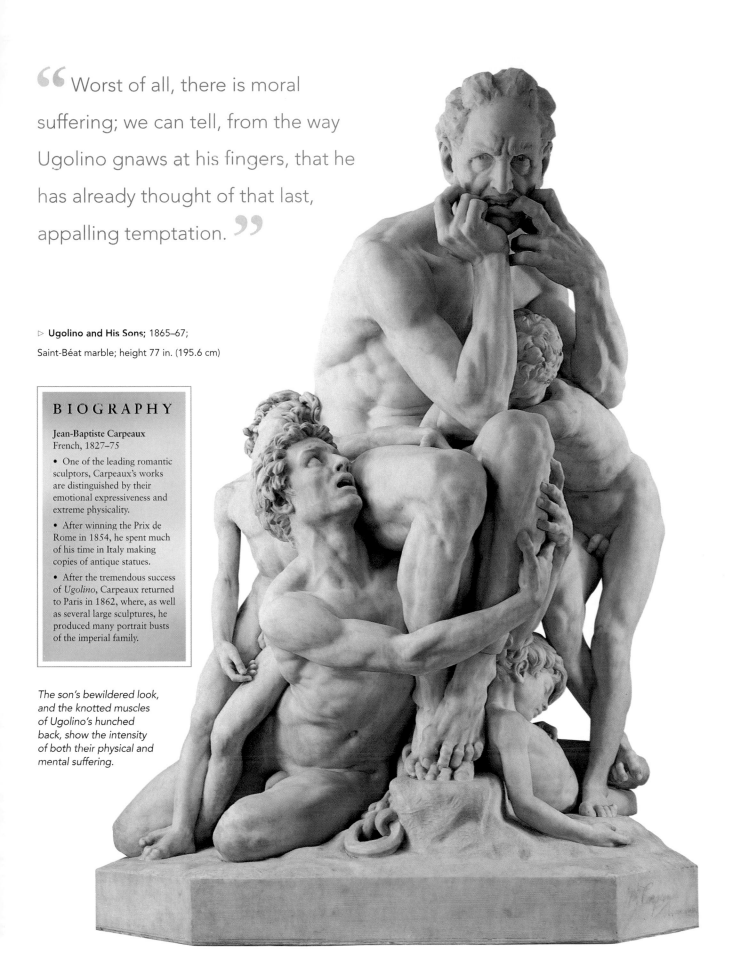

> **❝** Worst of all, there is moral suffering; we can tell, from the way Ugolino gnaws at his fingers, that he has already thought of that last, appalling temptation. **❞**

▷ **Ugolino and His Sons;** 1865–67;
Saint-Béat marble; height 77 in. (195.6 cm)

BIOGRAPHY

Jean-Baptiste Carpeaux
French, 1827–75

• One of the leading romantic sculptors, Carpeaux's works are distinguished by their emotional expressiveness and extreme physicality.

• After winning the Prix de Rome in 1854, he spent much of his time in Italy making copies of antique statues.

• After the tremendous success of *Ugolino*, Carpeaux returned to Paris in 1862, where, as well as several large sculptures, he produced many portrait busts of the imperial family.

The son's bewildered look, and the knotted muscles of Ugolino's hunched back, show the intensity of both their physical and mental suffering.

The Rape of Persephone

ITALIAN

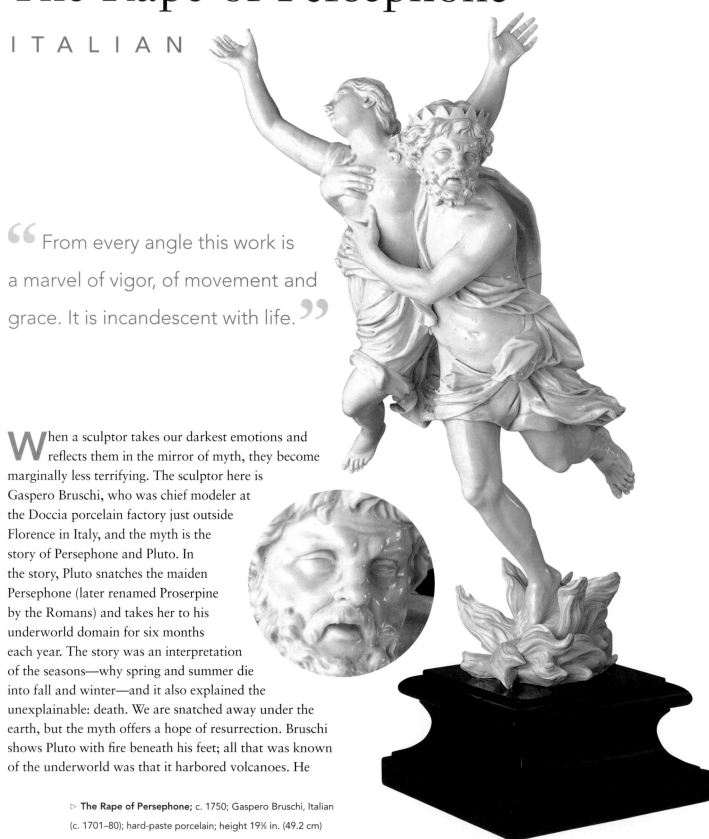

> " From every angle this work is a marvel of vigor, of movement and grace. It is incandescent with life. "

When a sculptor takes our darkest emotions and reflects them in the mirror of myth, they become marginally less terrifying. The sculptor here is Gaspero Bruschi, who was chief modeler at the Doccia porcelain factory just outside Florence in Italy, and the myth is the story of Persephone and Pluto. In the story, Pluto snatches the maiden Persephone (later renamed Proserpine by the Romans) and takes her to his underworld domain for six months each year. The story was an interpretation of the seasons—why spring and summer die into fall and winter—and it also explained the unexplainable: death. We are snatched away under the earth, but the myth offers a hope of resurrection. Bruschi shows Pluto with fire beneath his feet; all that was known of the underworld was that it harbored volcanoes. He

▷ **The Rape of Persephone;** c. 1750; Gaspero Bruschi, Italian (c. 1701–80); hard-paste porcelain; height 19⅜ in. (49.2 cm)

PERSEPHONE AND PLUTO

*The Greeks and Romans thought there were three gods
who ruled the world: Neptune, lord of the sea; Jupiter, lord
of the sky; and Pluto, the ruler of Hades, the underworld.
Earth's fertility was the domain of Flora, who had one
maiden daughter, Persephone. Persephone was wandering
in a meadow picking flowers when Pluto erupted from
the underworld, snatched her, and disappeared. For six
months Flora mourned, searching for her child; and the
earth died. Then suddenly, Persephone returned—but only
for six months each year. After that, she was doomed
to return to her dark lover, beneath the earth.*

*Bruschi and Foggini's works have
both similarities and differences.
In both, Pluto dares not look
at the maiden he is violating.
However, while Persephone's
breast is modestly covered in
the bronze, Bruschi strips it
bare. Despite this vulnerability,
however, Pluto seems to bracket
her small breast with respect
rather than with violence.*

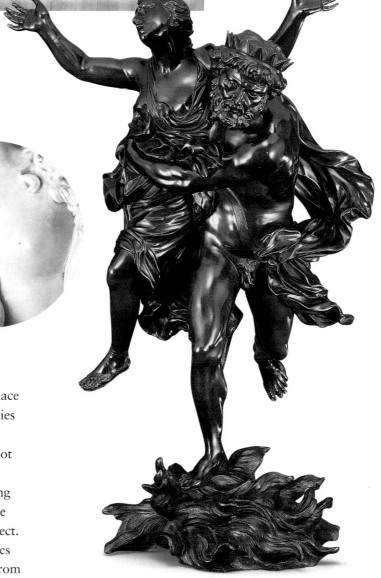

hardly dares look at the girl he
abducts with implacable lust; it is
not yet a rape in the modern sense
of the word—but soon will be.

Bruschi modeled his piece on an
earlier work in bronze by another Italian
artist, Giovanni Battista Foggini. There are significant
differences. Not only does the soft, milky radiance
of porcelain (one of the loveliest artistic mediums) replace
the hard darkness of bronze, but the shapes of the bodies
are subtly different. Bruschi changes the legs, so that,
instead of being parallel, they are opposed—this will not
be a happy union. Foggini has Persephone's breast
modestly covered, but Bruschi strips it bare. She is being
seized with violence, yet she is not violated, because the
god's hands bracket that small breast almost with respect.
The suggestion is that whatever death does to us, it does
not destroy our integrity: we go down into it whole. From
every angle this work is a marvel of vigor, of movement
and grace. It is incandescent with life. It may be small, but
artistically it is very great.

△ **The Rape of Proserpine by Pluto;** 1702; Giovanni Battista
Foggini, Italian (1652–1725); bronze; height 21½ in. (54.5 cm)
© Art Gallery of Ontario/Musée des Beaux-Arts de l'Ontario

Nymphenburg Figures from the Commedia dell'Arte

GERMAN

Franz Anton Bustelli, the chief modeler at the Nymphenburg porcelain factory in Germany, was fascinated by the band of wandering comedians known as the commedia dell'arte. They portrayed stock characters and plots but improvised their dialogue. He started by making two figures, Harlequin and Columbine, responding to each other in dance. The Met has only the Columbine: all flirtatious grace, but (I regret to say)

making a very vulgar Neapolitan gesture at Harlequin. That saucy twiddle to her hat repays his even ruder gesture; she is giving him "the cuckold's horns." After these figures, Bustelli was encouraged to make sixteen more (eight pairs), and the Met has five of them, including an interrelating pair, Harlequin and Columbine. Harlequin holds a monkey dressed as a baby, and Columbine dances forward with food for it. We can see

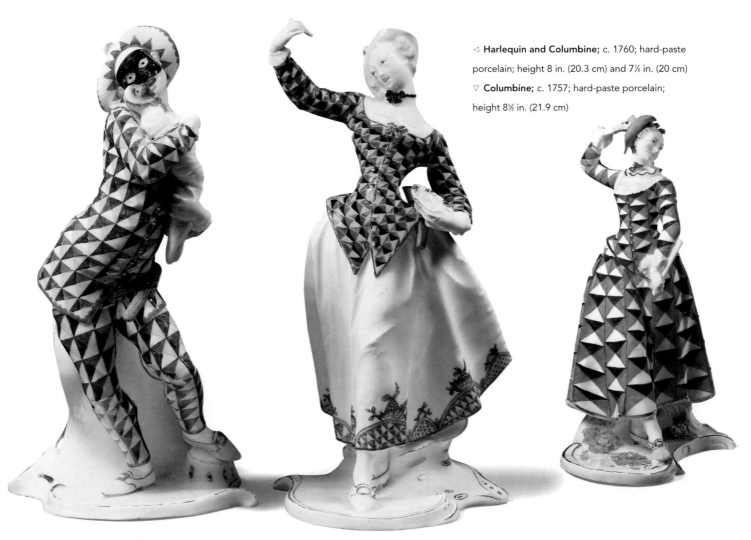

◁ **Harlequin and Columbine;** c. 1760; hard-paste porcelain; height 8 in. (20.3 cm) and 7⅞ in. (20 cm)
▽ **Columbine;** c. 1757; hard-paste porcelain; height 8⅝ in. (21.9 cm)

that they are part of some enchanting adventure, and that they are having glorious fun. As Harlequin dandles and Columbine whirls, it is clear that Bustelli's much-praised grace is not effeminate. His figures have strong athletic bodies; balletic bodies, poised to dance through life.

There is also Pantaloon, the miser: old, lascivious, without a wife but wanting one. He flirts with all of the maids, and weasels his way around, sticking out his stomach—every line proclaiming what he is: obsequious yet proud. Donna Martina is the doctor's wife, the only person in the comedy who does not get involved in amorous escapades. She dances, but in her own space; and though she holds a flagon of wine, she pours it for the others and only sips it herself. Lucinda, by contrast, is enraptured by Pierrot, and clasps his rose to her heart. She gestures him to come away, but her face tells us that she is not certain of his love. Those are questioning eyebrows, and there is a beseeching curve to those rosy lips.

Bustelli, who himself possessed so little, clothed the creatures of his alternative world with the utmost magnificence; they glitter in silks, satins, and brocade. This is a world of springtime, where all will end with smiles. It is a vision of life as a state of lighthearted grace—and I am grateful to share it.

“ **Bustelli, who himself possessed so little, clothed the creatures of his alternative world with the utmost magnificence; they glitter in silks, satins, and brocade.** ”

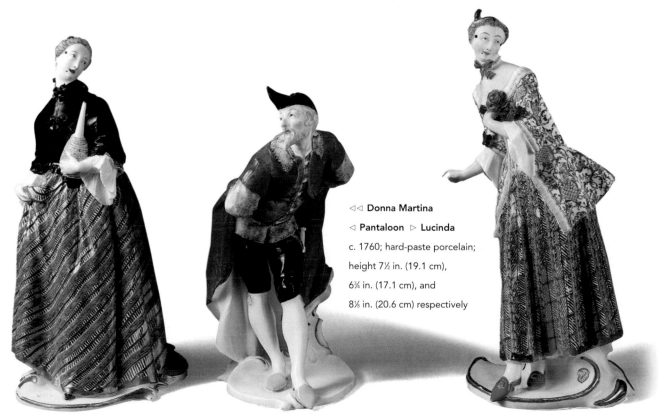

◁◁ **Donna Martina**
◁ **Pantaloon** ▷ **Lucinda**
c. 1760; hard-paste porcelain;
height 7½ in. (19.1 cm),
6¾ in. (17.1 cm), and
8⅛ in. (20.6 cm) respectively

Mezzetin

WATTEAU

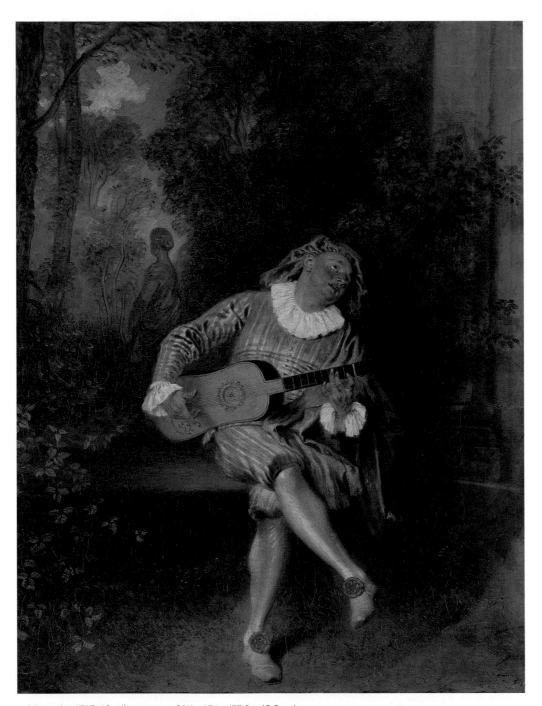

△ **Mezzetin**; 1717–19; oil on canvas; 21¾ x 17 in. (55.2 x 43.2 cm)

Watteau was preoccupied with the nature of reality. The figure of Mezzetin is vividly real—his head turned away in longing, his agile fingers on the neck of the guitar, his flushed face and neck—unlike the woman behind him, who is merely a painting of a statue. Mezzetin is not what he seems, however: Watteau depicts him as a poignant figure full of sorrow and pain, despite his theatrical costume of buffoonery.

Watteau is the artist of the wistful—of that longing for the unattainable. To call him a witness to the wistful sounds somewhat contrived, yet he was a perpetual onlooker. He was a sickly man, who died young—not long after he painted this picture. He never "belonged," and that sense of alienation is evident. Outsider though he was, he painted scenes of social merrymaking, especially portrayals of that zany and exhilarating company, the commedia dell'arte. Like Bustelli, who was enthralled by these actors (his porcelain figures are pictured on pages 28–9), Watteau responded in depth to their grace, but in his case, there is always an undertone of sadness. In *Mezzetin*, the wistful has deepened into the sorrowful. Mezzetin was a comic character, the valet, a buffoon who never got the girl. Dress up though he might, he always failed; and the rest of the cast laughed him to scorn.

Watteau shows Mezzetin in a stage set, with an obvious backdrop behind him. The woman in the picture typically has her back to him—but she is only a statue, and as a painted statue (this is only a backdrop, remember), she is all the more remote from reality. Watteau plays off that exquisite remoteness against the actuality of Mezzetin. When we get past the beauty of those clothes, and the silly rosettes and the funny hat, we encounter a strong male animal—and a creature in pain. Look at the nervous passion of his fingers as they play the guitar; the vigorous shoulders turned away in longing; the bull neck flushed; and the five o'clock shadow on the big red face. It takes time to look past the vivid physicalities of the scene and register the personal sorrow. Watteau seems to be questioning whether the situation is, after all, so

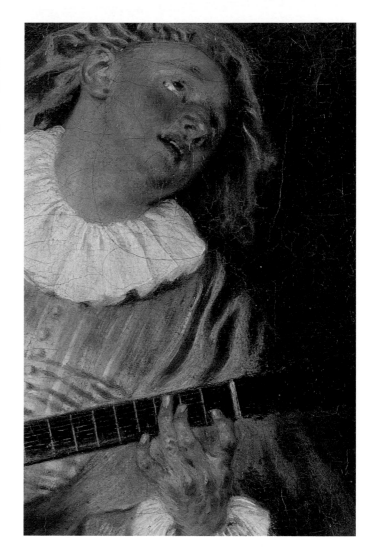

hilarious. He asks us also, I think, to consider the differences between the way we are seen, the way we present ourselves, and the way we really are. These are questions that have no answers, but Watteau poses them with a startling poignancy.

> " It takes time to look past the vivid physicalities of the scene and register the personal sorrow. Watteau seems to be questioning whether the situation is, after all, so hilarious. "

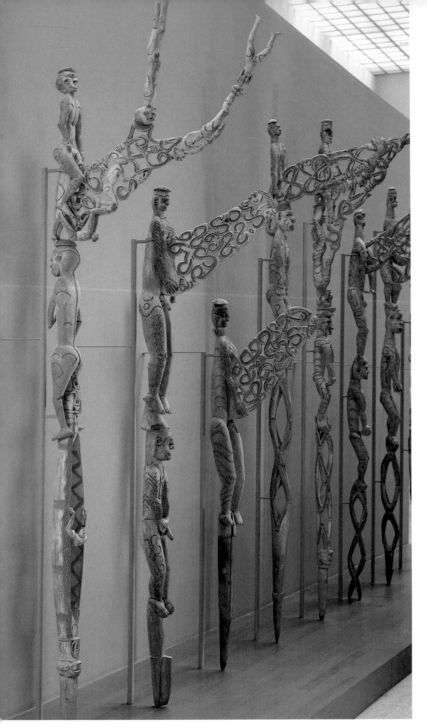

△ **Bis Poles;** 20th century, Asmat people; wood, lime, charcoal, ocher, and fiber

THE BIS CEREMONY

First, men went into the forest to "kill" a mangrove tree. The root was carefully preserved, because it would be the prow of the pole-canoe. While the artists carved the pole, the warriors went off to headhunt, and when the pole was ready, the heads were wedged into it. There followed a grand, uninhibited feast, as a result of which it was hoped children would be born, canceling death with the blessing of fertility.

" The bis pole was a gigantic and inspiring work of art, but it also had a spiritual function. "

Bis Poles

NEW GUINEA

Many galleries at the Met are devoted to civilizations that are alien to us, and no gallery is to me more eerie than that of the Oceanic cultures. The Asmat were a group of people who lived in New Guinea. They evolved an intricate theology, with certain fundamental beliefs. One was that no death was ever natural; it was always caused by a headhunter or a sorcerer. (Before you smile, ask yourself whether you feel emotionally that you will die, or whether you merely know it intellectually. Does not death always seem "wrong," or unnatural?) The Asmat also believed that death upset the balance of the world, and that it was their duty to set it right. They thought that there were three modes of being. There was life on earth, as we know it. There was death, into which you moved in a spirit canoe. Finally, provided the bis ceremony was performed, during which the bis pole was created, there was entry to the world of the ancestors, from which you could influence those still alive.

After the ceremony, the bis pole was planted in the forest and left, because it had done its liturgical work. Fortunately, a few survived, for us to contemplate. At the base is the peg that planted the pole. Above is a tiny canoe, which represents the receptive and female element. Then come the ancestors, crowned by the great prow that symbolizes male fertility and rears confidently up to the heavens. The Asmat were well aware that the bis pole was a gigantic and inspiring work of art, but it also had a spiritual function, and it was this function that mattered most. If it seems strange to us, do we not find common ground in our own struggles with the mystery of death?

Head of an Iyoba

NIGERIAN

Some societies—such as the Celts, the Romans, and the Oceanic peoples—are fascinated by the head. This interest can exhibit itself in a certain amount of ax-wielding, but as in the case of the Benin of Nigeria, it can express an awareness that the head shows what we are, as nations and as individuals. The kingdom of the Benin can be traced to 1300. In their early days, they did indeed wield the ax, and the heads on their altars were human. Over the centuries, however, they developed into sophisticates who understood the importance of commemorative art. They had an intense interest in history, and because they worked in durable metal, their art survived. They cast copper alloys, most commonly brass, with a skill that perhaps only the Chinese matched, and their dark, gleaming copper looks so like bronze that their sculptures are known as "Benin bronzes."

This is the head of a queen mother, the Iyoba. The proud self-sufficiency of this head hints at the consciousness of a rare and special status. This could be a head of the Oba himself—the ruler of Benin—were it not that the headgear tilts. All else is sacred to the Oba, in whose mystique his mother shared: the strings of taboo coral, for example, and the copper around the neck. It is

THE CULT OF THE IYOBA

The Iyoba, or queen mother, was regarded as sacred. Once her son was enthroned, she was moved to a special area where she reigned as chief, with powers of life and death. She had an altar on which were sacrificed roosters, the bird reserved to the male, since she was perceived as bridging the sexes.

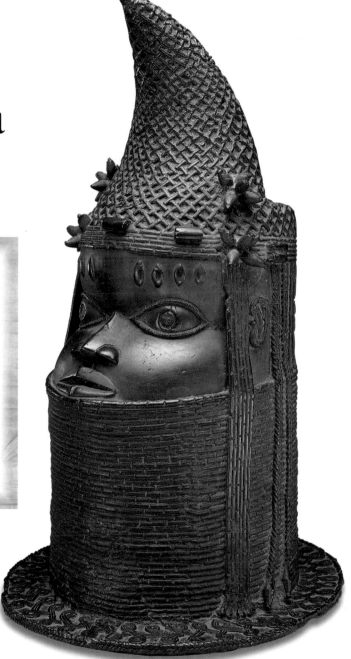

△ **Head of an Iyoba;** 18th–19th century, Court of Benin; brass and iron; height 21 in. (53.3 cm)

a work of stylized perfection, with intricate arabesques around the base and a looming sense of power. It is not the portrait of a person, but of power. In every sense, this is a work of great weight.

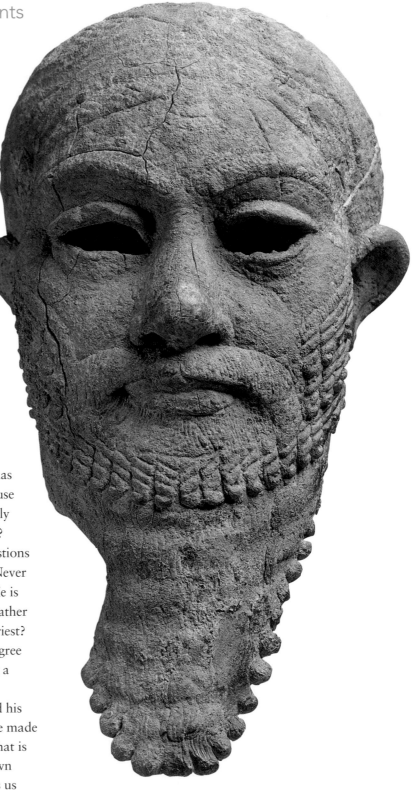

> " Here is an unknown man, centuries remote from us, yet he still confronts us with imperishable dignity, and assures us of the indestructibility of the human spirit. "

Head of a Dignitary

IRANIAN

This male head—obviously that of a dignitary—has given happy occupation to many scholars, because they cannot agree on its date and origin. It is certainly B.C., but is it the third millennium or nearer the first? It is clearly from Iran, but where in Iran? These questions lead to another: who is this impressive personage? Never mind not knowing his name, but what is his role? He is probably not a king, since he wears no crown, but rather a unique cloth cap with ribbons around it. Is he a priest? General? Sage? Philosopher? One thing we can all agree on is that whoever made this work was not creating a symbolic head. This is a real person. We can see the wrinkles on his brow, the strength of his mouth, and his prominent ears. Even without the inlays, which once made the eyes dramatic, the head challenges us. Perhaps that is the essential marvel of this work. Here is an unknown man, centuries remote from us, yet he still confronts us with imperishable dignity, and assures us of the indestructibility of the human spirit.

△ **Head of a Dignitary**; c. 2000 B.C.; arsenical copper; height 13½ in. (34.3 cm)

Fragmentary Head of a Queen

EGYPTIAN

Some works of art, such as this head of an Egyptian queen, are so purely, absolutely beautiful that all we want to do is look at them in silence. There are, however, three thoughts that occur to me. First, this head is carved from yellow jasper—an incredibly hard stone. The unknown sculptor who created a flow of grace and perfection with such seeming ease must have been a genius. Second, although scholars think that this artist lived about the middle of the second millennium B.C., they are not sure who the queen was. I wonder if there was a real-life model, or if this was an ideal that the sculptor dreamed up as the perfect wife for his divine pharaoh? A final, sad thought: the break in the sculpture—a terrible mutilation—happened hundreds or thousands of years ago, but we are the first civilization that can see it almost as an enhancement. We in our time respond to the mutilated. Many contemporary artists make something and then break or half-destroy it. This gives them a feeling of control; it takes away the terror of perfection—its apparent unreality. So we can look at this fragment of a head and admire the contrast between the polished jasper and the rough and darker interior of the stone. We can take artistic pleasure in the jaggedness of the crack, opposed to the ineffable smoothness and grace of the chin and lips. Although we lament the disfigurement, it makes an aesthetic whole to which we respond with admiration.

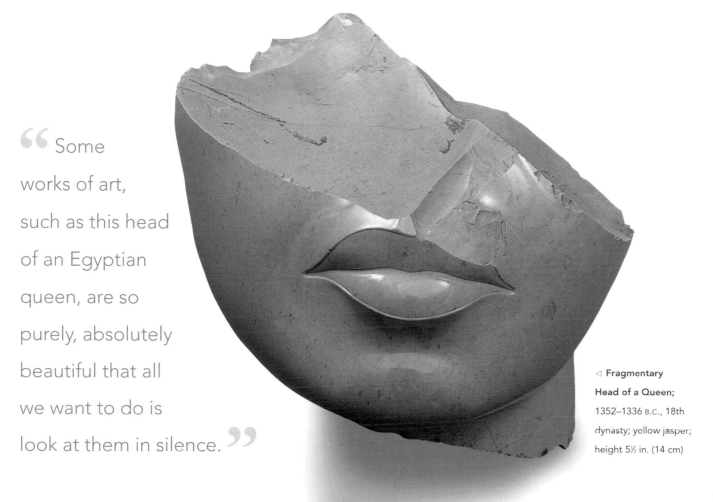

" Some works of art, such as this head of an Egyptian queen, are so purely, absolutely beautiful that all we want to do is look at them in silence. **"**

◁ **Fragmentary Head of a Queen;** 1352–1336 B.C., 18th dynasty; yellow jasper; height 5½ in. (14 cm)

The Harvesters

BRUEGEL THE ELDER

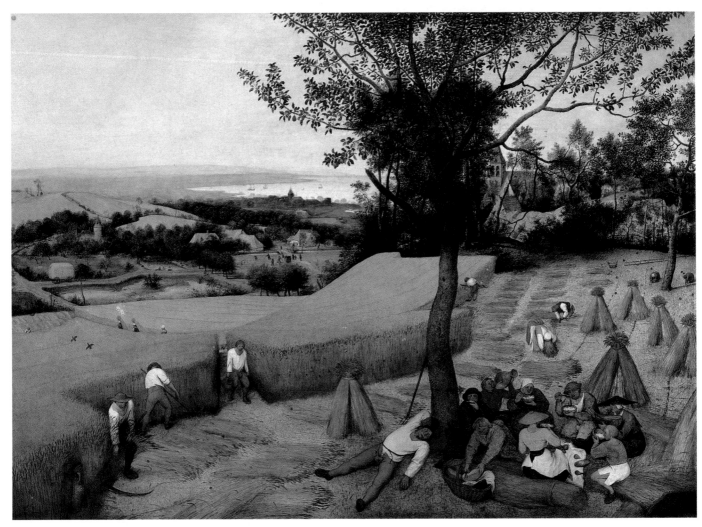

△ **The Harvesters;** 1565; oil on wood; 46½ x 63¼ in. (118 x 160.7 cm)

" No other landscape artist has treated a landscape
with such intellectual subtlety, yet Bruegel states nothing.
He simply stirs us into receptivity. "

Bruegel is the most deceptive of the old masters; his work looks so simple, yet is infinitely profound. *The Harvesters* is one of a series of paintings representing the months. Five of the series remain, and in Vienna, you can view three of them on one long wall in the Kunsthistorisches museum (which is lucky enough to own another eleven of Bruegel's paintings, representing nearly a third of his surviving works). Seeing the three in all of their majesty—each a world in itself—made me doubt Bruegel's wisdom in attempting a series. Each one is overwhelming, though it is easier to feel its impact than to explain it.

The Harvesters is basically, I think, a visual meditation on the near and the far. The near is the harvesters themselves—painted as only Bruegel can paint. He shows us real people: the man slumped with exhaustion, or intoxication; the hungry eaters; the men finishing off their work before their noontime break. Yet he caricatures them just slightly. He sees a woman with grain-like hair, and women walking through the fields like moving grain stacks. He smiles, but he also sighs. There is not a sentimental hair on Bruegel's paintbrush, but nobody has more compassion for the harsh life of the peasant. His faces are those of people who are almost brutalized— vacant faces with little to communicate.

He sets this "near" in the wonder of the "far": the rolling world of corn and wood, of small hills spreading in sunlit glory to the misty remoteness of the harbor. Into this distance, the peasants disappear, swallowed up. They cannot see it, but we—aloft with the artist—can see it for what it is: the beautiful world in which we are privileged to live. He makes us aware not just of space, but of spaciousness—an immensely satisfying, potential earthly paradise. No other landscape artist has treated a landscape with such intellectual subtlety, yet Bruegel states nothing. He simply stirs us into receptivity.

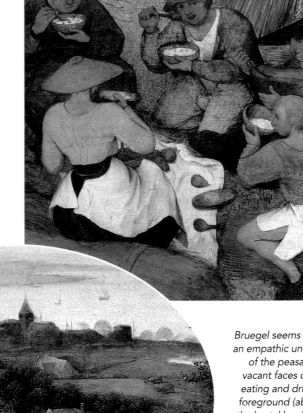

Bruegel seems to have had an empathic understanding of the peasant's lot. The vacant faces of the group eating and drinking in the foreground (above) reflect the brutal hardship of their lives. The harbor in the distance (left) represents a world of beauty they cannot see and will never reach. The man emerging from the fields (below) slumps heavily as he walks, weighed down by a lifetime of heavy toil.

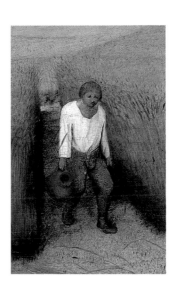

BIOGRAPHY

Pieter Bruegel the Elder
Netherlandish, c. 1525–69

• One of the greatest painters of the 16th century, Bruegel the Elder was noted for his landscapes and scenes of peasant life.

• Popularly known as "Peasant Bruegel" because of his paintings of rustic life, Bruegel's work combines minute observation of the human condition with great wit and originality, and outstanding draftsmanship.

The Mountain

BALTHUS

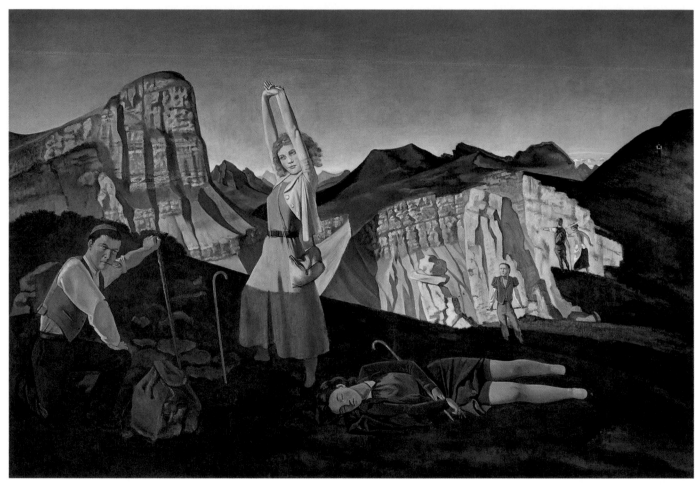

△ **The Mountain;** 1937; oil on canvas; 98 x 144 in. (248.9 x 365.8 cm)

❝ What makes the picture so fascinating is its blend of realism and the surreal. It is clearly a scene that Balthus knows, yet the people in it are dreamlike; they do not cohere into a narrative. ❞

Whenever I am tempted to indulge in melodramatic hand-wringing about the state of contemporary art, I remind myself of someone like Balthus: a major artist who knows what he is doing. *The Mountain* is a masterpiece of his early period, painted in his late twenties, just before World War II. When it was first exhibited, it bore a label explaining that it was the "first of a projected series of four on the seasons." He never painted that series, and I think we can guess why. Although this is a summery picture, with its harsh light and deceptive shadow, Balthus' interest is primarily in the mountain itself. It is a picture of verticals and horizontals. The verticals are the more emphatic: the walking sticks, the people, the soaring mountain, which is echoed by the blonde girl. The horizontals are slow and slanted, valley-dominated; and this, in turn, is echoed by the valley girl, sleeping in a strangely awkward position.

What makes the picture so fascinating is its blend of realism and the surreal. It is clearly a scene that Balthus knows (in fact, the mountains of his boyhood), yet the people in it are dreamlike; they do not cohere into a narrative. We can almost write off the man with his back to us, remote in the distance, and the gawky couple who seem intruders from another story; which leaves us with the two young men and the two young women. Both youths—especially the one in the foreground—look anxious, and seem to be pondering. I think the theme of those brooding thoughts is given in the mountain of the title. A mountain is always feminine—and the male climber conquers her. The valley girl is out of contention, and the youths are faced with the glorious golden girl of the mountain, with her unselfconscious vibrancy and physical challenge. We do not need to know that the model was Balthus' young wife to sense that an erotic element pervades the scene—but so subtly that the mystery remains intact. And is that not the essence of sexual mystery: to be kept looking, ever guessing, perpetually engrossed?

BIOGRAPHY

Balthus (Count Balthasar Klossowski de Rola)
French, 1908–

• Born into a Polish aristocratic family living in France, Balthus has painted many subjects, including landscapes, portraits, and interiors. The female form is his most recurrent theme.

• His work reveals a wide range of influences, including Piero della Francesca, Nicolas Poussin, Georges Seurat, and Gustave Courbet.

• Balthus' paintings possess an almost surreal eroticism, and the essence of sexual mystery forms a common thread running through his paintings.

The bright, slanting light highlights the young man in the background, who stares, mesmerized, at the unselfconscious but self-aware blonde girl in the foreground, their bodies echoing the strong vertical lines of the mountain. The couple with their backs to the viewer seem unaware of the drama taking place behind them.

Triptych with the Annunciation and the Cloisters Cross

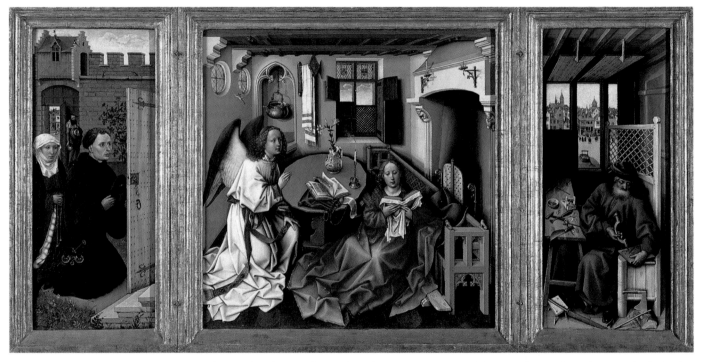

△ **Triptych with the Annunciation;** c. 1425; Netherlandish; oil on wood; central panel 25¼ x 24⅞ in. (64.1 x 63.2 cm), each wing 25⅜ x 10¾ in. (64.5 x 27.3 cm)

At the Cloisters, an auxiliary museum in northern Manhattan, the Met presents us with the finest collection of medieval art in the United States—perhaps in the world. These are real cloisters, not only fashioned from medieval stones that were brought across the ocean but pervaded with peace and prayerfulness—and I speak as a contemplative nun.

Of all the beautiful works within these ancient walls, there are two that linger longest in my affectionate memories. One is the altarpiece by Robert Campin: a small triptych featuring the story of the Annunciation that would have stood on a private family altar. The altarpiece

is radiant in its color (as fresh and sweet as when it was painted), in its rich symbolism, and in its sheer graphic strength. In one wing, St. Joseph waits; in the other are the patrons, husband and wife; in the center—both remote and astonishingly actual—the Virgin reads her prayerbook as the angel of the Annunciation bends before her.

If I could only choose one work, it would be hard to decide between the brightness of the Campin and the pale glimmer of the Cloisters cross. This is a unique object, rewarding hours of attention. It is a cross and not a crucifix, because the figure of Christ is missing. What makes the cross especially significant is that this was never

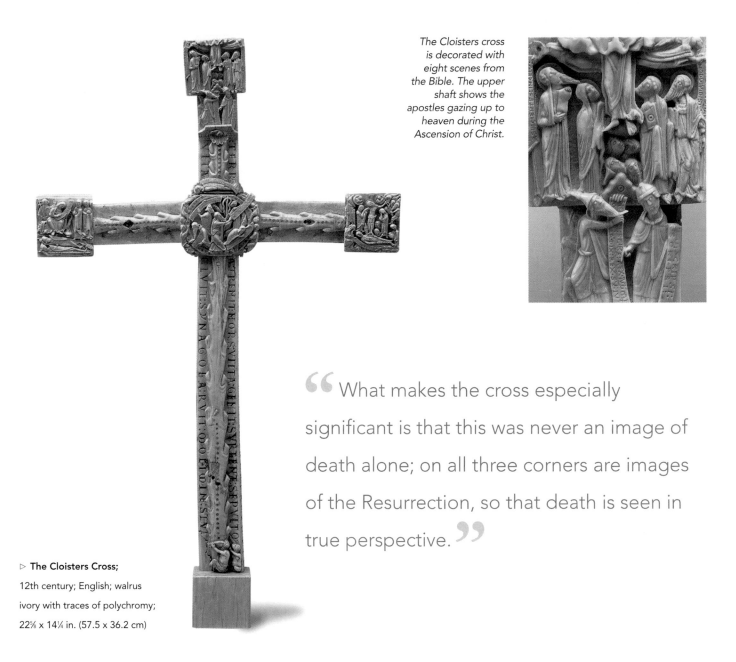

The Cloisters cross
is decorated with
eight scenes from
the Bible. The upper
shaft shows the
apostles gazing up to
heaven during the
Ascension of Christ.

66 What makes the cross especially significant is that this was never an image of death alone; on all three corners are images of the Resurrection, so that death is seen in true perspective. **99**

▷ **The Cloisters Cross;**
12th century; English; walrus
ivory with traces of polychromy;
22⅝ x 14¼ in. (57.5 x 36.2 cm)

an image of death alone; on all three corners are images of the Resurrection, so that death is seen in true perspective. It is life that is commemorated on this cross: eternal life. The detail that moves me most is at the very bottom, where Adam and Eve are climbing out of the pit of death and clinging onto the cross. He goes first, of course (this is the unenlightened side of the Middle Ages), but she reaches out with a terrible eagerness, struggling just to get there and hold on. It is a marvelous invention, a great theological truth, and intensely moving: her smallness, her unimportance in the great scheme of things, all is refuted by her passionate determination.

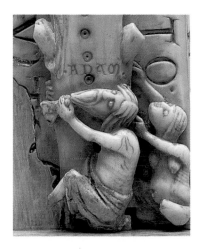

The lower shaft depicts
Adam and Eve, clinging
to the cross with passionate
determination as they
struggle to climb out of
the pit of death.

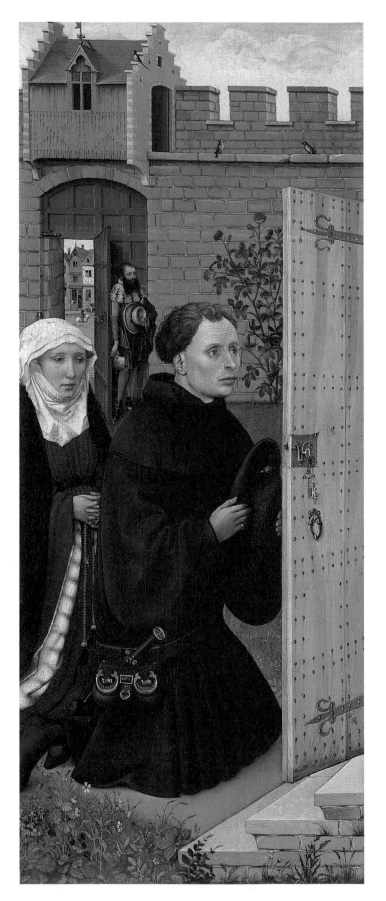

> **"** The altarpiece is radiant in its color (as fresh and sweet as when it was painted), in its rich symbolism, and in its sheer graphic strength. **"**

The couple kneeling in the left-hand panel are the patron who commissioned the triptych and his wife. One of the artist's innovations was setting the Annunciation in a contemporary home rather than an historical biblical setting.

The triptych shows the Virgin Mary, in glorious red, absorbed in her prayerbook, unaware as yet of the archangel Gabriel, who has come to tell her the miraculous news that she will bear the Son of God.

BIOGRAPHY

Robert Campin
Netherlandish, c. 1373–1444

• Most authorities identify Campin as the artist responsible for the paintings attributed to the "Master of Flémalle." The unknown author of these works was so named because three of the paintings were once believed, wrongly, to have come from Flémalle in Belgium.

• Campin is regarded as one of the founders of the Netherlandish school of painting, along with Jan and Hubert van Eyck.

• His figures have a sense of solidity that is heightened by the dramatic lighting.

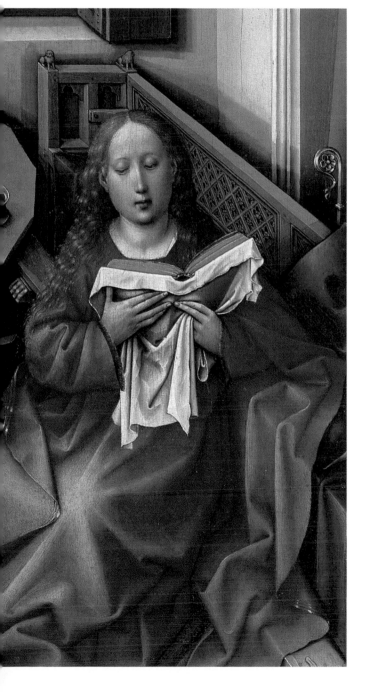

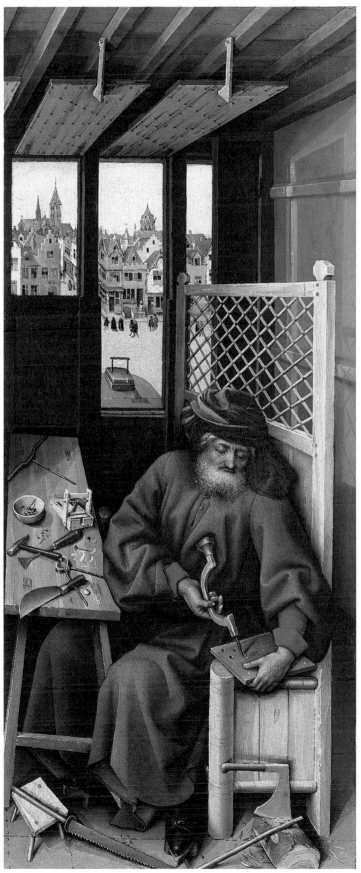

The right-hand panel shows Mary's spouse, Joseph, in his workshop, with the bustle of the town visible through the window behind him.

Mihrab

IRANIAN

This reassembled mihrab from Iran is in the Met's Islamic gallery. The word mihrab translates as "prayer niche," but it is a prayer niche of a specific kind. A mihrab is built to mark the wall in the mosque that looks toward Mecca. It is intended to focus the mind with its beauty, and enlighten the heart with its meaning. It summons the attention of the believer, as if it were a door and on the other side was the Holy City. Around its border are three different types of calligraphy—one of the purest of art forms. With exquisite grace, they spell out the duties of a devout Muslim: to profess the faith; to be true to the ritual hours of prayer; to give alms; to keep the fast of Ramadan; to go on pilgrimage to Mecca. In the center of the niche is the wonderful line: "For the devout, the Mosque is home." In the glory and balance of this calligraphy, we see the strength and balance of God Himself. Yet because the mihrab is made of ceramic tiles, the light that plays on it throughout the day and over the seasons flickers and changes; this symbolizes what it is to be human—to be as constantly subject to change as God is not. Everything about the mihrab speaks and teaches about holiness. It may no longer be in a mosque, but it sets this part of the museum apart as a holy place.

The beautiful calligraphy that borders the prayer niche states the duties of the devout Muslim (left), while that in the center panel declares: "For the devout, the Mosque is home" (above).

▷ **Mihrab**; c. 1354; composite body, glazed, sawed to shape, and assembled in mosaic; 11 ft. 3 in. x 7 ft. 6 in. (3.4 x 2.9 meters)

> " A mihrab is built to mark the wall in the mosque that looks toward Mecca. It is intended to focus the mind with its beauty, and enlighten the heart with its meaning. "

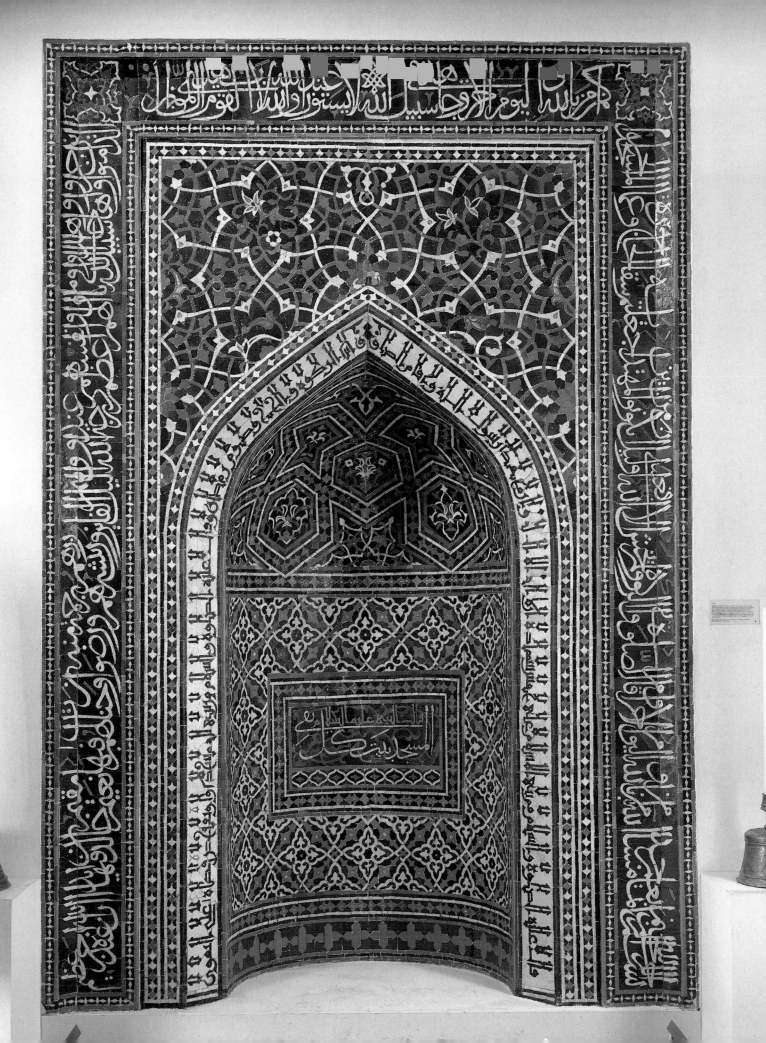

Page from the Koran

NORTH AFRICAN

To describe this simply as a page of illuminated manuscript—a superb work of art—and say no more, would be to commit grievous moral insensitivity. The scribe who created this page was not primarily concerned with making art, but with reverencing God. Writing was sacred to Islam. As Muslims began to understand the privilege of having had the word of God revealed to them, they described themselves as "people of the book." Generously, they also referred to Jews and Christians as "people of the book"—but no other book played the part in religious art that the Koran did.

To be worthy of writing it, the Muslim artist felt that he must be pure of heart, and strive with total concentration to make his work beautiful. The golden medallions, with their intricate interleaves, are punctuation marks. The calligraphy itself is distinguished by superb loops and arabesques, because nature—God's direct "script"—is never upright but always curved. It seems to me that though you could call this page perfect, there is something touchingly vulnerable in the very shape of the letters. I look at it with wonder, but of course, an illiterate like myself does not understand what the words mean. In fact, the Koran cannot be translated; it must be read in the inspired original. I am comforted to know that Muslims believe that just being in the presence of these words is to become blessed—whether we understand them or not.

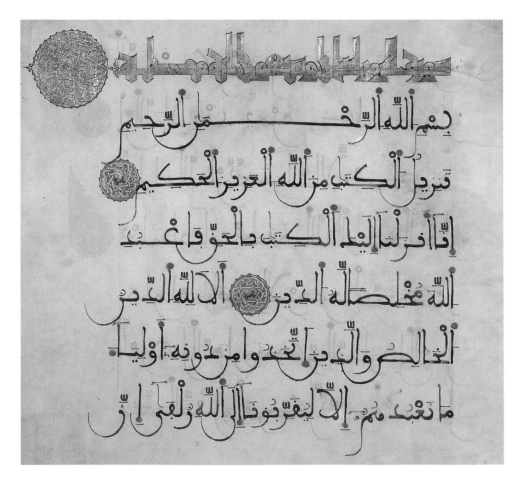

> 66 The scribe who created this page was not primarily concerned with making art, but with reverencing God. Writing was sacred to Islam. 99

◁ **Page from the Koran;** c. 1300; ink, colors, and gold on parchment; 21 x 22 in. (53.3 x 55.9 cm)

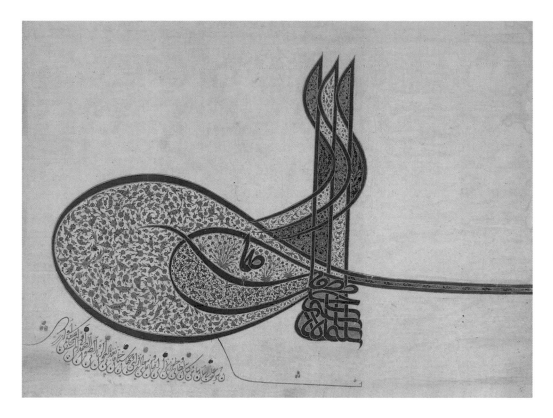

"What makes the tughra so beautiful is the sense of enclosure that it conveys—it is a small paradise."

◁ **Tughra of Suleyman the Magnificent;** mid-16th century, Ottoman period; gouache and gold leaf on paper; 20½ x 25⅜ in. (52.1 x 64.5 cm)

Tughra of Suleyman the Magnificent

TURKISH

Not all Islamic art is explicitly religious. This picture looks like a majestic piece of abstract decorative art, but it is not. It is a sultan's official letterhead. When a sultan took power, he established his own sign: his tughra. This could be very large—one example is five feet high and nearly eight feet long—or very small. This tughra is obviously a grand one. The essential information of the sultan's identity is in the area of dense interweaving on the lower right. This declares it to be the tughra of Suleyman the Magnificent, the Victorious, who reigned over the Ottoman empire c. 1520–66.

It is a work of compelling beauty. The pattern is much the same in all tughras. From the individual portion, the form swells out into a great oval, with a smaller oval enclosed, divided by an arabesque that sways through it. On the right are three verticals, linked by S shapes. Some scholars think that this form derives from the time when the tughra was literally a sign manual, and that this is the mark of the thumb and three fingers.

What makes the tughra so beautiful is the sense of enclosure that it conveys—it is a small paradise (the word originally meant "enclosed garden"), swelling out into space yet holding its blue, gold, and red flowers in a concentration of beauty. Here is condensed the glory of political power at its most dazzling; that such art could be made merely to introduce the sultanic wish! Yet because in Islam all power comes from God, even political power is imbued with a sense of the sacred.

The Horse Fair

BONHEUR

Looking at *The Horse Fair*, in all its vigor and light, could you honestly deduce the gender of the artist? Even had you ventured out in the early morning to the fair itself, you would still not have known, because Rosa Bonheur had permission from the police to dress as a man. She was an unconventional woman, accustomed from childhood to roaming alone in the forest and visiting abattoirs to study the anatomy of animals. When she decided, in her early thirties, that she wanted to paint the horse fair, it was obvious that going there twice a week for a year and a half, dressed in her skirts and bonnet, would make her very conspicuous. The extraordinary thing to me is that her unladylike behavior scandalized nobody. Queen Victoria invited her to visit, and the Empress Eugénie of France went one better—visiting Bonheur's house herself to present the artist with the Legion of Honor. The French president was another visitor, insisting that she received him wearing her trousers, so that he could see how a great artist worked.

> " The picture is alive with movement, and the wonder of animal and man working together. "

Why did people accept Bonheur so readily in a profoundly conventional age? I think you can guess the reason from the painting itself: it is such a single-minded and pure-hearted work. Bonheur's interests were art and animals. She had a longtime woman partner, but animals were her passion. At one time she kept a lion, but her main love was horses. This was a romantic devotion, and for all the convincing realism of the painting, Bonheur is responding to each horse as individual hero. She has the

setting admirably right. When criticized for making the trees too feathery, she went back and repainted them, in 1855, but it is the idealism of the fair, not its reality, that inspires her: the nobility of the horse, its courage and dignity, its comradeship with the men who are privileged to serve it. The picture is alive with movement, and the wonder of animal and man working together.

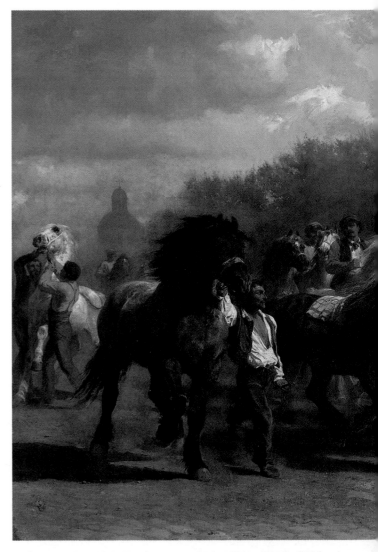

△ **The Horse Fair;** 1852–55; oil on canvas; 96¼ x 199½ in. (244.5 x 506.7 cm)

BIOGRAPHY

Rosa Bonheur
French, 1822–99

• Bonheur, a painter of animals and rustic scenes, began exhibiting her work at the Paris Salon in 1841.

• She was given permission by the police to dress as a man so that she could attend animal fairs and markets in order to make studies for her paintings.

• She quickly achieved popular success, and her paintings were noted for their dramatic lighting, vivid sense of movement, and realistic representations of animals.

The Horse Fair *is alive with movement, as the horses prance and rear around the painting while the men try to hold the beasts steady.*

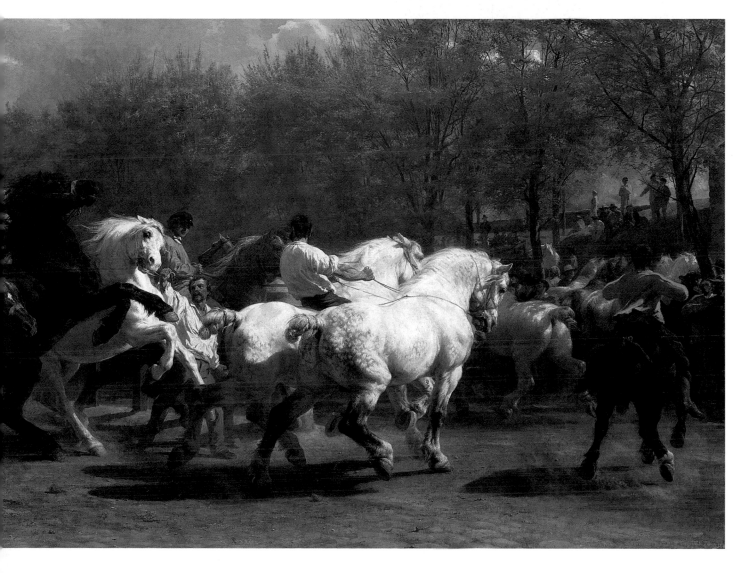

Young Woman Drawing

VILLERS

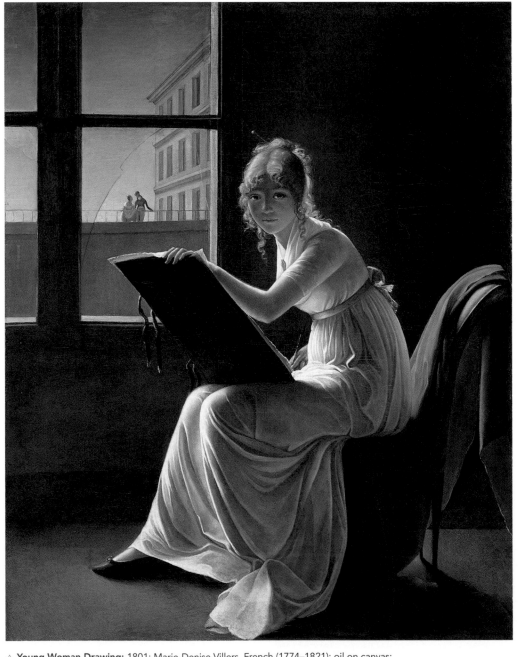

△ **Young Woman Drawing;** 1801; Marie-Denise Villers, French (1774–1821); oil on canvas;
63½ x 50⅝ in. (161.3 x 128.6 cm)

> " Villers seems to be looking straight at us, but she is really looking at herself in a mirror. This virginal creature, with the sun shining through her hair, is dedicating herself to art. "

Some years ago, there was a famous and controversial article titled "Why are there no great women artists?" The response was explosive: half the critics declared that a patriarchal society prevented women from becoming artists; the other half insisted that there were great women artists, but nobody took any notice of them. This picture lends support to the second argument. When it came to the museum, it was attributed to the great French neoclassicist, David. When it became clear that it was not David's work, it seemed increasingly likely, for a variety of complicated reasons, that it had been painted by a woman. It then emerged that there were at least nine women artists painting in Paris at the turn of the century whose work was so good that it had been attributed to David. The artist was eventually deemed to be Marie-Denise Villers, and since she would only have been about 26 at the time, I think it likely that this is a self-portrait.

The interesting thing is this: when David was thought to be the artist, the critics were in admiration of its quality (especially that of the light), its classic grace, and the sense of space—all of which is true. However, when the painting was ascribed to the unknown Villers, the weaknesses were noticed: the proportions from waist to knee are not right; and the artist evaded the difficulty of depicting the painting hand by concealing it at her side. Villers seems to be looking straight at us, but she is really looking at herself in a mirror. This virginal creature, with the sun shining through her hair, is dedicating herself to art. She came from a family that took art seriously; the work of one of her sisters, Marie-Victoire Lemoine, hangs next to hers. Villers sees herself at work in the perfect glass of her studio, while behind her, through a cracked windowpane— an imperfect glass—we see in the distance a couple in love, hemmed in by rails and buildings. She is free, as they are not. The implication seems clear: the pure life of painting, to which Villers devotes herself, is a superior vocation. It is an enchanting work—one of the most popular paintings in the museum—and the gender of the artist seems to me an irrelevance.

The sunlight streaming through the young woman's hair gives her an air of purity, perhaps reflecting the fact that she has devoted herself to the life of an artist. Her vocation has set her free, unlike the couple seen through the cracked window, who are hemmed in by rails and buildings.

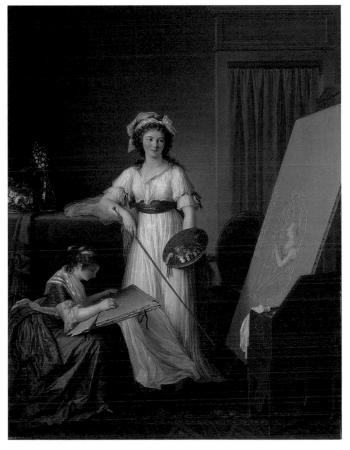

△ **Atelier of a Painter;** c. 1796; Marie-Victoire Lemoine, French (1754–1820); oil on canvas; 45⅞ x 35 in. (116.5 x 88.9 cm)

Kouros

GREEK

The Met has eight galleries of Greek art, splendidly installed in a manner that allows each period, from Prehistoric to Classical, to make its specific impact. Most Greek sculptures are not originals, but Roman copies. These works have their own greatness and fill the central gallery with their magnificence. Nevertheless, my personal preference is for the originals—pitifully few though they are. They may not have the elegance of the great copies, but what they do have is the nervous vitality that can only come from the creating sculptor's vulnerable touch.

This kouros (youth) is a moving and marvelous creature. He could be a textbook example of archaic Greek art. Here, in its eagerness, is that fruitful obsession with the human form that makes Greek art so very powerful—both in itself and in its influence. There is an element of abstraction here, a touch of Egyptian influence; yet the artist is well aware of how the body is built, even if his hands cannot quite match up to his knowledge. Not especially likable at first sight, he is a provocative figure: a young man moving with slow dignity into eternity, his face closed in on itself. This is a grave marker. When the son of a noble Athenian family died young, leaving no children to remember him, the family raised a marker—a kouros—so that he would not be forgotten. Although we shall never know his name, here at the Met he is remembered.

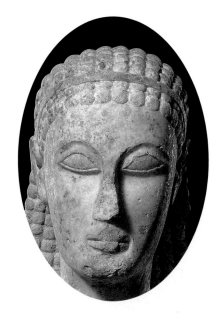

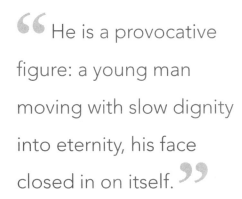

> " He is a provocative figure: a young man moving with slow dignity into eternity, his face closed in on itself. "

◁ **Kouros (Statue of a Youth);**
c. 590–580 B.C.; Naxian marble;
height without plinth 76 in. (193 cm)

Grave Stele

GREEK

Fifty years later than the kouros, here is another grave marker. This one is of scholarly importance, because it is the only surviving example with all three elements intact: the inscription, the shaft, and at the top, the capital and finial. Again we see a beautiful youth—a little more realistic now as sculptors grew in skill—holding the pomegranate of eternal life, as he moves, with his little sister, toward that long home. The irony, which this thoughtful young man might have appreciated, is that the sculpture only survived because it was thrown down and buried soon after it was erected. The leading Athenian families were always in and out of power, and an "out" period meant exile and the destruction of their graves.

At the top of the stele sits a sphinx, the mysterious figure that the Egyptians saw as a lion with a pharaoh's head. To the Greeks, the sphinx is more complex. It is winged, has a woman's head, and smiles an enigmatic smile. The Greek sphinx seems to have had two activities. One was asking riddles: serious riddles about life, death, and meaning. The second was to snatch young men away, which was why she smiled. Her smug, triumphant look is the ultimate irony here. She has indeed snatched away this youth, but to where? In practice, to the Met!

> " The Greek sphinx seems to have had two activities. One was asking riddles. The second was to snatch young men away, which was why she smiled. "

THE RIDDLE OF THE SPHINX

In Greek legend, the sphinx sat on a rock outside the city of Thebes, waiting for travelers to pass by. Whenever anyone approached, she asked the riddle: "What animal is four-footed in the morning, two-footed in the afternoon, and three-footed in the evening?" When the hapless travelers could not answer the riddle, the sphinx killed them. One day Oedipus passed by, and he replied that the answer was a man, who crawls four-footed when an infant, walks two-footed as an adult, and is three-footed in old age when he uses a cane. When the sphinx heard his answer, she threw herself over the cliff and died. The people of Thebes rewarded Oedipus by offering him the throne.

◁ **Grave Stele**; c. 530 B.C.; marble; 13 ft. 11 in. (4.2 meters)

Allegory of the Faith

VERMEER

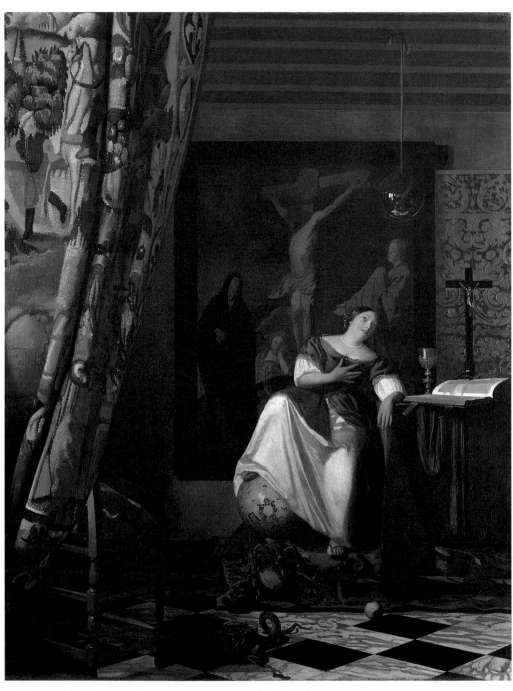

△ **Allegory of the Faith;** c. 1670; oil on canvas; 45 x 35 in. (114.3 x 88.9 cm)

> " I love the painting—even if it makes me smile a little. It is a moving example of a great artist daring to be vulnerable. "

BIOGRAPHY

Johannes Vermeer
Dutch, 1632–75

• The work of the genre painter Vermeer remained largely unknown and unheralded until the 19th century, but he is now ranked with Rembrandt among the greatest Dutch artists.

• Vermeer specialized in tranquil domestic scenes, depicting one or two figures absorbed in everyday tasks. The paintings' sense of serenity and the simplicity of their compositions give them their dramatic impact.

• Vermeer's works display an astonishing technical mastery: of composition, light, color, and brushwork. His paint surface has been described as being like "crushed pearls."

Vermeer is the most sought-after of artists. There are only thirty-five of his works in existence, and amazingly, the Met has five. What I love in this work is the rare glimpse into the personal life of this most private of artists. Vermeer, remember, lived in a small house with his wife, mother-in-law, and eleven children—and he painted only light and silence. Why I think we see something of the man himself here is that, much as his family must have mattered to him, perhaps his religion mattered equally. He lived at a time of intense religious strife between Catholics and Protestants. Vermeer, who came from a devout Protestant family, was cast out when he converted to Catholicism and married a Catholic. I presume, then, that faith was important to him, and when he was asked—possibly by a church—to paint an allegory of faith, he could not resist, even if he realized that this was alien ground for him.

If you look at the painting objectively, it is full of the great "Vermeer things," such as the light shining on the chair and the great swag of the curtain, on the chalice, and on the glowing crystal globe. Every object has a specific meaning. The woman emoting in the center is Faith herself, trampling on worldly temptations. She has her crucifix and her Bible; she spurned the serpent's apple and crushed him. Vermeer figured it all out, down to the detail that Faith is essentially private, and so the curtain must be pulled back for us to see. However, it remains an intellectual exercise; he wants to paint it, but he cannot integrate it. Large emotional women do not come naturally to his spirit. I often wonder if he recognized his comparative failure. Or did he only see what he so believed in: the importance of faith? Did he understand that artists are not really free to paint what they choose, but can only work at their best from something deep in their psyche that the will cannot control?

I love the fact that here, at the Met, there is such richness that even their least-admired Vermeer can be proudly displayed. For myself, I love the painting—even if it makes me smile a little. It is a moving example of a great artist daring to be vulnerable.

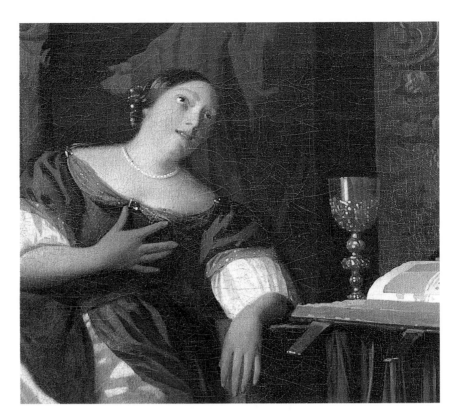

Vermeer was a master of light and color. The light coming from the left of the painting highlights the thick swag of the tapestry curtain before reaching the figure of Faith, who is wearing blue and white, the colors of purity and truth.

ON PROUD DISPLAY

Sadly, Vermeer's Allegory of the Faith *has not always received the appreciation it deserves. One scholar called it "Vermeer's one mistake." Another described it as "a large and unpleasant Vermeer." Even the auctioneer who sold it a few years after the artist died fumbled around to convey its theme, and came up with the unimpressive summary: "A sitting woman with deep meanings ... depicting the New Testament." Happily, these hesitations are things of the past, and the painting is on proud display in a glorious museum.*

A Maid Asleep

VERMEER

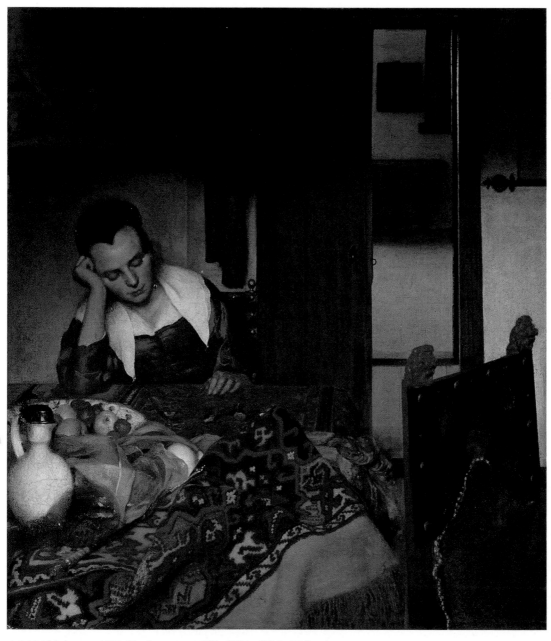

A Maid Asleep *is one of Vermeer's early works, painted before the artist understood that his genius was to react to light and to draw us into its silence. This painting is wonderful enough, but it is too dark and too suggestive of narrative to rank as one of his masterpieces.*

△ **A Maid Asleep;** c. 1656–57; oil on canvas; 34½ x 30⅛ in. (87.6 x 76.5 cm)

Young Woman with a Water Jug

VERMEER

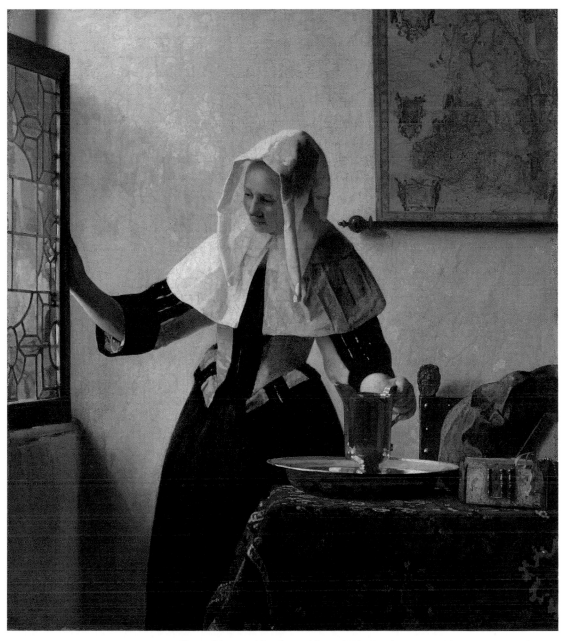

Young Woman with a Water Jug *is one of the supreme Vermeers. In its simplicity, it becomes pure poetry. It responds to the light with a spiritual intensity that is this artist's surpassing gift. Everyone stands silent before Vermeer; he can make all commentary seem superfluous.*

△ **Young Woman with a Water Jug**; c. 1660–67; oil on canvas; 18 x 16 in. (45.7 x 40.6 cm)

Woman with a Lute

VERMEER

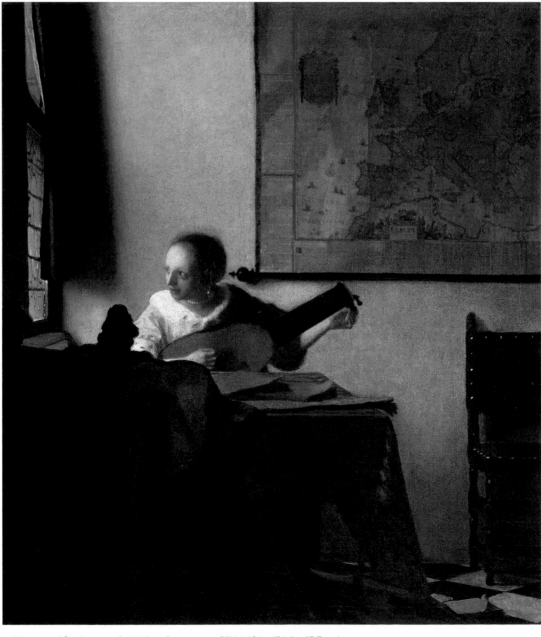

Woman with a Lute is a masterpiece, but one that the carelessness of time, with its destructive cruelty, all but obliterated. The Conservation department—the essential and unsung adjunct to every work on display in any museum—coaxed it back to a pale shadow of its original beauty. Even in ghostly form, it is magical.

△ **Woman with a Lute;** early 1660s; oil on canvas; 20¼ x 18 in. (51.4 x 45.7 cm)

Portrait of a Young Woman

VERMEER

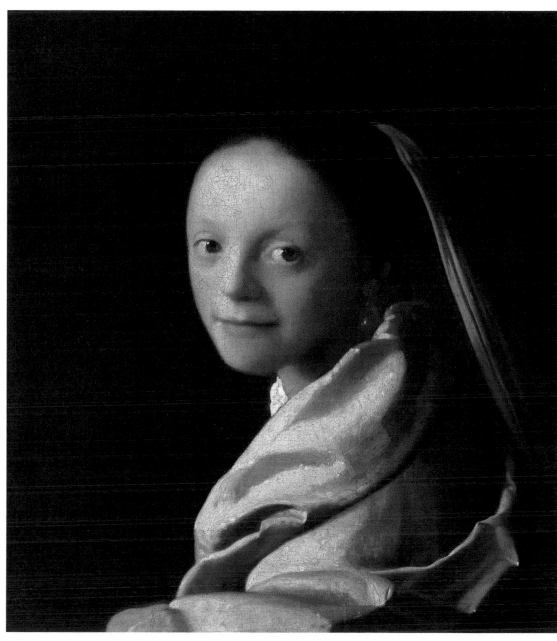

Portrait of a Young Woman is one of Vermeer's rare portrait heads. This head seems to me a representation not so much of a particular person, but of the nature of young womanhood: fresh, eager, gentle, kind. The girl has that pearly glow peculiar to Vermeer that makes a plain face lovely.

△ **Portrait of a Young Woman;** c. 1665–67; oil on canvas; 17½ x 15¾ in. (44.5 x 40 cm)

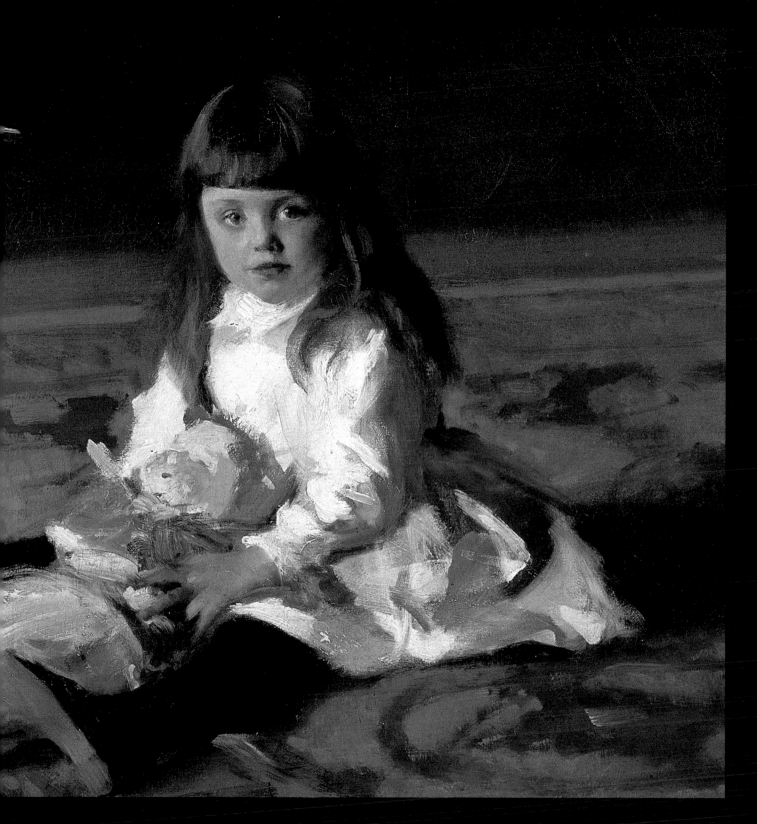

MUSEUM OF FINE
ARTS, BOSTON

Introduction

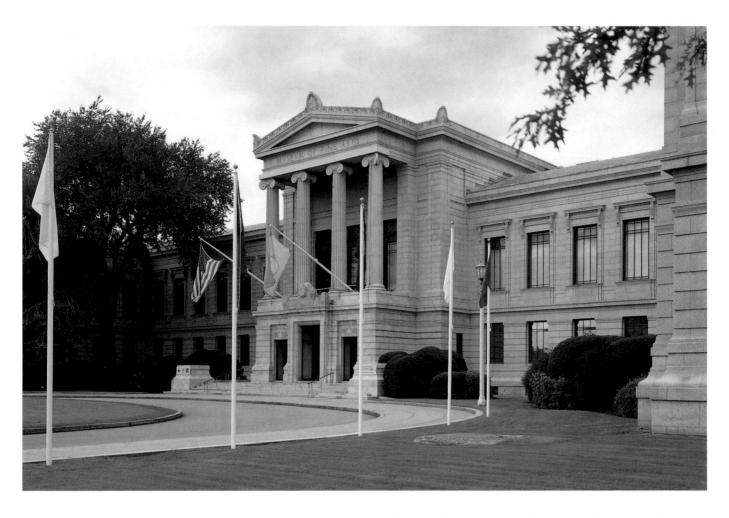

What drew me originally to the Museum of Fine Arts in Boston was its unrivaled Asiatic collections. To some people, Boston suggests primarily universities (Harvard on the doorstep) and upper-class families (the Boston Brahmins), but, of course, this city is a seaport, and ships have long sailed from here to the East, bringing home intellectual and aesthetic wealth as part of their cargo. Bostonians were always generous with their collections, donating them to the museum, and encouraging notable Asian scholars to come to the city to curate and to teach. What I had not realized was the grandeur of life in early Boston, and in consequence, the extraordinary material that was available to the American Decorative Arts department at the museum. American furniture, for example, was virtually a closed book to me—something that I knew about but without untoward

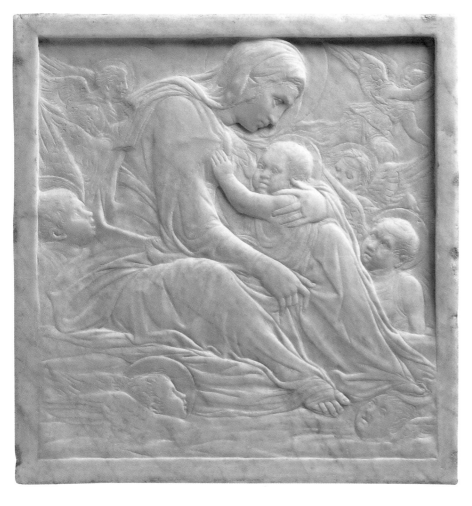

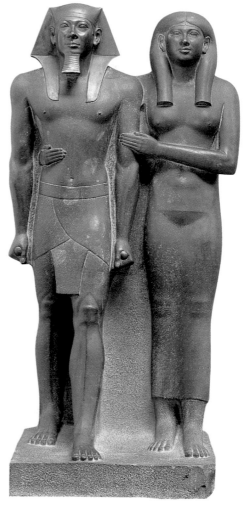

enthusiasm. This inexcusable ignorance was enlightened
at Boston. I was overcome by the excitement of what
I found there. The relatively familiar glories of Eastern
art were balanced by the unfamiliar but equally glorious
Western art: American furniture, silver, and ceramics.

The museum is one of the largest in the United States,
with over 500 full-time employees and nearly as many
part-time. It can also boast about 1,000 voluntary
workers. It seems to present two faces to the public. One
is railed in, with an elegant early 20th-century sculpture on
its lawns: Cyrus Edwin Dallin's 1909 *Appeal to the Great
Spirit*—a noble Indian chief on horseback with arms raised
on high. The other face, the entrance (usually thronged),
is distinguished by a massive and shapeless de Kooning
sculpture. It is between these two wildly incompatible
images that the M.F.A. maintains its celebrated diversity.

The Oak Hill Rooms

AMERICAN

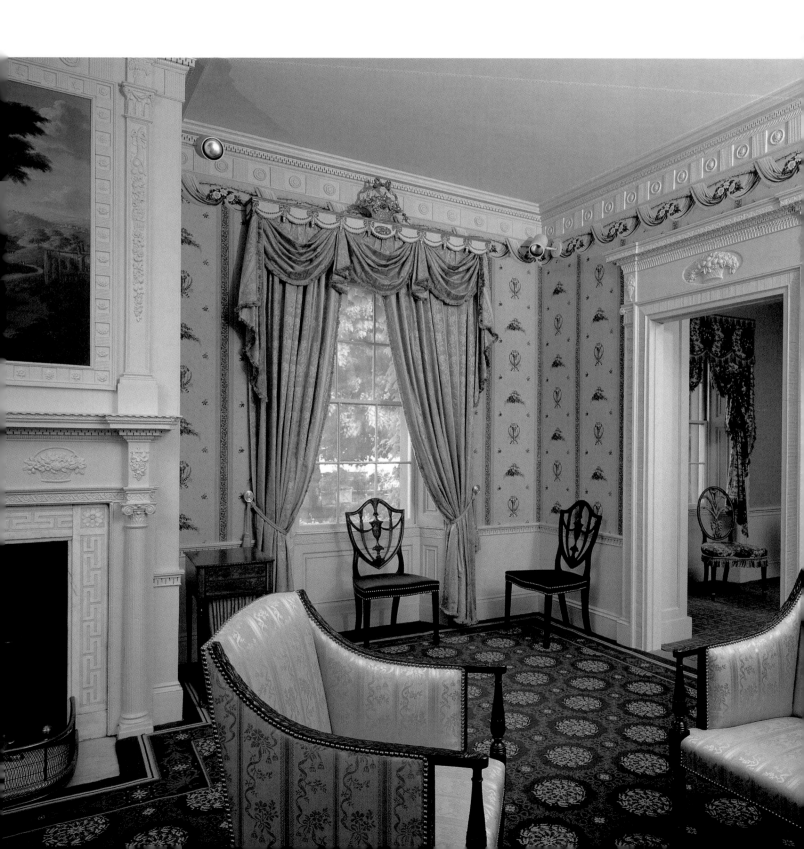

A period room is like a stage set—and it is rare to find one that is both completely authentic and also of extraordinary quality. The Oak Hill Rooms, created in 1800–01, represent a curatorial *tour de force*, because they were assembled by a person so rich, so discerning, and so determined that no pains were spared to make the rooms exceptional indeed. Money alone would not have been enough; what was also needed was discrimination and motive. All three of these qualities were present in abundance in Elizabeth Derby West, eldest daughter of the great Elias Hasket Derby.

The parlor is pictured here. Every detail in the room was planned and coordinated. A motif once introduced is repeated all around. The studs of the settee, for example, are repeated on the looking glass, and again on the swags above the drapes. Elizabeth was very particular about this; we have a letter she wrote to the upholsterer, complaining that the studs were insufficiently symmetrical: "You have ruined the HOLL BUTY [sic] of my sofa." She might not have been able to spell, but she knew what she wanted.

The disks on the carpet are picked up on the cornices, and on the furniture—and so it goes on, with element after element, subtly weaving the room into a whole. I think the most constant motif is that of the leaf and grape, which decorates her furniture, her porcelain, her crystal glass, and the fire stand, which she herself embroidered with a vase of flowers. There are flowers also above the fireplace, and around the room. She had only two paintings—*Saturday Evening* and *Sunday Morning*, by a traveling artist named Michele Corne—but she compensated by filling the house with the large, ornate mirrors for which she was famous.

> " Every detail in the room was planned and coordinated. A motif once introduced is repeated all around. "

Motifs are repeated throughout the Oak Hill Rooms. A fruit basket is used as decoration on the cornice above the drapes (below left) and is repeated on the upper door jamb (below), as well as elsewhere in the rooms.

◁ **The Oak Hill Parlor;** Elizabeth Derby West's home in Danvers, Massachusetts; 1800–01

△ **The Oak Hill Parlor;** Elizabeth Derby West's home in Danvers, Massachusetts; 1800–01

The fruit basket motif on a mahogany neoclassical side chair (1790–1800) whose design and carving are attributed to the American Samuel McIntire.

The room is so integrated that it takes time to realize that every object in it could be put on a pedestal and admired.

Where Oak Hill once stood, before the M.F.A. rescued these rooms, is now a giant shopping mall—an ironic tribute to a world-class shopper. Let me not end on a note of flippancy. These rooms are seriously beautiful. Elizabeth Derby West poured her passion into them, and we should be eternally grateful—both to her and to the museum, which labored and searched for years to create this installation.

ELIZABETH DERBY WEST

Much is known about Elizabeth Derby West, because her clergyman, the Reverend William Bentley, was impressed by her and wrote about her in his diary. Although he marveled that "she never violated the chastity of good taste," she did violate the rules of New England society by quarreling with her husband. When they reached the shocking climax of divorce, public opinion was all on the side of Captain West. "A more unreasonable, cantankerous woman never existed," it was said. The West children seemed to agree; they stayed with their father, while Elizabeth retired to her house at Oak Hill. There she apparently assuaged her heart by creating a house of classic elegance. Reverend Bentley said of Elizabeth and Oak Hill: "She'd decorated it, she'd furnished it, she had been long sick in it and she had died in it."

Chest-on-Chest

COGSWELL

Wandering in a daze of pleasure through the galleries of American Decorative Art, I was stopped in my tracks by this piece: furniture understood as sculpture. Its full title is *The Cogswell Boston Bombé Chest-on-Chest*: Cogswell made it; Boston is its place of origin; *bombé* is the technical term for "swelling"; and chest-on-chest is visually self-explanatory. What makes this chest so memorable is the way it marries a strong simplicity of shape with a glorious intricacy of detail. It has three parts, the lowest being the *bombé* underchest. From the splendidly curved legs it swells in a crescendo around its four drawers. The upper chest, by contrast, seems austere. It soars straight upward, with its five drawers, until it is crowned by the exuberance of the pediment, and in its center, a proud American eagle. The eagle is not there simply for elegance. This work comes from the heady first days of independence, when there were merchants with money to spend and patriotic pride to express. This is the only piece that the famous cabinetmaker John Cogswell signed, and we also know who commissioned it. Elias Hasket Derby was the first American millionaire, and his family were destined to be closely connected with the museum. Mrs. Hasket Derby ordered the chest for her grandson Johnny, who was about to go away to Harvard, and a Derby, naturally, needed a little chest or two in which to keep his books. I take pleasure in the thought that this aloof, glowing piece of furniture presided over the revels of a group of 18th-century college students.

> " I take pleasure in the thought that this aloof, glowing piece of furniture presided over the revels of a group of 18th-century college students. "

▷ **Chest-on-Chest**; 1782; mahogany and white pine; 89½ x 43½ x 23½ in. (227.3 x 110.5 x 59.7 cm)

Scholar's Desk

CHINESE

As early as the 12th century, the Chinese characterized the furnishings of a home as "elegant," in the sense not only of beauty but also of convenience and comfort. This was a moral issue, because elegance created an ambience responsive to the *qi*—the life force or spirit that flows through everything. Thus on the scholar's desk, he set a spirit rock. He would have searched for this in the lakes where they were especially to be found, seeking out a rock that encapsulated the landscape. Large rocks were placed outside the window in an inner court, but this one sat close to him. The rock had experience of the earth, and brought it into the study. It is particularly inspirational, because it has holes through which air and light can stream, bringing the *qi* of the earth to the spirit of the scholar. He also used a marble table screen; some

△ **Scholar's Table Screen with the Image of a Rock;** 18th century, Qing dynasty; Dali marble with wood stand

▽ **"Rock" Album;** 1893; Japanese; ink on paper

▷ **Spirit Rock;** 18th–19th century, Qing dynasty; white-veined lingbi rock with wood stand

historians have called marble "a dream stone." We might say that, by coincidence, the patterning of the marble resembles mountain ranges; the Chinese scholar saw the marble as "remembering" the mountains, bringing them into his study, and maintaining him in harmony and balance.

A Chinese gentleman made his own ink; here is the container from which he poured water onto his inkstone. It is porcelain, shaped like the peach of immortality, with a perky little parrot on top, encouraging him to let his brush take wing. The brushes stood in a holder—also a work of art. It is made of glass, a milky white background on which, carved in scarlet, are Chinese images of good fortune—including the bat (the word for bat is the same as that for success), and the pine of long life. The brushes needed to be handled with such concentration that the wrist would tire; hence the need for a brush rest. This one was made of jade and carved in the shape of a famous spirit stone from Lake Tai, reinforcing the spiritual presence of the mountains and the wind that blows through them.

△ **Water Dropper in the Shape of a Peach with a Parrot;** 13th century, Southern Song dynasty; Qingbai ware, porcelain with "white" glaze and molded decoration

△ **Brush Holder;** 1723–35, Qing dynasty, Yonghzhen period; carved glass with auspicious symbols in red; 4¾ x 4⅝ in. (12 x 11.9 cm)

THE FLOW OF *QI*

Nearly every civilization has based its art on the body—human or animal—but for the Chinese, the essence was the landscape; and for them, the landscape was a living creature. They believed that qi, an energy or spirit, flowed through the world; and a scholar at his desk was intent on making himself receptive to this spirit.

△ **Snuff Bottle;** 19th century, Qing dynasty; jade with
gold-rimmed jade stopper; 2⅜ x 1⅞ in. (6.2 x 4.9 cm)

> 66 For the Chinese, jade was the moral
> stone; hard, gleaming, always slightly
> warm to the touch; perfect. 99

The object of this dedication was to create a page, or even a few lines, in an album. This album has on every page a painting and a poem by a different scholar, all in honor of the specific rock that graced this desk. It was an expression of awe at the rock's power, an attempt to esteem this wonder of nature. Finally, composition done, the exhausted scholar would revive himself by taking up his snuff bottle. The intake of the scented snuff would refresh his body, but far more, handling the smooth beauty of the blue-green jade would refresh his soul. For the Chinese, jade was the moral stone; hard, gleaming, always slightly warm to the touch; perfect. It was what human beings strove to become. Holding it, caressing it, contemplating its virtues was a kind of communion—an intimation of divine peace, and divine *qi*.

A GENTLEMAN'S SKILLS

The Chinese gentleman practiced many skills: he needed to play the qin *(a kind of lute), to play chess, to be good at archery, to know the classics, and to be a poet. Above all, however, he had to be a master of the brush—not only a painter but a calligrapher. Every stage in the formation of the exquisite shapes of calligraphic art was important.*

▷ **Jade in the Shape of Mountains Brush
Rest;** pale green nephrite with wood stand

Three Ceramics

CHINESE

The M.F.A. has in its collections 100,000 works of Asian art. Here are just three of them, chosen because each seems to me supremely beautiful. Unexpectedly, when I began to examine them together, there seemed to be a tenuous connection between each object and one of the Chinese religions or philosophies.

The first bowl, pictured below, was made in the 6th century, in the Northern Qi dynasty. It is shaped like the begging bowl of a Buddhist monk, and has a touch of wild Zen-like poetry. Inside is a smooth layer of delicate celadon green; but the outside has unadorned brown at the base, then a wavy stretch of white, and finally a glorious pale yellow poured over the white slip, puddling and spilling at will—accepting the marvel of chance. This is a case of less being more. The purity of the primrose yellow is enhanced by the bareness of its unglazed lower half, and the contrast forces us to attend to the satisfying curve of the bowl's rotundity.

The jar—pictured on the following page—comes from the Tang dynasty in the early 8th century, but you could be forgiven for thinking it was contemporary. Here is a masterpiece of controlled exuberance, with chevrons of green and white, and a deep cobalt blue. The jar swells upward with majestic certainty—a celebration of the world's diverse beauty, the brilliance of its colors never confused or smudged. It reminds me of the Taoist

▷ **Bowl;** late 6th century, Northern Qi dynasty; stoneware with light yellow glaze over white slip; height 5⅜ in. (13.5 cm), diameter of mouth 5⅛ in. (13 cm)

> " I know of few more fulfilling experiences than communing silently with a great work of ceramic art. "

△ **Jar;** 700–50, Tang dynasty; glazed earthenware; height 11 in. (28.2 cm), diameter 10¼ in. (26.9 cm)

philosophy, which takes such delight in the beauty of the created universe.

The summer tea bowl, shown here, is 12th century, from the Southern Song dynasty. It is a splendidly sensible shape, offering cool tea for hot weather. It is Confucian in its practicality and its superb balance, contrasting the rich tortoiseshell of the outer glaze with the dim tea-dust appearance of the long and shallow interior. Inside are stenciled decorations, strong and clear: the plum blossom of purity, and a bird in flight. I am told that the bird is a pheasant, but it suggests to me a phoenix—that mythical bird that is continually reborn from death.

These objects are so beautiful, in shape as well as in color, that they can seem daunting. There is no "story" here—nothing for our minds to analyze and therefore feel that they control. That, I think, is the point. Here, beauty is in control. I know of few more fulfilling experiences than communing silently with a great work of ceramic art.

The interior of the summer tea bowl features a bird in flight (left) and the plum blossom of purity (right).

▷ **Tea Bowl;** late 12th century, Southern Song dynasty; Jizhou stoneware with mottled glazes; diameter of mouth 5⅞ in. (14.9 cm)

The Daughters
of Edward Darley Boit

SARGENT

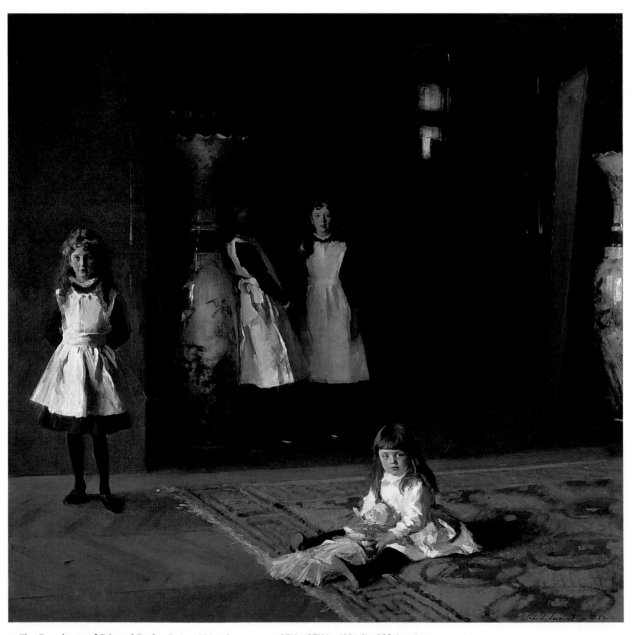

△ **The Daughters of Edward Darley Boit**; 1882; oil on canvas; 87⅜ x 87⅝ in. (221.9 x 222.6 cm)

The poses of the four daughters are very different: 14-year-old Florence stands in the shadows, pointedly ignoring the artist (far left), for example, while 8-year-old Maria Louisa is transfixed in the glare of the light coming from the window, no more at ease than her sister (near left).

Some scholars have suggested that this was not a commissioned work, but one that Sargent chose to paint, of his friend's daughters. It is not a conventional portrait. The only child looking at the artist is 4-year-old Julia, with a strangely judgmental air, while 8-year-old Maria Louisa is as far from her sister as she can get, poised to spring away the moment she is released. Jane, who was 12, stands rigidly to attention, with the frozen smile of someone being photographed. The only daughter refusing to cooperate is 14-year-old Florence, lounging back against that magnificent Japanese vase and visibly sulking. This is a family, but they do not look like one; and their setting does not resemble a home. There is a pathos about them, as if they had been abandoned. These impressions have some truth, since the girls are in a rented apartment in Paris, and it is the works of art—seen dimly but splendidly behind them—that made this place attractive to their parents. There was apparently little thought of providing a comfortable environment for the children.

Sargent was an economical painter, and he conveys unease about the girls through the way in which he treats the various whites. The baby, still in the sunlight, wears gleaming white, Maria Louisa's pinafore is more subdued, and the whites of the elder girls are shadowed—swallowed up in the cavern of their setting. It is as though, as one grows up, life becomes difficult. For all its appeal, there is something sad about the picture. When I discovered that the girls—all pretty, all wealthy—never married, and that the two in the shadow are said to have had mental difficulties in later life, I began to wonder if Sargent had intuited something of this. It is the way in which Sargent combined the opulence of the apartment, the beauty of the girls, and this floating sense of potential disturbance that makes this painting impressive. Sargent's brilliance at showing us people from the outside can cause us to forget that he could also convey what people were like within.

> **❝ It is the way in which Sargent combined the opulence of the apartment, the beauty of the girls, and this floating sense of potential disturbance that makes this painting impressive. ❞**

BIOGRAPHY

John Singer Sargent
American, 1856–1925

• Sargent was educated in Europe and traveled widely, enjoying an internationally successful career as one of the leading society portraitists of his era. His elegant and highly flattering paintings convey the privileged and glamorous lifestyles of his wealthy subjects.

• He painted in the style of the old masters, working with a heavily loaded brush and using the brushwork itself to enhance his works.

• He also painted remarkable watercolor landscapes, and was appointed official war artist by the British government during World War I.

THE BOIT FAMILY

Although he lived in England, Sargent was proud of being American, and Boston was his spiritual home. That cultured city may have held a special appeal for Sargent also because it was the home of one of his best friends: Edward Darley Boit, an artist and a rich man. Sargent had been acquainted with Boit's family for a long time, and this painting of Boit's daughters reflects his intimate knowledge of its subjects.

△ **Mimbres Bowl;** 1000–1150, Mogollon culture; painted earthenware; height 4¾ in. (12.1 cm), diameter 11¼ in. (28.6 cm)

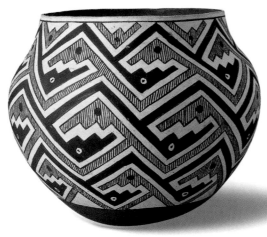

△ **Mimbres Pot;** 1985; Pablita Concho, American (c. 1900–c. 1990); painted earthenware; height 6 in. (15.2 cm), diameter 7 in (17.8 cm)

THE MOGOLLONS

The Mogollons were a cultured and sophisticated people living along the Mimbres river in New Mexico. They built large apartment buildings, and good roads and drainage. Around 1300, the Mogollon people vanished. It is not known whether this was because of war, or famine, or disease; mysteriously, the buildings remained intact but without inhabitants. Their greatest legacy is their pottery.

Mimbres Bowl

AMERICAN

About a thousand years ago, a Native American living in New Mexico, along the Mimbres river, made a pot (pictured top left). He or she belonged to the Mogollon civilization, and this exquisite pot represents the world. The Mogollons thought that there were six directions, which are symbolized here by geometric shapes. Around the world, moving in a leftward circle—the blessing direction—is the shamanistic figure of a beat-quail: an image of benign magic. The bowl of the pot was found capping the head of a dead man, who had been buried (as was the custom) beneath his own house. Before the bowl was interred, it was ceremonially "killed"; the central hole is evidence of this. The potter, it was believed, had poured his spirit into the bowl; killing the bowl set the potter's spirit free to journey with the dead into the rebirth of the afterlife.

Although the Mogollon people vanished around 1300, the potters of Acoma in New Mexico say that they live on in their pots. Pablita Concho made the pot shown center left in 1985. The spirit of the Mimbres is alive within it, because its clay was tempered with shards from ancient pots. There are literally generations of pots present. More than this, the people of the Mimbres survive in the pattern. The interlocked birds that give this pot such charm are unique to the clan. The design was handed down to Concho, and before she died, she passed it on to a clan granddaughter. So the long-ago Mimbres artist, who created this witty and simple pattern, lives on today.

Jar and Basket

DAVE THE POTTER AND MARY JACKSON

As we know, African-Americans did not choose to come to this country, and only God knows how many artists had their creativity crushed by slavery. However, nothing could quell the spirit of Dave the Potter. In 1857 he was in South Carolina, "owned" (blasphemous word) by Lewis Miles, who ran a pottery. I feel certain that Dave never felt that anybody owned him. He created these majestic storage jars for his own delight, and of course, like artists through the centuries, for money. He wrote on one side of the pot: "I made this jar for cash, though it's called Lucre Trash." He seems to have been a witty, articulate man, and a magnificent potter. Something about this jar—its dark color and its monumentality; its thickness; the confident curve of the handles—signifies to me the endurance of the slave and his patient power.

Also from South Carolina, but from 1992, comes a noble example of one of the few arts that the slaves brought with them from West Africa that was not destroyed: the art of basket making. They kept up the familiar tradition, with the men going out to cut the sweet grass, and the women weaving the baskets. Mary Jackson was taught the craft by her mother when she was five, and in her maturity, she transformed the craft into an art. She plays with techniques, looping out the handles with elegant freedom, and spreading the basket sides to make a deeply satisfying shape.

If Dave's jar stands for the strength of the African spirit, I think that the basket stands for the poetry, with all its controlled grace.

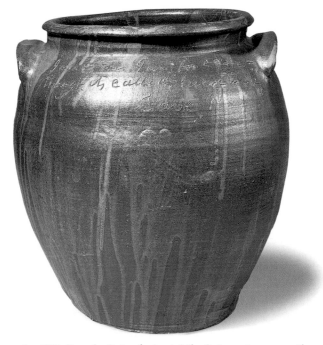

> **If Dave's jar stands for the strength of the African spirit, I think that the basket stands for the poetry.**

◁ **Basket with Lid**; 1992; Mary A. Jackson, American (1945–); plant fiber/grass; height 17 in. (43.2 cm), diameter 18 in. (45.7 cm)

△ **Jar**; 1857; Dave the Potter, for Lewis Miles Pottery; stoneware with alkaline glaze; height 19 in. (48.3 cm), diameter 17¾ in. (45.1 cm)

St. Francis

ZURBARÁN

Zurbarán is a heavyweight Spanish artist: grave, gracious, and austere, with a natural trait for suffering and silence (not a fashionable preoccupation in today's world). He painted many pictures of St. Francis, which always slightly puzzled me. St. Francis was a little, laughing man, who came dancing and singing into the Middle Ages, dispelling people's anxieties, speaking only of love and the goodness of God and of His world. Zurbarán does not seem lighthearted enough for Francis. Unfortunately, later generations felt that Francis was too lighthearted for himself; they wanted a more impressive figure, and they set about fashioning one.

Included in this reimaging was the creation of a very "Zurbaránish" legend. One of the popes, eager to see the saint's body, took a lantern and his entourage on a trip to the crypt. As they turned a corner, the story goes, they saw, with a shock of horror, the dead saint, standing in a niche, as if alive. Whenever I visit the European Painting galleries, I relive that shock. The museum hung this great Zurbarán in such a way that it is the first thing you see as you enter; it dominates the room. From a distance, it seems to loom, ghostlike. Only when we are closer can the shadows be seen, telling us that this is flesh and blood: the real St. Francis, in his patched habit, with the three knots on his rope girdle, representing the vows of poverty, chastity, and obedience. Closer still, and we see that there is nothing to frighten us. His face is incandescent with the joy of heaven. Francis is totally concentrated on the things that matter.

The three knots in St. Francis' girdle represent poverty—the saint's favorite vow—chastity, and obedience. His face is raised toward heaven with an expression of utter joy.

> 66 The museum hung this great Zurbarán in such a way that it is the first thing you see as you enter; it dominates the room. From a distance, it seems to loom, ghostlike. 99

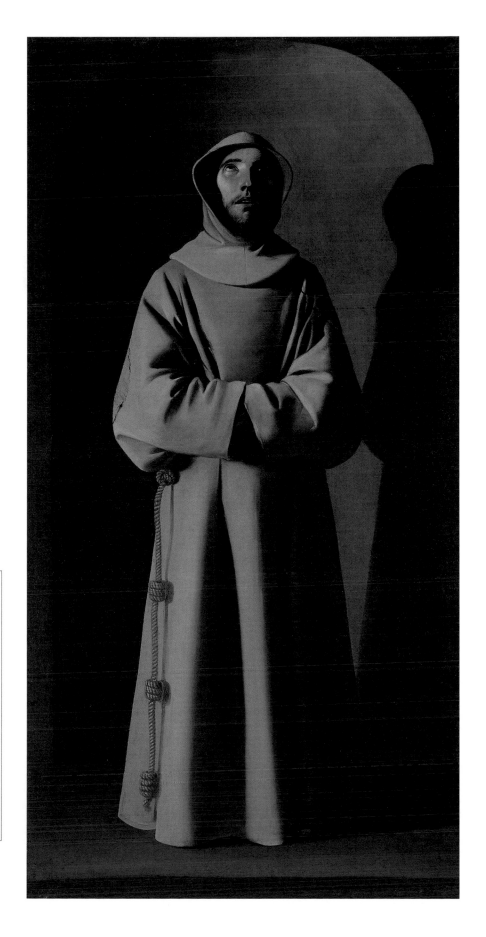

▷ **St. Francis;** c. 1640–45; oil on canvas; 81½ x 42 in. (207 x 106.7 cm)

Fray Hortensio Félix Paravicino

EL GRECO

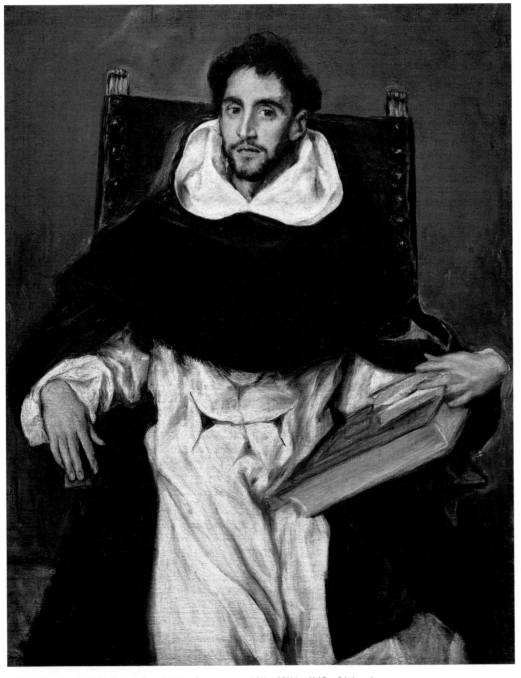

> " It was
> essentially the
> mystic portrait,
> summing up
> for him a peak
> of human
> achievement,
> that captured
> El Greco's artistic
> interest. Here
> we see what it
> means to be
> young, beautiful,
> intellectual, a
> poet, a priest. "

△ **Fray Hortensio Félix Paravicino;** 1609; oil on canvas; 44⅛ x 33⅞ in. (112 x 86.1 cm)

El Greco is a label, not a name. His real name was Domenikos Theotocopoulos, and apparently the Spanish found it too much of a mouthful. They dubbed him "the Greek," which seems somewhat lacking in friendly warmth. He did have friends, however, and this is a portrait of one of them: Fray Hortensio Félix Paravicino. Paravicino was splendidly good-looking, as you can see, and he was a devout Trinitarian monk. This was a peculiarly Spanish order, founded to ransom Christian captives from the Moors, and they wore a black and white habit, marked by a red and blue cross. The sneaking suspicion shamefully crossed my mind that the austere color and folds of this habit may be one of the reasons that drew this young idealist to the order.

El Greco sees him as somebody who is not quite aligned with our humdrum world; his chair is askew, and those great burning eyes are looking past us and away into the distance. His face is luminous with thought and prayer, oblivious to the surroundings. One hand—the priestly hand, the poet's hand—droops, contemplative, while the other—the scholar's hand—holds his books.

Some artists lamented that they painted too many portraits: Gainsborough and Ingres, for example; and Sargent, who recommended the M.F.A. to buy this picture. Looking at it, I could almost feel that El Greco, on the contrary, did not paint enough portraits. Yet I am probably wrong. It was essentially the mystic portrait, summing up for him a peak of human achievement, that captured El Greco's artistic interest. Here we see what it means to be young, beautiful, intellectual, a poet, a priest. (Sister Wendy sighs, enviously …)

Fray Hortensio's face is luminous with prayer and his eyes burn with the depth of his faith. The cross on his tunic indicates that he is a Trinitarian monk.

BIOGRAPHY

El Greco (Domenikos Theotocopoulos)
Greek, 1541–1614

• Born in Crete, Theotocopoulos studied in Venice in the 1560s, then moved to Spain in 1577, where he was dubbed El Greco.

• With his Byzantine roots, Venetian training, and the Spanish traditions of the country in which he worked, El Greco developed his own unique style, characterized by a cold, bluish color palette and elongated figures (this has sometimes been attributed to the eye condition astigmatism).

• A sculptor and architect as well as a painter, El Greco enjoyed his greatest success painting deeply spiritual portraits of religious figures.

FRAY HORTENSIO FÉLIX PARAVICINO

The interesting thing about the friendship between El Greco and Paravicino was the age gap: Paravicino was 29, and El Greco well into his 60s. Their acquaintance possibly arose from mutual admiration, because each was aware of the other's genius. Paravicino could write and speak Latin when he was 5, and was a full professor at 21; he was a leading intellectual, a renowned preacher, and a famous poet— he wrote sonnets in honor of El Greco.

Grand Piano

SHERATON

Museums can collect objects for many reasons: because they are beautiful; because they are rare, or unique; because they are fascinating, or have an historical interest. On all those levels, this grand piano triumphs. It fascinates the musicologists because it is the earliest extant six-octave piano, and it was made by the great English firm Broadwood, which is still going strong. Another cause for scholarly excitement is that this piano is the only known piece documented and signed by the renowned English cabinetmaker Thomas Sheraton.

It is splendid proof of Sheraton's skills, made in 1796 when there was no one alive who had more experience with wood. He blended the gleaming satinwood, the contrasting purpleheart, and the scarlet tulipwood—though time has dimmed the intensity of the shades. Sheraton's patterns are broad, simple, and grand, as befits the piano. Moreover—and now ceramic lovers become enthralled—he set all around the case cameos and medallions of Wedgwood jasper, of the finest period. Over the keyboard, he arranged coin casts by Thomas Tassie—less obtrusive but equally beautiful. The piano was commissioned by the Spanish prime minister, Manuel de Godoy, and from there began its mysterious travels, through Spain, through France, through England—until it finally came to rest at the M.F.A.

> " This piano is the only known piece documented and signed by the renowned English cabinetmaker Thomas Sheraton. "

▷ **Grand Piano;** 1796; veneered case of satinwood, tulipwood, and purpleheart with Wedgwood cameos and medallions; 97⅞ x 43⅞ x 35⅞ in. (248.7 x 111.5 x 91.2 cm)

BIOGRAPHY

Thomas Sheraton
English, 1751–1806

• Sheraton's reputation is based on his four-volume book of designs, *The Cabinet-Maker and Upholsterer's Drawing Book*, published 1791–94.

• His name is used to describe the style of English furniture at the end of the 18th century, characterized by straight lines and elegant proportions.

The Wedgwood medallions portray a charming variety of cavorting mythological figures.

Sons of Liberty Bowl

REVERE

△ **Sons of Liberty Bowl** *(both sides)*; 1768; silver; height 5½ in. (14 cm), diameter of lip 11 in. (27.9 cm)

The year 1768 was an important one for America. This was the year, it seems to me, in which revolution and victory became inevitable. The Massachusetts House of Representatives wrote a loyal and respectful letter to the king about the injustice of their tax burden. Foolishly, the authorities overreacted. The Representatives were told to rescind their letter or face dismissal. Seventeen voted to rescind; 92 voted against. Within a mere five weeks of their decision, Paul Revere crafted the magnificent *Sons of Liberty Bowl*: one of Boston's most precious possessions, and a tremendous feat of patriotic energy.

On one side is the number 45: the number of the journal published in England by the politician John Wilkes, in which he championed the American cause. Wilkes became identified with liberty, and the number 45 became significant. There are 45 ounces of silver in the bowl; it can take 45 gills of punch; and when the Sons of Liberty, of whom Revere was one, met at the Green Dragon Tavern, they would drink 45 separate toasts. On the other side of the bowl is a solemn commemoration of those who stood against what was seen as tyranny.

BIOGRAPHY

Paul Revere II
American, 1735–1818

• Revere was a revolutionary hero who, on the eve of the War of Independence, on April 18, 1775, rode to Lexington to warn the people that the British army was coming.

• He was also a silversmith, whose style developed from fairly plain early Georgian designs to delicately engraved pieces. He also engraved political prints during the war.

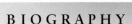

" The magnificent *Sons of Liberty Bowl*: one of Boston's most precious possessions, and a tremendous feat of patriotic energy. "

Paul Revere

COPLEY

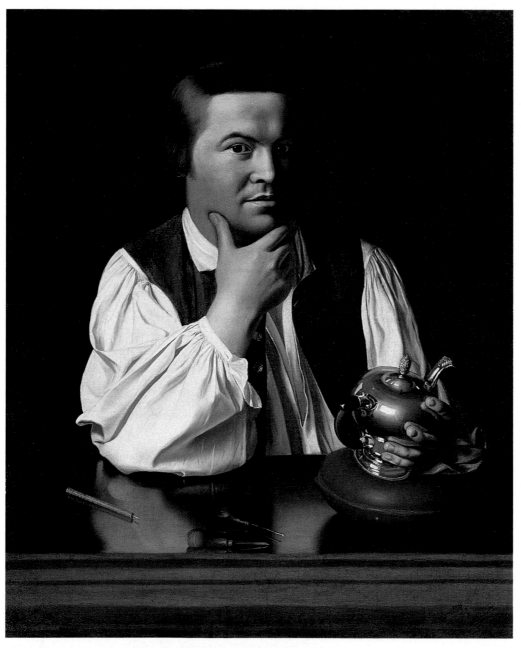

> " The great expanse of bare sleeve makes a political statement. There was supposed to be no linen in America unless it was imported. "

△ **Paul Revere;** 1768; oil on canvas; 85⅛ x 28½ in. (89.2 x 72.4 cm)

The year 1768 was an important one for two young Bostonians: John Singleton Copley, who painted this picture, and Paul Revere, who sat for it. They were both in their early thirties, and they could not have been more different. This was a time of extreme political tension, when Boston was divided into Whigs, who wanted freedom, and Tories, who were content to stay British. Paul Revere was deeply political—and 100 percent Whig. Copley, on the other hand, was completely uninterested in politics; he wanted only to be neutral, which was not possible. He was about to marry into one of the leading Tory families, the Clarkes (owners of the notorious tea concession). Copley was performing a balancing act, but this was the year when he wrote that he felt he must leave America and go to live in England. There he could be an artist and a gentleman—while silversmith Paul Revere was happy to be a craftsman.

It was costly to have one's portrait painted, and very unusual to be painted without a gentleman's coat. Revere's descendants misunderstood this picture. They thought it made him look like a workman, and they hid it in the attic, but Revere is wearing an elaborate vest with gold buttons. The great expanse of bare sleeve—a fullness of flowing linen—makes a political statement. There was supposed to be no linen in America unless it was imported. The ladies of Boston objected to this, and in this very year they produced a hundred ells (about 125 yards) of linen. Revere is honoring this act of defiance, sporting a symbol of his country's freedom. The problem is the teapot, because tea was a burning issue. Only the Tories drank tea; the Whigs drank "Boston Tea," which was punch. Why does Revere hold a teapot? Is Copley deliberately trying to balance the Whiggish sleeve? Or was it Revere's own choice—to show off his skills as a silversmith? I see this picture as almost a confrontation between the two young men. Looking at Revere's solid, brooding face, I am not surprised that he won. Copley signed the portrait, but in letters so minuscule that hardly anyone could read them.

Unusually, Revere is not wearing his gentleman's coat but instead displays an expanse of white linen. This was a political statement against the British, who had banned the production of linen in America. The teapot is probably an indication of Revere's trade as a silversmith.

The Mystic Marriage
of St. Catherine

BARNA DA SIENA

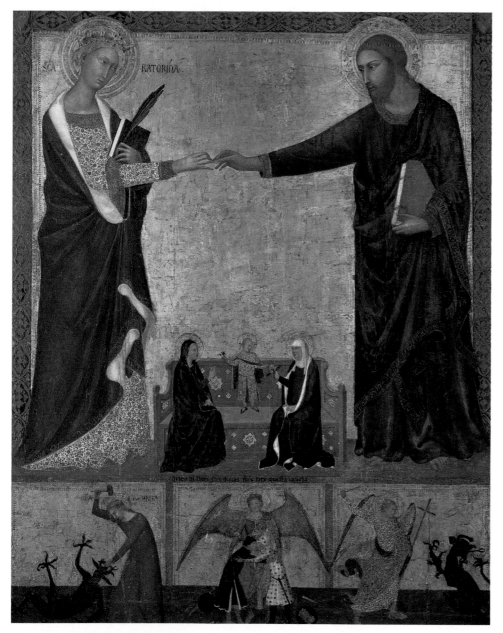

△ **The Mystic Marriage of St. Catherine**; c. 1340; tempera on panel; design 53⅛ x 42⅛ in. (134.8 x 107.1 cm)

THE VISION OF SAINT CATHERINE

Catherine was one of many children of a family of Sienese dyers, and her mother was understandably anxious to have her married and away from the family home. Catherine, while not feeling called to the convent, was passionately devoted to Christ. She had a vision, in which Christ put a ring on her finger and betrothed her in marriage, sealing her status as a virgin. (Her mother was furious.)

BIOGRAPHY

Barna da Siena
Italian, active mid-14th century

• Very little is known about Barna da Siena's life, and only a few known works can be reasonably attributed to him.

• These include: *The Mystic Marriage of St. Catherine* (c. 1340); *The Crucifixion* in the Episcopal Palace in Arezzo (1369); and *The Life of Christ* frescoes in the Collegiata at San Gimignano (c. 1350–55).

• His works, characterized by compositions filled with unusually lively figures and a forceful drawing style, are progressive for the period.

> " What is ultimately memorable about this work is its intellectual clarity, and the visual power of its summons to friendship. "

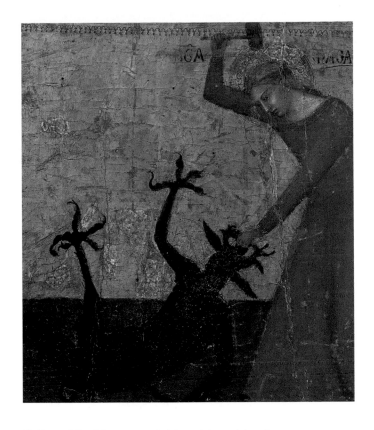

We know very little about Barna—except that, presumably, he came from the Italian town of Siena. Of the few works attributed to him, this is the masterpiece. It is a wonderfully inventive painting. Marriage to Christ is not an uncommon theme in art, but it is always the infant Christ who is depicted. Only Barna daringly considers that so mature a passion should be matched with a mature Christ. The two tall figures dominate the panel—not physically close (Christ leans from a distance to accept His bride), but establishing a mood of loving acceptance. Beneath them is the infant Christ, reaching out in love to His mother Mary and His grandmother Anne. Immediately below that is a third scene of acceptance: an angel spreads his wings over two embracing knights beneath the written legend "Arigi di Neri Arighetti ordered this picture to be painted." The shields and swords cast aside tell us that this is a celebration of reconciliation.

To make the message even clearer, on either side are images of what reconciliation entails, which is struggling with one's demons. St. Michael conquers the devil with a flail, and St. Margaret clobbers him with a hammer. Interestingly, neither saint uses a sword—a weapon that is obviously to be abjured. Evil is seen as repulsive and formless, whereas the image of virtue is of ordered graciousness. I am intrigued by the choice of St. Margaret as warrior. There are several male saints who battle the devil (think of St. George), but she is the only female to fill this role, and I cannot help wondering whether the quarrel between Arigi and his erstwhile foe—whatever it was—might have involved a woman. However, what is ultimately memorable about this work is its intellectual clarity, and the visual power of its summons to friendship.

St. Catherine and Christ reach their hands toward each other, symbolizing the fact that this painting is a summons to reconciliation and friendship (left). At the bottom of the painting, two saints are shown vanquishing evil in the form of the devil. Unusually, the artist has chosen the female St. Margaret as one of the saintly warriors (above).

Where Do We Come From? What Are We? Where Are We Going?

GAUGUIN

△ **Where Do We Come From? What Are We? Where Are We Going?**; 1897; oil on canvas; 54¾ x 147½ in. (139.1 x 374.6 cm)

This is Gauguin's ultimate masterpiece—if all the Gauguins in the world, except one, were to be evaporated (perish the thought!), this would be the one to preserve. He claimed that he did not think of the long title until the work was finished, but he is known to have been creative with the truth. The picture is so superbly organized into three "scoops"—a circle to right and to left, and a great oval in the center—that I cannot but believe he had his questions in mind from the start. I am often tempted to forget that these are questions, and to think that he is suggesting answers, but there are no answers here; there are three fundamental questions, posed visually.

On the right (Where do we come from?), we see the baby, and three young women—those who are closest to that eternal mystery. In the center, Gauguin meditates on what we are. Here are two women, talking about destiny (or so he described them), a man looking puzzled and half-aggressive, and in the middle, a youth plucking the fruit of experience. This has nothing to do, I feel sure, with the Garden of Eden; it is humanity's innocent and natural desire to live and to search for more life. A child eats the fruit, overlooked by the remote presence of an idol—emblem of our need for the spiritual. There are women (one mysteriously curled up into a shell), and there are

animals with whom we share the world: a goat, a cat, and kittens. In the final section (Where are we going?), a beautiful young woman broods, and an old woman prepares to die. Her pallor and gray hair tell us so, but the message is underscored by the presence of a strange white bird. I once described it as "a mutated puffin," and I do not think I can do better. It is Gauguin's symbol of the afterlife, of the unknown (just as the dog, on the far right, is his symbol of himself).

All this is set in a paradise of tropical beauty: the Tahiti of sunlight, freedom, and color that Gauguin left everything to find. A little river runs through the woods, and behind it is a great slash of brilliant blue sea, with the misty mountains of another island rising beyond. Gauguin wanted to make it absolutely clear that this picture was his testament. He seems to have concocted a story that, being ill and unappreciated (that part was true enough), he determined on suicide—the great refusal. He wrote to a friend, describing his journey into the mountains with arsenic. Then he found himself still alive, and returned to paint more masterworks. It is sad that so great an artist felt he needed to manufacture a ploy to get people to appreciate his work. I wish he could see us now, looking with awe at this supreme painting.

The young women (above), with their close association with birth, represent the question "Where do we come from?" The old woman (right) is asking "Where are we going?" The youth plucking fruit (far right) symbolizes "What are we?" as he reaches for new experiences.

A GOLDEN MURAL

This masterpiece cost Gauguin a month of hectic, passionate work. He poured his spirit into it, furiously attempting to express what mattered to him most. He did not intend it to be realistic, and he made that clear by saying that he imagined it as a mural on a golden wall—the wall of paradise, perhaps. He peeled down the corners to reveal the gold; and signed his name on one side, and the title on the other. It is a very long title, and he swore that he had not even thought of it until the painting was finished.

BIOGRAPHY

Paul Gauguin
French, 1848–1903

• Gauguin, Cézanne, and van Gogh were among the greatest of the postimpressionists.

• In search of a more natural way of living, Gauguin settled in Tahiti in 1891, and spent most of the rest of his life in the South Seas, where his work was profoundly influenced by local primitive art.

• Gauguin rejected naturalism and developed his own style, called synthetism, which used simplified forms and bold colors to convey ideas and moods expressionistically.

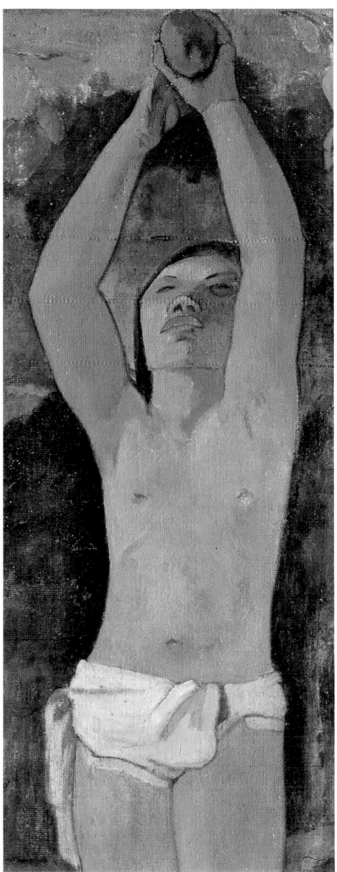

“ This is Gauguin's ultimate masterpiece—if all the Gauguins in the world, except one, were to be evaporated (perish the thought!), this would be the one to preserve. ”

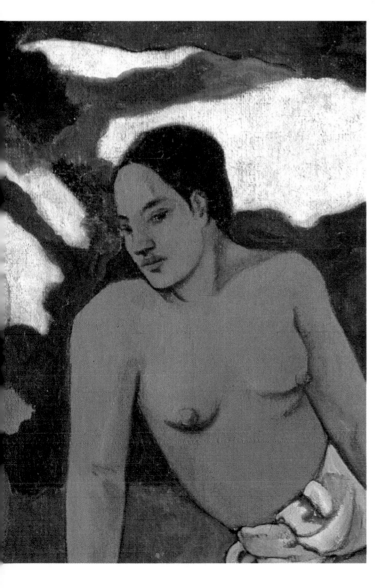

> **"** The female body is created to enter into that most divine of activities: conceiving and bearing a child. The appropriate reaction is reverence. **"**

Yakshi

INDIAN

This Yakshi—a fertility goddess and tree spirit—comes from high up in the north of central India, where there was a giant stupa: a huge mound of earth, at the center of which was buried a relic of the Buddha. All around this mound were magnificent stone carvings, relating the story of the Buddha's life; and there were four great archways. Each of these was guarded by a Yakshi, leaning from a branch and inviting worshipers to enter. This, of course, is not part of Buddhism. It came from Hinduism—perhaps to make new believers feel that this new religion did not mean casting off the old.

Of all the world's great faiths, only Hinduism has completely understood the sacred nature of the human body. If you think the Yakshi is too exposed, you have not understood that she is carved as an act of worship. It is God who made the body—and made it beautiful. The female body is created to enter into that most divine of activities: conceiving and bearing a child. The appropriate reaction is reverence. Even in her mutilated state—head, arms, and legs broken off, and beautiful melon breasts destroyed—this Yakshi, torn from her doorway, still invites us to prayer.

She was never meant to be realistic. The worshiper saw her first from the front—a sacred image promising happiness and new life. Sideways on, she appears narrow and unreal, but once through the gate, looking back, one would see her cascading hair and her delicate garment.

△ **Yakshi (Torso of a Fertility Goddess);** c. 25 B.C.–A.D. 25; sandstone; height 28⅜ in. (72 cm)

Architecture

GIAMBOLOGNA

Jean Boulogne was one of the northern artists who came to visit Italy—in his case from Flanders—and never went away again. He became Italianized as Giambologna, and is one of the great sculptors. This is a reproduction of his allegorical *Architecture*: small, at just over 14 inches high, but incredibly beautiful. Giambologna was himself an architect, and everything in this allegory is brilliantly conceived. Every part of the work makes clear to us his architectural ideal. The figure holds a drawing board in one hand, and surveying instruments in the other; but these are fairly obvious props. What is creative are the various details, such as her hairstyle—specifically designed to give her height, which a building needs. The triple string around her neck suggests a plumb line. It is not merely decorative but, as the classical theory held, it is also functional. The function is to direct our attention to that exquisite body, with the small, high breasts and the long, liquid sweep of thigh and leg.

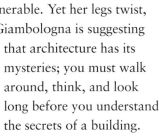

We are confronted with this body, as if with a building; a body that somehow does not seem to me truly "naked." She is clothed, paradoxically, in her skin—with none of the soft vulnerability of flesh. She is perfect, which is what 16th-century architecture aspired to be: strong and invulnerable. Yet her legs twist, and she turns her head away. Giambologna is suggesting that architecture has its mysteries; you must walk around, think, and look long before you understand the secrets of a building.

△ **Architecture**; late 16th century; bronze; height 14¼ in. (36.2 cm)

" She is clothed, paradoxically, in her skin—with none of the soft vulnerability of flesh. She is perfect, which is what 16th-century architecture aspired to be. "

White Rose with Larkspur No. 2

O'KEEFFE

There are certain artists whose names nearly everyone recognizes: Michelangelo, say, or van Gogh. I think that most Americans, even if they never saw her work, know the name of Georgia O'Keeffe. When you do see her work—especially her characteristic paintings from the 1920s and 1930s—it is not easily forgotten. She painted flowers as no one else painted them: in enormous close-up. You feel the flowers pressing against your face; you smell them; you sense the silky petals. The flowers are partly realistic—notice the creamy radiance of the white rose—and partly abstract; there are merely touches of blue and pink for the larkspur. Both seem to expand off the canvas, engulfing us.

The approach is deeply sensuous, and critics at the time did not quite know what to make of it. Even those who admired her used the term "sexual." O'Keeffe, a redoubtable woman, found this very annoying. Her answer was: "I made you take time to look at what I saw. And when you took time to really notice my flower, you put all your own associations with flowers onto my flower." She kept her vision focused, insisting on seeing a flower as a world.

For a long time the M.F.A. sought a painting from O'Keeffe's most typical period but could not find one. Finally, when she was 92 and living in New Mexico, they went to see her and explained the problem, whereupon she went into her bedroom and brought out this picture. O'Keeffe was, I think, a very fortunate woman. She lived to be nearly 100, and she had enormous willpower, strength, and beauty.

BIOGRAPHY

Georgia O'Keeffe
American, 1887–1986

- Georgia O'Keeffe had her first one-woman show in 1917, at Alfred Stieglitz's renowned 291 Gallery in New York. She married Stieglitz, a passionate advocate of modern art in the United States, in 1924.

- O'Keeffe's subject matter included architecture and landscapes, and her execution varied from abstract, symbolic representations to enormously magnified, semi-abstract close-ups of organic forms, most notably flowers.

- She was fascinated by the desert landscape of New Mexico, and around 1930 began including images of bones in her paintings, at first alone and then placed within landscapes.

> **" She painted flowers as no one else painted them: in enormous close-up. You feel the flowers pressing against your face. "**

ALFRED STIEGLITZ

Georgia O'Keeffe had one blessing that no other artist had: she married one of the 20th century's greatest photographers, the American Alfred Stieglitz (1864–1946), who devoted himself to celebrating her beauty. He photographed her, muffled to the neck, and in a dress open to the waist. He photographed her far off; or he zoomed in, as she did on her flowers. He was engrossed by that strong, noble face—always grave, always inwardly preoccupied. Above all, he focused on her hands: long, powerful artist's hands—resting, active, caressing. If O'Keeffe had never painted, we would still know her name.

△ **A Portrait—Georgia O'Keeffe;** 1918; Alfred Stieglitz; palladium print; 9⅛ x 7½ in. (23.3 x 19.1 cm)

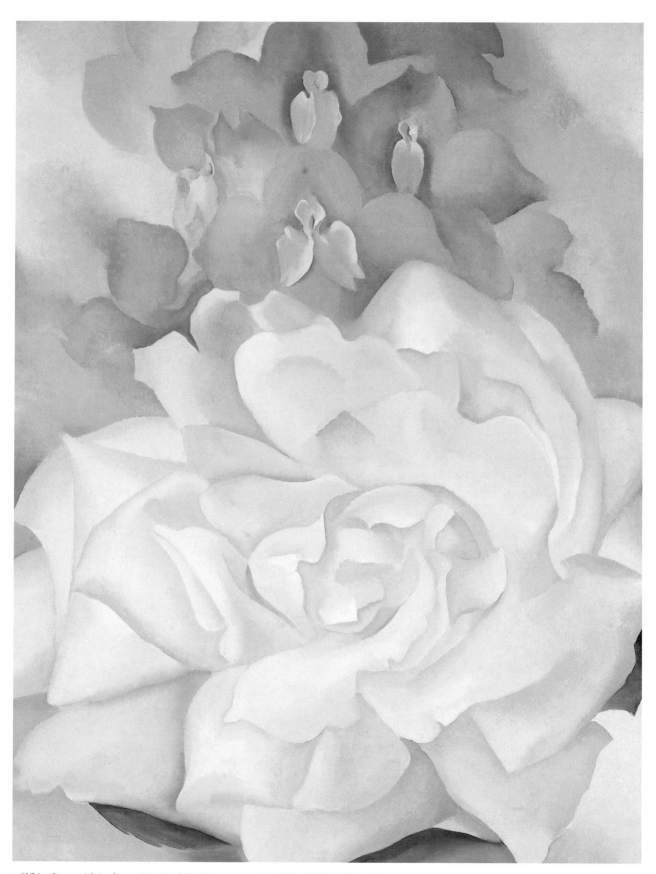

△ **White Rose with Larkspur No. 2;** 1927; oil on canvas; 40 x 30 in. (101.6 x 76.2 cm)

Approaching Storm: Beach Near Newport

HEADE

Sadly, many artists have at times dropped out of history and been long forgotten—think of Vermeer or La Tour, for example. The forgotten American was Martin Johnson Heade. He was a loner, a wanderer, and a man whom no one remembered after his death. It was the

M.F.A.—or rather, one of its patrons—who rehabilitated him. Maxim Kuralik was a Russian opera singer, who married an heiress of the Derby West family, nearly forty years older than he. Kuralik is said to have made her very happy—and he made the M.F.A. very happy also, as a

△ **Approaching Storm: Beach Near Newport;** 1867; oil on canvas; 28 x 58¼ in. (71.1 x 148 cm)

most generous benefactor. Perhaps because he was a Russian, unused to the optimism and spacious, romantic landscapes of American art, he was able to appreciate a vision as different as Heade's.

Kuralik responded to the power of this work, which is Heade's masterpiece. It is the reverse of welcoming; it displays a chilling indifference to humanity. A strange, surreal light plays with a sharp intensity over these barren rocks and sands and waves. There is an almost abstract use of light and dark in the sky, and the small sailboats bounce about on the top of threatening dark seas—exposed and isolated. The scene is ominous. The date is 1867, so the Civil War is over; could

this be aftershock? Or does the mood stem from Heade's anxiety over his father, who was soon to die? It could be a cosmic feeling—a perception of the world as inhospitable. Now that Heade is recognized as a great American artist, many people see sublimity in this work.

My impression is primarily of menace and uncanniness. I will, however, admit that it is a sublime uncanniness.

Heade depicts a land of barren rocks and empty sand, with a raging sea—on which small boats sail precariously—encroaching upon the shores.

> " There is an almost abstract use of light and dark in the sky, and the small sailboats bounce about on the top of threatening dark seas. "

BIOGRAPHY

Martin Johnson Heade
American, 1819–1904

• Heade was part of a group of American painters known as the luminists, who were concerned with reproducing the atmospheric effects of light on the landscape.

• He traveled widely in the Americas and Europe for most of his life, painting the different views he encountered. His works, with their dramatic play of light and shade, often have an almost surreal ambience.

• Heade eventually settled in Florida at the age of 64, where he produced beautifully detailed and atmospheric still lifes of flowers and foliage.

The Garden of Tenshin-en

JAPANESE-STYLE

Painting can be reproduced fairly successfully by the camera, provided we keep in mind dimensions and manner of painting. Sculpture is difficult, because we cannot see its three-dimensionality—the way in which it invades our space. A garden is impossible. The reproduction can do little more than whet your appetite. The M.F.A. has a Japanese garden. Their Oriental collection was termed "the finest in the world under one roof," but this is a work that evades the roof and takes to the open air. It is known as the Garden of Tenshin-en, the Garden of the Heart of Heaven. It is a Zen garden, created by the museum in honor of one of their greatest Japanese curators, a scholar and a saint, Okakura Kakuzo.

In one enclosed space, the garden seeks to express the entire natural world: mountains and waterfalls, rivers, islands, and the mighty sea—but this is not the Sea of Japan. The creators of the garden flew over all of New England to find the truest way to render the contours of this lovely coast. Moreover, the "water" is dry—water of the mind—formed by gravel that is raked into the pattern of waves. A great rock at the rear is a mountain, with smaller rocks cascading down as a waterfall. There are two islands, made from local rocks into the shapes of a turtle and a crane: the images of immortality. Bridges link them, but no one will cross the bridges or climb the mountain. This is a sacred space, in which only your spirit is free to wander. The concept of dry water—of inviting your imagination to think of the sound of water, the feel of water, and the sight of water, pure and green—seems very Japanese, and a wise corrective to our materialist preoccupations. This is not a garden for walking in, nor is it for talking; we must sit still and let our spirit journey.

> "This is not a garden for walking in, nor is it for talking; we must sit still and let our spirit journey."

▷ **The Garden Tenshin-en (The Garden of the Heart of Heaven);** dedicated on October 24, 1988, to the memory of Okakura Kakuzo

Seven Forms

CHIHULY

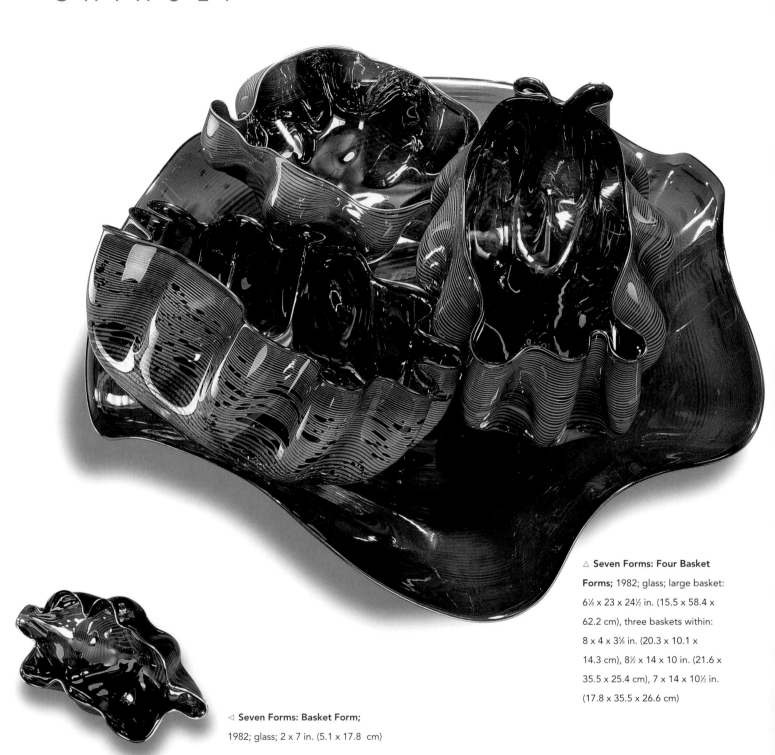

△ **Seven Forms: Four Basket Forms;** 1982; glass; large basket: 6⅛ x 23 x 24½ in. (15.5 x 58.4 x 62.2 cm), three baskets within: 8 x 4 x 3⅝ in. (20.3 x 10.1 x 14.3 cm), 8½ x 14 x 10 in. (21.6 x 35.5 x 25.4 cm), 7 x 14 x 10½ in. (17.8 x 35.5 x 26.6 cm)

◁ **Seven Forms: Basket Form;** 1982; glass; 2 x 7 in. (5.1 x 17.8 cm)

A s somebody with no artistic skills, I find all art-making magical. One day there is nothing, and then, through skill and training, perseverance and vision, something wonderful comes into existence that can change the way we see the world. Of all art-making, glass art is the most magical. Dale Chihuly is the greatest contemporary glass artist—although since he lost an eye (he wears a piratical black patch), he orchestrates his creations rather than blowing them himself. Yet it is entirely his work: blown from his sketches and under his directions.

The M.F.A. has either one work or seven, depending on how they are displayed. They cohere, but loosely and variously: no arrangement will ever exhaust their potential. The effect is of sea shapes that formed organically. This art makes simultaneous and paradoxical demands: the most intense control, and the most profound spontaneity. The result is paradoxical also: smooth and strong, yet alarmingly fragile. Chihuly has said that glass has an interior space like nothing else—literally, of course, you can look into these gleaming hollows, and see space, but he means more. Here is also the artist's own space—his inner space—created by his breath, his spirit (*spiritus* is the Latin word for breath). Here is an extension of himself. In a mystical way also, these forms represent another dimension. They are colored light made visible—a rapturous expression of freedom and joy. It was remarked that when people look at works by Chihuly, they always smile. They smile because of the pleasure the Seven Forms give, but I think they also smile with amazement.

> " It was remarked that when people look at works by Chihuly, they always smile. They smile because of the pleasure the Seven Forms give, but I think they also smile with amazement. "

△ **Seven Forms: Pouch Form and Sea Urchin Form;** 1982; glass; pouch (above): 6 x 5½ x 4½ in. (15.2 x 14 x 11.4 cm), sea urchin (below): 2 x 7 in. (5.1 x 17.8 cm)

BIOGRAPHY

Dale Chihuly
American, 1941–

• Chihuly has studied with a number of people, including Harvey Littleton, a pioneer of studio glass in the U.S.

• In 1968 Chihuly became the first American glassblower to work at the Venini factory in Italy, which produces wonderful modern glass using traditional techniques.

• Chihuly's mastery of Venetian glassmaking techniques is evident in his work, as are the influences of Native American designs.

Glass V

LICHTENSTEIN

Sometimes, I am ashamed to admit, there are works of art that I have at first dismissed with a quick glance but that appear entirely differently when I take the time really to look at them. I would probably not have noticed Roy Lichtenstein's *Glass V* had it not been for its position, directly in front of the museum's café area: a seductive invitation, perhaps, to enjoy a refreshing drink. Thinking about this and standing before it, I began to see what a clever piece of work it is. It is ambiguous: both a painting, because it is a flat surface with paint on it; and a sculpture, because it is a bronze and stands upright. It is both a full glass, with colored stripes; and it is empty, since we can see through it. Lichtenstein makes us wonder what he had in mind.

Pop artists declared that they had no interest in the soul and their own emotions; they wanted to focus outward, not inward. Lichtenstein said he wanted to look at the world "impersonally," but, of course, all looking is to some extent subjective—and this is surely not an impersonal work. It is strangely magnanimous, and communicates a cheerful sense of order. Put simply, Lichtenstein created it because he liked the look of it—and after pausing to pay attention, I found that I liked the look of it also.

△ **Glass V;** 1978; painted and patinated bronze; 69¾ x 26½ x 17¾ in.

(177.2 x 67.3 x 45.1 cm)

> " It is both a full glass, with colored stripes; and it is empty, since we can see through it. "

BIOGRAPHY

Roy Lichtenstein
American, 1923–97

• The American painter and sculptor Roy Lichtenstein was one of the major artists of the pop art movement of the 1960s, in which the techniques of commercial art were adopted to portray everyday objects from popular culture.

• His most famous works are enlarged comic-strip frames, using primary colors to replicate the dots of the printing process, with the forms thickly outlined in black.

Please Be Seated

AMERICAN

The one necessity for art appreciation, it is said, is a chair. You need to be comfortable in order to look. Boston's American Decorative Arts department came up with the brilliant idea of commissioning contemporary furniture artists to make chairs and benches for the galleries. (I attribute this creativity to the bliss in which they and the Oriental department must spend their days, surrounded by their astonishing collections.) Not only would visitors have physical comfort, but they would also be able to enjoy an intimate association with art. It is worth noting that many people are nervous about art, especially contemporary art.

△ **Settee**; 1979; Wendell Castle, American (1932–); cherry; 58 x 36 x 24 in. (147.3 x 91.4 x 61 cm)

The department's program, entitled "Please Be Seated," invites the museumgoer into familiarity and confidence. I suppose the best known of the furniture artists whose works appear are Sam Maloof (he has a rocking chair in the White House) and Wendell Castle, both leading members of the crafts revival movement that began in the United States in the 1950s. Castle said that he does not want his work to seem "obvious"; he likes ambiguity. He wants us to be uncertain whether his benches are art or not, and to make up our own minds, since learning to make considered judgments is essential for genuine appreciation. He adds that he refuses to explain his art. I shall not try to explain it either, but simply praise the museum for possessing the enlightenment that makes a museum great.

> **"** The one necessity for art appreciation, it is said, is a chair. You need to be comfortable in order to look. **"**

△ **Settee**; 1975; Sam Maloof, American (1916–); walnut; 30¼ x 42½ in. (76.8 x 108 cm)

ART INSTITUTE
OF CHICAGO

Introduction

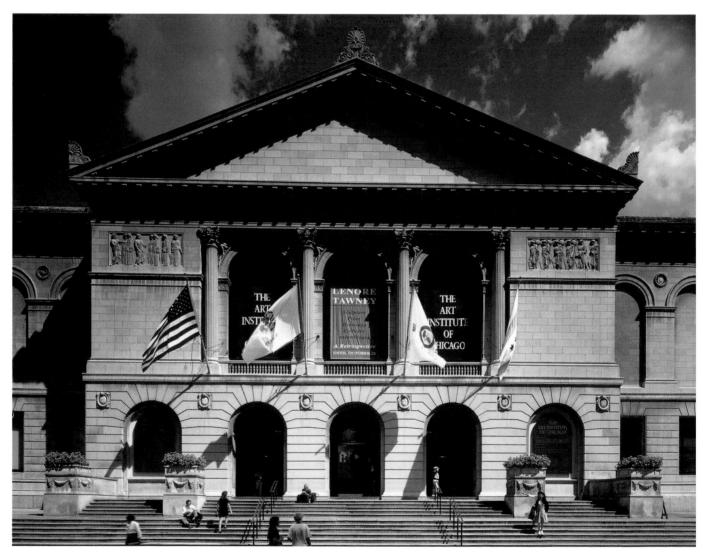

△ Exterior view of the Michigan Avenue entrance to the Art Institute of Chicago

Most people can probably recall their first glimpse of the Art Institute of Chicago—especially if, like me, they were walking along a bustling street, all thoughts of art silenced by the thunder of trains passing overhead, in downtown Chicago's famous Loop. I stopped at a traffic light, glanced to my left, and there, one block down, symbolically holding out its arms to the noisy city, stood the museum. I felt—and still feel—a shock of pleasure at its sheer accessibility. This is a museum that fronts a commercial street (though one that also contains the Chicago Symphony Orchestra); that backs onto the sail-strewn waters of Lake Michigan; and that has Illinois Central train tracks running beneath one of its halls.

The Art Institute is a very large museum, containing over a quarter million works of art, yet it gives an impression not of size but of dignified friendliness. The *Family Guide* to the A.I.C. says that the museum covers the space of four football fields—a homely image, with its sense of communal good cheer and shared excitement. Foolishly, I was originally skeptical about the A.I.C. Its world-renowned collection of impressionist art is almost too renowned. I had feared that the museum might be an impressionist paradise, with small alternative areas on the periphery. I could not have been more mistaken. The Monets, Manets, Renoirs, and Degas' are wonderful indeed—all of the great names and many of their most gifted followers—but these form only a small part of the immense wealth of a museum that lies at the heart of a rich and generous city. The A.I.C. is clearly much loved by those to whom it reaches out, and who reach back with educated affection.

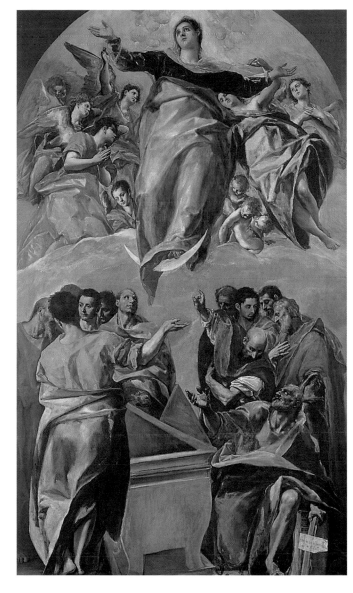

△ **The Assumption of the Virgin;**
1577; El Greco, Greek
(1541–1614); oil on canvas;
158 x 90 in. (401.4 x 228.7 cm)

◁ **Teardrop I;** 1996; Magdalene
Odundo, Kenyan (1950–); ceramic;
23⅜ x 19⅞ in. (60 x 48 cm)

Lady Sarah Bunbury Sacrificing to the Graces

REYNOLDS

Lady Sarah Bunbury was in many ways the Princess Diana of the 18th century. She did not have Diana's saintly side—no visiting hospitals for Lady Sarah—but she did have Diana's glamour. When she was just 15 years of age, the future king of England fell in love with her, though his infatuation was unrequited. Both he and Lady Sarah were promptly married off to more suitable partners. In this painting, Sir Joshua Reynolds has shown her as a new bride of barely 18, with her wedding ring very visible on her finger.

Reynolds did not like painting portraits, and preferred to depict classical myths. He decided to paint Lady Sarah as a Roman matron, offering sacrifice to the gods. The sweeping robes show off Lady Sarah's superb figure, and on the tripod the serpent of the Garden of Eden appears frozen into bronze in the presence of her virtue. She is shown sacrificing to the Graces—a witty invention, because the phrase was much used as a social cliché, meaning to do what was expected of you, no matter how you felt. Society approved of Lady Sarah's withdrawal from her royal affair, unaware that she had only laughed at her prestigious lover. Reynolds shows the Graces in an unusual position. One was traditionally seen from the back, as the goddesses gave, received, and returned. For their intimate, Lady Sarah, all three turn in her direction—remote and feathery, as if they are present only to her imagination. The picture aroused comment, some of it jealous. "She never did sacrifice to the Graces," it was said indignantly. "She had a gloriously handsome face but she used to play cricket and eat beef steaks on the Steyn at Brighton." Lady Sarah was a wild and unconventional spirit, and it was Reynolds who sacrificed to the Graces—with this pleasing result.

The Three Graces were three sister goddesses who could bestow beauty, grace, and charm, qualities for which the newly married Lady Sarah, with the wedding ring of respectability very much in evidence on her finger, was renowned.

A WOMAN OF HIGH SPIRITS

Lady Sarah was the most beautiful woman of the age, and the subject of much gossip. When she was 15, the heir to the throne (soon to be King George III) fell in love with her. Since royalty had to marry royalty, he was quickly wedded to a plain German princess, who made him an excellent wife. Lady Sarah was married also—to Sir Charles Bunbury, who soon discovered that his lovely, high-spirited wife did not care for living in the country and looking at horses. Ahead lay scandal, divorce, and elopement.

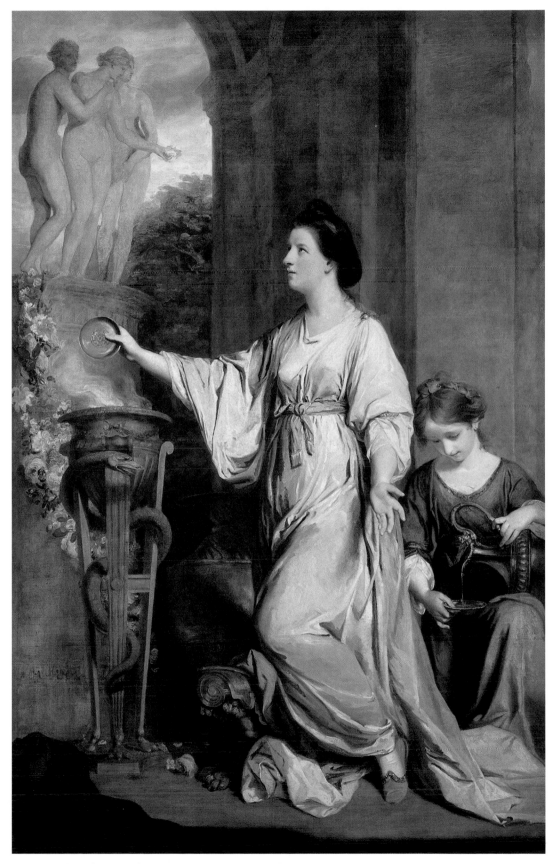

> "The sweeping robes show off Lady Sarah's superb figure, and on the tripod the serpent of the Garden of Eden appears frozen into bronze in the presence of her virtue."

△ **Lady Sarah Bunbury Sacrificing to the Graces;** 1763–65; oil on canvas; 95¼ x 59⅝ in. (242.6 x 151.5 cm)

Acrobats at the Cirque Fernando

RENOIR

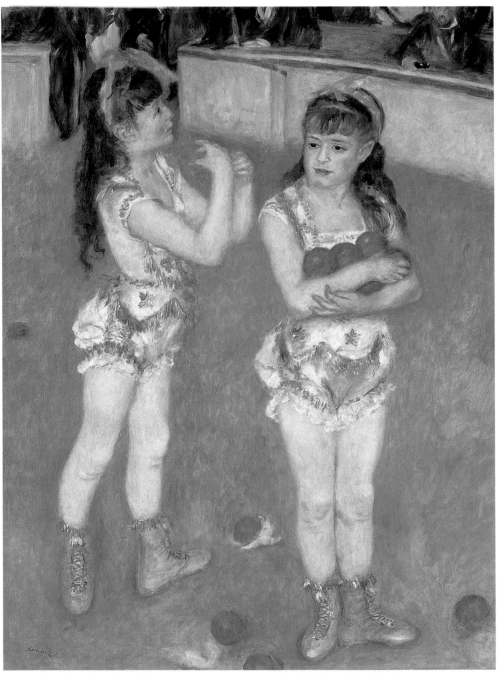

△ **Acrobats at the Cirque Fernando (Francisca and Angelina Wartenberg);** 1879; oil on canvas; 51¾ x 39⅛ in. (131.5 x 99.5 cm)

> ❝ That is Renoir's magic. He made the girls what they must have longed to be: beautiful little dancers. ❞

This painting has hung on walls throughout the world, because it belonged to Mrs. Potter Palmer, the great collector and traveler. It was her favorite picture, and she took it everywhere. We can see why she loved it. Here are little girls at their most charming: flushed cheeks, starry eyes, brown hair rippling down their backs. They have just finished their circus act, and Francisca, with childish aplomb, is accepting the applause, while Angelina looks shyly away, clasping to herself the oranges the girls were given instead of a bouquet. They bring to mind the little girls of the nursery rhyme, made of "sugar and spice and all things nice"—it is worth remembering that Mrs. Potter Palmer had no daughters, only sons.

This sweetness is an ideal, not the reality. These are not even "little" girls: Francisca was 17, and Angelina about 15. Nor were they (as used to be thought) the pampered daughters of the circus owner. They were part of a troupe of wandering German acrobats. We have photographs of this troupe: agile but muscular people, bulging with energy—not at all like these dainty creatures.

We know what happened to Francisca Wartenberg, one of the little girls in the painting (left). She married a German-American, went to live in San Francisco, and raised three robust American children (above).

That is Renoir's magic. He made the girls what they must have longed to be: beautiful little dancers. Look at their feet—in perfect ballet-school positions.

There is another dimension to the painting, also. Renoir was an artist of moral sunlight, who rarely touched on the dark side of life. He held that the purpose of art was to give pleasure. Yet here he shows us not just innocence, but innocence under threat. The girls are isolated in the arena, and for the 19th century, they are scantily clothed. All around, peering at them, are not happy family parties, but predatory gentlemen on the watch for prey. One has brought his opera glasses, so as to view them close up, and on the left, lounging in the arena itself, is an army officer at leisure. I think that the position of the girls' arms— clutching inward, as opposed to the outward gesture of acknowledgment—shows that, at some level, they themselves feel threatened.

Angelina clasps the oranges— given to the girls instead of a bouquet—almost in a gesture of self-protection, as the pair stand, spotlighted and isolated, before the male audience.

A Sunday on La Grande Jatte

SEURAT

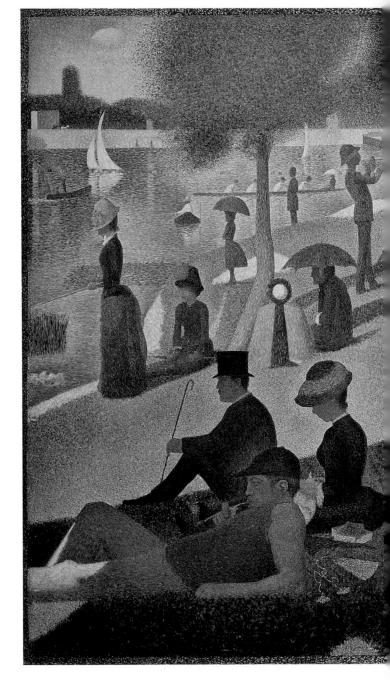

Seurat's *Grande Jatte* is one of those rare works of art that stand alone; its transcendence is instinctively recognized by everyone. What makes this transcendence so mysterious is that the theme of the work is not some profound emotion or momentous event, but the most banal of workaday scenes: Parisians enjoying an afternoon in a local park. Yet we never seem to fathom its elusive power. Stranger still, when he painted it, Seurat was a mere 25 (with only seven more years to live), a young man with a scientific theory to prove; this is hardly the recipe for success. His theory was optical: the conviction that painting in dots, known as pointillism or divisionism, would produce a brighter color than painting in strokes.

Seurat spent two years painting this picture, concentrating painstakingly on the landscape of the park before focusing on the people; always their shapes, never their personalities. Individuals did not interest him, only their formal elegance. There is no untidiness in Seurat; all is beautifully balanced. The park was quite a noisy place: a man blows his bugle, children run around, there are dogs. Yet the impression we receive is of silence, of control, of nothing disordered. I think it is this that makes *La Grande Jatte* so moving to us who live in such a disordered world: Seurat's control. There is an intellectual clarity here that sets him free to paint this small park with

an astonishing poetry. Even if the people in the park are in pairs or groups, they still seem alone in their concision of form—alone but not lonely. No figure encroaches on another's space; all coexist in peace.

This is a world both real and unreal—a sacred world. We are often harried by life's pressures and its speed, and many of us think at times: Stop the world, I want to get off! In this painting, Seurat has "stopped the world," and it reveals itself as beautiful, sunlit, and silent—it is Seurat's world, from which we would never want to get off.

◁ **A Sunday on La Grande Jatte—1884**; 1884–86; oil on canvas; 81¾ x 121¼ in. (207.6 x 308 cm)

▽ **Seated Woman with a Parasol**; 1884; study for *A Sunday on La Grande Jatte* in black conté crayon on ivory laid paper; sheet 18¾ x 12⅜ in. (47.7 x 31.5 cm)

A PAINSTAKING PROCESS

Seurat spent two years on this picture, visiting the park on weekdays, when it was empty, and making sketch after sketch—getting the grass right, the trees right, the river right. The A.I.C. has some of these miraculous sketches. Seurat's friends, who were slightly in awe of him, were distressed to see a Frenchman working through the lunchtime break, and even (quelle horreur!) sustaining himself with a chocolate bar.

The Mocking of Christ

MANET

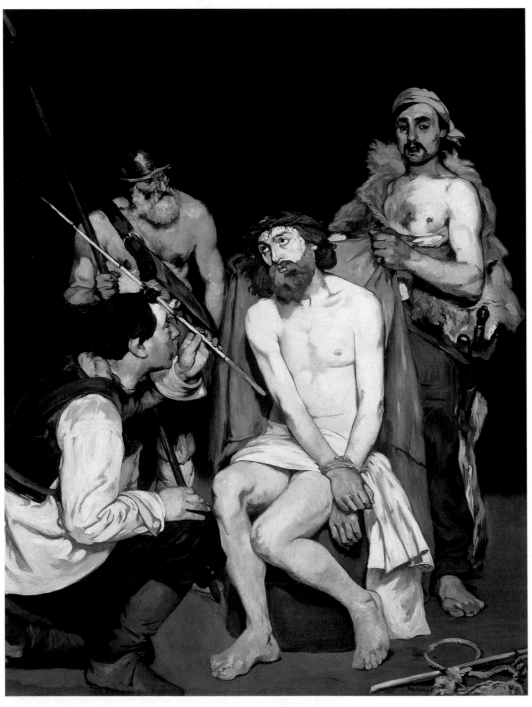

△ **The Mocking of Christ;** 1865; oil on canvas; 74⅞ x 58⅜ in. (190.8 x 148.3 cm)

> " The soldiers are neither evil nor ugly, but ordinary human beings (like the viewer)—baffled by the peace with which this tortured man endures. "

First, I must make a confession. On a previous visit to the Art Institute, the director showed me this work and asked me if I thought it was a truly religious painting. To my shame, I must I admit that I fudged my answer. I have two (somewhat feeble) excuses. One is that, as a Christian, I always find it difficult to look at images of Christ suffering with enough detachment to appreciate them as art. My second excuse is that Manet was not what one would call a religious man. He was a wealthy *bon vivant*, a man about town, a dandy—but then I found a letter he wrote to his closest friend, in which he says that he always longed to paint an image of Christ on the cross. No images of heroism or love can compare, he writes, to that of suffering; and he adds, enigmatically, that suffering is "the root of humanity, the poetry." Literally, of course, this is hardly true, since animals also suffer, but I think he means that only humanity can consciously accept suffering, master it emotionally, and refuse to let it crush the spirit.

Manet found a perfect example of this inner strength in the story of Christ's passion. This scene, where the Roman soldiers, who have heard that Christ claims to be a king, amuse themselves by taunting him, was frequently painted. Christ was always shown as wholly beautiful and wholly good, whereas the soldiers were evil and ugly. In Manet's version, Christ is wholly good, but he is not beautiful. Manet caused great offense by using a workman as a model. We notice the knobbly legs, the misshapen feet, the scrawny body; this is a poor man, which is, of course, exactly what Christ the man was. The soldiers are neither evil nor ugly, but ordinary human beings (like the viewer)—baffled by the peace with which this tortured man endures. The one high point of color is the scarf on the head of the soldier who looks out at us, meditating and wondering. I believe, unequivocally, that this is a great religious painting.

The only point of color in the painting is the soldier's headscarf, which contrasts with the somber hues in the rest of the picture and the paleness of Christ's skin.

BIOGRAPHY

Édouard Manet
French, 1832–83

• One of the most influential artists of the 19th century, Manet's painting style was heavily influenced by his study of the old masters in the Louvre, especially Velázquez.

• His works were often considered unconventional, and even outrageous, because of his realistic rather than idealized portrayals of contemporary models and the starkness of his lighting.

• Manet characteristically used a dark color palette, with harsh contrasts of light and dark in place of half-tones.

• In the 1870s he became part of the impressionist circle, and although he never took part in their exhibitions, he shared their concern with using color and brushwork to depict light effects. Like many of them, he began painting in the open air.

Series Illustrating Tasso's *Gerusalemme Liberata*

TIEPOLO

Giovanni Battista Tiepolo is the supreme genius of the ceiling, not to mention the staircase, and most of his great works are still *in situ*. The Art Institute has the good fortune to possess four of the works that once adorned the walls of a Venetian palace. The nobles who commissioned these paintings wanted something supremely decorative but also uplifting, and that is what Tiepolo gave them: splendid stories of moral grandeur.

These four pictures illustrate a story from Torquato Tasso's epic *Gerusalemme Liberata* ("Jerusalem Delivered"), in which the Italian poet sang of the virtuous Crusaders who liberated the Holy City from the Saracens. It is a morality tale, a fable about the eternal battle between good and evil. Tiepolo concentrates on a single episode: the relationship between the enchantress Armida and Rinaldo, the Christian knight; how they interact and how, through it all, Rinaldo comes to maturity. In these four paintings, we pass from the initial encounter to the final stage of emotional freedom. The story is developed by many subtle touches: as Rinaldo grows from

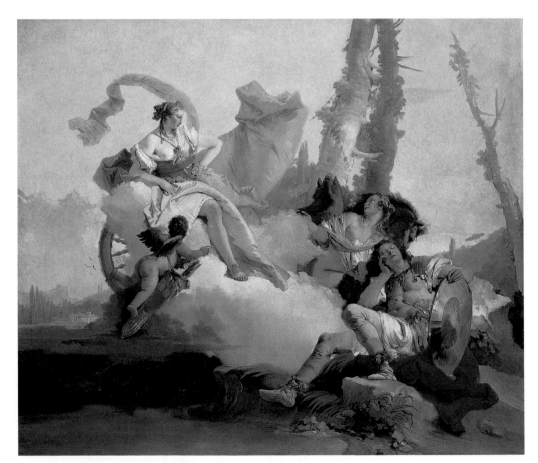

△ **Rinaldo Enchanted by Armida**; 1742–45; oil on canvas; 73⅜ x 85⅜ in. (187.5 x 216.8 cm)

△ **Rinaldo and Armida in Her Garden;** 1742–45; oil on canvas; 73⅜ x 102⅛ in. (186.9 x 259.5 cm)

ARMIDA AND RINALDO

The enchantress Armida watches the sleeping knight Rinaldo, and then snatches him and takes him to her garden. He is enraptured by her, but she only looks at him in her mirror, a sign that this love is unreal. When his fellow knights come to summon him back to duty, Rinaldo painfully accepts, to Armida's grief (she has matured; she has learned to love). In the final scene, Rinaldo sets out once more to wage the battle against evil.

△ **Armida Abandoned by Rinaldo;** 1742–45; oil on canvas; 73⅜ x 102⅛ in. (186.9 x 259.5 cm)

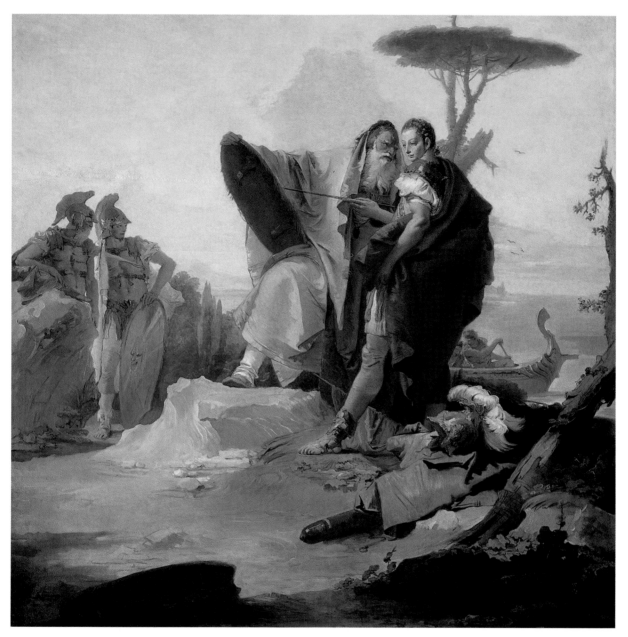

△ **Rinaldo and the Magus of Ascalon;** 1742–45; oil on canvas; 71⅞ x 72 in. (182.4 x 182.9 cm)

infatuation to emotional freedom, his position relative to that of Armida changes, and his loose curls gradually metamorphose into adult severity.

This is a myth, of course, but it is a myth about things that truly matter: courage, truth, duty, and love. The paintings enchant the eye with their soft colors and gracious forms, but they also ennoble the spirit. There is something great-hearted about them, something large, spacious, and clear. Tiepolo's touch may be light, but the overall effect is magnanimous.

> ❝ The paintings enchant the eye with their soft colors and gracious forms, but they also ennoble the spirit. There is something great-hearted about them. ❞

Sanctuary

PURYEAR

The title of this piece, *Sanctuary*, is a word with a long history. Sanctuary refers to that central secret place where we are safe, where there is total stability. This is a place that we must seek, and we may need to run for sanctuary, all of which involves mobility. Stability and mobility are central to Puryear's thought. He likes movement; he says that there is a saving grace in it. In search of his ancestral roots, he moved to West Africa to work with village carpenters; and then to Scandinavia, Russia, and Japan. When he came home, his studio burned down, with all his work. After the first shock, he felt lightness and freedom, and moved once more, this time to Chicago, where he made *Sanctuary*. He had come to understand that moving can become escapism—survival by flight—and that you can only afford mobility if you have stability: the sanctuary. The piece is structured between these two concepts. The crafted box at the top is the sanctuary, and the wheel on the floor is mobility. Both are fixed, while between them dangle the branches, ending in the animal-like feet that grip the wheel.

It took me some time to respond to this work. I admired the wit that used branches as legs, and the way that the square and circle balanced each other, but at first I did not see the profundity of the thought. The delicate implication here is that we do not first run for sanctuary and then find it; we are always doing both at the same time. The wheel and the box, the search and the finding, are part of the same process. This is what it means to be human, and to exist—if we are fortunate—in a state of dynamic tranquillity.

> 66 Sanctuary refers to that central secret place where we are safe, where there is total stability. This is a place that we must seek. 99

▷ **Sanctuary**; 1982; wood and mixed materials; 126⅞ x 27½ x 18 in. (320 x 70 x 45.7 cm)

BIOGRAPHY

Martin Puryear
American, 1941–

• Puryear graduated in 1963 from the Catholic University in Washington, and obtained a Master of Fine Arts degree from Yale University in 1971.

• He has studied and worked in many countries. In search of his ancestral roots, he lived and worked with village carpenters in West Africa, and he has also lived in Scandinavia, Russia, and Japan.

• His abstract wooden sculptures typically feature softly curved yet dramatic forms. His key themes include stability and mobility.

Salome with the Head of St. John the Baptist

RENI

△ **Salome with the Head of St. John the Baptist;** 1639–40; oil on canvas;
97¾ x 88½ in. (248.5 x 224.8 cm)

> ❝ I find it perpetually shocking—this contrast between the elegant princess in her lovely robes, so gracious and so morally cold, and the literal coldness of the dead saint. ❞

THE STORY OF SALOME

Salome was the beautiful stepdaughter of Herod the Great, King of Judea. Herod lusted after Salome and requested that she dance for him. After the princess had danced for her drunken stepfather, he rewarded her exquisite performance by offering her anything that she wanted. Her unpleasant mother, who loathed John the Baptist for rebuking her lack of morals, told Salome to ask for John's head upon a dish. Salome asked, and the head was duly presented.

BIOGRAPHY

Guido Reni
Italian, 1575–1642

• Guido Reni trained under the Flemish mannerist painter Denys Calvaert, but was more strongly influenced by fellow Bolognese Ludovico Carracci, who advocated using classical sculptures as models for idealized figures.

• Reni worked mainly in Bologna but also made several trips to Rome, and it is there that he painted his most famous work, the ceiling fresco *Aurora* (1613).

• Reni's paintings are remarkable for their beautiful coloring and graceful figures. At one point his reputation suffered under the label of sentimentality, but the exquisiteness of his creations is now recognized once more.

One of the maids looks toward Salome with grave sadness, but the other can only turn to her fellow servant in dismay, as their mistress roughly grasps the bloodless head of John the Baptist; all the poor page can do is stare at the scene, aghast.

Guido Reni was known as the "divine Guido" in 17th-century Italy. He was enormously successful, and kings lined up to buy his pictures. He made a fortune, and wasted it on his sole vice: gambling. I love him dearly, and I always mourned the eclipse of his reputation that followed his death. Happily, he is now returning to well-deserved favor. There are six people present in the painting. The two girls at the back are shocked and saddened. The maid, drawing the drapes to let in the light, is horrified. The page is aghast. They surround the central encounter, between Salome and the dead John. She is ravishingly beautiful. I can think of nothing lovelier in the entire history of art than the exquisite pink of her robe, or the faint flush on her cheeks, or her creamy skin. Yet it is an impassive face. She alone shows no reaction to the terrible sight before her, the consequence of her own words.

I used to think, unable to refuse indulgence to one so fair, that she was silently coming to understand that words have effects. Finally, I realized that Reni reveals her mind in the movements of her hands. One hand disgustedly pulls her robes free from contamination, while the other, with a gesture of frightening violence, yanks back the murdered head. I find it perpetually shocking—this contrast between the elegant princess in her lovely robes, so gracious and so morally cold, and the literal coldness of the dead saint. His noble head becomes increasingly the center of the picture. We start to feel that his nobility is beginning to blot out her triviality; that it is not she who contemplates him, but he who passes judgment on her. The dead John is the most living person present.

Madame de Pastoret and Her Son

DAVID

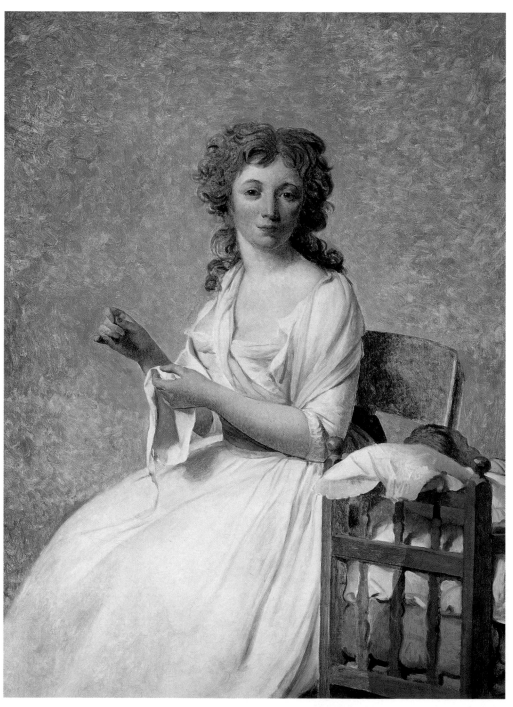

△ **Madame de Pastoret and Her Son;** 1791–92; oil on canvas; 51⅛ x 38⅛ in. (129.8 x 96.6 cm)

A WOMAN OF GOOD WORKS

One day, Madame de Pastoret heard wailing from a tenement house, and went to investigate. She found a 5-year-old girl, left to look after her baby brother while her parents were at work. The baby had broken his arm. Adelaide went on to organize a chain of day nurseries throughout France for the children of working mothers.

BIOGRAPHY

Jacques Louis David
French, 1748–1825

• David was one of the greatest artists of the neoclassical movement, which was largely a reaction to the frivolity of the rococo that aimed for a more heroic form of art based on the models of classical antiquity.

• A fervent supporter of the French Revolution, David painted the revolutionary martyrs and designed pageants and monuments for the new Republic. He was appointed court painter to Napoleon I in 1804, but spent his last years in exile after Napoleon's downfall.

• His works are characterized by their economic compositions, and the greater importance of drawing over color.

Adelaide Anne Louise married Claude Emmanuel Joseph Pierre, Count de Pastoret, with spectacularly bad timing, on July 14, 1789—Bastille Day, the climax of the French Revolution. She was clearly an impressive young woman, with her noble forehead, firm mouth, and general air of charming composure. Although she was a member of the aristocracy, Adelaide pioneered the setting up of day nurseries across France for the children of working mothers. The baby in the cradle beside her, although he is her own newborn son Amédée-David, is probably also a reference to this work of practical charity. Adelaide's dress is designed to make it easy to breastfeed—an unusually enlightened choice for an aristocrat.

Neither the simplicity of her dress nor her good works, however, availed her in David's prejudiced eyes. He is an intriguing artist. As a painter he was balanced, lucid, and intelligent. As a man he was the opposite: fanatic, vain, and foolish. He was flattered by the revolutionaries, and became an avid supporter of the guillotine. He had Count de Pastoret sent into exile, and for a time had Adelaide and her baby imprisoned. At some stage it must have become clear that the portrait would never be finished, and that no needle would ever be painted in Adelaide's sewing hand. It is impossible to know who called the halt, but David certainly boasted that he would never paint a woman of the aristocracy who did not share his principles.

For over thirty years the painting languished, unwanted. Then David died, and the de Pastorets immediately snapped it up. I rather like it unfinished, with its pleasingly natural air. The irony is that both the artist and the sitter were revolutionaries of a kind—she from Christian principle, and David from knee-jerk republicanism—but because David could not appreciate her, the work stayed incomplete: a lasting memorial to the folly of political intransigence.

Madame de Pastoret, with her steady gaze and air of composure, was clearly aristocratic, but, unusually for an aristocrat, she wears a bodice designed to make breastfeeding easier. The painting itself is unfinished— her hand should have held a sewing needle.

Amédée-David, Marquis de Pastoret

INGRES

> " The sinuous line of his body, with hand imposingly on hip, snakes up to the hauteur of his face, stern in its arrogance. Yet it is so clearly the arrogance of one who overestimates himself: a toothless tiger. "

△ **Amédée-David, Marquis de Pastoret;** 1823–26; oil on canvas; 40½ x 32¾ in. (103 x 83.5 cm)

Ingres uses props to reveal de Pastoret's interests and character: a scroll for his poetic skills; gloves and a hat to indicate that he is a man about town; and the Legion of Honor cross to show that he is a man of considerable prestige.

The baby Amédée-David, horizontal in the cradle beside his mother in David's austere *Madame de Pastoret* (pictured on page 122), reappears thirty-five years later. This time, the portrait is by David's great successor Ingres, and Amédée is splendidly vertical—and intensely self-important. Ingres must have found it difficult to paint this portrait. He was a hypersensitive man, over-ready to perceive slights and over-receptive to appreciation. De Pastoret was an ardent appreciator, who had built up a small collection of Ingres' works, and now demanded a portrait. Ingres must have known his admirer's reputation as a status-seeker of ludicrous pretensions. De Pastoret was mocked for his conceit, his smug conviction of his physical charms, his poetic skills, and his political acumen. How to paint him truthfully without offense?

The result is one of Ingres' greatest works. He displays the count in all his attempts at well-bred demeanor— a skintight black uniform, with the scarlet ribbon and jeweled cross of the Legion of Honor prominent, and elaborate gold accessories on either side. There is a scroll to hint at his literary interests, and elegant gloves and a bicorn hat to hint that this man of affairs is also a man about town. The sinuous line of his body, with hand imposingly on hip, snakes up to the hauteur of his face, stern in its arrogance. Yet it is so clearly the arrogance of one who overestimates himself: a toothless tiger.

Like that other great portraitist Goya—who painted the Spanish royals with devastating truthfulness while delighting them with a sense of glamour—Ingres pleased de Pastoret. This seems to be the sole portrayal by Ingres of a sitter to whom he did not warm. It reveals the painter's disinterest while concentrating on the attributes that did affect him: the suave ostentation, the sense of privilege, the sheer impudence of the man. Apparently Ingres refused to paint de Pastoret wearing anything but official black—and we can see why. The somber, well-bred decorum of the garment provides a piquant contrast to de Pastoret's bombast.

Cupid Chastised

MANFREDI

When this picture came to the A.I.C., it was thought to be by Caravaggio. This was not an impossible attribution; the true artist, Manfredi, was a little younger than Caravaggio, and admired him enormously. I sometimes feel that he has Caravaggio's energy but not his poetry; though here, for "energy," read "violence," because this is a terrifying work. Without the crumpled wing that reveals this to be a myth, we would take it to be a scene of child abuse. We see a large and brutish male, bearing viciously down on the small, savaged child, while the anguished mother stands helplessly by. In reality, the great red brute is Mars, the god of war. He has flung his helmet down on Cupid's arrows and smashed his bow, furious because he thinks he has been made a fool. The handsome peasant woman is Venus, goddess of love, and those are her doves flying away in panic. To underscore the panic, Manfredi shows us the wing only of one of the birds, as if anger had snapped it in two.

Mars is raging because Cupid has made him fall in love with Venus—but where there is war, there is no place for love; where there is love, there can be no war. If he embraces Venus, he will lose his role and become nothing. This picture is evidence that great art does not necessarily give pleasure. Manfredi focuses with repulsive realism on the soft and helpless flesh of the child. He makes us shrink. I dislike the picture, but I cannot forget it and what it says about violence, in the world and in ourselves. Both reactions seem to be a tribute to the picture's power.

" This picture is evidence that great art does not necessarily give pleasure. Manfredi focuses with repulsive realism on the soft and helpless flesh of the child. He makes us shrink. "

The face of Venus eloquently portrays her anguish at the violence of Mars. Cupid, with his crushed wing, lies on the ground, helpless to resist the terrifying onslaught of the wrathful god.

△ **Cupid Chastised;** 1605–10; oil on canvas; 69 x 51⅜ in. (175.3 x 130.6 cm)

Entertainer

CHINESE

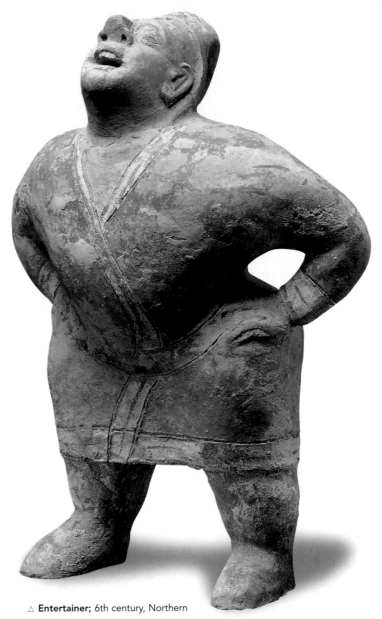

△ **Entertainer**; 6th century, Northern dynasties; buff earthenware with pigment; 10⅝ x 10 in. (27 x 25.4 cm)

Scholars sometimes write as if the Tang dynasty (A.D. 618–907) had the monopoly of tomb figure masterpieces. Yet the Entertainer—a masterpiece if ever there was one—comes from the turbulent 6th century, from a north China ravaged by wars, invasions, and rebellions. It was one of the most violent times in the country's history, but the Entertainer seems to be a born survivor. He is so concentrated on performing his trick that background turmoil could have passed him unnoticed.

The unknown sculptor communicates a strong sense of this small man's personality: instinct allied with coiled energy, both mental and physical. He is so vital that it pains me to think that he was made for the darkness under the earth, to play his tricks in the tomb for some dead aristocrat. Whatever the nature of those tricks, I feel sure they were impressive, because he is massively self-confident. They certainly included balancing and juggling, since just below his ridiculous little hat is a hole in his forehead to take the pole on which he supported whatever he was juggling. The pole has not survived, but we can imagine it. He is in a gallery on the first floor, and looking at his strength and energy—pulsating now in a vacuum—I have a fantasy of the museum itself being able to balance on his pole, safe from earthquakes.

CHINESE TOMB FIGURES

Funerary ceramic art flourished in China during the centuries immediately before and after Christ. A wide variety of animal and human figures, as well as everyday objects, were reproduced to accompany the soul of the dead person into the afterlife, performing the same functions for their master in death as they had in life. These tomb figures provide us with a vivid, highly accessible insight to the lives of their makers. Chinese funerary artists excelled in realistic representations, choosing rounded, curving shapes to portray both a sense of solidity and the fluidity of movement.

Equestrienne

CHINESE

This 8th-century tomb figure is known as the Equestrienne (or Horsewoman). The title suggests to me an elegant Parisienne, perched complacently, sidesaddle, on her horse. What my imaginary rider and the splendid tomb figure have in common is an air of self-satisfaction. Our figure has every right to be pleased with herself: she is an expert horsewoman. I know nothing about riding, but I can see from the way she holds the reins (not extant) that there is a true rapport between her and her horse. She is a wealthy woman, with a blanket of expensive fur, and she sports the latest hairstyle. The fashion was for hair in a bun, which may look unattractive to us but was ubiquitous in contemporary high society, in a variety of forms with various names. One was known as the "falling-off-a-horse bun," which I think our Equestrienne might have relished—being a woman who does not fall off horses.

She needs a sturdy horse because she is a portly figure; and that also was fashionable. One of the Tang emperors had a dearly loved consort who was a Rubenesque beauty, and the tombs of the period are filled with figures whom an irreverent posterity dubbed "Fat Ladies"— all with their buns, little turned-up shoes, and an air of ineffable smugness. The Equestrienne does not seem to me to be excessively self-satisfied. She is too intent upon her horse—and that may tell us something about her. Figures of women riding horses, once common, were becoming rare in the 8th century. The objects in a tomb were meant to offer occupation in eternity, but many aristocrats no longer had time to indulge in riding. Their estates had become too large, and they spent their time administering them. The fact that this woman still rides, and wants her horse in her tomb to comfort her, may give us some insight into her character. The paint has flaked off the horse, but the rider—funny, charming, and poised—is indestructible: a great aristocrat and a fine figure of a woman.

> **"** I can see from the way she holds the reins that there is a true rapport between her and her horse. **"**

▷ **Equestrienne;** 700–750, Tang dynasty; buff earthenware with traces of polychromy; 22⅛ x 19 in. (56.2 x 48.2 cm)

Celadon Ewer

KOREAN

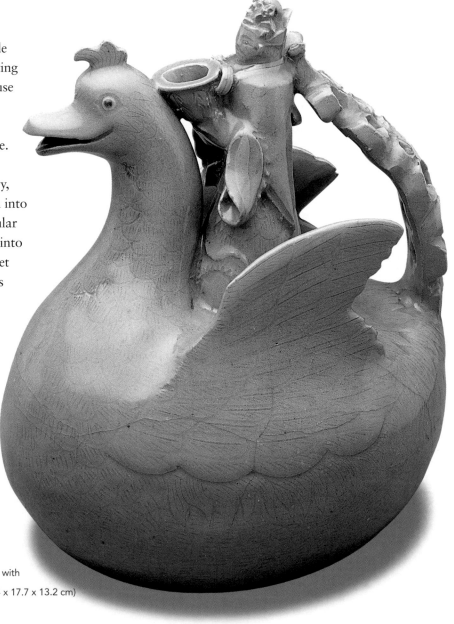

The 12th-century Korean potter who made this ewer must have known he was creating a small masterpiece. I say this not only because of the color—the blue, green, creamy-gray translucence known as celadon—but because of the sculptural strength of its shape. The artist imagined a composite bird, with a foolish, ducklike beak, crowned by a cheery, impudent cockscomb. The neck swells down into a fine rotundity of body, with delicate, irregular wings, far too slight ever to lift this creature into the air. It has a swan's tail, looping up to greet a small man of great importance, who stands on the bird's back, stiffly holding a bowl. For all its fantasy, this is a functional vessel, filled through a hole in the bowl and pouring its liquid from the beak. I imagine generations of Koreans coming home at night, grumpy after a bad day and being cajoled into a smile at the sheer good humor of this ewer.

▷ **Celadon Ewer;** 12th century, Koryo dynasty; stoneware with celadon glaze and incised decoration; 8⅜ x 7 x 5¼ in. (21.4 x 17.7 x 13.2 cm)

Carved Flask

KOREAN

The maker of this 15th-century flask from Korea, intended for the domestic market, probably never dreamed that it would end up treasured in a museum. The flask is perfect for its purpose: robust, well shaped, with a foot on which to stand, and a good spout for pouring. It gleams; it sings—and with typical Korean subtlety, it sings in two keys. One side is the heavenly key, showing a stylized image of the sacred lotus. This is the Buddhist symbol of transformation and hope, because the lotus is a pure white flower that grows from mud and dirt. The other side of the flask is earthly—or rather watery, because here the artist had great fun drawing fish. Four swim strongly to the left, with a baby trying to catch up; and one fish is determined to do its own thing and swim in the other direction, and on its back, too. The artist's pleasure in these fish is infectious; he individualizes them and they amuse. When I look at the lotus side of the flask, I can imagine the liquid within being water or milk, or even a thin soup; but the other side persuades me that the liquid must have been wine.

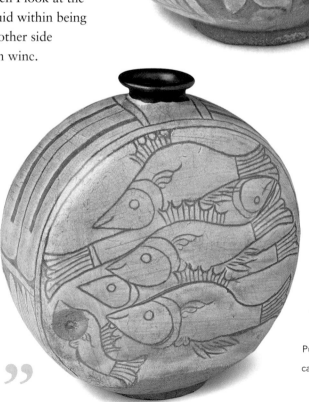

> " When I look at the lotus side of the flask, I can imagine the liquid within being water or milk, or even a thin soup; but the other side persuades me that the liquid must have been wine. "

◁ △ **Carved Flask** (*both sides*); 15th century, Choson dynasty; Punch'ong ware, stoneware with carved slip decoration; 8¾ x 7⅞ x 5⅛ in. (22.3 x 20.2 x 13.1 cm)

Tea Ceremony Jar

JAPANESE

The sheer weight of this jar is astonishing. It made me vividly conscious of its incandescent color, and of its imperfection; it was flawed in the making. It is a water jar used in the Japanese tea ceremony, and it was precisely to provide the opportunity to appreciate the beauty of such objects that the tea ceremony came into being.

A poet said of the ceremony that it was "the mist in spring, the cuckoo hiding under green leaves in summer, a lonely-looking sunset in autumn, a wintry, snowy sunrise." Looking at the jar we can perhaps experience the union of all those seasons, as we ourselves enter into a wholeness. The wholeness comes from the Zen belief that integrity flows from not seeking to be perfect, from admitting mistakes, and accepting our flawed reality. Yes, this great jar has a crack—it sags—but these very weaknesses make this beautiful object more accessible to us in its vulnerability. Contemplating this jar may be as near as most of us will get to experiencing the liberation of the tea ceremony.

> " Yes, this great jar has a crack— it sags—but these very weaknesses make this beautiful object more accessible to us in its vulnerability. "

THE TEA CEREMONY

The tea ceremony was essentially a coming together of people who knew each other. It was said that you must encounter the other participants as if you would never see them again. It was a solemn meeting, and took place in a specially arranged room, with an alcove containing one great work of art, to focus the mind. Flowers were set before it, and there was a fire to boil the water. It was the prayerful yet joyous way in which this was done that made the activity spiritually significant. All of the objects used had to be beautiful: the tea bowls; the tea kettle; the tea caddy with the bitter green tea that awoke both mind and heart; the scoop for stirring the tea to a froth; and finally, the water jar, of which this is so fine an example.

▷ **Tea Ceremony Jar;** late 16th century, Momoyama period; Iga ware, natural glazed stoneware; height 13 in. (33 cm), diameter 9⅝ in. (24.5 cm)

Ceremonial Knife

P E R U V I A N

T his is a tumi, a ceremonial knife, crafted with three different goldworking techniques by the Chimu people of Peru. For a nontechnical person like myself, the chief interest is in the figure: the fierce little creature that glares out at us. Scholars suggest that he may represent Naymlap, a legendary tribal hero. However, throughout the ancient Americas there seems to have been a cultural consensus that it was not the body itself that was interesting—as it was in Europe— but what the body wore. The artist is relatively unconcerned with Naymlap as a person, but concentrates on the attire, because that shows his significance. He lavished endless care on the accurate representation of the intricate headgear. He used the turquoise—the sacred stone whose startling blueness mystically represented the sky, with its life-giving rain, and the sea, from which came the Chimu's staple food of fish. Of course, this golden knife was only technically a tool; it would never have been utilized. For sacrificing, the Chimu used a copper knife.

THE LOST EMPIRE OF THE CHIMU

About one thousand years ago, the mighty empire of the Chimu arose in Peru. It lasted six hundred years, and was then swallowed up by the Incas. Whenever the Incas assimilated a new race, they moved its people to a different area, so that they would lose their sacred places and traditions. The Chimu are lost to history except for the one skill they possessed that the Incas cherished: their mastery of metalwork. Chimu gold- and silversmiths were not sent away but were brought to the Inca capital—and the wonderful craftsmanship of this knife shows why.

◁ **Ceremonial Knife;** 1200–1470, Chimu culture; gold and turquoise; 13⅜ x 5 in. (34 x 12.7 cm)

This splendid artifact would have been ceremoniously carried in procession on solemn occasions, before some king or priest.

The Incas eventually superseded the Chimu, and there is little trace of this lost race apart from evidence of their superb goldworking skills. I am drawn to the Incas, about whom we know a great deal, but even more to the vanished Chimu, about whom we know so pathetically little. This squat, glowering little figure glitters out at us— and keeps his mystery intact.

City Landscape

MITCHELL

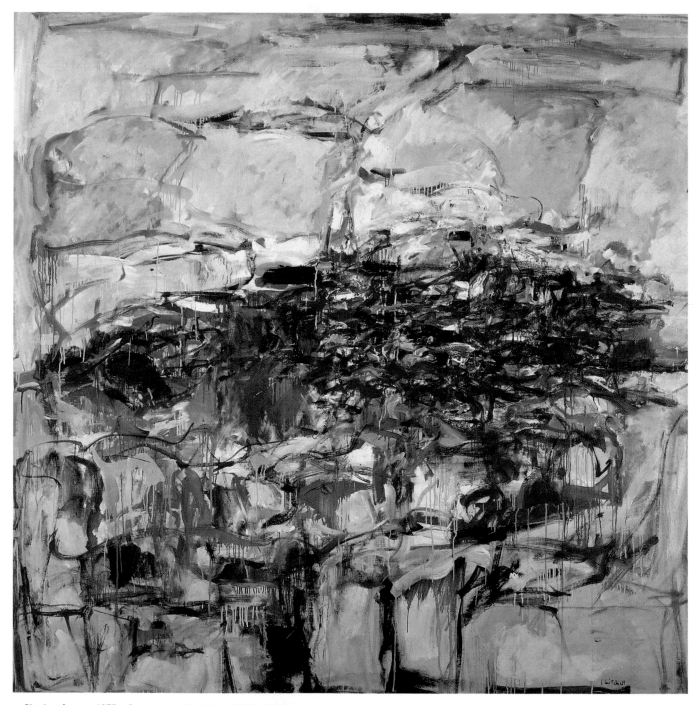

△ **City Landscape;** 1955; oil on canvas; 80 x 80 in. (203.2 x 203.2 cm)

In the center of the painting, framed and controlled to some extent by the white skyscrapers, is a riot of thickly textured color that vividly depicts the chaos and excitement of life in a big city.

Many artists have lived in Chicago or were born there. Joan Mitchell lived in an apartment overlooking the lake in Chicago. If Mitchell had named this work *Urban Landscape* or *Village Landscape*, I would have tended to see here snow-covered mountains with a vibrant small community in their midst. When I read *City Landscape*, however, I remember at once the sensation of looking down from a high building in a busy part of the city. Mitchell said that when she painted landscapes, it was the feeling of them—the remembered experience—that filled her mind. Here we have precisely that: sight recalled. The buildings rear up, solid, still, and white; the skyscrapers apt for Chicago. Below is the chaotic bustle of the street,

with the brightness of automobiles in the center, and people moving rapidly along the sidewalks, past the glitter of store windows. This torrent of activity, the *mélange* of color, is controlled by the canyons of the buildings that funnel the flood and keep it moving. Mitchell depicts this brilliantly. I feel I understand again what it means to live in a city that encompasses both excitement and stillness; the excitement of the street, and the stillness of the buildings: both matter in the total experience. Even Mitchell's whites are colorful—as vital as the clamorous reds, blues, blacks, and yellows in the middle. *City Landscape* opens our eyes to what we can miss in the rush of the city, and to the wonder of being alive in such an exhilarating world.

> "The buildings rear up, solid, still, and white; the skyscrapers apt for Chicago. Below is the chaotic bustle of the street."

Nighthawks

HOPPER

Apparently, there was a period when every college dormitory in the country had on its walls a poster of Hopper's *Nighthawks*; it had become an icon. It is easy to understand its appeal. This is not just an image of big-city loneliness, but of existential loneliness: the sense that we have (perhaps overwhelmingly in late adolescence) of being on our own in the human condition. When we look at that dark New York street, we would expect the fluorescent-lit café to be welcoming, but it is not. There is no way to enter it, no door. The extreme brightness means that the people inside are held, exposed and vulnerable. They hunch their shoulders defensively. Hopper did not actually observe them, because he used himself as a model for both the seated men, as if he perceived men in this situation as clones. He modeled the woman, as he did all of his female characters, on his wife Jo. He was a difficult man, and Jo was far more emotionally involved with him than he with her; one of her methods of keeping him with her was to insist that only she would be his model.

From Jo's diaries we learn that Hopper described this work as a painting of "three characters." The man behind the counter, though imprisoned in the triangle, is in fact free. He has a job, a home, he can come and go; he can look at the customers with a half-smile. It is the customers who are the nighthawks. Nighthawks are predators—but are the men there to prey on the woman, or has she come in to prey on the men? To my mind, the man and woman are a couple, as the position of their hands suggests, but they are a couple so lost in misery that they cannot communicate; they have nothing to give each other. I see the nighthawks of the picture not so much as birds of prey, but simply as birds: great winged creatures that should be free in the sky, but instead are shut in, dazed and miserable, with their heads constantly banging against the glass of the world's callousness. In his *Last Poems*, A. E. Housman (1859–1936) speaks of being "a stranger and afraid/In a world I never made." That was what Hopper felt—and what he conveys so bitterly.

The man and woman sit at the counter like a couple, but they are lost in misery, with nothing to communicate to each other.

△ **Nighthawks;** 1942; oil on canvas; 33⅛ x 60 in. (84.1 x 152.4 cm)

“ This is not just an image of big-city loneliness, but of existential loneliness: the sense that we have (perhaps overwhelmingly in late adolescence) of being on our own in the human condition. ”

THE IMPACT OF PEARL HARBOR

Hopper's wife Jo kept diaries, and it is from these that we learn a crucial fact about Nighthawks: that Hopper painted it immediately after the Japanese assault on Pearl Harbor. The attack, in December 1941, caused possibly the greatest psychic shock in American history. One moment the nation was in control, looking on at another's war, and the next it was plunged uncontrollably into the conflict. We know now that New York was not bombed, but at the time it was conceivable that it might happen. Hopper channeled and transposed all of this terrible anxiety into his picture.

American Gothic

WOOD

△ **American Gothic;** 1930; oil on beaverboard; 29¼ x 24⅝ in. (74.3 x 62.4 cm)

> "The daughter looks away, as if, despite her suitably impassive expression, she wants more. Her dress may be totally form-disguising, but how pathetically she tried to adorn her pinafore with braid and pinned a cameo brooch at her neck."

While the father stares grimly at the viewer, his daughter—with her brooch adornment, flowering pot plants, and escaping tendril of hair—seems to be trying to break through the gothic façade.

BIOGRAPHY

Grant Wood
American, 1892–1942

• Grant Wood spent most of his life in his native state of Iowa, and was one of the leaders of the regionalism movement, whose adherents depicted people and scenes from the American Midwest.

• During a visit to Germany to supervise the manufacture of a stained-glass window he had designed, he became familiar with northern Renaissance art, which led him to drop the impressionistic style of his early years in favor of a more detailed, highly polished finish.

You can recycle the *Mona Lisa* any way you want; upside down, back to front, caricatured, it remains instantly recognizable. That is the ultimate compliment, and one that was also paid to Grant Wood's *American Gothic*. It seems to speak directly to the national psyche, though what it says is not as simple as might appear. Wood drew all of his inspiration from his native Iowa, and it was there, driving through the countryside, that he saw this farmhouse—bare and austere, with an incongruous peaked roof and gothic-style window. He peopled it with his sister, as the daughter, and his dentist (said to be a jovial man) as the father: two faces that he felt would fit his concept.

The pair stand, foursquare, defending their territory—or rather, the father defends, with his pitchfork. He is grimly confrontational, looking us straight in the eye; but she? Is she part of the "territory"? The daughter looks away, as if, despite her suitably impassive expression, she wants more. Her dress may be totally form-disguising, but how pathetically she tried to adorn her pinafore with braid and pinned a cameo brooch at her neck. The cameo shows the head of a lovely nymph with free-flowing hair; and we then notice the daughter's hair, scraped back in a bun, with one soft golden tress escaping. Dressed differently, encouraged to express herself, this homely drudge might be a beautiful woman. Behind the father rises the utilitarian strength of the barn; but behind the daughter we see a window shade that is slightly askew, and plants—firmly potted but bursting with life. *American Gothic* is a label, and what this picture tells us, perhaps unconsciously, is that labels can be misleading.

Woman Descending the Staircase

RICHTER

When it comes to contemporary art, it is almost impossible to be certain which will last. Who will still be admired in the third millennium? One whose work I think will endure is the German artist Gerhard Richter—and I am happy that the Art Institute apparently agrees with me, because they have set aside a small gallery that shows only his paintings. Many conceptual artists make my heart sink, because they have nothing to share but a concept. Once that concept has been grasped, their work seems dull. Richter is different, because what he does is beautiful and perpetually engrosses our attention. We may not always understand it, but we want to look at it, and to wonder about it.

Woman Descending the Staircase refers back to a famous painting by Marcel Duchamp: *Nude Descending a Staircase* (1912). Duchamp was the first—and is still the greatest—of the conceptual artists, and he painted this seminal work in the conviction that nudes and beauty and the visual world, as such, were now the province of photographers. Richter also used a photograph, but almost in order to refute Duchamp's thesis. The original was cut from a glossy magazine, and shows an unknown model (though there have been critical attempts to upgrade her by claiming her to be Maria Callas or Queen Sorya of Iran). The model is designedly anonymous; Richter is not concerned about her but about the entire idea of fashion photography. What are we seeing, Richter ponders, when we look at a photograph of some glamorous beauty sweeping down a grand staircase? How true is it? What does it tell us about life, about the things that are important? Clearly he agrees with Duchamp—as who could not?—that representation in the modern world has changed, but how? The image is beautiful, blurred, and challenging.

RICHTER'S DUAL STYLES

Richter is a difficult artist, partly because he paints in two distinct styles. One is photorealist—with the image blurred and indistinctly black and white—and the other is richly abstract. This is not because, like Picasso, he has many skills and wants to flex his artistic muscles. It is because of a concept. Richter is interested not so much in what he paints or how he paints it, but rather in the meaning of painting as such. What is representation? How true is any image? Has abstraction validity? Photography has changed our view of the image: what remains?

> 66 What are we seeing, Richter ponders, when we look at a photograph of some glamorous beauty sweeping down a grand staircase? How true is it? What does it tell us about life, about the things that are important? 99

▽ **Nude Descending a Staircase**
No. 2; 1912; Marcel Duchamp, French (1887–1968); oil on canvas; 58 x 35 in. (147.3 x 88.9 cm)
© Philadelphia Museum of Art

△ **Woman Descending the Staircase;** 1965; Gerhard Richter; oil on canvas; 79 x 51 in. (200.7 x 129.5 cm)

Ice 1–4

RICHTER

Hanging in the same room as Gerhard Richter's *Woman Descending the Staircase* (pictured on page 141) is a series of abstractions that he painted after a period of intense stress. The exhibits are titled *Ice 1–4*. With their strong, free shapes and colors, we tend to think of works like these as coming from the artist's imagination, spontaneously. On the contrary, they were painted with full deliberation, in a search for the beautiful—almost in despair. The painting reproduced below, in which the ice melts, is my favorite. It exudes a spiritual chill, yet conveys a stubborn sense of hope— of the possibility of new life and warmth in the spring.

△ **Ice (1);** 1989; oil on canvas; 80 x 64 in. (203.2 x 162.6 cm)

△ **Ice (2);** 1989; oil on canvas; 80 x 64 in. (203.2 x 162.6 cm)

△ **Ice (3)**; 1989; oil on canvas; 80 x 64 in. (203.2 x 162.6 cm)

> **"** We tend to think of works like these as coming from the artist's imagination, spontaneously. On the contrary, they were painted with full deliberation, in search for the beautiful— almost in despair. **"**

A brief biography of Richter can be found on page 141.

△ **Ice (4)**; 1989; oil on canvas; 80 x 64 in. (203.2 x 162.6 cm)

Meissen Tureen and Stand

GERMAN

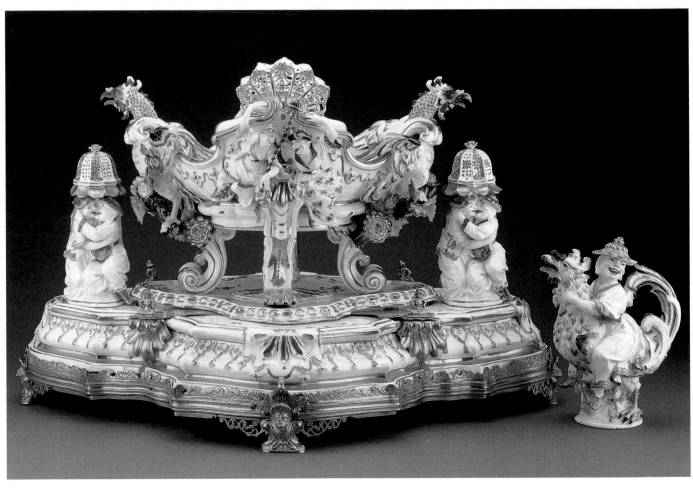

△ **Meissen Tureen and Stand;** 1737; Johann Joachim Kändler, German (1706–75); hard-paste porcelain with polychrome enamels, gilding, and ormolu mounts; bowl 11 x 17½ x 10 in. (27.9 x 44.5 x 25.4 cm), stand 6 x 26 x 20 in. (15.2 x 66 x 50.8 cm)

" Cynical and demonic sculptor that he was, I think Kändler's intention was to create a work so glorious and inventive that these uninhibited lovers would be set before the most prudish lady in the land and no one would dare to raise an eyebrow! **"**

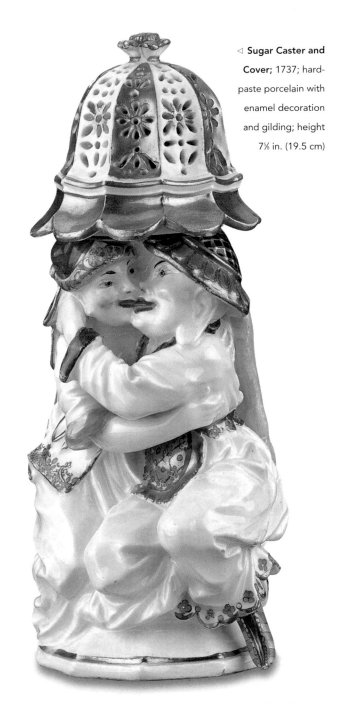

A WORK OF WONDER

In 1739 Sir Charles Hanbury Williams, British minister to the court of Dresden, was invited to a state banquet held by Count Heinrich von Brühl. At the banquet, course followed course, until the meal reached its climax: the dessert. The table was spread with custards and gâteaux, puddings and pies, molded confections, and fruits and nuts—all heaped around the great porcelain centerpiece, flanked by sugar casters, and laden with that exotic delicacy: the lemon. Sir Charles was stunned. He wrote to England: "I thought it was the most wonderful thing I'd ever beheld." His admiration was probably evoked by this tureen and stand, which belonged to the Countess von Brühl, and was new from the hands of Johann Joachim Kändler, Meissen's great modeler.

Johann Joachim Kändler was a superb modeler working at the Meissen porcelain factory in Germany, and this is one his most magnificent pieces. It belonged to the wife of Count Heinrich von Brühl, prime minister to the Elector of Saxony and administrator of the Meissen factory. Kändler based this masterwork on two elements: the rooster and the Chinese lovers, and in both I suspect a subtext. The rooster exudes splendor and self-importance, yet the legs dangle impotently. I cannot but wonder whether there was a hidden reference here to von Brühl, who was all strut and show, while he allowed the state to sink into debt. That is, of course, speculation. I am on firmer ground with the Chinese lovers. China and all things Chinese were the height of fashion, but ignorance of China was nearly total. The half-clad exhibitionists that make up the body of the sugar casters—nuzzling each other without restraint—would have astonished and offended the modest Chinese. Kändler neither knew nor probably wished to know. Cynical and demonic sculptor that he was, I think Kändler's intention was to create a work so glorious and inventive that these uninhibited lovers would be set before the most prudish lady in the land and no one would dare to raise an eyebrow!

There are many kinds of pleasure in a museum. There is easy pleasure, when we are charmed; and profound pleasure, when we are silenced; but also, very rarely, there is what I would term difficult pleasure. We find it, say, in Picasso, and we find it in Kändler. These artists of beautiful things sometimes make a work that is hideous—yet the hideousness is so wonderful that we are swept away in amazement.

Du Paquier Gaming Set
A U S T R I A N

The great social activity of the 18th-century aristocrat was gambling. It could be an obsession. Houses, great estates, entire fortunes were wagered on the turn of a card. This precious gaming set has a double connection with gambling. Most of the great European porcelain manufacturers—Sèvres, Meissen, Nymphenburg—were state-supported. Du Paquier, in Vienna, was on his own. For twenty-six years he gambled so that he could make a living producing exceptional works of art. Then, in 1744, he went bankrupt.

This is a profoundly romantic piece—all the more so, perhaps, for its associations with the bankruptcy, heartbreak, and suicide that are the dark side of gaming. I know nothing that so recalls the sensuous stateliness of life in pre-revolutionary Europe. It would have been handled by ladies with powdered wigs, and feathers, and beauty spots; and by men, likewise powdered, rouged, and bejeweled, silken and elegant, sitting at table to play whist (a rudimentary form of bridge). A footman, with gloves and a silver salver, would have proffered the gaming set.

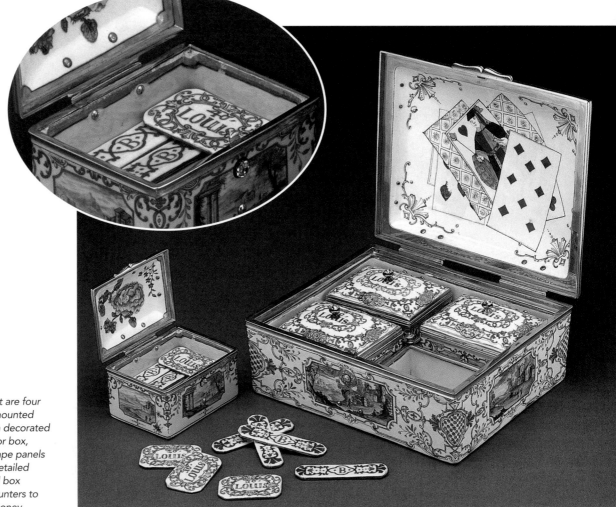

Inside the Gaming Set are four gold- and diamond-mounted porcelain boxes, each decorated as richly as the exterior box, with exquisite landscape panels depicting ruins and detailed strapwork. Each small box contains porcelain counters to be used in place of money.

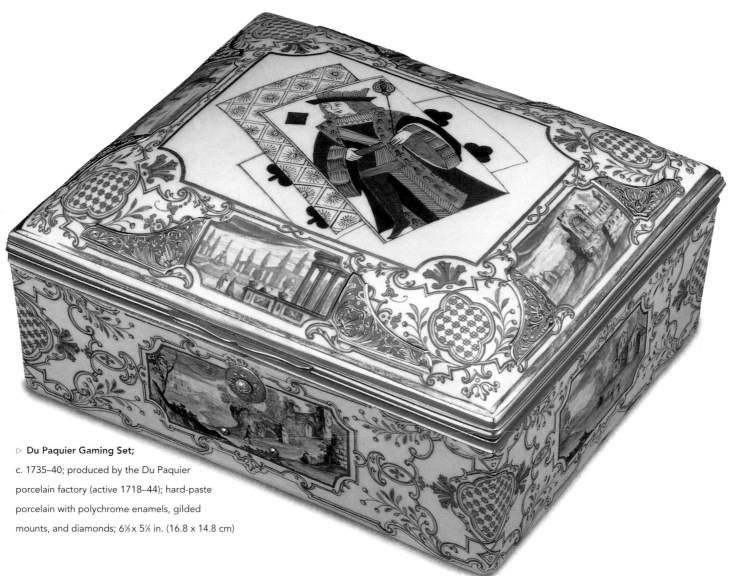

▷ **Du Paquier Gaming Set;**
c. 1735–40; produced by the Du Paquier
porcelain factory (active 1718–44); hard-paste
porcelain with polychrome enamels, gilded
mounts, and diamonds; 6⅝ x 5⅞ in. (16.8 x 14.8 cm)

The box is decorated with three playing cards, framed
in patterns of violet and gold. Panels depict—ominously
for those who attended the omens—landscapes of ruins.
Inside are four compartments, each with a smaller box
(likewise golden and painted) containing porcelain
counters, so that nothing as vulgar as money would sully
the gaming table. The entire set is glorious, with its
twenty-four landscapes and six still lifes—all exquisite.
I think poor Du Paquier might agree with me that in the
feverish excitement of the gaming room, no one probably
had time to appreciate his beautiful gaming set. I feel
he would be glad, as I am, that it made its way from
St. Petersburg to Chicago, where it can finally receive
the reverent admiration that is its due.

❝ This is a profoundly romantic
piece—all the more so, perhaps, for
its associations with the bankruptcy,
heartbreak, and suicide that are the
dark side of gaming. ❞

Monumental Seated Ancestor Figure

MEXICAN

There can be occasions when having very little background knowledge about a work can mean that we encounter it in a different way; we cannot hide from its impact under the shield of our knowledge. This figure, with the massive simplifications of the turban and the great clear outlines of the body, with the strongly patterned belt and flowered necklace and bracelets, seems made to be seen at a distance—perhaps on a temple, overlooking a public square. Yet "temple" does not seem to ring true; there is great authority here, but it does not strike us as divine authority. Why do we perceive this figure as a young aristocrat, in either idealized or portrait form, but lacking any divinity? I believe it is because the sculptor shows him as uninterested in the viewer; he is an introspective figure. I feel that he is impartial, which, of course, would make him an ideal ruler. He does not wish to impose his sovereignty, but bring him a problem, and he would be ready to solve it justly. He dominates the space where he sits in the museum, but not by virtue of will; he dominates by the quality of the art.

> **Monumental Seated Ancestor Figure**; 250–550, Early Classic period; terracotta; 34 x 26 in. (86.4 x 66 cm)

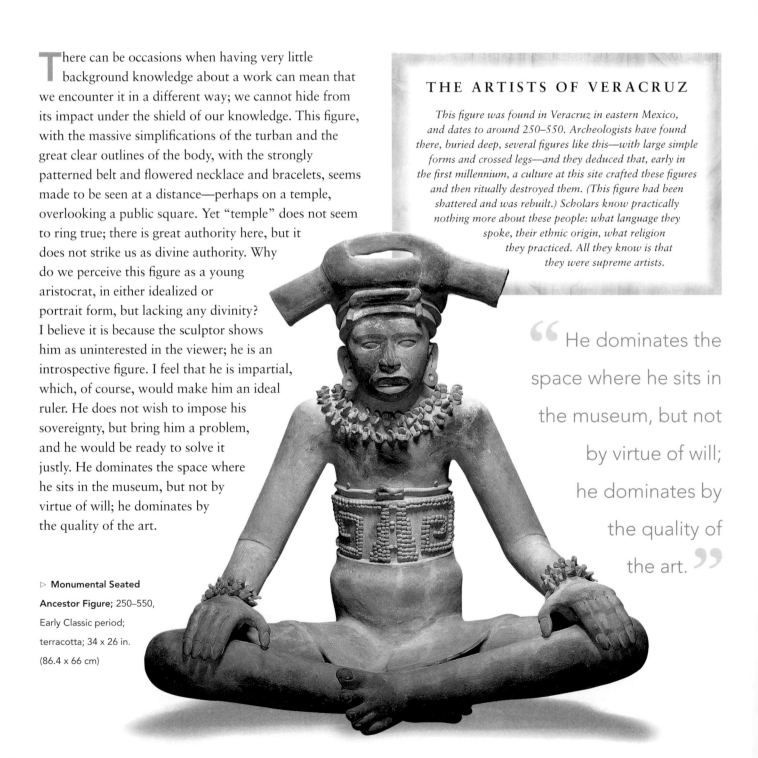

THE ARTISTS OF VERACRUZ

This figure was found in Veracruz in eastern Mexico, and dates to around 250–550. Archeologists have found there, buried deep, several figures like this—with large simple forms and crossed legs—and they deduced that, early in the first millennium, a culture at this site crafted these figures and then ritually destroyed them. (This figure had been shattered and was rebuilt.) Scholars know practically nothing more about these people: what language they spoke, their ethnic origin, what religion they practiced. All they know is that they were supreme artists.

> " He dominates the space where he sits in the museum, but not by virtue of will; he dominates by the quality of the art. "

Ceremonial Drum

IVORY COAST

Sometimes we have the great good fortune to find a work that seems to sum up an era or a people. Scholars of African art make that high claim for this drum: a ceremonial instrument from the Senufo people of the Ivory Coast in West Africa. The unknown sculptor who carved it at the turn of the 20th century somehow summed up the spirit, philosophy, and religion of his tribe. It is easy for us, outsiders, to make a glib misreading, and to see a drum, held by a woman and played by a man, as the sexes in their typical Western imbalance. However, here almost the opposite is true. The Senufo trace their lineage from their mothers, and this work celebrates woman. She is seated—always a sign of dignity—a great matriarch, upholding the entire structure and spirituality of her people by her own virtue and nobility. The sculptor emphasizes her beauty and her strength, her noble power.

Senufo art was geometrical (the cubists loved it), and the woman was conceived in strong abstract shapes, with the cones of her breasts and the squareness of her thighs, and the long nose of that impassive queenly face. What she upholds with such majesty is the great drum that would be used only for the most sacred ceremonial occasions. The drum would be played at a funeral or a memorial for the dead, when the people felt very close to the afterworld; or perhaps at initiations, when the young Senufo underwent a ritual acknowledgment of another step toward the responsibilities of maturity. On these occasions, when the drum was beaten, the spirits were summoned.

> " The Senufo trace their lineage from their mothers, and this work celebrates woman. "

▷ **Ceremonial Drum**; 1930–50, Senufo people; wood, hide, and applied color; 48⅜ x 19⅜ in. (122.9 x 49.2 cm)

IMAGES OF WAR

All the decoration around this drum is symbolic. There are three images of war: the warrior on his horse with his spear; the triumphant warrior with the manacles; and the antelope horn, which holds the preventive medicine that the warrior would take into battle. These images refer to both tribal wars and to the competition that was held by the Senufo each year, in which men strove to show their skill and endurance. On an even deeper level, they symbolize the struggle within all human beings to combat their own evil and be worthy of humanity. This work refers to three kinds of warfare: with outsiders, within the tribal family, and within the heart.

The America
Windows

CHAGALL

The Jewish menorah reflects the religious tolerance of American society, and Chagall depicts the U.S. as a dove rather than an aggressive eagle.

▽ **The America Windows**; 1977; stained glass

Marc Chagall was a Russian Jew, who spent most of his long life in exile. During World War II, he lived in the United States. Chagall wanted to express his gratitude to the country, and to celebrate the bicentennial of the Republic, by creating a great stained-glass window. It is fitting that the windows he created should be at the A.I.C.—Chicago can lay claim to being the quintessential American city, and its museum is an intimate part of the city: trains run beneath, stores crowd the sidewalk opposite, and the trees in the courtyard were trimmed so that the windows could face east without obstruction.

In the central section, Chagall acclaims the United States and what it means: he sees it primarily as a country of liberty. Here he depicts the signing of the Declaration of Independence, with the sun of liberty rising brightly; and here also is the Statue of Liberty—hijacked from New York. Chagall, who was by temperament a dove, found it hard to show an aggressive American eagle, so he compromises with a soft pink, portraying the United States as a gentle giant.

The side sections honor American culture. On the left—radiant with reds, golds, and greens—is the Chicago

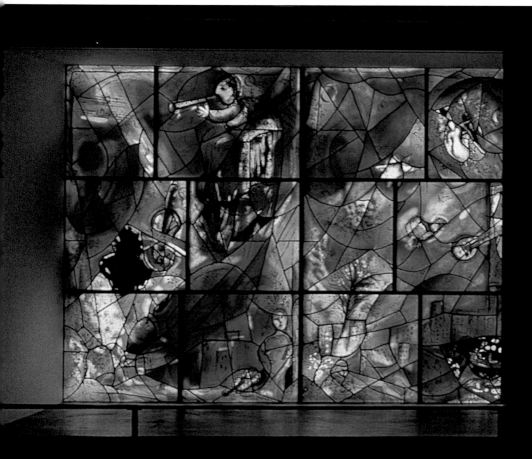

> **"The three sections are unified by the dominant blue—lovely in itself, and perhaps also hinting at the heavenly blue of stained-glass church windows."**

Symphony Orchestra; and the museum itself is represented in images of palettes, brushes, and models. On the right we see music and dance: a window of exuberance and whirling theater masks. In the center of the festival, however, is the Jewish menorah. This is Chagall's way of saying that the United States is a religious society, and a tolerant one, where worship is honored.

The three sections are unified by the dominant blue—lovely in itself, and perhaps also hinting at the heavenly blue of stained-glass church windows. They are united also by the skyline of towering buildings that runs throughout. Chicago is, of course, the original home of the skyscraper. This is a city that celebrates architecture—what better place could there be for the America Windows?

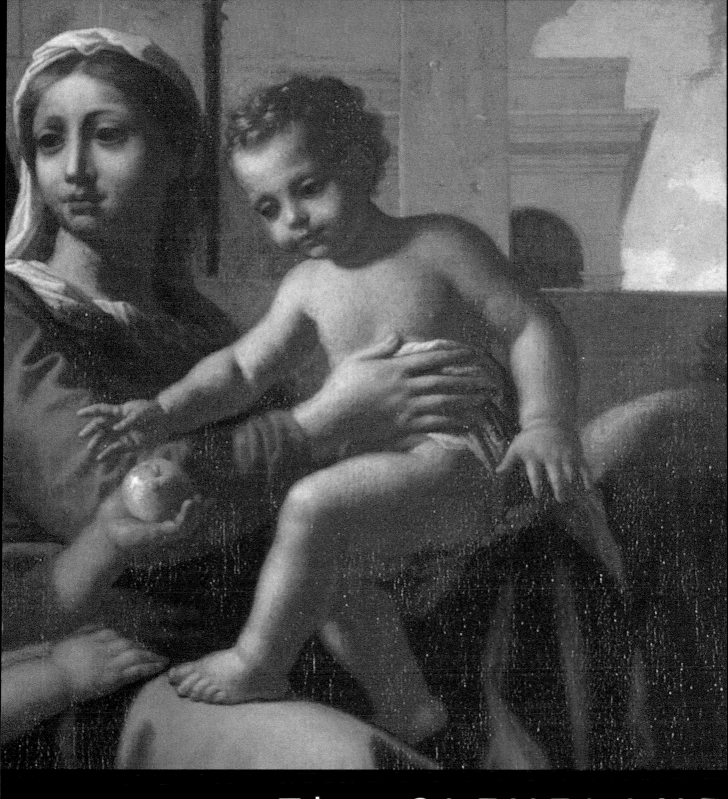

Introduction

A museum can be located in the heart of the city, or be removed from it, and Cleveland emphatically chose removal. It lies in an area of colleges and hospitals, wooded and watered: a parkland. Either location has advantages. To be central to commercial hustle highlights art's accessibility; to be remote stresses its almost sacred significance. Of course, all great museums—and Cleveland is a very great museum—are conscious of both

◁ **Guelph Treasure: Medallion with the Bust of Christ;** late 700s; German; cloisonné enamel on copper; height 2 in. (5 cm)

▽ **View of the south façade of the Cleveland Museum of Art, including the Fine Arts Garden**

△ **Guelph Treasure, left to right:**
Ceremonial Cross of Count Ludolf
Brunon; c. 1037; German; gold,
cloisonné enamel, gems, pearls,
and mother-of-pearl on oak core;
9½ x 8½ in. (24.1 x 21.6 cm)

Portable Altar of Countess
Gertrude; c. 1045; German; red
porphyry, gold, cloisonné enamel,
gems, and pearls on oak core; 4 x
10½ x 8 in. (10.2 x 26.7 x 20.4 cm)

△ **Guelph Treasure: Arm**
Reliquary of the Apostles;
c. 1195; German; silver, gilt,
and champlevé enamel;
height 20 in. (50.8 cm)

Ceremonial Cross of Countess
Gertrude; c. 1038; German; gold,
cloisonné enamel, gems, pearls,
and mother-of-pearl on oak core;
9½ x 8½ in. (24.2 x 21.6 cm)

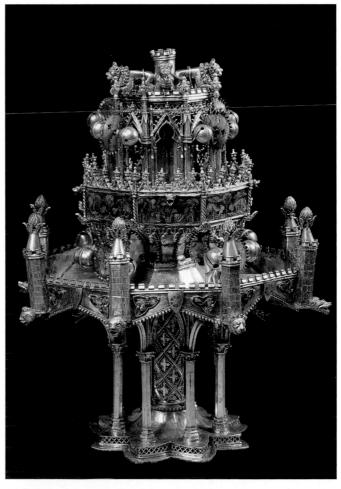

△ **Table Fountain;** 1300–50; French; silver gilt and translucent
enamel; height 12¼ in. (31.1 cm)

aspects of their vocation, and the journey to the
Cleveland Museum of Art is rewarded by the warmth
of the welcome it offers, with flowers, well-designed
and comprehensible galleries, and general graciousness.

This is not one of the biggest museums, though it is
certainly large: there are well over 30,000 works, and
structural expansion is needed (for the fourth time). What
strikes one most, however, is not so much the size of the

museum's holdings, but their quality. In gallery after gallery, we come across unique treasures and exquisite art of the rarest kind. This is because Cleveland had exceptional good fortune in its directors. There was the great medievalist William Milliken, who knew Europe well and secured for the museum some astonishing works, such as the Guelph Treasure from 11th-century Germany: golden, bejeweled, and intricate in their decoration. Intricacy (the pure *joie de vivre* of artistic skills) marks many of the museum's pieces—whether medieval, such as the dazzling Table Fountain pictured on page 155, or 18th-century rococo, such as the Meissonier Tureen pictured opposite. Milliken was followed by a still more famous scholar, Sherman Lee, who, as every student of the subject knows, wrote *the* book on Far Eastern art.

When major art comes onto the market, Cleveland's museum is always to be seen alongside New York's Metropolitan, in hot pursuit—and more often than not, triumphant. The results of this wise and moneyed pursuit are perhaps most evident in the Eastern and Medieval galleries, but they are abundant everywhere, making this museum a place of sublime and never-ending satisfactions.

> " In gallery after gallery, we come across unique treasures and exquisite art of the rarest kind. This is because Cleveland had exceptional good fortune in its directors. "

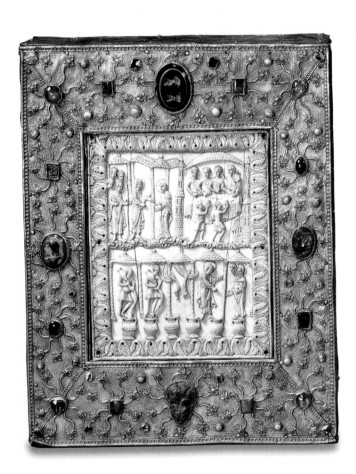

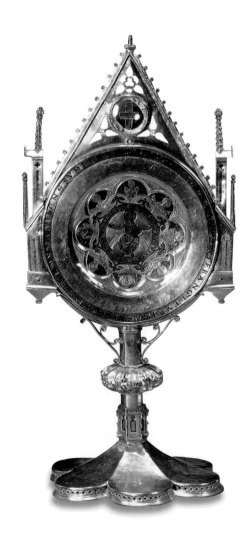

△ **Guelph Treasure, opposite page, left to right: Reliquary in the Form of a Book;** c. 1340; German; ivory plaque set within a frame of gilt silver; 12⅜ x 9½ x 2¾ in. (31.5 x 24.1 x 6.9 cm)

Monstrance with the "Paten of St. Bernward"; 14th century; German; paten: gilt silver and niello, monstrance: gilt silver and rock crystal; height 5¼ in. (13.5 cm)

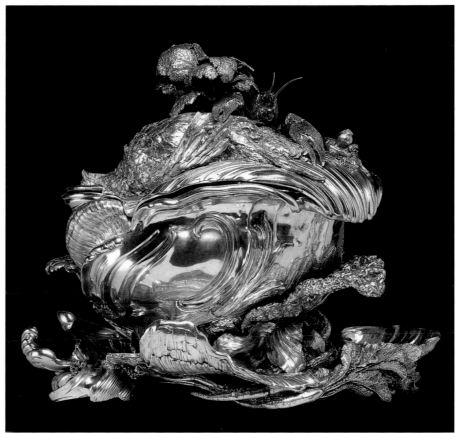

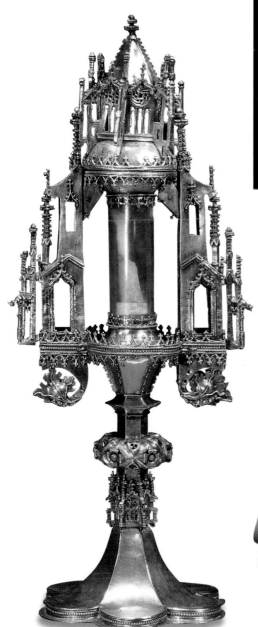

△ **Tureen;** 1735–38; designed by Juste Aurèle Meissonier, French (1695–1750); silver; 14½ x 17¾ in. (36.9 x 45 cm)

◁ **Guelph Treasure: Monstrance with a Relic of St. Sebastian;** c. 1475; German; gilt silver and rock crystal; height 18½ in. (47 cm)

△ **Guelph Treasure: Horn of St. Blaise;** 12th century; Sicilian-Arabic, Palermo; ivory; width 4¾ in. (12 cm)

Half-Armor
for the Foot Tournament

DELLA CESA

Since the museum opened, I am told, the unforgettable memory for Cleveland children is the excitement of the Armor Court. I can believe it; even for the staid and elderly, it is a romantic place—though ambiguous also. There is a sad irony in that the accoutrements of war should be among the most magnificent objects made. The consolation is that the more exquisite the armor, the less likely it was to be risked on the battlefield.

This half-armor was designed for foot tournaments, which were fought over a barrier, so that the warrior was safe below the waist. It was created around 1590 by Pompeo della Cesa (active 1572–93), the greatest Milanese armorer. It was essentially a fashion statement: an emblem of wealth, position, and power. No male attire was ever more costly. If you had enough money to commission a Pompeo—kings and dukes were eager to order from him—he would come to measure you, and bring his pattern book, so that you could choose the most suitable embellishment. Below the steel the wearer would have looked very splendid in rounded breeches and vividly colored stockings.

There are only about forty Pompeos in existence, and the owners of about half of these had them signed. This man evidently reasoned that those who could not recognize an original Pompeo when they saw one did not deserve to know. Looking around the court I sense that some of the armor here has known fear and blood, but this piece was predestined to be displayed in a museum.

> **There is a sad irony in that the accoutrements of war should be among the most magnificent objects made.**

▷ **Half-Armor for the Foot Tournament**; c. 1590; etched and gilded steel, with brass rivets, and leather and velvet fittings

Above the helmet would have been the arrogant curl of a scarlet ostrich feather, with a special attachment to keep it upright.

Eleven-Headed Guanyin

CHINESE

Guanyin is the Buddhist deity of compassion. In the early days in India—as here, in 8th-century China—the figure was always male. You can understand the reasoning: only the strong and powerful (by definition male) are able to show mercy. However, as the centuries went by and the world grew quieter, it seemed more appropriate that the god should display a mother's tenderness, and so Guanyin became a woman. This reasoning is not entirely false, but it is simplistic. In fact, a theological understanding of the nature of compassion requires it to assume whatever form is most needed. So Guanyin has many forms: eighty-one, by some counts.

This image is the Eleven-Headed Guanyin. The idea is that in the god's eagerness to seek and find those in need, one head is not enough. So at the top—sadly battered now—are small heads, anxiously peering out in all directions. There is also a charming myth, which says that the god's heart so grieves over human suffering and folly that he gets tension headaches. Hence the use of the other heads, to take over the headaches and leave the divine concentration intact. The sway of this wonderful figure is an Indian influence and so is the bare chest—the Chinese were very modest. Virtually everything else—notably the goldleaf and patterning—is profoundly Chinese.

△ **Eleven-Headed Guanyin;** 700–25, Tang dynasty; gray sandstone; 51 x 25 x 10 in. (129.6 x 63.6 x 25.4 cm)

The Holy Family on the Steps

POUSSIN

Poussin's *Holy Family on the Steps* is one of the greatest paintings in the United States, let alone in Cleveland. Yet I have stood in its gallery and seen people look at it only in passing, though I expected them to stop, amazed and awed. The reason seems to me that Poussin had two exceptional and contradictory qualities. He was immensely intellectual. He planned everything, even making small models in order to get his pictures absolutely balanced. He was able to impose the geometry of rationality on our haphazard world—and I admit that

this can sound unenticing. Perhaps the casual viewer notes his lucidity and thinks the work is too simple to repay study? However, Poussin was also a great sensuous poet, and when lucidity is infused with poetry, it produces passionate intellectuality—or geometric lyricism, if you prefer—and this work displays it overwhelmingly.

There is the cold, hard geometry of the horizontal steps and the great vertical columns. This is a picture of what architecture can be: strong, sure, manmade—dead. Even the plants are trimmed or held in urns. Opposing this is

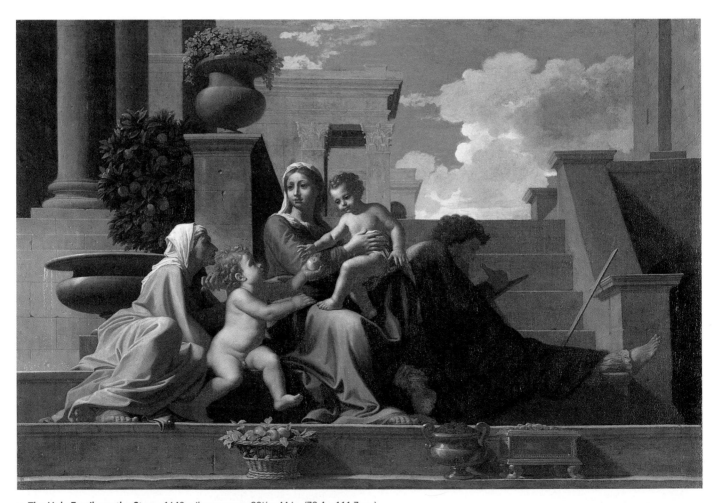

△ **The Holy Family on the Steps;** 1648; oil on canvas; 28½ x 44 in. (72.4 x 111.7 cm)

another geometry—soft, warm, and human: the triangle of the Holy Family. On one side is the aging St. Elizabeth, with her son John, reaching up to the apex of Virgin and Child; on the other side is St. Joseph, working. One side is sunlit and emotional: the longing of prayer. The other is shadowed, intellectual, concentrated on work: the necessary balance to prayer's intensity. Yet how wittily Poussin shows Joseph's connection to the central group by spotlighting part of him with sunshine: his handsome bare foot, with its ridiculous little frilled pantalet peeking out; there is more to this saint than architectural severity, it would seem. In front—pushed away, as it were—are golden urns, recalling the myrrh and frankincense that the Wise Men brought to the stable at the Child's birth. They are not wanted. What is wanted is the wicker basket of apples, which, of course, recalls Eden and Eve's eating of the apple. Here, one innocent child hands it to another: a Jesus haloed not by hard gold but by the summer sky.

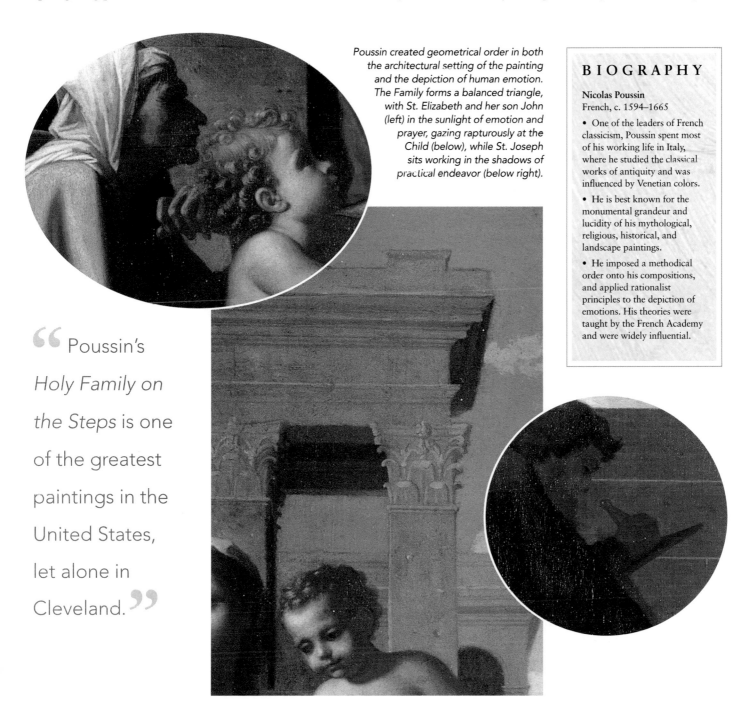

Poussin created geometrical order in both the architectural setting of the painting and the depiction of human emotion. The Family forms a balanced triangle, with St. Elizabeth and her son John (left) in the sunlight of emotion and prayer, gazing rapturously at the Child (below), while St. Joseph sits working in the shadows of practical endeavor (below right).

BIOGRAPHY

Nicolas Poussin
French, c. 1594–1665

• One of the leaders of French classicism, Poussin spent most of his working life in Italy, where he studied the classical works of antiquity and was influenced by Venetian colors.

• He is best known for the monumental grandeur and lucidity of his mythological, religious, historical, and landscape paintings.

• He imposed a methodical order onto his compositions, and applied rationalist principles to the depiction of emotions. His theories were taught by the French Academy and were widely influential.

" Poussin's *Holy Family on the Steps* is one of the greatest paintings in the United States, let alone in Cleveland. "

Twilight in the Wilderness

CHURCH

△ **Twilight in the Wilderness;** 1860; oil on canvas; 40 x 64 in. (101.6 x 162.6 cm)

" Some paintings seem to bear their nationality on their faces. Church's *Twilight in the Wilderness* could only, I feel, be American. "

Some paintings seem to bear their nationality on their faces. Church's *Twilight in the Wilderness* could only, I feel, be American. Church specialized in works inspired by the sheer vastness of the American continent. He went to South America, and painted the Andes; he traveled north, and gloried in the Niagara Falls; and he moved on to the huge silences of the icebergs. He held one-painting shows of these immense canvases, which people flocked to see, encountering these marvels of nature for the first time. Here, he painted the east coast: his own Maine.

What I find fascinating is that everybody who looked on this magnificent scene and published a reaction seems to have a different interpretation. Some homed in on the eagle, up there on the left, and saw a symbol of American power. Some noticed where the branches cross, and saw a suggestion of Christianity. Others, noting the absence of human beings, claimed the pines as our surrogates— standing tall and strong, as the frontier expects. I must say that the pines most evident are somewhat twisted and scruffy, which gives the landscape a remarkable air of conviction; this is no ideal place, but truly what Church looked down upon. The one interpretation that I find sustainable hinges on the painting's date. In 1860, the menace in the sky would have been all too real. The Civil War would soon break out, and the blood-red tide would spread throughout the land.

BIOGRAPHY

Frederic Edwin Church
American, 1826–1900

• Church was the only pupil of the American landscape painter Thomas Cole, and developed a similar sense of awe for spectacular scenery.

• He traveled to many places, making preparatory oil sketches on which to base his landscapes, which he produced on immense canvases that reflect the vastness of the American continent itself.

• His *Falls of Niagara* (1857) received great acclaim at the Paris Universal Exhibition in 1867, and this success encouraged Church to travel beyond the American continent in search of new vistas.

Many different interpretations have been made of this painting. Some see the eagle as a symbol of American power (right, inset). Others see the ominous blood-red tide of clouds sweeping across the sky as symbolic of the approaching Civil War (right).

Yosemite Valley

BIERSTADT

ight beside Frederic Church's painting *Twilight in the Wilderness* (pictured on page 162) hangs Bierstadt's *Yosemite Valley*. Bierstadt was an almost exact contemporary, but this was painted in 1866. The war is newly over and all is at peace. Moreover, the subject this time is the West: that almost unimaginable territory that was still largely unexplored. Photographers had just begun to venture there—among them Bierstadt's own brother—but it was still the artist's privilege to bring back a sense of what the West was like. This is the Yosemite Valley—and observe that it is not uninhabited. Already living there are Native Americans, in a paradise world of quiet and natural beauty, where sky and water reflect only sunlight. Like Church, Bierstadt was inspired by an awareness that he lived in one of the most beautiful countries on earth, and that it was his responsibility—as it is ours—never to abuse that privilege.

BIOGRAPHY

Albert Bierstadt
American, 1830–1902

• Bierstadt grew up in the United States, but studied at the Düsseldorf Academy in Germany, his country of birth.

• On returning to the U.S. in 1857, Bierstadt specialized in spectacular representations of the American landscape, and was one of the leading artists of the Rocky Mountain school, a group of artists who painted Rocky Mountain scenes.

Bierstadt shows the American West as an earthly paradise bathed in sunlight and inhabited by Native Americans.

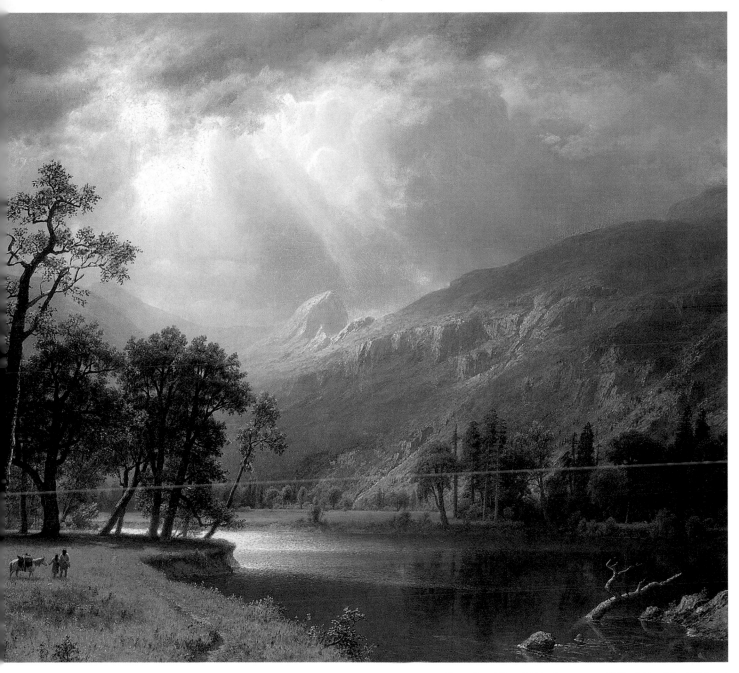

△ **Yosemite Valley;** 1866; oil on canvas; 38¼ x 56 in. (97 x 142.3 cm)

❝ Bierstadt was inspired by an awareness that he lived in one of the most beautiful countries on earth, and that it was his responsibility—as it is ours—never to abuse that privilege. ❞

Don Juan Antonio Cuervo

GOYA

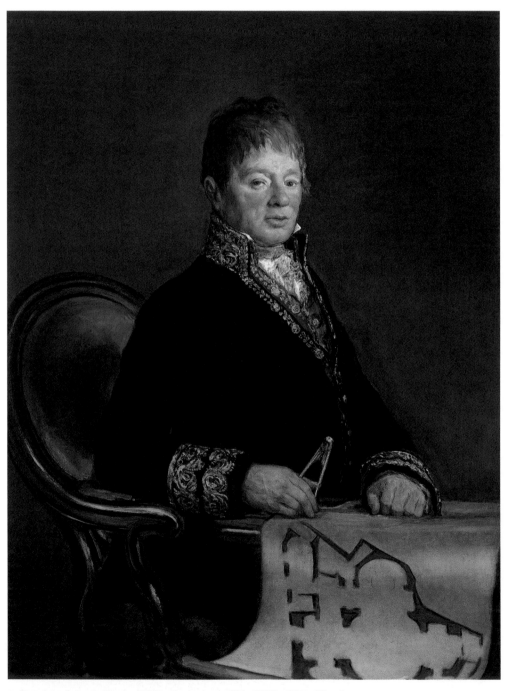

△ **Don Juan Antonio Cuervo;** 1819; oil on canvas; 47¼ x 34¼ in. (120 x 87 cm)

> " I wonder if Goya's empathy for architects came from the way he saw their profession, as a way to make soaring imagination ground itself? "

Goya was a man whose life fell into two parts. He was always successful, but in his younger days he was a pleasure-loving, reckless fellow. Then, in his mid-forties, he contracted a mysterious illness. He recovered, but was left totally deaf and spiritually darkened. Over twenty years later, when this portrait was painted, the disease came back. He had been retired for some years, and only painted his friends.

Don Juan Antonio Cuervo practiced architecture, a profession for which Goya seems to have had an affinity; he painted several architects, including Cuervo's nephew. This man, however, could almost be claimed as *the* architect: President of the Spanish Academy, shown in all the panoply of high office. His status demands a splendid green and gold chair and matching table, but Goya notices how the fine furniture shuts him in. He is wearing the official presidential uniform, with its stiff, high collar; once again, it is constricting. His only personal choice is a pleasantly quirky one: the latest hairstyle imported from England, spiked and unattractive. All else is dominated by convention, and the tension, if subtle, is unmistakable. One big farmer's hand is clenched taut on the table, while the other, holding a protractor, rests over the long, dangling architectural plan. The plan shows far more empty spaces than it does drawings. I wonder if Goya's empathy for architects came from the way he saw their profession, as a way to make soaring imagination ground itself? Even the tight gold braid, meant only to decorate, has here a celebratory brightness. This is a true architect: free, despite all the inhibitions of bureaucracy. Every time I see it, I am struck by the encounter we have with those bright eyes, and I imagine Goya, in his seventies now, old and sick, looking almost enviously at his younger friend, still caught in the conventions of Spanish society yet so easily dominating them.

Goya demonstrates both the constriction and the glory of Cuervo's presidential position at the Spanish Academy by the stiff, gold-braided collar and cuffs of his uniform, but Cuervo's eyes gleam brightly as he handles the tools of his trade, which allow him to soar above the conventions inherent in his position.

Gray and Gold

C O X

You will not find John Rogers Cox in any art histories, unless there is one devoted to artists who lived in Indiana. This early work seems to have been his peak, and Cleveland were wise to buy it; it is an extraordinary painting. You can see where the gray of the title comes from: that great ominous sky—clearly influenced, I think, by the fact that World War II was raging. The sky, though, is not raging; it is controlled, cloud peaked upon peak, as if the artist will not let nature escape him. The gold, of course, is the corn: lawn-like, meticulously cared for, every little stroke even. The more we look, the more unreal the scene becomes. We are distanced from it by its perfection, and by the fencing. Even over the grass, a manicured strip, there rises barbed wire. There is a crossroad, giving us the illusion of options. We can go over the hill between the corn; or come down the hill away from the corn; or we can walk past it. What we cannot do is go through the corn. It is remote from us, and we have no access to it. Even the telephone poles march away, distancing us. This is what gives the work its haunting quality.

△ **Gray and Gold;** 1942; oil on canvas; 35¾ x 49½ in. (90.8 x 125.7 cm)

The title of the painting is derived from the ominous gray clouds in the sky and the golden corn below, through which the deserted road runs.

In every museum there are more paintings than space to hang them, and I am told that curators several times put this work into storage—and caused an outcry. By public demand, it was brought back and reinstated. Cox may be an unknown, but I can understand this reaction. It is an oddly inhospitable picture, yet one cannot but like it.

66 In every museum there are more paintings than space to hang them, and I am told that curators several times put this work into storage—and caused an outcry. By public demand, it was brought back and reinstated. 99

Mat Weight
in the Form of a Bear
CHINESE

Until the beginning of our millennium the Chinese did not sit on chairs, which they called "sitting with legs hanging down." They sat cross-legged on the floor, as many Asians still do, with low tables. At banquets, guests sat on woven cloths, which were anchored at each corner by a weight. This bear is one of the four weights that were found in the tomb of an aristocrat who lived at the time of the Western Han dynasty, around 2,000 years ago—give or take a few hundred. All four bears have made it to the United States.

This is both an enchanting object and a masterpiece of sculpture. Do not be misled by its charming smile and the glitter of gold: this is the Black Asian Bear; and we realize that the sculptor actually saw this wild creature, so convincing is its form. The probable location of the encounter was the nature reserve that the emperor kept beside his palace, where an artist could observe the animals in safety. Small though this bear is, it is a hulking, tight mass of power. I like to think that the long-dead nobleman, who took his bears and his mat into the tomb, must have sat through many a state banquet, with its interminable speeches and toasts, comforting himself by reflecting on the coiled power and good humor of this and his other personal bears.

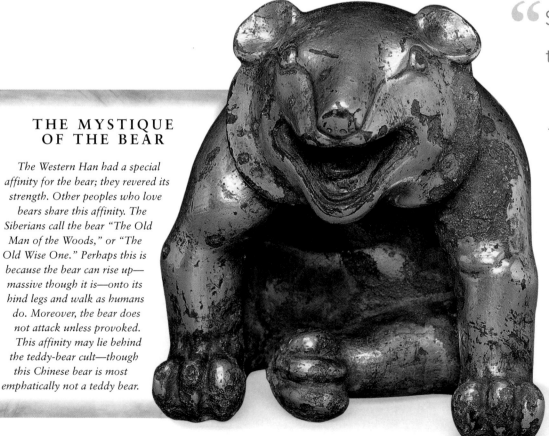

THE MYSTIQUE OF THE BEAR

The Western Han had a special affinity for the bear; they revered its strength. Other peoples who love bears share this affinity. The Siberians call the bear "The Old Man of the Woods," or "The Old Wise One." Perhaps this is because the bear can rise up—massive though it is—onto its hind legs and walk as humans do. Moreover, the bear does not attack unless provoked. This affinity may lie behind the teddy-bear cult—though this Chinese bear is most emphatically not a teddy bear.

66 Small though this bear is, it is a hulking, tight mass of power. **99**

◁ **Mat Weight in the Form of a Bear;** 206 B.C.–A.D. 220, Western Han dynasty; gilt bronze; height 6⅛ in. (15.7 cm)

> " He takes you up into that world of quiet and simple bliss that is the god's homeland. "

△ **Krishna Govardhana;** 500–50, Pre-Angkor period; gray limestone; height 46¾ in. (118.8 cm)

Krishna Govardhana

CAMBODIAN

Krishna, whose name means "the dark one," is the best known of the Hindu gods. He plays many roles: he is hero; he is lover; he is flute-player, articulating the music of the world; he is protector. Although thieves thrust this Cambodian sculpture down from its niche and broke it, centuries ago, we can tell from the position of the arms that this is Krishna the Protector (Krishna Govardhana). When the museum received the sculpture, not only were the arms broken but there was little below the waist either. Then began an enthralling saga of patient detective work, through which the curator tracked down the other pieces, or at least some of them—mysteriously buried in a Belgian backyard. With diplomatic skill, the lady of the house was coaxed into allowing excavation beneath her cherished flowerbeds, until enough fragments could be pieced together to make an almost complete figure.

The work tells the story of the gods Krishna and Indra, and Mount Govardhana. You can deduce the mountain as your eye takes in those great load-bearing feet, the strong thighs, the effortless body of a young male in his prime, and the patient smile as he lifts a mighty arm and one steady finger to support the unseen colossus. Even without knowing the story, I think you would be uplifted by the quality of the figure—he takes you up into that world of quiet and simple bliss that is the god's homeland.

Stag at Sharkey's

BELLOWS

Bellows has a unique distinction: he is the only major artist who financed his artistic beginnings from his earnings as a semipro baseball player. (He was also a basketball star at Ohio State.) You could perhaps deduce from his work that he was a man with a ballplayer's eye and an instinct for physical movement. He did not paint ballgames, however, but boxing: a sport in which he said he had no interest. My guess is that he was half-attracted and half-repulsed. Here is this good Methodist boy—his

mother gave him Wesley as a middle name because she hoped he would be a minister—up from the country to the big city, and opposite his studio he finds Sharkey's Athletic Club. New York had several athletic clubs, which were a way of getting around the prohibition on public boxing matches. Instead of an illegal entrance fee, spectators at the boxing matches, or "stags," paid a "subscription" for club membership. If you look around the picture, you see that Bellows had scant respect for the boxing audience;

△ **Stag at Sharkey's;** 1909; oil on canvas; 36¼ x 48¼ in. (92 x 122.6 cm)

he caricatures them. However well some may be dressed, they are vulgarians to a man—and "man" is the word, because this is stag night.

However, I think there is a pun here. In the mating season, stags fight brow to brow, often with antlers locked, and they heave massively to and fro. Bellows sees something of the stags' innocence and power in the boxers, because unlike the sleazy watchers, they do attract his admiration. These men may be competing for a purse, but Bellows thinks of them as fighting for honor—locked together like stags. He venerates their young courage, blurring the paint as if he can hardly catch their motion. The referee behind spreads his arms, because at any moment they might break out of the clench. Of course, they never do break; I think Bellows could not bear to have one of these heroes defeated. So they sway in rapid motion, forehead to forehead, gleaming in the light, lifted above the throng of littleness: images of courage and of "grace under pressure."

Bellows seems to admire the courage of the boxers, whom he depicts with the blurred brushstrokes of violent motion, locked together in battle like stags, forehead to forehead (left). He does not seem to feel much sympathy for the audience, however, whom he caricatures (below).

" In the mating season, stags fight brow to brow, often with antlers locked, and they heave massively to and fro. Bellows sees something of the stags' innocence and power in the boxers. "

BIOGRAPHY

George Wesley Bellows
American, 1882–1925

• Bellows was a pupil of Robert Henri in New York, where he became associated with the Ashcan school of painters, who portrayed scenes from everyday American life in a realistic style.

• A former semipro baseball player, Bellows is best known for his vigorous depictions of boxers, utilizing blurred brushstrokes to give a vivid sense of movement.

• His later works show his concern with the life of the urban poor. He also produced many lithographs, portraits, and landscapes.

The Biglin Brothers Turning the Stake-Boat

E A K I N S

Typically, Eakins does not show the famous Biglin brothers at their moment of victory in the race, but instead at the moment of greatest uncertainty. Passing the stake-boat was the only time when the rowers did not pull together. John Biglin must keep absolutely still, while his brother Barney, with his head turned, figures out the complex calculations of rounding the stake-boat as efficiently as possible. Aptly enough, blue-collar worker John was the brawn, and Barney, a clerk who would later serve in the New York Assembly, was the brains. They harmonize to perfection. Spectators throng the banks to watch the race, wildly excited, but they cannot see what we see. We seem to be actually in the water. We can feel its liquid coolness. We see the sun glinting on the two young men, catching the relaxed trustfulness of one and the tension of the other. They are three-and-a-half lengths up on the challengers from Pittsburgh, and will finally beat them by fifty seconds: a near-run thing.

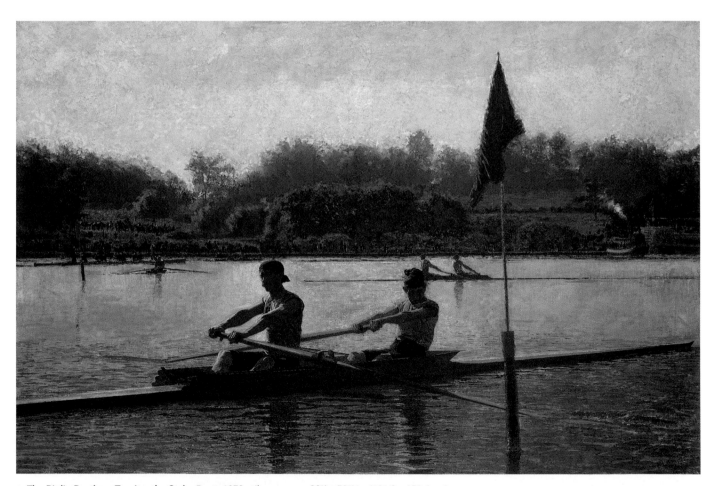

△ **The Biglin Brothers Turning the Stake-Boat;** 1873; oil on canvas; 39⅛ x 59⅝ in. (101.3 x 151.4 cm)

When Eakins painted this—the masterpiece among his rowing studies—he put himself in the picture. He is the man in the skiff, frenziedly waving his handkerchief. Literally, he is cheering his heroes on. Figuratively, though, I believe he is also cheering himself on. By now he knew what he could achieve: how he could make us aware of air and sunlight and water, of the sweaty power of those young bodies. He enables us to feel what the Biglins were putting into the race, and how determined they were to win. He was also cheering on his own determination to win as an artist—and win he did.

The sunlight glints on the skin of the two young men's bodies, gleaming with sweat: one is relaxed (above, inset), the other tense with exertion (right).

BIOGRAPHY

Thomas Eakins
American, 1844–1916

• Eakins spent most of his life in Philadelphia, but studied in Europe from 1866–70, where he was deeply influenced by the realism of Velázquez.

• He specialized in portraiture and genre scenes of everyday life—boating and bathing were among his favorite subjects—all characterized by his uncompromising realism.

• Eakins was a controversial figure. His anatomically realistic portrayal of a human dissection in *The Gross Clinic* (1875) was badly received, and he was forced to resign from his teaching position at the Pennsylvania Academy in 1886 for allowing a mixed class to paint from a nude male model.

THE BIGLIN CHALLENGE

In 1872 the famous Biglin brothers, who lived in New York, issued an international invitation to a pair-oared competition. The only takers were a bold couple from Pittsburgh: the men shown in the background of Eakins' painting, with red caps. Eakins himself, aged 28, had recently finished his studies in France and gone home to Philadelphia. Most of his friends were married and had good jobs, while he was a dependant in his father's house. Mid-Victorian that he was, he may have felt uneasy, and looked to the one place where he was equal to anybody: the river. Like many young Philadelphians, he was a good oarsman—though he would not have challenged the Biglin brothers.

" He enables us to feel what the Biglins were putting into the race, and how determined they were to win. "

The Fight of a Tiger and a Buffalo

ROUSSEAU

△ **The Fight of a Tiger and a Buffalo;** 1908; oil on canvas; 66⅞ x 74⅝ in. (170 x 189.5 cm)

> " What interests him is his own private world: the Rousseau world, which is wholly unlike that of anyone else, which only he can create, and into which he can draw us. "

Rousseau once declared to Picasso that they were the two greatest artists of the era. However, I have my doubts about the seriousness of Rousseau's statements about his genius, because he lived a fantasy life. He said he could paint these pictures of jungles because he had been there, whereas in fact (and on some level he must have known this) he had only been to the zoo, the botanical gardens, and the vegetable markets. In *The Fight of a Tiger and a Buffalo*, he copied the buffalo from a children's book: *Animal Friends*. We can guess that he had only seen bananas on sale, since he has them growing upside down. Somebody who saw him paint this work said that he first painted all the greens (Rousseau told him he was using twenty-two different shades), then he painted all the reds, and then he painted all the blues.

Whatever he thought he was doing, he was, in fact, creating an abstract pattern, weaving together shapes and colors, each magically outlined by the sun. As for the so-called "fight," the animals are inert. There is no attempt to enliven them, either. He is not at all interested in trying to show a life-and-death encounter. What interests him is his own private world: the Rousseau world, which is wholly unlike that of anyone else, which only he can create, and into which he can draw us. It is impossible not to be enthralled at the strange and convincing otherness of such a creation.

Rousseau said that he used twenty-two shades of green in this painting, and that he painted each color in turn: greens, then reds, then blues.

ROUSSEAU AND PICASSO

At the turn of the 20th century in Paris, Picasso and his circle (young and brilliant) derived a great deal of amusement from Rousseau (old and untrained). They dubbed him Le Douanier *(customs officer), though he really worked at a tollgate. He eventually abandoned that job, because he was convinced of his artistic genius. A remark that had the young artists helpless with mirth was made to no less a luminary than Picasso himself: "You and I, Picasso, are the two greatest artists of the era," Rousseau declared. "You in the Egyptian style and me in the modern." No one can quite figure out what he meant, but this work—which is certainly not in the "ancient style"—is a strange and wonderful picture.*

BIOGRAPHY

Henri Rousseau
French, 1844–1910

• Rousseau was a self-taught artist, and although his almost childlike, primitive paintings were at first ridiculed by some viewers, he is now considered to be one of the greatest of all naive painters.

• He is best known for his exotic jungle scenes, filled with highly stylized foliage painted in bold, pure colors.

• His fantastical visions and abstract patterns influenced a number of 20th-century art movements, such as surrealism.

Still Life with Two Lemons

CLAESZ

Still life with Two Lemons is a quintessential 17th-century Dutch masterpiece, and I think we respond with such immediate pleasure because it is so convincing. Claesz convinces us that these objects were really before him, and he re-created them with such power that we can almost smell the lemon and warm to the sun that sparkles on the glass and on the pewter plates. However, it eventually dawned on me that there is no narrative in this picture. What did Claesz actually see? This is not a breakfast, nor is it a lunch. What are the lemons doing there? There is no fish or shellfish; and even if they are to be squeezed into the water or wine, three lemons is too many. The olives also, at the back: what is their function?

I began to realize that Claesz set this tableau up simply because he liked the look of it. He wanted to paint those ovals; those subdued and gleaming hues; the fascinating ellipses of plates, and circles on the glass. He rejoiced in the wet green of the olives and the yellow of the lemons—

△ **Still Life with Two Lemons;** 1629; oil on panel; 16⅞ x 23⅜ in. (42.7 x 59.3 cm)

not just the cut fruit, with its juicy rococo peel, but the massive, stage-stealing lemons in the center. They are the sole force of vivacity. It is a long table, but he kept this little group anchored with the diagonal of a knife pointing in one direction, while the dark gleam of its sheath points in the other. The artist's enjoyment of what he arranged, his almost rapturous response to the play of light over the varied textures: all this is infectious. It changes our way of looking. Through Claesz, we see the world afresh.

BIOGRAPHY

Pieter Claesz
Dutch, c. 1597–1661

• Pieter Claesz, along with William Claesz Heda, were among the most important exponents of monochromatic still life painting in the Netherlands.

• He was renowned for his "breakfast pieces," with their simple but perfectly balanced compositions.

• Claesz preferred a muted palette of greens and browns.

Claesz was a master of still life, and created beautiful, harmonious compositions of objects. He particularly delights in the play of light on the different surface textures: for example, the circle of light on the curve of the glass, with its reflection in the liquid contained within; and the mouthwatering juiciness of the curling piece of cut lemon.

A GALLERY OF STILL LIFE

Cleveland has a gallery dedicated to still life. It is a brilliant idea, but also a bold one: even in 17th-century Holland, when still life was at its zenith, it was denigrated as the lowest form of art. Its practitioners were regarded as "mere foot soldiers in art's army." This was, of course, sheer hypocrisy, since everybody loved still life—and still does.

Nome Gods Bearing Offerings

EGYPTIAN

" The prayer portrayed on these slabs is: 'May there be hundreds and thousands of years until eternity.' Looking at this amazing work, we can only say: amen. **"**

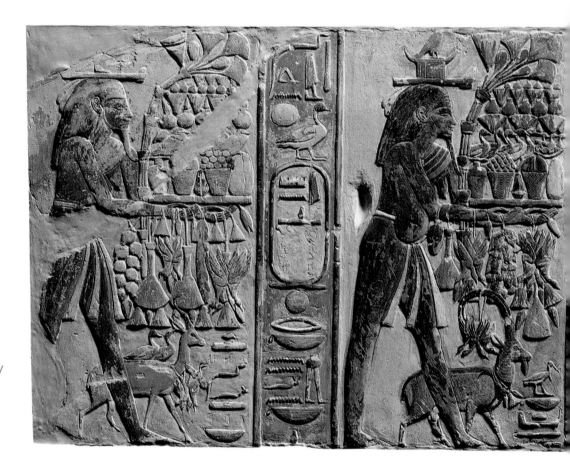

The Cleveland is fortunate enough to own a truly rare and exceptional piece of Egyptian art. These are two colored slabs from what was once a chapel of Amenhotep III, in which the pharaoh appears five times. Once, at upper right, only his foot remains, as he offers his country to those other feet—clearly those of a god (probably Horus). Egypt, like all big countries, was divided into administrative districts. They were known as nomes; and since the pharaoh *was* Egypt—its physical reality—he was the god of each nome. Four nomes are shown here: the

Oryx, the Dog, the Falcon, and the Crossed Scepters. In each, Amenhotep appears as nome god, offering the produce of the district to the greater gods. As he bows down under the weight of his land's fertility, his woman's breasts flap limply, and he exhibits a pregnant-looking stomach. With a refreshing lack of self-consciousness, he is showing himself as both male and female. He is Egypt, and the fruitfulness of the country depends upon him.

These slabs are wonders of intricate and amusing detail. On the far right, in the Oryx nome, there is a duck, sitting

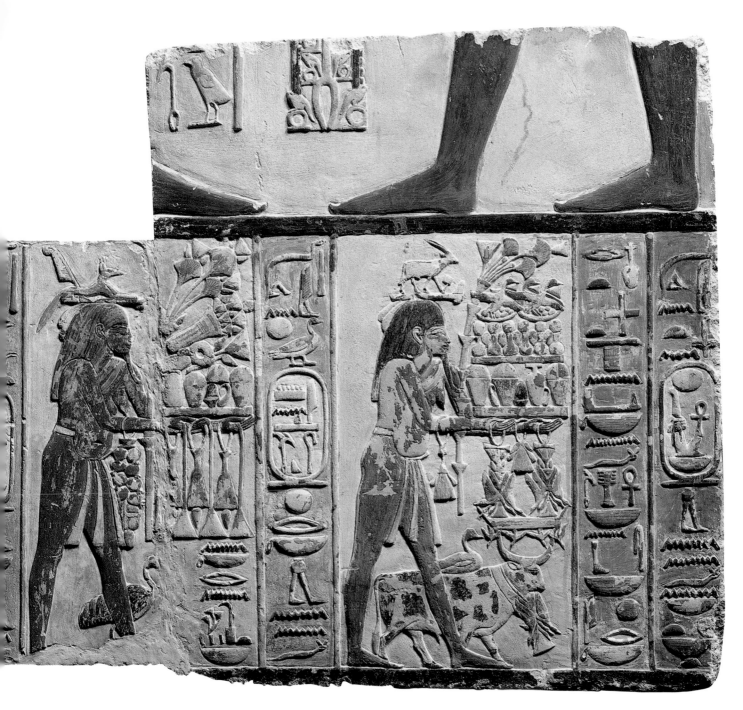

△ **Nome Gods Bearing Offerings;** 1391–1353 B.C., 18th dynasty; painted limestone; 26 x 52⅜ in. (66 x 133 cm)

complacently on the back of a bullock. Above are birds' nests with the eggs still in them. To the left, in the Dog nome, there is a fat string of pomegranates hanging from the king's elbow, and a baby ostrich—which ostrich specialists say is exactly four months old (they can tell from the feathers and the tilt of the tail). To the left again there is a majestic ibex in the Falcon nome, with a gaggle

of birds slung insolently from its curving horns, while above dangle fish and figs. All is rich with life and fertility, even in the last nome—the least well preserved Crossed Scepters—where a duck nibbles gently at a gazelle's ear. These details are not mere decoration. They have a serious theological import, making visible what it meant to be a pharaoh: to express in oneself every aspect of this teeming

country and be responsible for it, weighted by it, as one brought it before the gods. At the upper right, on the broken relief, we can still see the god's staff and rings, which meant eternity; the tadpoles, which meant hundreds and thousands; and the jagged palms, which meant years. So the prayer portrayed on these slabs is: "May there be hundreds and thousands of years until eternity." Looking at this amazing work, we can only say: amen.

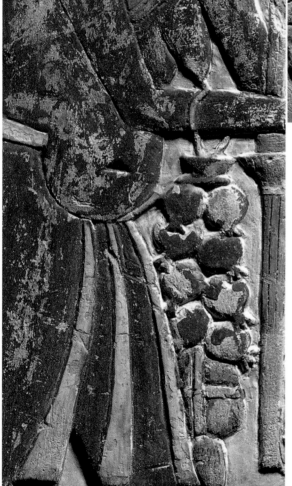

In each of the slabs, the image of the pharaoh is one of fruitfulness: he has the pendulous breasts and rounded stomach of a pregnant woman.

Each of the slabs is teeming with amusing decorative details that also serve the practical purpose of displaying the fecundity of that particular district of Egypt. In the Oryx nome (above), a duck perches on the back of a bullock. In the Falcon nome (near left), a string of birds hangs from the horns of an ibex. In the Dog nome (far left), a line of juicy pomegranates dangles from the king's elbow.

THE COLORS OF EGYPT

Cleveland acquired the first of the Nome God slabs in 1961, and the second fifteen years later. They had been pulled down and used for rebuilding, but luckily, they had been laid face down, so that the colors are still as bright as when the artist first painted them, using sixteen different colors and glazes. The face of Amenhotep III is recognizably his, but his color changes. As well as Upper and Lower Egypt, there was also Red Egypt (the desert) and Black Egypt (the rich soil around the Nile). The king does not play favorites; he alternates black and red.

Amenhotep III Wearing the Blue Crown

EGYPTIAN

Amenhotep III was one of the great pharaohs of the 18th dynasty; in fact, one of the great pharaohs of any dynasty. He had a long and peaceful reign, and was able to indulge his passion for erecting enormous statues of himself all over the country. If you have visited Luxor, or seen pictures of it, you will remember the pair of statues known as the colossi of Memnon, each of which weighs 720 tons. The Greeks named the statues in honor of the Trojan hero Memnon, who was slain by Achilles in the Trojan War. These were, in fact, statues of Amenhotep, from his mortuary temple. He built another, even larger statue, of which only the feet are left: it was 69 ft. (21 m) high. As a result of all this building, it is not rare to find at least a remnant of Amenhotep's works, and Cleveland has a very beautiful example. Only the royal head remains, wearing the cultic blue crown, which indicates that he is acting as Egypt incarnate. It is an extraordinarily remote face, with huge eyes and thick, sensual lips. It is clearly a masterpiece, although it does not take us any way into the life of the king, like the *Nome Gods Bearing Offerings* (pictured on pages 180–1). On the contrary, it seems intended to keep us away—admiringly at a distance.

◁ **Amenhotep III Wearing the Blue Crown;** 1391–1353 B.C., 18th dynasty; granodiorite; 15⅜ x 11⅞ x 10⅞ in. (39.1 x 30.3 x 27.7 cm)

> "It is an extraordinarily remote face, with huge eyes and thick, sensual lips. It is clearly a masterpiece."

The Story of Jonah

EASTERN MEDITERRANEAN

▷ **Jonah Swallowed;**
c. 270–80; marble; 20⅜
x 6⅛ x 10⅜ in. (51.6 x
15.6 x 26.2 cm)

When I started to study art, nearly 60 years ago, I was a little dismayed to discover that in absolute, big-name terms, there is no early Christian art. Hence my delight to find this sculptural group—small but distinguished. It seems almost too good to be true, but scholarly investigation indicates its authenticity. The figures were apparently hidden in a large pot in the eastern Mediterranean, some time toward the end of the 3rd century; and the marble can be proven to come from the imperial quarry in Turkey. It is obvious that the person who carved them was thoroughly familiar with Hellenic art, and reused its forms for the biblical story of Jonah: one of the shortest books of the Old Testament but by far the most exciting.

The first sculpture shows Jonah being swallowed by a huge fish. In the English translations it is called a whale, but the original seems merely to call it a "large fish," with the implication of monstrous. This baffled the artist, who understood fish, but only knew Hellenic monsters, with dragonlike paws. We therefore have this astonishing fish-with-legs—worthy of this astonishing story! As it gulps down Jonah, with a triumphant froglike grin (we can almost hear the swoosh of the prophet's disappearance), the tail-fin waves merrily over his sadly disappearing toes. The second sculpture shows Jonah being cast up from the whale onto dry land. The whale's tail-fin droops dejectedly, and Jonah surges forth with an air of jubilation. I am convinced that the sculptor read the gospels, because Jesus compares his resurrection to Jonah's emergence from the whale after three days—and this is surely a resurrection image.

◁ **Jonah Cast Up;**
c. 270–80; marble;
16 x 8½ x 14¾ in.
(40.6 x 21.6 x 37.6 cm)

JONAH AND THE WHALE

God summoned the prophet Jonah to go to the pagan city of Nineveh and convert it. Jonah, disgusted at the very idea, immediately took a ship in the opposite direction. A storm arose, and the superstitious sailors thought that this must be because someone on board had offended the gods. They threw lots, and it turned out to be Jonah, who suggested that they throw him into the sea. Lo and behold: waiting to swallow him was a huge fish! For the next three days, Jonah was inside the whale's belly, admitting to God that he had made a big mistake. Not surprisingly, this gave the whale indigestion, and Jonah was vomited forth onto dry land.

In the next episode of Jonah's story, the sculptor shows a large, resurrected Jonah thanking God for delivering him from the whale, with his arms uplifted in prayer. The expectation was that we know what follows, which the artist does not depict: how God repeats his order about going to Nineveh, and this time Jonah obeys. The final sculpture depicts the concluding episode of Jonah's story, and shows Jonah sitting under a gourd vine. That is where the story ends, but another of the sculptures that were in that same urn makes the theological point of Jonah's story.

△ **Jonah Praying;** c. 270–80; marble; 18½ x 5½ x 8⅛ in. (47 x 14 x 20.6 cm)

◁ **The Good Shepherd;**
c. 270–80; marble; 19¾ x
10⅛ x 6¼ in. (50.2 x 25.7
x 15.9 cm)

▽ **Jonah Under the Gourd
Vine;** c. 270–80; marble;
12⅝ x 18¼ x 6⅞ in. (32.1
x 46.3 x 17.5 cm)

This is the figure of the Good Shepherd from the gospels, who is defined by his love for all his sheep, good and bad. The message of the Jonah story is that God loves the wicked pagans just as much as he loves the chosen Jews: all are dear to Him.

These sculptures never reached their destination, but how were they to be used? Scholars think they were probably intended to be set around a fountain in a family's inner garden. Yet Christianity was still a forbidden religion: would it have been safe for pagan visitors to see them? I realized that, intentionally or not, each of these works can be read in two ways. The nonChristian Roman would have seen images of Apollo, often depicted as a shepherd; of a reclining god; of a philosopher; of a hero fighting a sea monster. Those in the know would have understood the Christian significance. If nonbelievers had been let in on the secret, I think they would have felt, condescendingly, that it was "too good to be true."

JONAH UNDER THE GOURD VINE

After being delivered from the whale, God once again told Jonah to go Nineveh. This time he obeyed, and preached to the Ninevites to repent or be destroyed. Jonah then waited outside the city, lounging under the shade of a gourd vine. The Ninevites did repent, and God spared them, but Jonah was angry—he had been looking forward to a spectacular destruction. To teach Jonah another lesson, God destroyed the gourd vine under which he was sheltering. Jonah was distressed, but God pointed out how much more distressing it would have been for God if He had destroyed the people of Nineveh.

Christ and St. John the Evangelist

GERMAN

△ **Christ and St. John the Evangelist;** early 14th century; polychromed wood; 36½ x 25½ x 11¾ in. (92.7 x 64.8 x 29.8 cm)

John's hand rests in that of Jesus, symbolic of Christ's love and support for his disciple, and John's utter faith in his Lord.

" We can visualize this image glowing gold and white in a candlelit chapel. Yet it is far from sentimental; this is a powerful proclamation of the meaning of faith. "

This image is so unexpected that it can be surprising to realize that it is not unique. There is another example in Antwerp, for instance. All of these figures appear to come from medieval Germany, in a region around Lake Constance, and they seem to have originated in convents. The Europe of the Middle Ages had a growing spiritual thirst to know God, to become close to Him; nobody, of course, would have felt this more acutely than a nun.

We must remember that the normal way to human maturity is through human relationships, such as marriage, friendship, and family. A nun entrusts her entire hope of fulfillment to a Christ whom she cannot see, or hear, or touch. Around 1300, some unknown genius was inspired to use that wonderful passage in the gospels about the Last Supper before Christ was crucified, when John—described as "the disciple whom Jesus loved"—rested his head on the breast of his Lord. We can visualize this image glowing gold and white in a candlelit chapel. Yet it is far from sentimental; this is a powerful proclamation of the meaning of faith. If we look at the face of Jesus, we see that he is lost in prayer. He seems remote, from us and from John; yet although he does not look at John, he is supporting him. One hand rests on John's shoulder—a hand that John cannot see; the other hand—and this, I think, is significant—supports John's hand but does not actually hold it. John's hand rests on that of Jesus. So Jesus is not looking at John and not holding his hand, and nevertheless John's face is alight with the ecstatic happiness of someone who is certain of being individually loved. Since this is a question of faith—something given and not earned—John is blessedly relaxed and at peace.

I can imagine generations of nuns—whose life, remember, is solitary though never lonely—affirming their faith through this image of protective love.

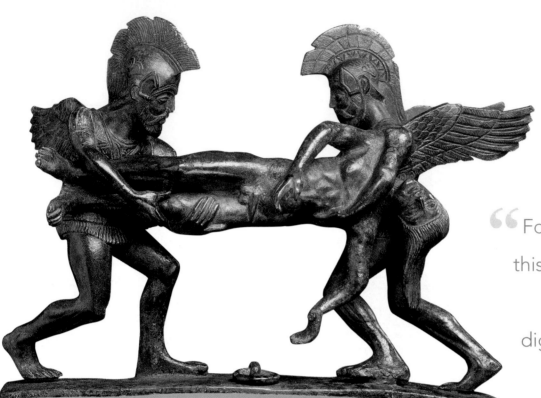

> " For all its smallness,
> this image expresses
> to perfection the
> dignity of death. "

Cista Handle

ETRUSCAN

*Sarpedon's head falls backward—
so obviously dead rather than
asleep— as Sleep and Death
gently carry him away for burial.*

When a work of art is huge and mounted aloft, we know to admire. When it is small and functional, we must use our eyes and our judgment. The museum does indeed mount this small bronze, but in "real life," it was the handle of a jewelry case. It was an Etruscan case, and Etruscan art is often somewhat cruel, yet there is no more tender work in the museum.

In the *Iliad*, Homer speaks of one of the Trojan heroes, "godlike Sarpedon of the brazen helmet, Lord of Lycia and son of Zeus." He was killed instantaneously when "a spear struck the beating heart where it is closed in the arch of the muscles," and he fell, says Homer, like a towering tree. The Greeks stripped him of his armor, and Zeus, his divine father, grieved. So he sent Apollo "to rescue him from under the weapons, to wash away the dark suffusion of blood, to bear him away to the waters of a running stream, to wash him, anoint him with ambrosia and give him over to those swift messengers, Death and Sleep, twin brothers. They would bear him to his own rich countryside where his brothers and his countrymen would give him due burial." For all its smallness, this image expresses to perfection the dignity of death. Sarpedon is so young, so beautiful, and so very dead: his head lolling back, his arm flapping down. Death and Sleep, winged and armored, are grave, reverent, tenderly concentrated, as they bear him away from the horrors of battle. The owner of this vase, holding this handle, must often have pondered that you cannot tell the difference between Death and Sleep. He or she treasured this figure and took it into the tomb—where, as we know, between fearsome Death and gentle Sleep, there is no difference.

Raft Cup

ZHU BISHAN

Breaking bread, sharing salt, having a meal or a drink together: these things can be sacramental. In every culture, artists have celebrated this, crafting magnificent tableware—for the gods, for the ancestors, or for domestic use. This silver cup was made by Zhu Bishan (c. 1300–c. 1362), the greatest 14th-century Chinese silversmith—probably the greatest ever. He dated and signed it, and he also signed it with a literary name: Huayu. This may well have been because in China, sculptors were not especially regarded: they were artisans. A gentleman scholar, however, had his work taken seriously; and Zhu Bishan was a very serious artist—and a genuinely inventive one.

He made several raft cups—all different, all unique; this one was in the emperor's collection. The traveler, slumped in bliss, with his swelling belly and belly button, holds in his hand a stone that tells us what the story is about. It bears the inscription "Look-supporting Stone," referring to a fable about a man journeying on a raft when he found

that he was lost, and who unknowingly visited the heavens. If you look at the traveler's expression, well-fed he may be, but his face is filled with wonder and with longing. Here is the man who could have had it all but wasted his opportunity. Of whom might this not be more true than the emperor? For all its complexity, this is a genuine cup. Every time the emperor drank from it, he would be eyeball to eyeball with that face—ecstatic and yet forever yearning. I would love to know his thoughts.

In his hand the traveler holds the stone that the Spinning Maiden gave him when he was lost in the heavens (above). It bears the inscription "Look-supporting Stone."

▷ **Raft Cup;** 1345; hammered silver pieces soldered with chased decoration; 6¼ x 8⅛ in. (16 x 20.5 cm)

THE LOST TRAVELER

A lost traveler saw a maiden weaving, and a herdsman. He asked them where he was, but the maid simply gave him the stone that supported her loom and told him to ask an astrologer when he got home. He did so, and was told that there was a star named the Spinning Maiden, and another named the Herdsman, and on that night a small star was seen wandering between them. A verse engraved on the back of the cup states the significance of the story: "You went to the heavens, and all you brought back was a stone. Why did you not seek some of the heavenly maid's brocade?"

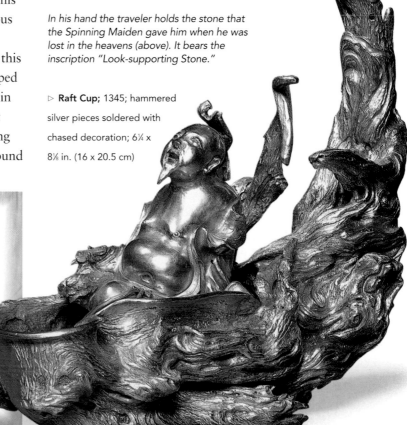

The Thinker

RODIN

Several American cities (Baltimore and San Francisco, for example) have a Rodin *Thinker*, but Cleveland alone has the sad distinction of owning a Rodin *Thinker* that has been exploded. In 1970, a time of radical protest, a bomb was laid here, and the 900 lb. (over 408 kg) of bronze statuary fell violently to earth. Since it had been an original cast from Rodin's studio, the museum decided that restoration would blur its authenticity, and so conserved it in its damaged state.

The first *Thinker* that Rodin sculpted was only 27 in. (68 cm) high, and it stood 13 ft. (4 m) up on the very top of Rodin's masterwork, *The Gates of Hell*. From there, *The Thinker* was meant to look down and see the folly of moral humanity and try to make sense of it. *The Gates of Hell* was never finished, and Rodin decided to enlarge *The Thinker*, but he still insisted that

it should be placed at a height, which is a problem for museums. At Cleveland it is a special problem—not because of the location, which is superb, but because of the damage. Rodin said that his *Thinker* did not just think with his head, he thought with his entire body—with every muscle, down to his gripping toes. At a height, it is precisely those gripping, thinking toes that viewers would most encounter; at Cleveland, however, the toes are now gone. If we can draw any comfort from such an act of vandalism, it is this: here *The Thinker* is no longer perched above human conflict; he was plunged into it. He is exposed as vulnerable—as we are—and that makes him tragically accessible.

" Rodin said that his *Thinker* did not just think with his head; he thought with his entire body. "

▷ **The Thinker;** c. 1904; bronze; height 28½ in. (72.3 cm)

BIOGRAPHY

Auguste Rodin
French, 1840–1917

• The French romantic sculptor Rodin produced remarkably realistic representations of the human form, often based on symbolic or literary characters, and raised the art form to new heights of public awareness.

• Rodin's works are powerfully expressive and bursting with energy and movement. Just like the impressionist painters, he preferred an "unfinished" look to that of smoothly polished perfection.

> " Hotto Kokushi is so small and yet so large. He continues to confront us by the sheer impact of his spirit. "

Portrait of the Zen Master Hotto Kokushi

JAPANESE

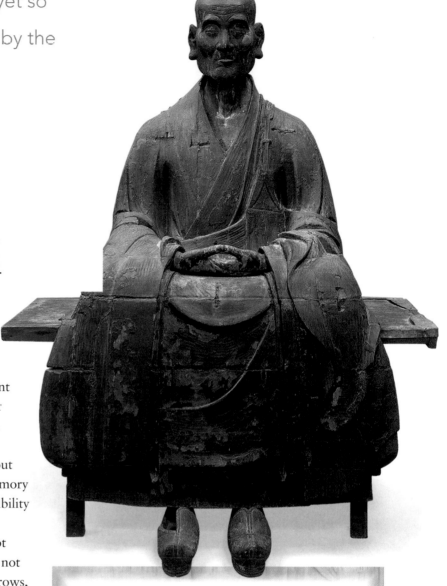

Zen masters often gave pupils nearing enlightenment a picture of themselves, on silk or paper, as a spur to progress. This work represents that idea writ large. Four statues of Hotto Kokushi survive, and three are still in their Japanese monasteries. They are brought out reverently on the anniversary of his death, and his memory is a continuing inspiration. Cleveland has the responsibility of providing a sanctuary for this fourth image.

All of the images look almost exactly the same—not idealized, not a dear old father abbot, but a stern and not very attractive figure. He has a domed head, jutting brows, big ears, high cheekbones with sunken cheeks, and a pursed little mouth with protruding underlip. Although we can see from his neck that he is physically scraggy, he looks bulky because of the Japanese underclothes, and because the wooden figure was swathed with hemp cloth, and then lacquered. He sits on a humble monk's stool, not an abbot's chair, and for all his austere dignity, there is something touchingly modest here. Hotto Kokushi is so small and yet so large. He continues to confront us by the sheer impact of his spirit—not giving us answers, not even asking us questions. Stern, intense, and yet dispassionate, he draws us to pose our own questions; to understand our own questions; and finally, if we are blessed, to move beyond questions into the freedom like his own.

HOTTO KOKUSHI

Those who take any spiritual tradition seriously need a teacher—not to convey learning, but to communicate that knowledge of the heart, that living understanding known as wisdom. What is really needed is a saint. For the Zen Buddhist, monk or layman, it is contact with a saint that leads to true enlightenment. Hotto Kokushi was such a saint. He was born in 1203 and lived almost to the end of the 13th century. He went twice on pilgrimage to China, and the wisdom he brought back he taught, not in great cities such as Kyoto, but in small monasteries in western Japan.

△ **Portrait of the Zen Master Hotto Kokushi**; c. 1286, Kamakura period; wood with hemp, cloth, black lacquer, and iron clamps; height 36 in. (91.4 cm)

Vaulting

ROTHENBERG

With the guidance of the title, it is easy enough to make out the image. We can see the bar at the top, and the vaulter, in his dark trousers, caught in split-second movements as he soars over and down. He splatters at the bottom, as if the air still remembers his flight and a faint ghost of it lingers on. Since the title is *Vaulting*, as opposed to *Vaulter*, another figure—this time in green—floats over the bar, to keep the subject general.

Despite the relative clarity of the narrative, there may be those who puzzle at the style. If so, they will enjoy the story of Rothenberg's session as a pupil at a drawing school, just before she painted this. She signed in as a housewife, and the instructor, who had no idea who she was, thought her work badly in need of correction. "What are you using those hairy lines for?" he complained. "I want you to look, and observe, and use a clean, simple, nice, clear line." This might be excellent advice for beginners, but a mature artist is not really free to change styles at will. In fact, Rothenberg's early style, when she focused on a schematic horse, had, for all its subtlety, a fairly clear outline. When she came to the end of the horse theme, she embarked on a series of bones, heads, and

△ **Vaulting;** 1986–87; oil on canvas; 90⅛ x 132½ in. (229 x 336.5 cm)

hands, and then experienced what she calls "desperate anxiety," as she sought another subject. She was living by the sea at the time, with the constant movement of the water and light, and she had recently changed from acrylic to the liquidity of oil. Movement began to engross her. She did not want to paint a moving body, but the body as movement. She herself is a very physical woman: a dancer, and a cheerleader when in high school; she is highly aware of the personal space a moving body experiences. I must admit that I myself, as a profoundly sedentary woman and ponderous when in motion, do not know this experience; but on the rare occasions when I moved quickly, I saw how the world around can blur. So here Rothenberg does not paint vaulting against a background; her painting portrays the inner experience of vaulting.

This work reminds me of Shakespeare's lines: "Vaulting ambition that o'erleaps itself and falls on the other side." You can see the o'erleaping, and the fall. What we are not given is any sense of the triumph of the vault: the soaring. The emphasis is on the descent—the moving down, with a terrifying velocity. Rothenberg talked about "controlled chaos" in her work, which suggests an anxiety to keep things in order. It is this anxiety, harnessed in the service of art, that communicates itself here with haunting force.

> **BIOGRAPHY**
>
> **Susan Rothenberg**
> American, 1945–
>
> • Rothenberg has worked on a number of themes: a schematic horse (1970s); bones, heads, and hands (early 1980s); and speed and motion (from the mid-1980s), inspired by the movement of the sea.
>
> • Her work is characterized by her expressive brushwork.

" With the guidance of title, it is easy enough to make out the image. We can see the bar at the top, and the vaulter, in his dark trousers, caught in split-second movements as he soars over and down. "

The Hours of Queen Isabella the Catholic

FLEMISH

> **Every page of the book has such images of brightness and beauty: the glory of the world that remains undimmed whatever devastation we suffer personally.**

△ **Folio 146v: The Massacre of the Innocents and the Flight into Egypt;** c. 1497–1500; ink, tempera, and gold on vellum; 8⅞ x 6 in. (22.5 x 15.2 cm)

This Book of Hours was a gift to Queen Isabella of Spain. It is in such perfect condition that we know she did not use it much—not because she lacked devoutness (she was known as "Isabella the Catholic"), but because the regular books in her private chapel were more suitable for constant use. She would have kept this in her library and only opened it on special occasions. I hope she opened it in 1497, in 1498, and in 1500: years in which she had great personal griefs. Her son died, and then her daughter, and then her grandchild. The first of the pages shown here, "The Massacre of the Innocents," would have spoken to her heart. The gospel tells how King Herod—afraid that the birth of Christ would take away his power—sought to find and kill him. When he could not, he ordered the slaughter of all male children under the age of two.

Notice how the soldier in the front presses his heel against the frame of the picture, as though violence wants to erupt and must be held in; and notice also how bestial this man looks. There is a terrifying crudeness about this cruelty: the slaughterers so ugly, and the mothers and children so helpless. The alley between the houses narrows like a funnel; there is no escape. Yet over the river, we see Mary and Jesus on a donkey—a great rock hanging ominously over their heads but with open land ahead. They escape, solely because of the sacrifice of the other children. The mothers may not understand it, but the martyrdom of their sons will mean life to the world.

BOOKS OF HOURS

One fact that could be said to encapsulate the deep-seated influence that the Catholic religion had on all strata of society in the Middle Ages is that the bestselling book—consistently and overwhelmingly—was a prayerbook. Monks and nuns prayed approximately every four hours of the day, and people wanted to associate themselves with these hours of prayer, in addition to having images of the saints, who were such encouraging examples. The wealthy could commission artists to make such a book: a Book of Hours, filled with images from the scriptures and the lives of God's friends.

All around the scene the artist sets images of the world's beauty. In fact, the idea of placing human sorrow in the context of natural beauty is fundamental to this book. All of the flowers that surround this picture of young death are spring flowers: the forget-me-not, the flowering pea, the daisy, the viola—and there is even a spring butterfly. Every page of the book has such images of brightness and beauty: the glory of the world that remains undimmed whatever devastation we suffer personally.

I hope Isabella also looked at the picture of St. Michael. He was said to have cast the devil down to hell, but here he is not fighting, just waving his sword. By his very appearance—armed, virtuous, and glowing with light— he makes the demons fall. Isabella had a difficult reign, with much to fight against, and this vision may have encouraged her to find a way through her troubles, not with aggression but with steady confidence in God.

△ **Folio 167v: St. Michael the Archangel;** c. 1497–1500; ink, tempera, and gold on vellum; 8⅞ x 6 in. (22.5 x 15.2 cm)

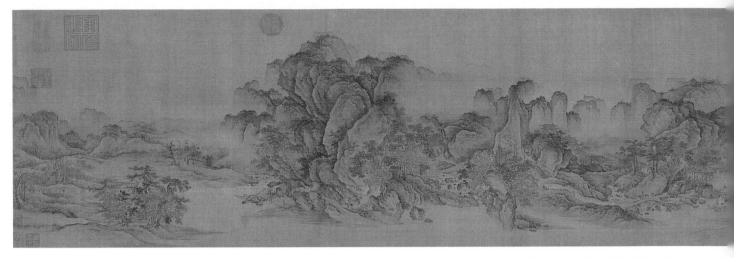

△ **Streams and Mountains Without End**; early 12th century, Northern Song dynasty; handscroll, ink with slight color on silk; 13⅞ x 83⅞ in. (35.1 x 213 cm)

Streams and Mountains Without End

CHINESE

Whenever I visit museums, I find myself continually astonished, jolted suddenly to a deeper level of being, but nothing has been such a revelation to me as this Chinese scroll. I always loved Chinese painting—who would not?—but I also felt diffident about it, anxious that I did not know enough. What this work, *Streams and Mountains Without End*, taught me is not that I need to know more, but that I need to know differently.

In the West, when an artist composes a landscape, he or she looks at it, "controls" it. That attitude is alien to the East. Artists here do not look "at," they are "in" the landscape. If anything, the landscape looks at the artist! This scroll is about 7 ft. (213 cm) long—not vast by the standards of our day, when large pictures are popular, yet to show it fully unfurled would be barbaric. We are not intended to see it in full. (This, of course, makes reproduction almost impossible; we have to be content with details.) The art lies in making this seem like an entrancing landscape through which we are walking. We stroll forward, through mountains, with water always close at hand, vistas changing as we move. There is always a path, yet we are not on a journey to a fixed destination—say, to the end of the scroll. We can go on, or we may choose to unroll no more and stay to enjoy the view where we are. Only a portion is open at any time, just as in a real walk through the country. We can stop, go back, move around, take pleasure now in the low-lying misty mountains, and now in the life of the small village, with its boats and activities. We might know that, if we unroll farther, we shall come to a temple or to higher mountains, dominating the sky with a strangely lyrical solidity. Yet why move, with our Western eagerness to go somewhere? This is Northern Song painting at its most sublime: a private and contemplative experience.

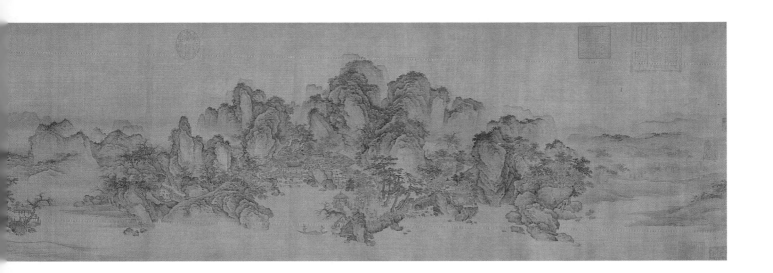

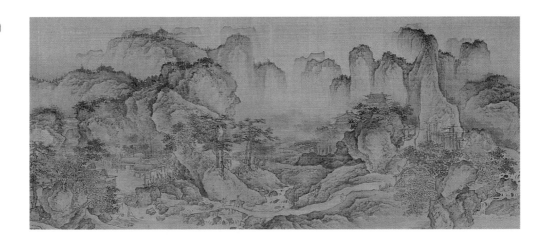

> **This is Northern Song painting at its most sublime: a private and contemplative experience.**

The scroll is meant to be unfurled and enjoyed section by section, like walking through the mountains and streams of a real landscape.

COMMENTARIES

Previous owners of the scroll wrote commentaries at the end. One, in 1205, says simply: "in old age this is a nice place to go." Another records that he would like to build a thatched hut there. One admits to being "very busy, weak, sick with exhaustion," but adds: "When I open this scroll it washes my sand-dimmed eyes." It is easy to understand his sense of bliss and purification.

KIMBELL ART MUSEUM,

Introduction

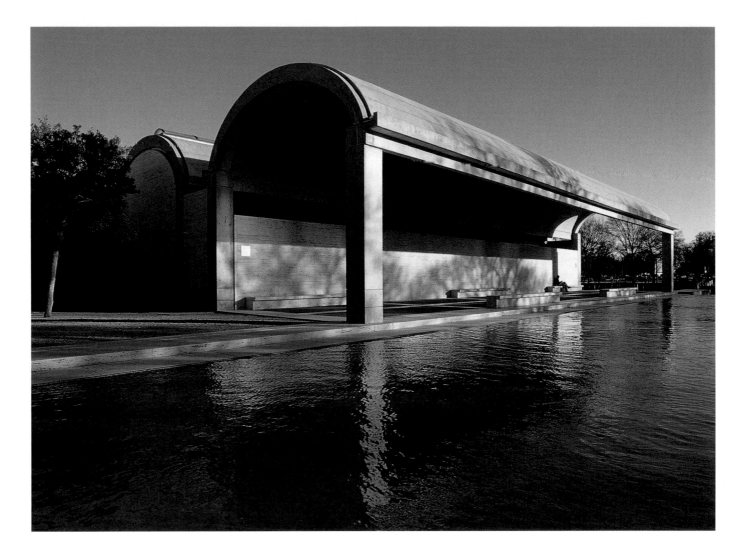

For all their differences, the museums in this book are largely homogeneous: big, encyclopedic, long-standing. The Kimbell is the exception—and this is the museum that some have named "America's best." Such terms are relative, and comparisons are proverbially dangerous, but the enthusiasm that the Kimbell generates springs first from the perfection of its architecture. In this, its late appearance on the national scene was a blessing. Plans to build began in 1966—precisely the period when American architects were entering upon their years of glory. With a wealth of practicing genius from which to choose, the Foundation was inspired to opt for Louis Kahn, whose masterwork may well be this museum. It is

as great in quality as any of the art within it—not because it eclipses its contents, but because it most sensitively and powerfully enhances them. The best praise I can give this building—so simple, austere, warm, and reticent—is that one does not notice it. What one does notice is the air, sunlight, and space; the sense of beautiful objects superbly at ease in their new environment. The intention was to unite charm with practicality, elegance with ease: to create an environment where art can be enjoyed at leisure.

An advantage, of course, is that the Kimbell is small. Where the other museums count their collections in tens, or even hundreds, of thousands, the Kimbell houses 315. Moreover, it will never expand. The guiding principle was

△ L'Asie (Asia); 1946; Henri Matisse, French (1869–1954); oil on canvas; 45¾ x 32 in. (116.2 x 81.3 cm)

◁ View of the southwest portico of the Kimbell Art Museum, with reflecting pool

▷ Constellation: Awakening in the Early Morning; 1941; Joan Miró, Spanish (1893–1983); gouache and oil wash on paper; 18⅛ x 15 in. (46 x 38 cm)

to create an ideal setting for an ideal assembly of great art. As new and finer art becomes available, older objects are sold, continually refining the collection rather than enlarging it. There are types of art that the Kimbell does not include: decorative arts, prints and drawings, and photography, for example. Two neighboring museums—the Amon Carter and the Museum of Modern Art—specialize in American art and the contemporary, so the Kimbell has nothing of the former, and little from the second half of the 20th century. What it does have is exquisite examples of all the ancient cultures: Chinese, Japanese, Indian, African, pre-Columbian, Egyptian, Greek, Roman, Assyrian. It has paintings and sculptures of dazzling quality: from Fra Angelico and Caravaggio to Cézanne and Matisse; from Houdon to Maillol and Miró. Small though the Kimbell may be, there was no museum from which I found it so hard to make a selection—and no museum that I remember more fondly.

Portrait Head of a King

NIGERIAN

One of the wonderful things about a museum—very marked at the Kimbell—is that we are suddenly confronted with art from alien traditions, so that we learn to expand our horizons. Sometimes the opposite happens, and we come across a work from far away in time and place, from a foreign culture, and it is so beautiful that we are unaware of any barriers. Think of Michelangelo's *Pietà*: is there anyone who, just as a human being, does not respond to the Madonna's face? It is on that transcendent level that I would put this head of a king.

It comes from the Ife people of southwest Nigeria, in the 12th, 13th, or 14th century—but it is essentially timeless. The head is made of terracotta, and was once joined to a body that subsequently decayed: made of wood, the scholars think. When a king died, his portrait was buried in a grove under a giant tree, and once a year it was resurrected and honored. Strangely enough, although this is intended as a "portrait," the few other heads that were excavated over the years all have the same look of ineffable inner peace. What distinguishes one royal portrait head from another is the crown, different in each.

The four-square construction of this king's crown is complicated. There seems to be a central cone with rectangles shutting it in, and an elaborate network of intersecting beads as embellishment. The point, however, is the uniqueness: only this king wore this crown; and I wonder if the "portrait" was not confined to this? The crown announced this king's personal identity, but the face said what he was: a divine ruler of his people; their spokesman before the gods; and the focus of their aspirations.

▷ **Portrait Head of a King (*Oni*);**
12th–14th century, Ife culture;
terracotta; height 9 in. (22.9 cm)

It is the elaborate crown that distinguishes one king's portrait head from another's.

66 The crown announced this king's personal identity, but the face said what he was: a divine ruler of his people; their spokesman before the gods. 99

Idealized Head of a Woman

CANOVA

We can be slow to warm to Canova, and it must be because we think him cold. This is an age that likes passion, authenticity, earthiness, movement. What we do not like is perfection, and Canova was the greatest neoclassical sculptor, so perfection is exactly what he sought: perfectly polished marble; cool, gleaming figures; grace and elegance; everything infinitely remote from the hurly-burly. This is just what he achieves in the Idealized Head. He presents us, on a pedestal, with flawless features, and an astonishing profusion of curls. Her ringlets cascade down with rigid exactitude, absolute control—yet still so springy. Her face is one of almost superhuman charm—and yet impassive.

Canova made four idealized heads for his four benefactors, as a way of expressing his gratitude. The Kimbell head is the one he made for Charles Long. Long was enthralled by it. He wrote saying that he was passionately in love with her, that he had never seen anything so lovely. I would not go that far myself—there is an icy regularity to those features—but it is certainly a memorable work of art.

△ **Idealized Head of a Woman;** c. 1817; marble; height 22¼ in. (56.3 cm)

> **"** He presents us, on a pedestal, with flawless features, and an astonishing profusion of curls. Her ringlets cascade down. **"**

CHARLES LONG'S GIFT

After Napoleon's defeat at Waterloo, the pope sent Canova to negotiate the return of the works of art stolen from Italy by the emperor, but the French refused to receive him. The British sent a delegation to force them to return Italy's art—or, at least, most of it. The delegation's financier, Charles Long, even persuaded the Prince of Wales to pay toward the transport back. This bust is Canova's gift of thanks to Long.

BIOGRAPHY

Antonio Canova
Italian, 1757–1822

• One of the finest of the neoclassical sculptors, Canova produced idealized pieces based on classical themes.

• His graceful, smoothly polished marbles were widely sought, and he received commissions from the papacy, royalty, and aristocracy, including the Bonapartes.

The Cardsharps

CARAVAGGIO

This painting was highly original when Caravaggio painted it, and is full of complex oppositions. At first sight we notice only the opposition between the two young men: the good boy and the bad. The good boy is a soft, pretty, pampered youth—look at those perfect eyebrows—in an expensively understated garment with ladylike little lace collar and cuffs. The bad boy is a thin, wiry youth, who looks as if he fought his way up. He sports a dagger, drawing our attention to the gorgeous stripes on his breeches, and an exuberant feather to emphasize the modishness of his hat. There is another and far less obvious opposition, however. On the left, we have the astonishing realism of the backgammon set, and it is contrasted implicitly with the theatricality of the older man: the cardsharp supreme. Everything about him oozes duplicity—all the way down to his gloves, which have the cutaway fingers of the professional cheat, who needs to feel the marked cards. He is so heavily unconvincing that we marvel why even a dovelike innocent cannot pick up the signs. No need to feel for marked cards here, though,

△ **The Cardsharps**; c. 1594; oil on canvas; 37⅛ x 51½ in. (94.2 x 130.9 cm)

because he is signaling with a stagy ostentation to his junior partner in crime.

I think what Caravaggio wants us to notice is the difference between how we imagine a cheat—a villain who looks the part and relishes the play-acting—and the reality, nervous and distasteful, that the young man experiences. This is what it truly means to be a cardsharp. The boy is rigid with anxiety—forcing himself to go through with it because he needs the money. I cannot help but feel that Caravaggio did not warm to the soft boy—and still less to the great bully in the center—but his sympathies are very much with the novice cheat. He is like a thin little puppy, facing the charming tom kitten on the other side. Caravaggio's heart goes out to this bad boy, and so do ours.

> " What Caravaggio wants us to notice is the difference between how we imagine a cheat—a villain who looks the part and relishes the play-acting—and the reality, nervous and distasteful, that the young man experiences. "

Caravaggio was a man of violent temper—he spent his last years in exile after killing a man in a brawl—and he seems to warm more to the nervous bad boy, with the jaunty feather in his hat (left) than to the pampered, soft-skinned rich boy (above).

BIOGRAPHY

Michelangelo Merisi da Caravaggio
Italian, 1571–1610

• One of the greatest painters of his period, Caravaggio turned away from mannerism in favor of realism, choosing always to paint from nature.

• After painting genre pieces and still lifes in his early years, he then concentrated on dramatic religious subjects.

• His masterful use of light and shade, rich colors, and naturalistic figures had a profound influence on European painting.

CARAVAGGIO'S PATRON

When Caravaggio painted The Cardsharps, *at the end of the 16th century, he was a very young man from the provinces, struggling to keep his head above water in Rome—and not succeeding. This was the painting that made his name, because it was bought by the wealthy and influential Cardinal del Monte, who became his committed patron. The cardinal, who was a gambling man himself, was smitten by the originality of the work.*

The Cheat with the Ace of Clubs

LA TOUR

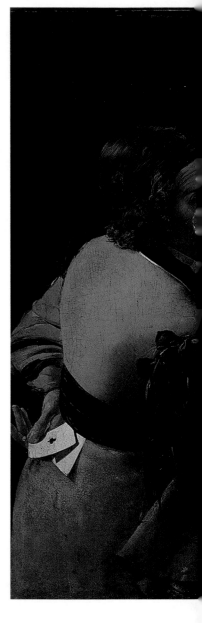

Around thirty-five years after Caravaggio painted *The Cardsharps* (pictured on page 204), another artist remembered how successful it was, but this artist, Georges de La Tour, was far from the center of things in Rome or Paris. He lived in Lorraine, northeast France, and his version of the theme, *The Cheat with the Ace of Clubs*, was perhaps an attempt to reach out to a more sophisticated clientele.

With this picture, what we must watch is the eyes. The dupe (so extravagantly dressed that we feel he has newly come into a fortune and spent much of it on his clothes) has eyes that look downward and inward—at himself.

He is the epitome of smugness; so pleased with himself that we almost desire his downfall. In the center is the Madame of the establishment. Her face is an alarmingly perfect oval, and she also is markedly overdressed, sporting the most fashionable of hats, and well aware of her splendor—even to the elegance of the corsets that are cutting into that unappealing expanse of bosom. She makes a double signal: with her hands she alerts the cheat, but her eyes are swiveled toward the apprentice courtesan, the maid—so delightful in her embroidered blouse, and so distressing in her complicity. I am always affected by the look on that pretty face, as her eyes dart across to the youth so as best to gauge the moment when the wine is to be produced and cause a distraction.

The cheat himself is a hardened professional, but perhaps not especially successful. He is shabbily dressed and hatless, though he has made a pathetic attempt at smartness by adding numerous bows to his costume. He looks out at us, making sure that his chicanery has no witness. His red hair and furtive expression remind me of a fox—with the youth an obvious goose (as compared to Caravaggio's suggestion of

BIOGRAPHY

Georges de La Tour
French, 1593–1652

• Georges de La Tour worked in Lunéville, where he ran a successful studio and enjoyed the patronage of the Duke of Lorraine and possibly also of King Louis XIII.

• He specialized in genre and religious paintings, and is best known for his candlelit religious scenes, with their somber, dramatic lighting in the style of Caravaggio. His later works are characterized by simplified forms.

• La Tour was largely forgotten for several centuries after his death, but today he is considered to be one of the major figures in 17th-century French classicism.

The blank, impassive oval of the Madame's face is belied by the movement of her sharp, worldly eyes, which watch the maid watching the young man they are about to dupe.

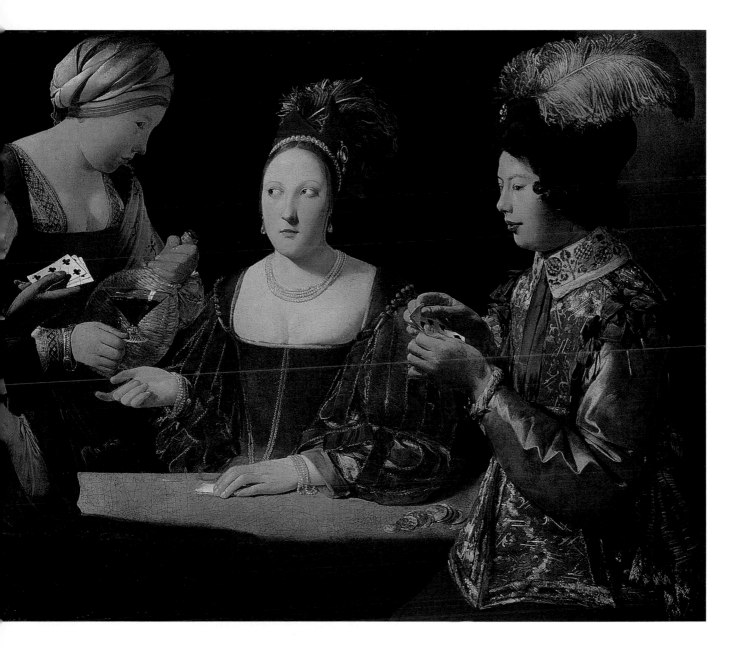

cat and dog). With Caravaggio's youths we can still feel hope—they might grow up to something better—but in the La Tour, everybody seems caught in a trap of pettiness. I marvel at the mastery of the painting, and the servility of the painted. It is a splendid and unforgettable work, which unfortunately I cannot bring myself to like.

△ **The Cheat with the Ace of Clubs;** late 1620s; oil on canvas; 38½ x 61½ in. (97.8 x 156.2 cm)

Four Figures on a Step

MURILLO

The most famous artist in 17th-century Seville was Murillo. His fame did not endure, because as time went by, his religious imagery—and most of his work is religious—began to seem sugary. In an age that prefers realism, all those sweet little Infants Jesus can easily come across as sentimental. There is, however, another side to this gifted artist, and the Kimbell has a great example of it. This is Murillo as a genre painter, whose narrative, as here, is so subtle that the viewer is left guessing.

The theme of the picture is still undiscovered. The museum sat firmly on the fence and titled it: *Four Figures on a Step*. Who are these figures? What are they doing? Attempts to describe them as a family founder on their all-too-obvious incompatibility. Here is a young man—perhaps a very young man—somewhat gaudily overdressed; and next to him a girl, holding him and forming a pair with him. She lifts her veil, which has been identified as the gesture of a courtesan beckoning a client,

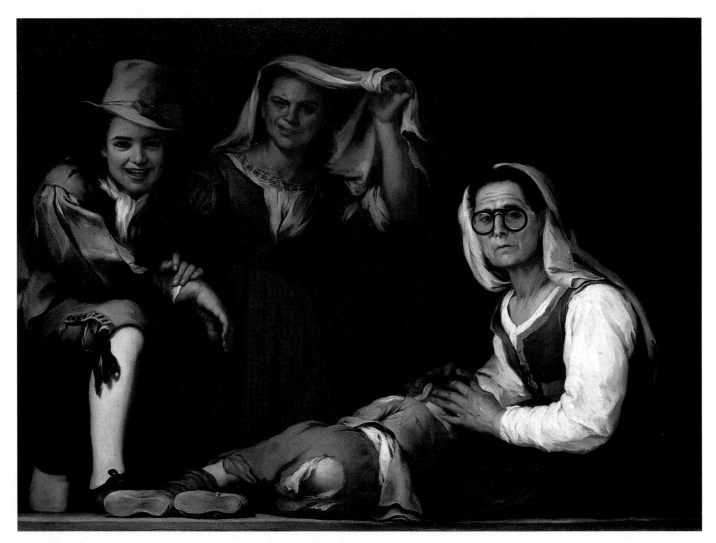

△ **Four Figures on a Step;** c. 1655–60; oil on canvas; 43¼ x 56½ in. (109.9 x 143.5 cm)

but her expression is anything but seductive. The youth is all excited laughter; the girl critical, quizzical, with an uncertain half-smile. Over from them is another pair: an elderly woman (a grandmother?) and a small child. The woman wears fashionable granny eyeglasses, which were sometimes made of plain glass and worn for the impression of wisdom they gave. Her face is dourly disapproving. As for the child, face down on her lap, all we see of him—but see prominently—is the rent in his pants.

The three adults are watching something and reacting very differently. At first I thought the picture was a version of the Three Ages of Man—and that might be Murillo's main intent—but what could

the figures be watching so intently? The bare bottom of the child, rare for Murillo, might be a clue. Could they be surprised by some public act of a private nature, something sexual—perhaps a passionate kiss? The boy, only too eager for his own experiences, thinks it is hilarious. The girl is taken aback and hesitant. The elderly lady, glasses and all, is aloofly disapproving. The child sees nothing, because his head is held down firmly to keep him from the sight. Only that innocent flash of bare flesh hints at a clue—or maybe not?

> " The theme of the picture is still undiscovered. The museum sat firmly on the fence and titled it: *Four Figures on a Step.* Who are these figures? What are they doing? "

The elderly woman holds the child's head firmly down, as if to prevent him from seeing something, while the girl lifts her veil in the gesture of a courtesan, perhaps indicating that the unwelcome sight is a sexual one.

BIOGRAPHY

Bartolomé Esteban Murillo
Spanish, 1617–82

• Murillo is chiefly known for his paintings of religious subjects, especially the Immaculate Conception, and his genre paintings of urchins and street scenes.

• He helped to found the Spanish Academy in 1660, and became its first president.

• He dropped his early realism in favor of idealized depictions of his subjects, characterized by soft outlines and vaporous, atmospheric effects.

Girls on a Jetty

MUNCH

△ **Girls on a Jetty;** c. 1904; oil on canvas; 31¾ x 27¼ in. (80.5 x 69.3 cm)

The subject of this picture could be seen as idyllic: three young girls stand on a jetty on a late summer evening, with the moon full and low in the sky. In a strange way, *Girls on a Jetty* is indeed idyllic—but it is a sinister idyll, because the artist here is Munch. In all his works, at some subliminal level, we hear the echo of *The Scream*: his unforgettable image of human misery and despair. On the surface, this work has little to do with despair and the howl of horror that it awakened in him. At some point he must have seen young girls on a jetty, because he painted them at least six times, not to mention sketches and prints.

This is his last version—and I think his best. As we study it, we discover that it is not wholeheartedly realistic: a pink and pearl jetty merging imperceptibly into a road, and the trees so unnaturally simplified. The scene has a dreamlike quality, and is eerily convincing. Two of the girls look toward the land, toward those squat houses, with their narrow windows and their air of ominous expectancy. Even the trees clump into an oppressive mass. The third girl looks past us, out to the invisible sea. She has no face. I think that Munch felt she was too young, too inexperienced to have suffered; and it is suffering, he believes, that makes us human. Although they look in different directions, the girls have no real choice. Sooner or later, these three must walk out of childhood and into the adult world, off the jetty, and onto that heavy, brooding land. Like tombstones, life waits for them. Despite its radiance of color, what can we call this but melancholic? Melancholic indeed, but that is Munch—and because this is what he genuinely believes, the painting works.

> "Although they look in different directions, the girls have no real choice. Sooner or later, these three must walk out of childhood and into the adult world, off the jetty, and onto that heavy, brooding land."

BIOGRAPHY

Edvard Munch
Norwegian, 1863–1944

• The great Norwegian artist Munch was a forerunner of German expressionism.

• His works resonate with symbolism and exude emotion, notably in *The Scream* (1893).

• He was also an inspired printmaker, producing many woodcuts, etchings, and lithographs of his paintings.

The houses and trees represent the adult world. Two of the girls look toward them, but the third turns to the viewer to reveal a featureless face—she has yet to experience the suffering that will come with adulthood.

Maison Maria with a View of Château Noir

CÉZANNE

△ **Maison Maria with a View of Château Noir;** c. 1895–98; oil on canvas; 25⅝ x 31⅞ in. (65 x 81 cm)

Cézanne uses choppy brushstrokes in the sky in order to evoke a sense of changing light and moving clouds.

BIOGRAPHY

Paul Cézanne
French, 1839–1906

• One of the greatest of the postimpressionists, Cézanne is considered to be one of the fathers of modern art. His works had a profound influence on the development of cubism and abstraction.

• In his early years he painted dark, melodramatic, and often erotic pictures, but upon meeting Camille Pissarro in 1861, he came to know the impressionists and adopted some of their techniques.

• He was dissatisfied with the lack of structure and solidity in impressionist paintings, and began to analyze the underlying structures of his subjects. As a result, he began to distort perspective and simplify forms into three fundamental shapes: cylinders, spheres, and cones.

One of my limitations is that I am not particularly interested in how things are made. What draws me is the product, and what it means. It is ironic, then (and probably serves me right), that the artist I most love and admire, Cézanne, is great precisely because of the way he paints. I do have an escape clause in that his greatness is not merely stylistic—as evidenced in the short and choppy parallel strokes we see here in the sky. It comes from something infinitely more profound, something I struggle in vain to articulate.

On the level of what he painted, here it is simple enough: a house, Maison Maria, and to its side the Château Noir, with Cézanne's thematic Montagne Sainte-Victoire in the distance. Cézanne kept his painting utensils in the Château, and went along this road every morning; one day he decided to go no farther but to paint what he saw. Ah, but what did he see? Here is where Cézanne becomes so special. He was the first artist to grasp, intellectually and emotionally, in all his senses (he called it his *petite sensation*), that what he saw was not something "out there," nor was it something "in here": it was both. He came to a unique understanding of the relationship between the artist and his motif: that they are in symbiosis; that all of us are on a rolling ball in space; that space and time interrelate; and that as an artist looks at a motif, it will change. Light will change, the air will change, the artist will move, the eye will progress from a simple view without much detail to an awareness of complexity not seen at first. Many forms will coalesce (you can see where Picasso and the cubists are coming from). The tonal blur that is the eye's first response will develop into the specific—from the glorious smudge of rocks and foliage that he catches out of the corner of his eye to the wonderful yellow high on the wall of the Maison. (You can see where Matisse is coming from.) What challenges Cézanne is the need to be utterly true to the one image that he must create, while at the same time depicting with equal truthfulness the changes that occur as he looks.

> What challenges Cézanne is the need to be utterly true to the one image that he must create, while at the same time depicting with equal truthfulness the changes that occur as he looks.

Man in a Blue Smock

CÉZANNE

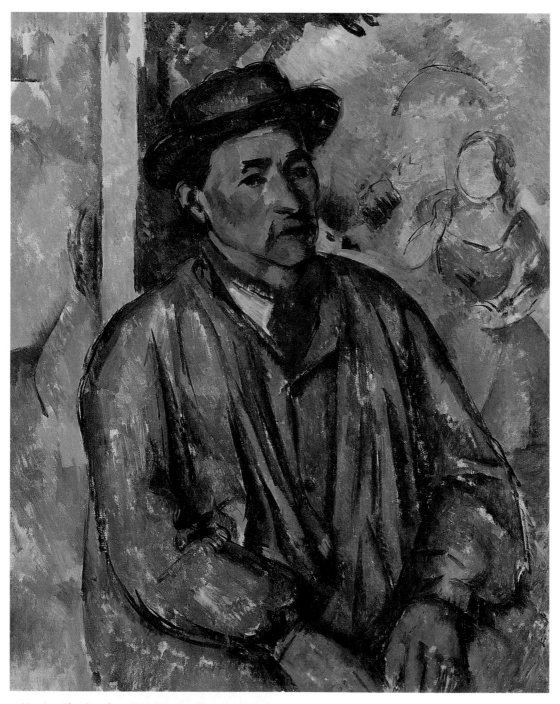

A brief biography of Cézanne can be found on page 213.

△ **Man in a Blue Smock;** c. 1892–97; oil on canvas; 32⅛ x 25½ in. (81.5 x 64.8 cm)

As with landscape, so with portraiture: Cézanne seeks heroically for the truth. *Man in a Blue Smock* is an exceptional Cézanne that the museum bought as a tribute to its first director, Richard Brown. What gives this work its edge above all other Cézanne portraits is that behind the laborer from his father's estates, he set as background the first picture he ever painted. He was 19 at the time, and his best friend, the future famous novelist Émile Zola, helped him. At 19, Cézanne is shy and ineffective: the girl floats there, unreal, without a solid body. Forty years later, Cézanne had learned. Just as this workman lived forty years into his present shape—solid as a stone—so Cézanne lived into the demands of art. He understood structure, he came to know color. He is reverent before the tonalities of brown: the gold-brown of the hat, the red sun-tanned brown of the face, the gray-brown of the vest. They are energized by the bright scarlet of the necktie, while all around wash the heavenly blues of the smock: indeterminate, wholly convincing.

As a contrast, his early work and its faint blues do not convince at all. Cézanne no longer tries, as in his youth, to paint externals, and nothing more. He portrays an encounter: what we experience when we meet someone and sense their body opposite ours. What we actually "see" is limited; it is rather a sense of personal solidity to which we respond. Again, although he considered this man for hours, day after day (Cézanne was a notoriously slow painter), he can still only create one motionless image. At the end of his life, he wept: he had struggled so passionately and, he felt, he had never got there. Always, always, he felt, he had failed. We could call it the most magnificent failure in art history.

" What gives this work its edge above all other Cézanne portraits is that behind the laborer from his father's estates, he set as background the first picture he ever painted. "

Cézanne uses blocks of rich color to build the face of the man into a real, solid presence, a far cry from the ethereal woman in the background, who floats in space on his earliest known work.

A Mountain Peak with Drifting Clouds

FRIEDRICH

△ **A Mountain Peak with Drifting Clouds;** c. 1835; oil on canvas; 9⅞ x 12 in. (25.1 x 30.6 cm)

> **This painting is a perfectly genuine landscape, and yet we cannot see it without responding to the inner significance.**

Friedrich depicts two distinct worlds: the remote mountains, representing heaven, death, and eternity (left); and the woodlands of earth, life, and time (below).

Sometimes it baffles me why, when I love romantic music (Beethoven, Schubert) and romantic poetry (dear Keats!), I have a difficulty with romantic painting. Too often I am tempted to feel that the artist wants to push me to a predetermined response. The major German romantic was Friedrich—one of the greatest pushers of all time—and what makes it worse is that he always had the noblest intentions. He was a profoundly religious man, living in the first half of the 19th century, when images of religion—such as the crucifix or the Madonna—had apparently lost their power. He conceived the idea of using natural images but with a symbolic force. The religious charge would come from the unexpressed sentiment, which the viewer would easily understand.

That is what he did here. This painting is a perfectly genuine landscape, and yet we cannot see it without responding to the inner significance. He shows us, in effect, two worlds: the remote and distant mountain, with its shining clouds; and, full in our face as it were, the brown, earthy world of the woodland. At the back stand tall young trees; then we move on to the battered middle-aged trees (with whom I feel much sympathy); and then, prominent in the foreground, we have the dead tree. On the one hand, the world where things do not last; on the other, the world where things do last: time and eternity; earth and heaven; life and death. Perhaps because this work is very small—or perhaps because Friedrich was nearing the end of his life when he painted it, and there is an autobiographical subtext—I can, for once, say truthfully that I respond with pleasure. If Friedrich is pushing me, I am a contented pushee.

Aymard-Jean de Nicolay

HOUDON

Aymard-Jean de Nicolay was both state treasurer and lord chief justice of France. Houdon, a master of psychology as well as the chisel, wanted to convey what that meant. Physically the bust is almost frighteningly realistic. This is the true body of an aging man: wrinkled and baggy-eyed, with sagging jowls, and a big body straining against the clothes. I do not know whether it was Houdon or de Nicolay who suggested that he should not be portrayed in his garments of state. Instead, he is dressing. He has not yet donned his great wig, which would disguise the flowing gray locks; his buttons are undone; he has pulled his sash of office too tight and bunched the bow, so that his cloak cannot fall smoothly. Yes, but all these factors add up to an impression of enormous moral power. Here is a true statesman, a wise and cultured man of intellectual strength, who set himself to become worthy of his positions. Literally, this is not an ideal portrait, but for us at the turn of the 21st century, there is a sad flavor of the ideal: this is what a man in government ought to be. If we could be so lucky!

There are some works here at the Kimbell that make you think: how beautiful! With this masterwork, I think we look in amazement at the crispness of the carving: the artistic excitement with which Houdon has carved buttonholes, the sway of a jacket, wrinkled flesh. On technicalities alone, it is an exhilarating work, and makes us think: how marvelous!

> " Physically the bust is almost frighteningly realistic. This is the true body of an aging man: wrinkled and baggy-eyed, with sagging jowls. "

◁ **Aymard-Jean de Nicolay;** 1779; marble; 35½ x 29⅛ in. (90 x 74 cm)

BIOGRAPHY

Jean-Antoine Houdon
French, 1741–1828

• One of the greatest neoclassical sculptors, Houdon is best known for his portraits of such luminaries as Voltaire, Benjamin Franklin, Catherine the Great, Napoleon, and George Washington.

• Houdon's skill lay in his ability to capture and render the expressions and gestures unique to his sitters.

DE NICOLAY'S INHERITANCE

For almost three hundred years, the de Nicolays, father to son, served the king of France as both state treasurer and lord chief justice. The subject of Houdon's bust, Aymard-Jean de Nicolay, had not won these two positions of great power but inherited them. However, de Nicolay proved himself worthy of them, and died happy in the knowledge that he was passing on his offices to a worthy son. Luckily he did not know that ten years later, in 1789, would come the French Revolution, when his son would be guillotined simply for being what he was: a great, responsible nobleman.

Chibinda Ilunga Katele

ANGOLAN

Chibinda (The Hunter) has been described as the most beautiful woodcarving to come from Africa south of the Sahara. It is from the Chokwe people of Angola, and depicts the cult hero and king Ilunga Katele. The horn he carries contains magical powders for the hunt. He was also a traveler, and in his other hand, he bears a traveler's staff. When this image was solemnly displayed, every member of the Chokwe could see the responsibilities of kingship. The huge, intricate crown is based upon the wings of the black stork: legendary in the Chokwe nation. The head is large, because a king must think and plan; the eyes are great, because he must see and foresee and oversee. He has the beard of wisdom, and the large hands and feet of one ever waiting to be summoned to work and travel for the people. For all the dynamic energy, the crouching tension, Chibinda is at rest, patiently awaiting that summons.

I think the Chokwe saw more than what it meant to be a king; they saw what it meant to be a human being: to take responsibility for your life and your dependants, to be a hunter for the truth. The unknown genius of a carver delighted in the abstract beauty of form, pouring his spirit into it—making something sacred that still summons us today.

The proportions of Chibinda are designed to reflect his responsibilities; he has huge eyes in order to see, foresee, and oversee.

▷ **Chibinda (The Hunter) Ilunga Katele;**
mid-19th century, Chokwe people; wood, hair, and hide; height 16 in. (40.6 cm)

ILUNGA KATELE

Ilunga Katele was a prince of the Luba, the greatest hunters in Africa. His exceptional hunting skills, coupled with his royal lineage, meant that he was seen as a threat by the ruler, so Ilunga left his home and set off traveling. He came to the Lunda tribe, where the chief was a young woman; they married and Ilunga became king. He taught his people new ways of hunting and was an exemplary ruler. The Chokwe people—the creators of this carving—were renowned sculptors of court art for the Lunda, and adopted Ilunga Katele as their own hero.

> " Chibinda (The Hunter) has been described as the most beautiful woodcarving to come from Africa south of the Sahara. "

Cylindrical Tripod Vase with Effigy Cover

GUATEMALAN

he vase is supported by four Pauahtuns, the guardian spirits of the Mayan underworld. They were not Herculean figures, because everything is upside down in the underworld. They were wrinkled, old, toothless gods, and their heads were in their bellies. Each has an extraordinary fish headdress, a body formed from the wings of a stingray, a stingray spine, and the feet of a wading bird. The lid is unlike the vessel itself. The knob was left unpainted, and adorned with a sculpted head. The head is unmistakably that of a Mayan prince, with his earplugs, noseplugs, and elaborate headgear. He obviously loved this vase as he took it with him to the grave, where the Pauahtuns could guide him to the underworld.

The vase was actually a drinking vessel, but it occurred to me that images of death might seem misplaced at feasts. Scholars suggest that during its lifetime use it was perhaps not painted, merely burnished. It was only when death drew near that the owner had it arrayed with these guardian spirits, so that, lying in the grave for all eternity, he would at least have supportive company.

> " The head is unmistakably that of a Mayan prince, with his earplugs, noseplugs, and elaborate headgear. "

◁ **Cylindrical Tripod Vase with Effigy Cover**; 300–400, Mayan culture; ceramic with stucco and polychrome decoration; height 11 in. (27.9 cm), diameter 6¼ in. (15.9 cm)

If we could read them, the glyphs on the lid might give the name of the vessel's owner (far left).

Wine Flask

JAPANESE

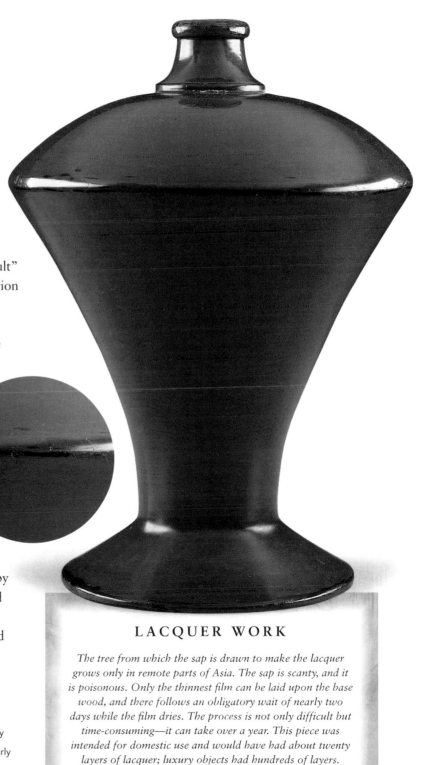

Sometimes when I am called upon to admire a piece of lacquer work, I have the sinking feeling that the selling point—artistically speaking—is that lacquer is so hideously difficult to work with. With this wine vessel, the word that comes to mind is not "difficult" but "perfect." It seems to me to come as near to perfection as humanity can reach. What makes it even more fascinating is that this is Negoro work: a vessel for use. The name comes from a long-lost monastery, where the monks crafted robust equipment for daily use in their lives and rituals. So here is a piece of ordinary household ware, made into an object of supreme beauty. I marvel at the eye that first created this shape: narrow-spouted and then swelling out to a majestic rotundity that sweeps down to a slender base and out again. The play between volumes is completely satisfying; it has a rightness that we instinctively recognize.

Which gives more pleasure: the shape or the color? Ten layers of black lacquer would have been followed by ten of red, and during centuries of domestic use, the red rubbed off in places. For the Chinese, this would be an impairment; they like the pristine. For the Japanese, and for ourselves, it is an enhancement. We respond to the variation of color intensities—the abstract beauty of it.

This flask was clearly made for everyday use: the surface red lacquer has worn away in places to reveal the black lacquer that lies beneath (above center).

▷ **Wine Flask**; late 16th or early 17th century, Momoyama or early Edo period; lacquered wood; height 11¾ in. (29.9 cm)

LACQUER WORK

The tree from which the sap is drawn to make the lacquer grows only in remote parts of Asia. The sap is scanty, and it is poisonous. Only the thinnest film can be laid upon the base wood, and there follows an obligatory wait of nearly two days while the film dries. The process is not only difficult but time-consuming—it can take over a year. This piece was intended for domestic use and would have had about twenty layers of lacquer; luxury objects had hundreds of layers.

Composition No. 8

MONDRIAN

When we first see this work—so pure and so radical that Mondrian named it simply *Composition No. 8*—and then we notice from the date that it took him three years to paint, we may well wonder why. The answer is that Mondrian was a Dutchman, who escaped from the Nazis in 1939, and began this picture in England. Bombs drove him out to the United States, where he finished the work in 1942. When he was not escaping, he would have been pondering, because everything he painted came from what he called "inner necessity." He drew from his depths the vision of what he thought was the essential truth of life.

Despite the cruel folly of war, he saw that truth as pure, straight, strong, and simple. He stripped himself down to the three primary colors: red, yellow, and blue (God's

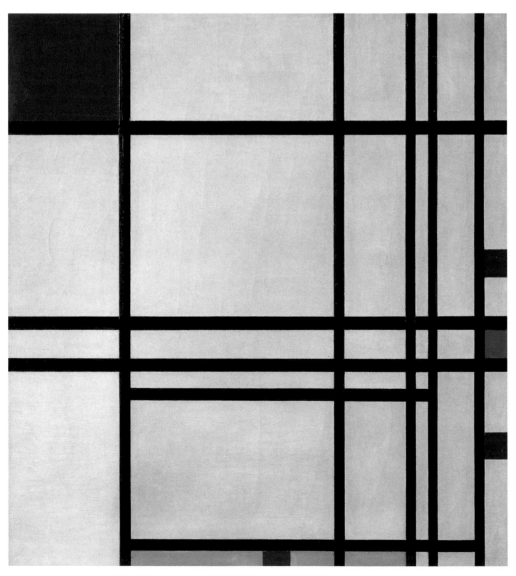

△ **Composition No. 8**; 1939–42; oil on canvas; 29½ x 26¾ in. (74.9 x 67.9 cm)

> **"** A rectangle of right angles was 'right,' Mondrian felt—morally right. The very thought of a slovenly diagonal made him feel faint. **"**

◁ **Composition No. 7 (Façade);** 1914; oil on canvas; 47½ x 39⅞ in. (120.6 x 101.3 cm)

colors—none of our manmade mixtures); and the two noncolors, black and white. White is the background (the purity of the divine): a great rectangle, with five straight verticals of black, and five horizontals; and with five small rectangles of color. A rectangle of right angles was "right," Mondrian felt—morally right. The very thought of a slovenly diagonal made him feel faint.

He had not always seen life with such theological rigor. Twenty-five years earlier, when he looked at a Parisian street and painted *Composition No. 7 (Façade)*, also in the Kimbell, he found pleasure in diagonals, curves, and blended colors. In his maturity, however, he was possessed by the conviction that art must express the austere spiritual truth of life, which can sound like a recipe for boredom. Amazingly, none of his great works is dull. The eye follows with continual interest the signs of Mondrian's hand (not easy to see in reproduction), and responds to the perfect balance with which his vision is presented. Change one element—even the thickness of a line—and the thing falls apart. At all times, Mondrian is not merely "painting a picture"; he is sharing a spiritual vision of the world.

MONDRIAN'S NEW YORK PICTURES

A Mondrian follower can tell at once that Composition No. 8 *is one of his New York pictures. His friends thought that he would hate the city—rigid puritan that he seemed— but in fact he loved its excitement and energy. The grids of the streets and the spacings of traffic lights eventually led him to his Boogie-Woogie pictures, in which the rectangles shrink to small squares, and—as in* Composition No. 8— *a red invades the space of a yellow.*

An Exiled Emperor on Okinoshima

JAPANESE

When the Japanese want to divide the interior space of their houses, they do not build a heavy wall. Instead, they set up a light screen, which has the added advantage of providing a movable mural. This screen, from the early 17th century, attracted me immediately—though I must admit that my attraction was as much personal as aesthetic. Yet, why not? We all bring to a museum who we are and what our life was and is; and though our preferences are not determined by these things, they must surely be influenced. Who I am is somebody who lives in solitude, in a trailer, in a little wood in the convent grounds, with my hazelnut and syringa trees. You can imagine how I bonded with this emperor, blessedly alone, not exactly in his trailer but in an Oriental equivalent. Around him are his cherry trees and his loved possessions—his musical instruments, books, and precious ceramic pots—and he is wearing the imperial version of a habit. There he sits, rapt in contemplation, with before him a bridge that leads nowhere, and far in the distance, the wild thin surge of the sea. He knows there is another world, where people are active and things happen, but that is not his affair: he lives in silence. Two small boats are evidence of that other world, and an emissary from it is trudging along the seashore. In my fantasy I see him bringing the emperor his daily provisions.

Only at this point did I read the title—*An Exiled Emperor on Okinoshima*—and I came to my senses. Far from being in solitude, which is a state loved and chosen, he is in exile; he is lonely. Nor is he lost in prayer, but rather he looks sadly out to sea, waiting for rescue—and rescue is coming. His faithful retainer has arrived with boats to take him back to the hubbub. Discard my subjective musings and it remains a wonderful piece (but I still long to point out to the emperor that to live alone is a great privilege, and he is making a foolish mistake).

▷ **An Exiled Emperor on Okinoshima;** c. 1600, Momoyama period; six-fold screen, ink, mineral pigments, and silver on paper; 58¼ x 237 in. (148 x 348 cm)

" There he sits, rapt in contemplation, with before him a bridge that leads nowhere, and far in the distance, the wild thin surge of the sea. "

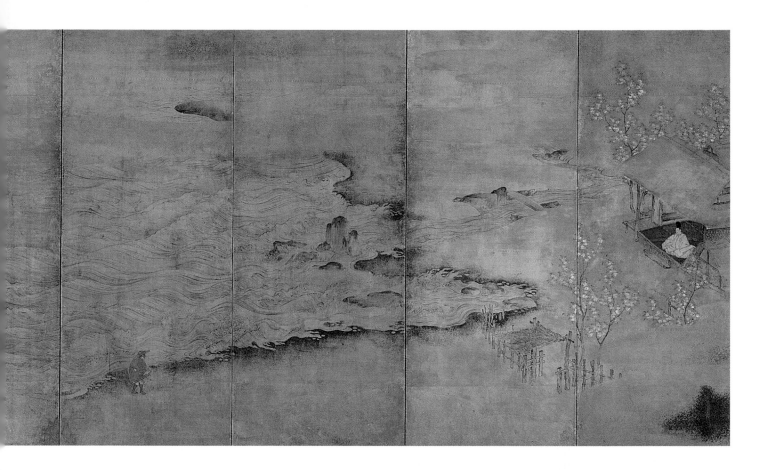

The exiled emperor sits in isolation among his treasured possessions; the two boats on the far shore have brought his faithful retainer.

Interior of the Buurkerk, Utrecht

SAENREDAM

△ **Interior of the Buurkerk, Utrecht;** 1645; oil on wood; 22⅞ x 20 in. (58.1 x 50.8 cm)

The artists of 17th-century Holland can be grouped under their specialities—portraits, landscapes, seascapes, still lifes, or animals—but Saenredam belongs to none of these groups. His unique speciality was church interiors: a predilection so unusual that if his father had not left him a small income, he might not have been able to survive. We should be grateful to that father, Jan, because his son Pieter produced works of a silent, light-filled austerity that are unforgettable.

He was a small, shy man with a hunched back, who would sit for hours in churches, making perfect architectural drawings, and then, perhaps years later, turn them into paintings. This picture, the *Interior of the Buurkerk, Utrecht*, waited nine years to be painted, and though it looks so convincing—a perfect Puritan church, with all decorations stripped away—this is not precisely what Saenredam saw. When he was in Utrecht in 1636, the plague was raging; every night and early in the morning, bodies were carried into the church and buried beneath the flagstones. When he came to sketch he must have seen evidence, but he shows us none of it. He is not concerned with the contingent, the passing. What Saenredam wants to give us is the essence of the church: its pure and lofty spaciousness, where all the color is on the floor—the earth—and the pillars rise quietly up to heaven. He wants you to feel what it is like to come from the hot, noisy bustle of the dusty street into the stone-gray, light-filled clarity of a building set apart for prayer.

> " What Saenredam wants to give us is the essence of the church: its pure and lofty spaciousness, where all the color is on the floor—the earth—and the pillars rise quietly up to heaven. "

The Apostle St. James Freeing the Magician Hermogenes

FRA ANGELICO

△ **The Apostle St. James Freeing the Magician Hermogenes**; c. 1428–30; tempera and gold
on wood; 10½ x 9⅜ in. (26.8 x 23.8 cm)

66 The wonder of a work such as this is that the lessons are truly there and they are serious, but at the same time they charm. 99

The prior of the Dominican Fathers of St. Marco in Florence was Fra Giovanni, a man of such radiant goodness that everybody called him Fra Angelico: the name by which he is known to us in art history. I believe that he was a very good man, but, on the evidence of my eyes, I know that he was a very good artist. Do not think that his commitment to the painting of only religious pictures means that he was some pious nobody on the fringes. Pious he was, but he was also a highly sophisticated and inventive figure of the early Renaissance.

This little painting would have formed part of a predella (the small scenes that fitted beneath a large altarpiece). The story of St. James (the saintly figure on the right) and Hermogenes (the big, angry man on the left, with a crowd of small devils swarming around him like mosquitoes) is an entertaining one. Fra Angelico, however, is not out to entertain but to teach. Spell the lessons out—forgiveness, grace, how malice ties us in knots—and it begins to seem heavy. The wonder of a work such as this is that the lessons are truly there and they are serious, but at the same time they charm. There is something for every viewer: the simplest can understand the lessons, while the most educated agnostic cannot but respond to the human drama, the clarity of the air, the strength of the architecture, the light-filled beauty of the meadow. We can sympathize with poor, baffled Hermogenes and shy, honored Philetus, and admire the magnanimity of St. James—and his sensitivity (he does not himself free his enemy but empowers Philetus to do so by tapping him on the shoulder with the staff). The power to appeal at every level: this is one of the marks of a true masterpiece.

ST. JAMES AND HERMOGENES

Nobody knows what St. James did after the Resurrection, but the early Church filled the vacuum of history with legends. This painting by Fra Angelico is illustrating one of the most dramatic. The story concerns the contest between the apostle and the magician Hermogenes. Hermogenes had tried to kill St. James through his dupe Philetus and attendant devils. St. James converted all of them: the devils bound Hermogenes and tormented him, but Philetus, demonstrating his new faith, returned with the saint's staff to set the magician free. St. James was the New Testament writer who explicitly advised always to repay evil with good.

St. James, who preached forgiveness, taps Philetus on the shoulder with his staff to empower him to free the magician Hermogenes, who is surrounded by a swarm of fantastical devils.

Brutus and Portia

ROBERTI

We all know the names of the artists of Renaissance Florence—and of Siena and Venice also—but Ferrara is somewhat forgotten. This is unfortunate, because the duke of Ferrara had at his court grand artists with a distinctive style: hard, wiry, and linear, and with acute psychological insight. His duchess, Eleanora of Aragon, was proud of her family motto—"death before dishonor"—and the court artist Ercole de' Roberti was asked to paint for her private apartments pictures of women who exemplified this virtue.

PORTIA'S SECRET SACRIFICE

The Roman senator Brutus decided, after much soul-searching, that it was his duty to assassinate his close friend Julius Caesar, because he was undermining the Republic. Brutus' wife Portia had to endure his tears, his moans, his jumping up at night in panics, without his telling her the problem. The reason for this extreme reticence was that the Romans had a ludicrous certainty of a woman's inability to keep a secret. To educate him, Portia took a knife and gashed herself on the thigh. She did not tell anybody and suffered in silence until she was nearly dead from blood poisoning. Her last-moment confession convinced her husband that here was a woman who could be trusted with anything.

Portia's open, pretty face—she is a picture of modest virtue—contrasts sharply with Brutus' closed, melancholy countenance, and his crossed hands holding in his secret turmoil.

The story Roberti chose to depict was that of Portia, who cut herself but told no one of her distress in order to persuade her husband Brutus, who was struggling over the decision of whether to assassinate Julius Caesar, that she could keep a secret and share his burden—you can see from his heavy, melancholy face that Brutus was not a man to make decisions lightly. However, Eleanora of Aragon was renowned for her modesty, and Roberti—obviously nervous of giving offense—has Portia gash her foot rather than her thigh. This somewhat diminishes the point of the story, which is that the wound was hidden and known only to Portia, who suffered in silence.

It is an impressive picture, showing Portia, plump as a partridge—pretty, alert, beaming with energy and self-confidence—and her squat, saturnine husband. I think that Roberti felt this "death before dishonor" motto was a little out of date for the late 15th century—which for him, of course, was modern times—so he subtly undercuts the melodrama by concentrating on the fascinating dynamics of a marriage.

BIOGRAPHY

Ercole de' Roberti
Italian, c. 1456–96

• Roberti was one of the greatest painters of the Ferrarese school of artists, along with Francesco del Cossa and Cosimo Tura, who are all characterized by their precise linear style.

• He contributed to the frescoes of *The Months* decorating the Schifanoia Palace, and in 1487 he succeeded Tura as court painter to the Duke of Ferrara.

• His paintings possess emotional intensity, tonal balance, and lively figures.

△ **Brutus and Portia**; c. 1490; egg tempera and shell gold on wood; 19⅛ x 13½ in. (48.7 x 34.3 cm)

A Country Road by a House

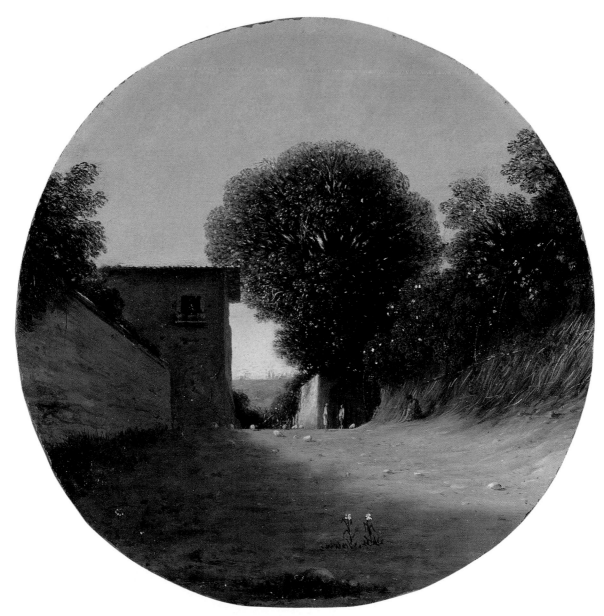

△ **A Country Road by a House**; 1620s; oil on copper; diameter 9½ in. (24.1 cm)

" This painting is intensely nostalgic, and it makes me aware
of the privilege of being a grateful child of earth. "

For a long time in the West, landscape was not considered a worthy subject for art. Even Wals' more famous pupil Claude, that glorious painter, always centers his theme on some activity. Wals went further, however. It seems to me—admittedly this is a nebulous speculation—that in strict terms, *A Country Road by a House* is not a landscape painting at all. This is a nowhere place. There is no romance or beauty to make it the subject of a picture—a deficiency unknown in the 17th century, though compatible with our contemporary thought. We can certainly talk about the work. We can point out how skillfully Wals contrasts the two sides of the scene: strong lines of stone and shadow on the left; on the right, the yielding lines of nature lit by the sun. We can see how the central tree fans out to echo the shape of the canvas, and how light leads the eye from the two daffodils on to the stones, on to the sheep, and then funnels us out to that distant city shining on the hill. However, when all that is said, I do not think it gets us very far in appreciating the small miracle that this work is. Whenever I see it, I feel a rush of pleasure. It evokes so strongly—yet so gently—the smell of the dust, the warmth of the afternoon sun, the quietness of a small place where nothing is happening and nothing will ever happen, where the road is so rural that flowers grow in it. This painting is intensely nostalgic, and it makes me aware of the privilege of being a grateful child of earth.

The two sides of the scene are in contrast: on the left is stone and shadow (left) and on the right sunlight and nature (below). Together they form a funnel leading the eye through the picture, from the shadows into the sunlight, and on to the distant city glimmering on the horizon.

GOFFREDO WALS

Goffredo Wals was born in Germany in 1595 and died in Italy in 1638. He is rarely referred to in art books. If he is mentioned, it is only in passing, as a teacher of the far more famous landscape artist, the French painter Claude. Wals died young, and he left only about twenty-five works, many of them (like the Kimbell's) small and round, and a few (also like this one) painted on copper, which preserves the peculiar brilliance of the color.

Standing Maitreya Bodhisattva

THAILAND

Centuries ago—perhaps even a millennium—at an unknown date, and for an unknown reason, the devout Buddhists of a remote little kingdom on the northeast border of Thailand decided to hide all of their sacred images. They wrapped them in cloth and laid them reverently in the basement of their temple. They never came back, and as time passed, they were forgotten, and there was nothing left but a little village and a dilapidated temple. In 1964, there was a massive storm in the area, and the floods swept away the temple and revealed the images. There were over one hundred: a few of Buddha but most of Bodhisattvas—of which the Kimbell, you will not be surprised to know, has one of the most beautiful. Maitreya Bodhisattva's image in the 7th and 8th centuries was of a wandering monk, an ascetic, dressed merely in a short skirt. He had no thought for himself, so his hair is matted (for which the symbol was stylized curls), and in the center has a tiny replica of a stupa, containing a relic of the historical Buddha, Sakyamuni. He has two pairs of hands: one to stretch out in welcome; and the other to raise in exultant expectation of the world to come. It is a very moving figure: the face intent, the body poised on its feet, as if ready to move away; ethereal; lyrical. Every aspect of this exquisite saint reminds us of what a Christian mystic said: "All shall be well and all shall be well and all manner of things shall be well." The look on the Bodhisattva's face, and the poetry of the slender body—like a fountain or a young tree—both speak of that supportive hope.

◁ ▷ **Standing Maitreya Bodhisattva;** c. late 8th–early 9th century, Pre-Angkor period; bronze; height 48¼ in. (122.5 cm)

66 He has two pairs of hands: one to stretch out in welcome; and the other to raise in exultant expectation of the world to come. 99

MAITREYA BODHISATTVA

A Bodhisattva is a saint who has passed through the ten degrees of perfection and reached enlightenment, and is poised on the threshold of nirvana: total bliss. Yet the Bodhisattva stays on the threshold, so that he can help and comfort others. The best loved of them all may well be Maitreya, who takes his name from a word meaning love, friendliness, kindness, reaching out to others, offering absolute acceptance. One day, Buddhists feel, a world must come in which all longings will be satisfied, and of that future world, the Buddha will be Maitreya.

Standing Bodhisattva

PAKISTAN

This statue of Maitreya Bodhisattva is very different from the one on the previous page. Scholars recognize his presence in the broken arm, almost certainly holding out a vessel: one of Maitreya's characteristics was that he offered the elixir of life, the promise of salvation. The Buddhists of Gandhara in Pakistan did not imagine Maitreya as a wandering monk, but as a prince: a Gandharan prince, with massive shoulders, hung with jewels, clad in sweeping robes, barbed and tonsured. It may be a less other-worldly image—prose rather than poetry—but it is equally impressive.

Art from Gandhara is instantly recognizable, because it provides brilliant proof that, though East and West may be different, it is untrue that "ne'er the twain shall meet." In his conquering travels, Alexander the Great passed through nearby Afghanistan, and there he left a colony. So these people had seen Greek sculpture and knew what the Greek gods looked like. Although this is not a Greek god, his profile is pure Apollo—but with the flowing hair, the mustache, the rich attire of a Gandharan noble. This could be a secular ruler, were it not that he stands in a temple, and his face has that inward look: the awareness of the sacred—that strong spiritual certainty integral to Maitreya. He half-smiles, knowing that the sorrows of this world will not last forever, and that there is a world of perfect peace and joy to come.

The statue has the inward look typical of Maitreya; the mustache of a Gandharan noble; and the profile of the Greek god Apollo.

◁ **Standing Bodhisattva;**
1st–2nd century, Kushan period, Gandhara region; gray schist; height 59⅛ in. (150.2 cm)

66 He half-smiles, knowing that the sorrows of this world will not last forever, and that there is a world of perfect peace and joy to come. 99

L'Air

MAILLOL

BIOGRAPHY

Aristide Maillol
French, 1861–1944

• Originally a painter and tapestry designer, Maillol did not turn seriously to sculpture until the turn of the century.

• Maillol's monumental female nudes were based on classical models, but he simplified and streamlined the forms.

• He also created woodcut and lithographic book illustrations.

Sometimes when we leave a museum, we are surprised to find that it is raining or has turned very hot; inside we were completely insulated from the realities of weather. This does not happen at the Kimbell. Not only are the vaults receptive of natural light, but there are courtyards—airwells that light up the interior space.

In 1967, when Maillol's masterpiece *L'Air* was bought, there was no Kimbell. It was still a plan in the mind of the first director Richard Brown, and the architect Louis Kahn, but I think that they decided at an early stage that the north court would be a marvelous setting for *L'Air*. Kahn even designed trellises for the vines that would enclose her, as if to prevent her from floating away. The first *L'Air* was commissioned by the French city of Toulouse, where airmen had trained in World War I, and was intended to commemorate those who had lost their lives. That work was in stone, but Maillol had always wanted to use bronze, both for its tensile strength—he could elevate the figure—and for its gleam. It does indeed gleam out at us all over the museum. Maillol took the dignity and grace of classical sculpture into the 20th century, simplifying and streamlining it. *L'Air* sprawls at ease, gently pushing away from the clouds, communicating that sense of bodily freedom that we all know personally from the experience—however long ago—of floating in water. As a divinity, she floats in all elements, unaware of our presence, serene in her happy isolation. Maillol seems not to have brought her down to our level, but to have lifted us up to hers.

> " As a divinity, she floats in all elements, unaware of our presence, serene in her happy isolation. "

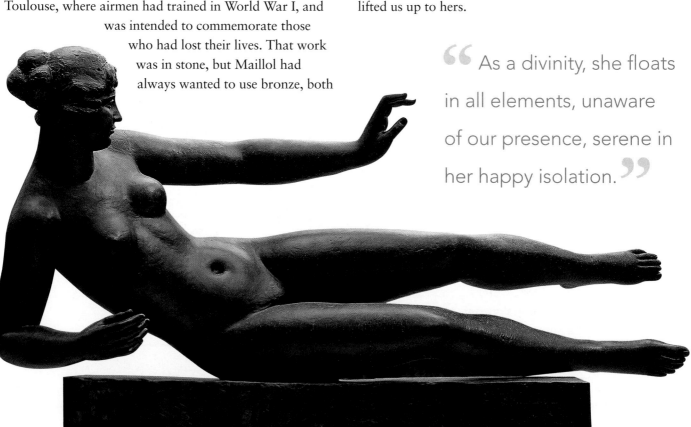

△ **L'Air**; designed 1938, cast 1962; bronze; 60½ x 94 x 58 in. (153.6 x 239.9 x 96.5 cm) including plinth

Hari Hara: The Supreme Hindu Deity

CAMBODIAN

To be human is to live in mystery: little able to control our life, little able to understand it. Of ourselves, we can have only two absolute certainties: that we were born, and that we will die. In the Hindu religion, these dual truths are expressed by two gods. Vishnu, the benevolent, is the Creator; and Shiva, the terrible, is the Destroyer. They are the opposite poles of existence: life and death, creation and destruction, light and darkness. Yet by an amazing feat of the imagination, these two opposites were conflated into one supreme god: Hari Hara.

The massive head reveals the duality. On his left is the smooth headgear of Vishnu, and on his right the tangled and matted patterns that suggest the curls of Shiva. Since Shiva has a third eye, half is present on the forehead. The four arms would have held emblems to make the meaning clearer: a mutilation that makes us realize how fragile is our hold on art. It seems to me that the artist has gone even further—not just blending the two deities, but also blending the essence of what it means to be a man and what it means to be a god. This is almost a naturalistic figure, with its strong eyebrows, its neat mustache, its direct and questioning look. We see a perfect athlete's body: a mature athlete, with muscles rippling under the silky skin, and a vast sense of easy power. He wears no adornment, merely the dhoti and a chain, so that all the emphasis is directed to the magnificence of the adult male. This is not a parallel to the Incarnation, when God became man. This is a fully human man, who in his strength and aloofness, and his menacing look, tells his worshipers about the divine Hari Hara, who by his very presence demands obedience.

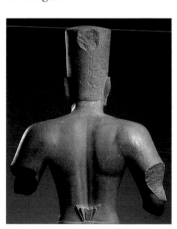

This statue is both god and man, with the smooth, taut muscles of a magnificent adult male.

◁ **Hari Hara: The Supreme Hindu Deity**; c. 675 700, Pre-Angkor period; stone; height 45½ in. (115.6 cm)

> **" On his left is the smooth headgear of Vishnu, and on his right the tangled and matted patterns that suggest the curls of Shiva. "**

LOS ANGELES COUNTY

Introduction

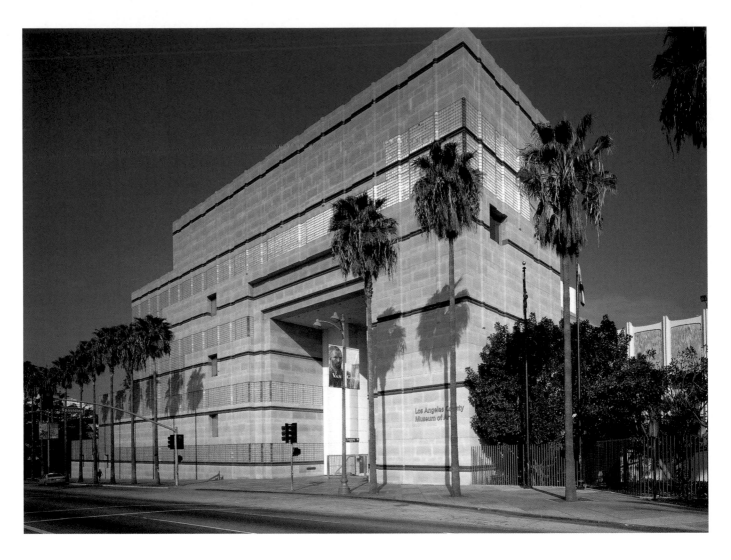

△ Exterior view of the Los
Angeles County Museum of Art
from Wilshire Boulevard

▷ **Beaker with a Theatrical Scene;**
late 2nd–3rd century; Egyptian
or Syrian; free-blown, painted,
and gilded glass; height 5¾ in.
(14.6 cm), diameter 3½ in. (8.7 cm)

Most encyclopedic museums, modestly conscious of their worth, face us fair and square with an impressive building. The Los Angeles County Museum of Art (affectionately known as LACMA) is large and splendid, but the extent of its architecture eludes the gaze. Individualistic in this as in much else, the buildings present themselves more as a conglomeration than as a whole. What a purist might consider defects, however, seem to me assets. It is a very accessible museum, and the large straggling courtyard that stretches between the more conventional parts of the museum and the Japanese Pavilion is always filled with happy crowds, talking, laughing, and obviously enjoying their cultural excursion.

I was amazed, on my travels around the country, to discover how relatively under-appreciated LACMA is. What drew me particularly was its Indian and Southeast Asian collection: one of the most significant in the world. The only drawback for a book that must deal with the entire museum is that it is too rich, too supremely beautiful. At one stage, having regard to the particular geographical position of Los Angeles—adjacent, in a sense, to both South America, and across the ocean, to the East—I had thought of structuring my choices around the rubric of the "Pacific Rim." The museum's superb pre-Columbian (Mezoamerican) collection and glorious Oriental art gave me abundant reason. You will note the vagueness of my geography when I add that I had blithely intended this rubric to include India, Tibet, and lands still farther east. That early and foolish concept would also have left little space for one of LACMA's greatest strengths: its holdings of painting and sculpture, both European and American. Then what to do about its Costume and Textile department—one of the finest in the country—or its unrivaled collection of glass? (The sad answer to this last question is that I did nothing; there was no time or space; and I hope that readers who visit LACMA will atone for my inadequacies.)

Perhaps lingering most fondly in my memory is the Japanese Pavilion, which seeks to give those who—like myself—have never visited Japan, the experience of its cultural spaciousness within material compression. The Pavilion is not physically large—but it can seem infinite. "Infinite" is perhaps a good word for LACMA generally: its ambitions and its hopes; its potential and its prospects. It is a happy place to visit.

△ **Buddhist Altarpiece;**
c. 800; Indian, Madya Pradesh, Sirpur; copper alloy, silver, and copper; 15 x 10¼ x 7 in. (38.1 x 25.7 x 17.8 cm)

A Musical Party
VALENTIN DE BOULOGNE

One can be walking around a museum and be stopped dead in one's tracks with a shock of joy. Cézanne always stops me, but Valentin de Boulogne? Here was an artist I knew—a respected follower of Caravaggio—but in whom I had never taken much interest. Yet his *Musical Party* overwhelms me. At first I think I was ravished by the colors; not so much the glorious orange-red of the soldier's doublet, or the blue and silver of the boy's sleeve, but by the soft skin colors. What could be more exquisite than the delicate five o'clock shadow on the flush of the boy's cheek, or the bright color of the gypsy's cheekbones?

It is our response to the color that draws us deep into the picture itself. Here are four people—ignore the man at the left side for the moment—who are lost in their music.

△ **A Musical Party;** c. 1626; oil on canvas; 44 x 57¾ in. (111.8 x 146.7 cm)

Scholars differ over the theme of this work, but it seems to me (and I am prepared to battle for this) that it is about the power of music. The old man with his flute, the soldier with his lute, the boy with his violin, the girl with her tambourine: they all come from different walks of society. They are as different in themselves as the instruments they play: the boy in his scruffy get-up; the gypsy girl, who was probably a prostitute; the respectable old man with his well-combed beard; the soldier with his very visible sword. Nothing brings them together except music, and they are aware of nothing save music. At one time, I thought the girl was yearning toward the boy, but since then I have seen just that expression on the face of an accompanist trying to keep in tone and tune with another player. She is not responding to him as a person—still less as male to her female—but to him as a musician. All four have attention only for the music they create together—and the man at the back, well-armored, savoring the last drop of his wine? He, I think, is the one out of the magic circle, because he finds his pleasure in his glass.

There is personal poignancy for me here. At home, in the trailer, I live in silence. I want that; it is my deliberate choice, which I would not change, but this picture makes me aware of what I am missing.

The beautiful colors of the skin tones help to focus attention on the rapt expressions on the musicians' faces. Although each of the participants is very different from the others, this disparate group of people is drawn together by their love of music. The deep pleasure it brings to them is clear on their faces.

" I was ravished by the colors; not so much the glorious orange-red of the soldier's doublet, or the blue and silver of the boy's sleeve, but by the soft skin colors. "

The Death of Lucretia

MAZZANTI

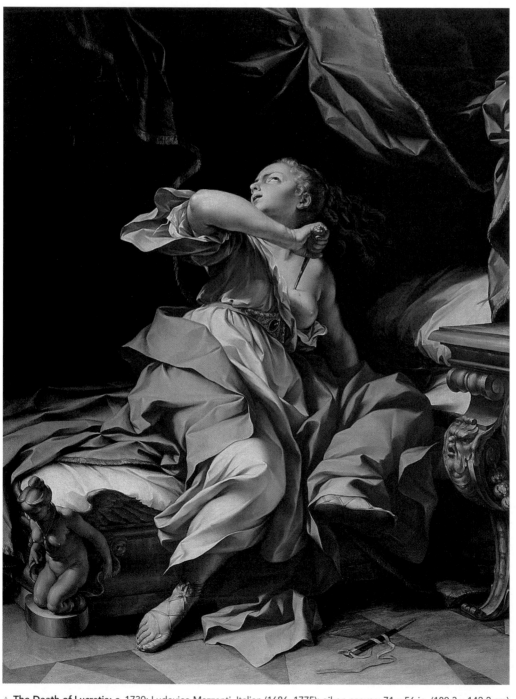

The Death of Lucretia; c. 1730; Ludovico Mazzanti, Italian (1686–1775); oil on canvas; 71 x 56 in. (180.3 x 142.2 cm)

> **"** The wind blowing through the picture is the wind of Lucretia's emotion—her tempestuous grief over what was done to her. **"**

Walking through a gallery full of old masters, I was amused to find my attention drawn to the far corner, where a tossing of drapery and fluttering of garments, and a curvaceous blonde reminded me uncompromisingly that this is Hollywood country. A closer look made me repent of my amusement, because the Italian artist Ludovico Mazzanti is showing us Lucretia and her suicide, which was—believe it or not—the cause of the founding of the Roman Republic.

Mazzanti simplifies the story of Lucretia's rape and subsequent suicide: we are standing where the Romans would have stood, her witnesses. If the artist does not want to show grave Roman senators, still less does he want a grave Roman matron for his heroine. Instead, he presents us with a delightful, bimboesque figure! But her heart is desolate—and Mazzanti makes the tragedy painfully clear. The wind blowing through the picture is the wind of Lucretia's emotion—her tempestuous grief over what was done to her. Beside her, on the nightstand, is carved the face of a satyr: the symbol of lust. Even this ugly face is wrinkled with sorrow and bewilderment. Most tellingly of all, at the foot of the bed is a carving of a beautiful woman. She has golden wings, but they are fixed to the bed. She is kneeling in a posture of submission, and her legs disappear into the bed's framework. Around her neck she wears the rope of a slave. For all his histrionics, Mazzanti could not give us a more striking image of what it does to a woman to be treated, in effect, as part of a bed. It destroys her metaphorically, just as Lucretia was truly destroyed.

Mazzanti portrays Lucretia as a tragic but voluptuous blonde rather than the grave Roman matron that she was. Her posture and actions are highly dramatic, demanding the viewer's attention, but Mazzanti indicates the reason for her suicide more subtly, in the form of the submissive figure at the base of the bed: Lucretia was raped, and the figure, wearing the rope of a slave, is fixed to the bed.

THE ROMAN REPUBLIC

The last king of Rome, Tarquinius Superbus (Tarquin the Proud), had a vicious playboy of a son, who seduced all of the Roman wives, except the chaste Lucretia. When her husband was away, the seducer crept in one night and raped her. He was convinced that she would be too ashamed to denounce him; it was her word against his—but hers was a powerful word. The next morning she called together all of her family and friends, told them what had happened, and begged them to avenge her; then, to spur them on, she killed herself. Her avengers proceeded to lead a rebellion that led to the expulsion of the Tarquins and the establishment of the Roman Republic.

The Martyrdom of St. Cecilia

SARACENI

Saraceni's *Martyrdom of St. Cecilia*—what a lovely painting this is—seems to me something of a paradox. There is an element of the paradoxical in St. Cecilia herself: a 2nd-century martyr of whom it was said that she always sang to God in her heart. Later this was misinterpreted to mean that she was a great singer, and she became the patron saint of music. Her emblems are strewn over the foreground: sheets of music, and musical instruments—the tambourine for percussion, the violin for strings, the recorder for wind. Cecilia herself is poised between life and death. Death, in the form of the executioner, advances on her in a large, menacing, pincer movement—one hand held high to grasp her hair and tug her back, so that the other hand can snake up and slit her throat. On her other side is life: the insubstantial angel—one hand pointing to heaven, and the other reaching out to accept her spirit.

I think that the paradox is this. Executioners were two-a-penny in 17th-century Italy, and in art they are usually vulgar, brutal creatures. Saraceni, however, gives us a beautiful, slender young man, elegantly dressed. At once we are made aware of another possibility. If that beautiful young woman would only turn, the advancing arms could become an embrace and she would find not death but life approaching. The angel, then, would be the angel of death. The paradox, subliminally raised, is only there to be

BIOGRAPHY

Carlo Saraceni
Italian, c. 1580–1620

• Born in Venice, Saraceni spent most of his short life working in Rome, where he produced many sensitive portrayals of religious figures.

• Two of his contemporaries had a profound influence on his style: the realism of Caravaggio's figures and Adam Elsheimer's lyrical landscapes.

• As well as producing altarpieces and other religious works, Saraceni painted mythological scenes and landscapes on copper, and decorative frescoes, often featuring distinctive tassels and draperies as backgrounds to his realistic, homely figures.

> She half-rises, trembling with eagerness, frightened but passionate in her desire. Her white face is turned toward what neither she nor we can see, but to which the angel points: heaven.

discarded—to emphasize Cecilia's certainties. For her, there is no paradox. She wears a blood-red dress that speaks of martyrdom, and the white of her blouse expresses her chosen virginity. She half-rises, trembling with eagerness, frightened but passionate in her desire. Her white face is turned toward what neither she nor we can see, but to which the angel points: heaven.

The instruments in the foreground reflect the fact that St. Cecilia is the patron saint of musicians.

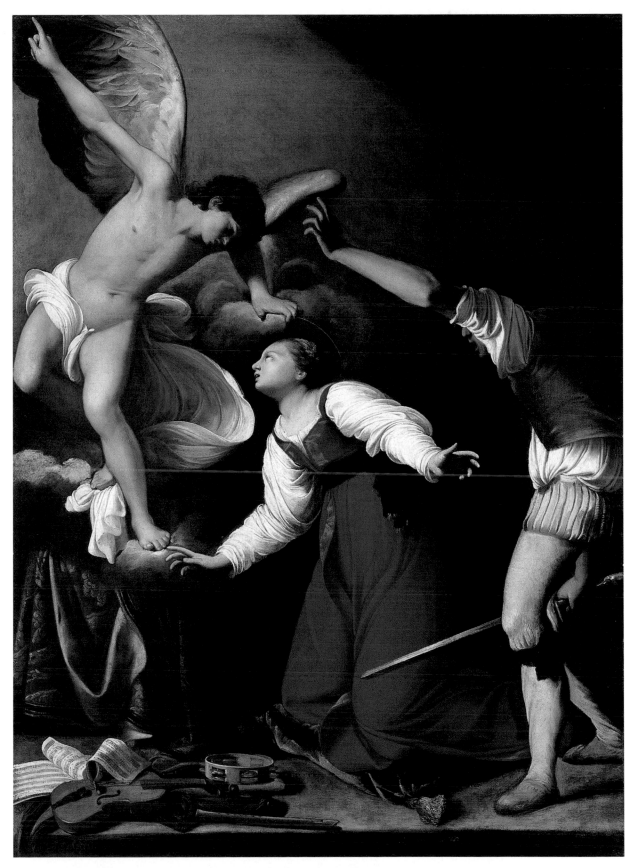

△ **The Martyrdom of St. Cecilia;** c. 1610; oil on canvas; 53½ x 38¾ in. (135.9 x 98.4 cm)

Emperor's Twelve-Symbol Dragon Robe

CHINESE

This Qing dynasty robe has twelve sacred symbols: six on the back, and six in front. At the neck are the sun and moon, with the strange Fu symbol of discernment; the axhead of justice flanks the waist; and around the hem are the water plants and the libation cups. Lesser mortals were allowed to have a dragon or two, but only the emperor could have a dragon with five claws. There are nine of them on this robe, cavorting around and holding the flaming pearl of wisdom: it is courage and wisdom that distinguish an emperor. The robe is a cosmology, depicting the universe. The lines at the bottom stand for the sea, and above them are the breakers, with treasures (coins and jewels) floating in them. Above again, are the earth rocks (mountains), in highly formalized design; and over them, also formalized, a sky of clouds and enchanting bats, the word for which means "happiness." Where there are no bats or clouds, there are golden dragons at play, until we come to the stars and moon. This robe was not "activated" until the Son of Heaven put it on. He was the backbone, the living center of China. The robe was inert until his head appeared above the sun and moon, and then his people knew that they were stabilized in harmony, and blessed by heaven.

> " Lesser mortals were allowed to have a dragon or two, but only the emperor could have a dragon with five claws. "

THE TWELVE SYMBOLS

In the 18th century, an emperor of the Qing dynasty issued a document about ceremonial dress. It stated that only the emperor and his empress could wear this shade of yellow. In addition, only the emperor could wear images of the twelve sacred symbols: the sun, the moon, the stars, the rock, the Fu, the dragon, the axhead, the flowery creature, the water plant, the libation cups, the flames, and the grain.

◁ **Back View of Emperor's Twelve-Symbol Dragon Robe (*Long Pao*);** 1821–50, Qing dynasty, Daoguang period; silk and metallic foil-wrapped yarn in tapestry weave (*kesi*); center back 60¼in. (153 cm)

Rooster, Hen, and Hydrangeas

JAKUCHU

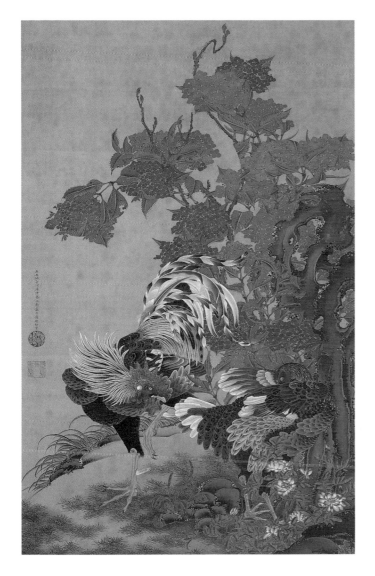

The 18th-century Japanese artist Jakuchu, a devout Buddhist, paints the rooster as a Buddhist bird, treated with the utmost respect, which may account for the astonishing meticulousness of his technique. Jakuchu used a method that makes extreme demands of the artist: on this silk, nothing can be redone. No line can cross or even touch another. All must be thought through in advance, and yet have the *élan* of the spontaneous. The surreal brilliance of the rooster's tail feathers, all silver and black, does indeed look like a fountain of inspiration—and so does the silvery gold of the spray from the neck. The hen also is a marvel, with the delicate little feathers of her wings. However, we forget the sheer achievement of the brushwork in our enchantment with the drama. Look how the rooster approaches, on those stealthy, predatory feet—and contrast that with his expression of disinterested affection. Look at that far less complex creature, the little hen, with her gauche feet, and how she hides beneath her wings and peeps out, shy and bright-eyed, to see her suitor.

On every side is the glory of the birds' setting: the brightness of the hydrangeas and the faint gold of the sky. It is a magical painting. Jakuchu named his studio "the house of the faraway heart," which I take to mean that he professes inwardness—a sense of the invisible; but he is also a master of the near-at-hand heart—the visible—and the two meet here as surely as the rooster and the hen.

△ **Rooster, Hen, and Hydrangeas**; 18th century, Edo period; hanging scroll, color and ink on silk; 54⅞ x 33½ in. (139.4 x 85.1 cm)

Jakuchu's careful study of domestic fowl can clearly be seen in the meticulous detail of the rooster's variegated plumage and bright red head.

" On every side is the glory of the birds' setting: the brightness of the hydrangeas and the faint gold of the sky. "

Dress from the "Staircase" Series, Winter 1994

MIYAKE

You won't be surprised to learn that I know absolutely nothing about fashion; though to snatch what credit I can, I have at least heard of, say, Dior and Versace—and of Issey Miyake, whose dress this is, from his "Staircase" series. I do not think this shortcoming matters, because we are not dealing here with fashion, as interpreted through glossy magazines and glamorous people. This is art: art as genuine as any other in the museum. I cannot look at this object, glimmering with its effect of rising stairs, without admitting that this is a true creation. It is a different kind of creation—a different kind of art. It cannot be hung on the wall, and it is also diminished if we turn it into sculpture. Essentially it is performance art, and needs a body inside it. We are meant to see it in motion, with the changing play of light. Miyake himself says that he does only half the work; the wearer does the other half. This seems to me very Oriental—as does the garment's simplicity, and its physical modesty (nice high neck).

Miyake insists that he is not an artist for one country alone. His name, "Issey," means "one life," and "Miyake" means "three houses." Japan, Europe, the United States: he is international. All the same, speaking from the depths of my ignorance, this still seems to me a very Japanese creation—and I compare it, to prove my point, with a very Western one: a dress by French designer Christian Lacroix (1951–). This is a lovely garment, but whereas for Miyake, the body enhances the dress, in the Lacroix, the dress enhances the body. It is a witty dress, plundering the past, with the panniers of an 18th-century ballgown, and a hint of Edwardian bustle and tight little corseted waist. It is a dress for joy: a butterfly of a dress. The Miyake, however—stone and moonlight—is a dress of such lovely gravity that whoever wears it must feel an obligation to be worthy.

The fabric of Lacroix's dress is designed to keep its shape, but that of Miyake's is intended to move fluidly with the wearer.

◁ **Woman's Evening Dress**; 1987; Christian Lacroix; printed silk taffeta; center back 26 in. (66 cm)

> " I cannot look at this object, glimmering with its effect of rising stairs, without admitting that this is a true creation. It is a different kind of creation—a different kind of art. "

▷ **Dress from the "Staircase" Series, Winter 1994;** Issey Miyake; metallic polyester, pleated; center back 45½ in. (115.6 cm), width approximately 84 in. (213.4 cm)

"Around this figure there always seems to be a circle of peaceful silence, however full the gallery."

JIZO BOSATSU

"Bosatsu" is the Japanese for "Bodhisattva," which means that he is a saint who postpones his passage into the bliss of nirvana so that he can stay on earth and help others. It was thought that the world would one day pass away, and there would be a new, golden world with another Buddha: the Buddha of the Future. However, just before he came, there would be a period of turmoil, with no Buddha—no one to turn to, except Jizo, who would always be there.

Jizo's left hand holds the jewel of wisdom (top), while his right hand once held a "jingle-staff" (above).

▷ **Jizo Bosatsu**; late 11th–early 12th century, late Heian period; carved wood; height 57⅝ in. (146.5 cm)

Jizo Bosatsu

JAPANESE

The greatest grief for parents is the death of a child. For those who have faith, there is the consolation—even if only intellectual—of believing that the child is safe, happy forever in heaven, but imagine the sorrow if your faith taught that children went to hell. Only then can you understand why Jizo Bosatsu was so loved and revered in medieval Japan. He was the one who rescued children from hell, and he helped living children also, guiding them to virtue. Here, he stands on a lotus flower: a symbol of purity, because it rises, white and beautiful, from the mud. He is dressed with a monk's simplicity, and he holds in one hand the "wish-fulfilling jewel." This sounds suspiciously magical, but it is a divine enticement: it is the jewel of wisdom—and if you hold it, your wishes are indeed fulfilled, because you become enlightened. In the other hand, he holds a "jingle-staff," with rings that tinkle to warn small animals and insects to move away, in case they are trodden on. This seems typical of Jizo. It is not just children in need whom he helps, nor just despairing adults, but beasts, and ghosts—and even devils. The name Jizo means "matrix of the earth." He is a sort of seedbed, and wherever there is life, of whatever kind, Jizo will protect it. Around this figure there always seems to be a circle of peaceful silence, however full the gallery.

Netsuke

JAPANESE

What do you do if you have no pockets? (I ask this in the happy confidence of a nun with two very large pockets.) The kimono is an elegant garment, but it makes no allowance for a pocket. The Japanese solution was not to carry a purse, but to craft a small, sectioned box (an inro), which hung on a cord from the sash, with a toggle (a netsuke) to keep it safe. There were strict rules governing Japanese dress, and one of the few ways in which you could show your breeding was to have an exquisite inro, and turn your netsuke into a miniature sculpture. The museum has over 800 of these small works of art—each worth a serious and admiring look. They are creations of charm and ingenuity, but since I am forced to choose, I must admit that I have a very soft spot for the baku. This is one of the inspired inventions of Japanese folk imagination. He is not noted for his beauty, as you observe. He has an elephant trunk, small ears, and feathery hair, leading down into a lionlike body,

with curled tail and clumpy feet. However, despite the lack of physical attractions, he is a truly kind, moral, and helpful creature—he uses his very sharp, needlelike teeth (here endearingly displayed) to eat nightmares. The 18th-century gentleman who used this object as his toggle probably did not believe in the baku, but with all this ferocity and puppy-dog charm eager to be deployed on one's behalf, why not cherish it?

▷ **Dragon Standing on Clouds;** 18th century; attributed to Yoshimura Shuzan; painted soft wood; 3⅝ x 1¼ x 1¼ in. (9.1 x 3.1 x 3 cm)

◁ **Baku, Monster who Eats Nightmares;** 18th century; attributed to Gechu; ivory; 3¾ x 1⅝ x 1¼ in. (9.5 x 3.1 x 4 cm)

▷ **Inro;** early 19th century; Kajikawa Bunryusai; Shibuichi metal bead ojime and wood netsuke; 3⅞ x 2 in. (9.9 x 5.1 cm)

> " I must admit that I have a very soft spot for the baku. This is one of the inspired inventions of Japanese folk imagination. "

THE BAKU

It is with his teeth that the baku fulfills his function, which is to eat nightmares. Anyone with bad dreams had only to call upon him thrice, and the baku sprang forward and gobbled up all of the horrors. For this reason, he was sometimes painted on Japanese beds, or depicted holding a headrest. The worst nightmare for Japan was the nightmare of plague, but once again, the baku would run out obligingly and eat the plague germs.

Triptych with Scenes from the Life of St. George

SPANISH

A saint is by definition humble, so I am sure that St. George will not mind if I say that my primary attraction here was the dragon. It is so different from the dragons of the East, where they not only wear a white hat but a white halo. In the West, the dragon is the devil, and the hero overcomes him. This is a theme that goes back to the earliest nature religions. It is spring overcoming winter, light overcoming darkness, goodness overcoming malice.

St. George vanquishes the dragon, and saves the princess. On either side of this work, which would have stood on an altar, we see the stages of the story. At the left, on the top, St. George hands over the dragon to the princess to lead away on a leash; in the middle, he beheads it; at the bottom, he gives away all of the rewards that he was offered for his great act of courage. Humanly, this is the positive side. On the right, we see what happened next: authority rejects him, tortures him once, and again, and then beheads him. At first sight, this work may seem to us naive. (I particularly like the picture of the princess with her pet platypus!) However, the message, if simply conveyed, is profound. We smile at the princess, but the point is that evil cannot be toyed with—led on a leash. It has to be destroyed, as in the picture below. Goodness must reject temporal rewards, which anyway will not last. We do what is right for God's sake, and for our neighbor's—and the end will be death. If you live this lesson to the hilt, you may have the great good luck to die a useful death, as St. George did, but this altarpiece makes it clear that St. George did not act with his own strength alone. His body is aligned with the cross above him, and the whiteness of the steed that carries him is echoed by the white body of Christ. The best death, of course, is to die like Christ: the redemptive death of martyrdom. For all the charm and sweetness, medieval art can present us with a stark and powerful message.

> " His body is aligned with the cross above him, and the whiteness of the steed that carries him is echoed by the white body of Christ. "

St. George is seated on a white horse, echoing the whiteness of Christ's body above and symbolic of the triumph of light over darkness.

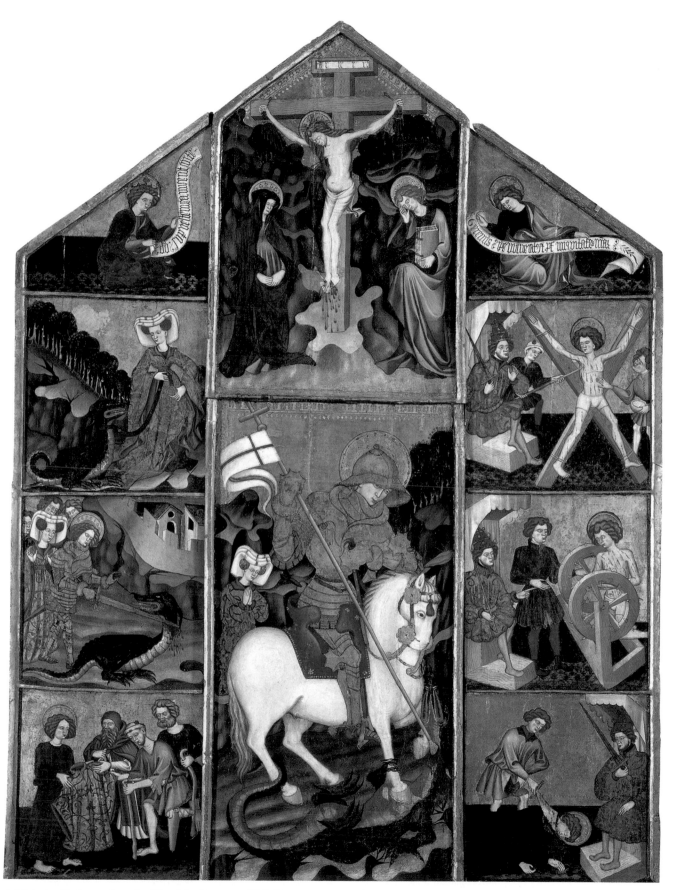

Triptych with Scenes from the Life of St. George; c. 1425–50; tempera on panel; 98 x 74 in. (248.9 x 187.9 cm)

The Flight of Europa
MANSHIP

ZEUS AND EUROPA

Zeus, king of the gods, was always falling in love. He would have terrified a girl had he appeared in his full glory, so for Europa, he took the shape of a bull, a gentle beast that ambled onto the beach one morning when she was there with her friends. Eventually he so won her confidence that she lay on his back, whereupon, with one bound, he was in the waters and swimming off with her.

◁ **The Flight of Europa**; 1925; bronze with parcel-gilt patina on original onyx base; 25¼ x 30 x 9 in. (64.1 x 76.2 x 22.9 cm)

The world has very few comic masterpieces, and this is one: *The Flight of Europa* by Paul Manship. He made it in 1925, when he was 40, and was already esteemed as a major American sculptor. He was esteemed, I think, not only for his exceptional technique, but also for his originality. He was drawn to archaic Greek sculpture, for its reticence and for its myths. The myth of Europa, in particular, fascinated him, and this is his third—and best—of three versions.

Clearly this is a myth about sexuality, and in his well-bred way Manship is aware of that. The great hulk of the bull is intensely masculine—and notice how Zeus the bull has his chin tucked in, with the secret, complacent smirk of a man who has what he wants. He has the girl, and he is in control. Then we look at Europa, slender and straight on his back, and we realize that, far from being abducted, she is riding on him. She sees herself as the one in control; she has what she wanted. She wears the distant smile of the bride planning her living-room drapes. A mutual sense of control might, in fact, be a good foundation for marriage. The little god of love Cupid whispers congratulations in her ear, but his body—blown backward by the speed of travel—takes us visually to Zeus. The two are united, literally, by love.

The visual aspect is striking throughout—and always at the service of the psychological narrative. Manship balances massive simplicities of form with intricate detail: the hair of Europa, for example, or Zeus' topknot. The dolphins seem to be diving into the onyx stand as they bear the god so rapidly through the waves. It is a very mannered piece, but it is Manship's manner—his personal style. He disliked the emotional, and abhorred Rodin. He would have said of Rodin's profundities that they were only superficially profound. Manship, for his part, is profoundly superficial—and I say that in admiration. "Superficial" refers to surface, and this is where Manship is strong: in the gleam of the material surface, and in his startling use of body language. He would have felt, I think, that to delve into the dark secrets of the heart was not the work of a gentleman.

> " This is where Manship is strong: in the gleam of the material surface, and in his startling use of body language. "

BIOGRAPHY

Paul Manship
American, 1885–1966

• The sculptor Paul Manship studied at the American Academy in Rome, where he developed his interest in classical subjects. He executed many public commissions, most notably *Prometheus* (1931–32), for the Rockefeller Center in New York.

• His work is characterized by the flowing, almost airborne, body movements of his figures, heightened by superb linear detailing; his use of rich, gleaming materials; and an overall sense of superficial elegance.

Manship decorated his pieces with superb linear detailing, which can be seen here in Europa's hair—in contrast with Cupid's curls—and also in Cupid's wings spread out behind him.

Mother About to Wash Her Sleepy Child

CASSATT

Strangely enough, one of the greatest painters of the mother-and-child theme—more than one half of her work—was a childless American spinster with no apparent inclination to marry. Mary Cassatt was well-to-do and attractive, with many friends (including Degas), but she had no close relationships outside the family. Art was her commitment.

This picture is thought to be the first time she tried this theme. It is very early Cassatt, when she was still deeply influenced by the impressionists. Later her work became more solid, but here there is a charming lightness of touch. Impressionism is evident in the way light gleams on the vertical stripes of the wallpaper, down onto the stripes on the chair, and then flows freely over the sprawled body of the child and its mother. There is a glimmering indistinctness about the figures, as though the child is squirming around a little. This sense of movement, of immediacy, is held firm by the anchor of the mother's hand: red and distinct in the water. Is it red because the water is too hot? Or is the subject a working woman?

Mary Cassatt was born near Pittsburgh and remained a daughter of the Midwest. She does not know how to flatter. The child is not an adorable bundle of charm, but a human being in a highly inelegant pose, and dead tired. What gives the picture its emotional force is the look on the child's face: half-smiling, half-impassive, but expressing absolute trust. We cannot see the mother's face in full, as she bends away from us, down toward her child—but the pose itself bespeaks an infinity of service and devotion. Cassatt's picture portrays what it means to be a child—one who trustfully expects to be cared for; and what it means to be a mother—a glad giver of all that is needed. Cassatt was an important painter with many works to her name, but this picture remained dear to her throughout her long life.

The mother's hand in the water serves to anchor the painting, which is otherwise full of movement. The completely trusting, half-smiling face of the child gives the painting its impact, neatly summarizing the intimate connection between mother and child.

> " Cassatt's picture portrays what it means to be a child—one who trustfully expects to be cared for; and what it means to be a mother—a glad giver of all that is needed. "

BIOGRAPHY

Mary Cassatt
American, 1844–1926

• Mary Cassatt settled in Paris in 1866, and was invited by Degas, her friend and mentor, to exhibit with the impressionists. She was the only American painter to become an established member of the French impressionist movement.

• Her work is primarily figurative, and she is best known for her mother-and-child studies, which comprise around half of her output.

• Cassatt was an excellent draftswoman, and took up the Japanese drypoint method of engraving. She also incorporated several Japanese stylistic elements into her paintings, including bold patterns and linear designs.

△ **Mother About to Wash Her Sleepy Child;** 1880; oil on canvas; 39½ x 25⅞ in. (100.3 x 65.8 cm)

Allegory of Salvation
ROSSO FIORENTINO

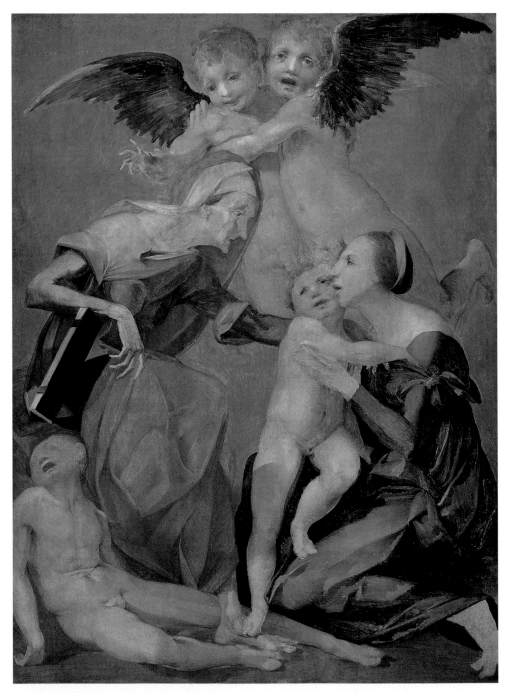

> " The painting is a lament for dead children, but Rosso puts it into a larger context: for children to die is so tragic that even angels weep. "

△ **Allegory of Salvation with the Virgin and Child, St. Elizabeth, the Young St. John the Baptist, and Two Angels;** c. 1521; oil on panel; 82 x 72 in. (208.3 x 182.9 cm)

Most interpretations of this painting hinge on the mother and child being the Virgin Mary and Jesus. However, perhaps the old woman represents Death, carrying the Book of Life and a shroud as she comes to claim a mother's second child (below). The angels above look on in anguish and weep for the dead children (left).

When we see this picture, we feel shock—even horror. Although Rosso never finished it, I think that is exactly what he intended: to disturb. We also feel baffled, and perhaps he intended that also. Let us look at what is before us. At the top are two small angels in obvious distress. Below is a young woman, who is frightened, with a terrified child clinging to her—its hair streaming back from the speed with which it rushed to its mother. We come to a prostrate child—either dead or unconscious—and above him, a strange witchlike old woman, reaching forward with one hand and clutching a book with the other.

There seems to be a general consensus that the mother and child are the Virgin Mary and Jesus, that the other child is St. John the Baptist, and that the old woman has just announced that Jesus will one day be rejected and crucified—which caused St. John to faint with grief. Who is the old woman? Some think she is St. Anne, the Virgin's mother, who is often shown with a book, because she taught Mary to read. Some think she is the prophetess Anna, who met Mary in the temple when Jesus was circumcised, and the book is a book of prophecy. But what have these to do with St. John? Others are convinced that the old woman is St. Elizabeth, the mother of St. John—but she has no need of a book, and we are still left with the problem of why the family of Mary should know more about the future of Jesus than Mary herself does.

You may not be surprised to learn that I have a completely different theory, which seems to me to account for the strange atmosphere of this work, with its acid colors and its haunting sense of sadness and fear.

Forget the angels at the top, for a moment. The mother and child I take to be any mother and child, not necessarily Mary and Jesus. The old woman is Death. She has already taken one child; stepping over the leg of his corpse, she reaches out to take another child. The orange-yellow swathe on her lap is either a shroud or a sack in which to put the bodies, and the book, of course, is the Book of Life, in which the names of the dead are recorded. Remember how high infant mortality was in the 15th century. Hardly a family would have seen this picture without a shudder of recollection and of fear. The painting is a lament for dead children, but Rosso puts it into a larger context: for children to die is so tragic that even the angels weep.

The Raising of Lazarus

REMBRANDT

△ **The Raising of Lazarus**; c. 1630; oil on panel; 37⅞ x 32 in. (96.3 x 81.3 cm)

A brief biography of Rembrandt can be found on page 17.

This work is by the very young Rembrandt—painted in his early twenties, when he was still living in his home town of Leyden, but was already a great painter. His special gift was for drama; he had an almost instinctive understanding of the human heart. It always puzzled me, therefore, that only once, at the very beginning of his career, did he tackle the most dramatic of the gospel miracles: the raising of Lazarus.

Lazarus had lain dead for several days, and his body was beginning to decay, when the distress of his sisters moved Jesus so much that he summoned him back from the dead. This is a fairly frequent subject in art, highlighting the intense confrontation of Jesus, the life-giving Savior, and Lazarus, the corpse. As we might expect, Rembrandt treats it as does no other. His Jesus dominates the scene, but not as a triumphant godlike figure. This is a weary Jesus, almost astonished at the effect of his words—drained by the effort of the miracle. Lazarus is not even aware of Jesus. He is just coming back to life, the blood not yet flowing; and he concentrates on that central flicker of renewal. He has no attention for anything but himself. He does not see his weapons hanging behind him; he does not notice his friends, or his anxious sisters: respectable Martha and flamboyant Mary. He stays motionless, looking inward.

Rembrandt was not only a devout Christian, he was a thinking Christian—not always the same thing. He sees this miracle as a parable. It is not so much about bodily life, but about the life of the spirit. Lazarus is the image of the hardened sinner who feels the first movement of grace; or of the convinced materialist who suddenly feels a twinge of conscience. He is not yet alive: he is poised, able to move forward into life or sink back into the grave. Rembrandt kept this picture nearly all his life, and I think he did so without attempting the theme again because he knew he would never be able to touch more profoundly on the mysteries of moral and physical life and death.

> **It is not so much about bodily life, but about the life of the spirit. Lazarus is the image of the hardened sinner who feels the first movement of grace.**

Lazarus' sister Mary leans forward into the light at the sight of the unfolding miracle. Her image is full of life, while that of her brother is still in the ghostly half-shadows between life and death. Rembrandt is showing the sinner Lazarus at the point where he can choose to move toward life and spiritual grace.

Plague in an Ancient City

SWEERTS

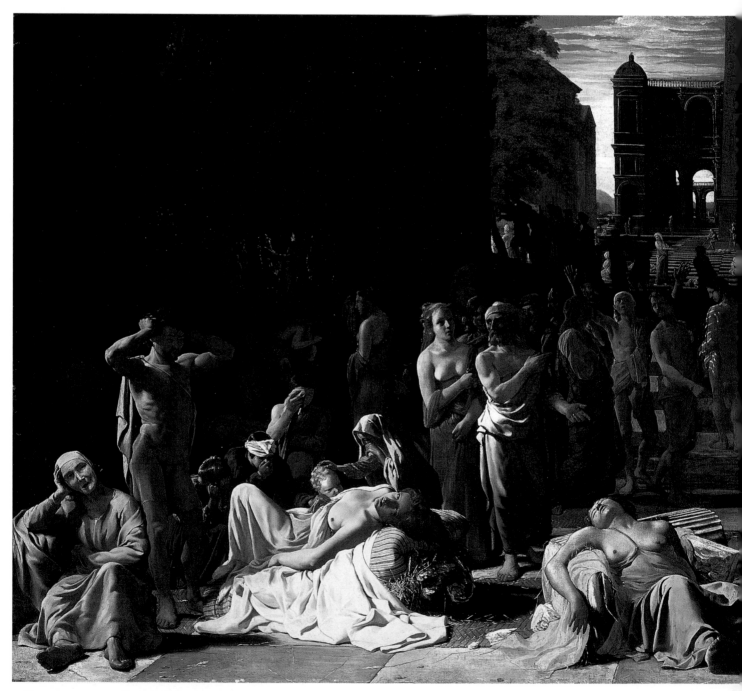

△ **Plague in an Ancient City;** c. 1652–54; oil on canvas; 46¾ x 67¼ in. (118.7 x 170.8 cm)

S weerts was a quarrelsome, wandering man, but an alluring painter with an enigmatic quality. *Plague in an Ancient City* is his largest painting, and is also recognized as his masterpiece. It was originally thought to be by Poussin, who also painted a plague: the biblical plague at Ashod. Sweerts' plague is not somewhere specific; it is the generic plague known to everybody of his time.

There were, in fact, two terrible outbreaks of the plague in Rome shortly before this picture was painted, in the middle of the 17th century. They are not what Sweerts paints. He chose an imaginary but typical classic city, because that is where the human intellect is shown at its finest: heroic architecture, noble streets, great squares. All of this is crumbling, because of the irrationality of sickness. This is what happens to a civilized people when disease comes. Death is omnipresent and omnipotent. In a setting built for elegance, there are only bodies that are dead, dying, or mourning. We see a child, grieving over its mother; a man distraught at the loss of his beloved. Some stand in stoic disbelief; others wander around, bewildered. Even the authority figure—the man in blue in the center— can only make a vague gesture, signaling escape; there is nothing he can do.

This all-pervading helplessness is Sweerts' theme. We so long to control our lives—and here we have it forced upon us that for all our ingenuity, and creativity, and scientific advances, life is essentially beyond our control. Sweerts himself died young, far from home, in Goa, a Portuguese colony in India. I think that what gives this picture its tremendous force is his own sense of mortality.

Sweerts shows the human tragedy caused by plague, as the helpless child grieves for its dead mother.

" This all-pervading helplessness is Sweerts' theme. We so long to control our lives—and here we have it forced upon us that for all our ingenuity, and creativity, and scientific advances, life is essentially beyond our control. "

After the Hunt

HOMER

Where oil painting is concerned, Winslow Homer is among the great American artists; but in watercolor, he is indisputably the greatest (with maybe a stray voice favoring Singer Sargent). Something about this medium—its immediacy, its fluidity, its speed—liberated him. He was able to respond with a depth and a sensuousness that are rare in his more studied works. Here, he responds with passionate pleasure to the Adirondack Mountains in New York, where he went each year with his brother to fish. *After the Hunt* is not a fishing picture, though; it is a hunting picture, and at first

I had a problem with it. I confess to being a squeamish sentimentalist, and I thought the way the deer was killed was cruel. Dogs drove deer into the rivers and ponds, where they drowned or were shot. Homer also thought this was horrible, but that was when the perpetrators were rich men on vacation, enjoying the sport. He did not object to the local hunters, and as we can see, here are two hardworking country people.

Homer sets his four creatures in the light-flecked triangle of the boat. Behind is the dead deer. In front is the weary dog. In the middle are the old man and the boy,

△ **After the Hunt**; 1892; watercolor, gouache, and graphite underdrawing on off-white paper; 13⅞ x 19⅞ in. (35.3 x 50.5 cm)

The boy and man welcome the weary dog with evident love and respect. The water from which the dog is emerging seems to ripple with light.

who receive the dog with such evident love and respect, which is reciprocated. In front again, is the limpid transparency of water, and the air is crystal clear. Behind are the dark, rich glories of dying leaves. A sense of reality is paramount in Homer. He accepts that the deer is dead, and balances that against the fact that man and boy, and even dog, must earn their living. This is how nature works: cruel, maybe, but functional. It is in this context that Homer sees death, and it is this balance that turns what would be a pretty picture into a stern and beautiful one.

BIOGRAPHY

Winslow Homer
American, 1836–1910

• One of the greatest American painters of the 19th century, Homer originally trained as a lithographer and worked as an art correspondent during the Civil War.

• He went on to paint unromanticized scenes of everyday life, landscapes, and—his favorite subject—seascapes. His paintings are vividly naturalistic representations, with broad tonal contrasts of light and dark.

• As well as oil paintings, Homer produced many superb, astonishingly forceful watercolors, using rich color schemes and layering washes to create rippling avenues of light.

66 This is how nature works: cruel, maybe, but functional. It is in this context that Homer sees death, and it is this balance that turns what would be a pretty picture into a stern and beautiful one. 99

The Knight, Death, and the Devil, and Melancholia I

DÜRER

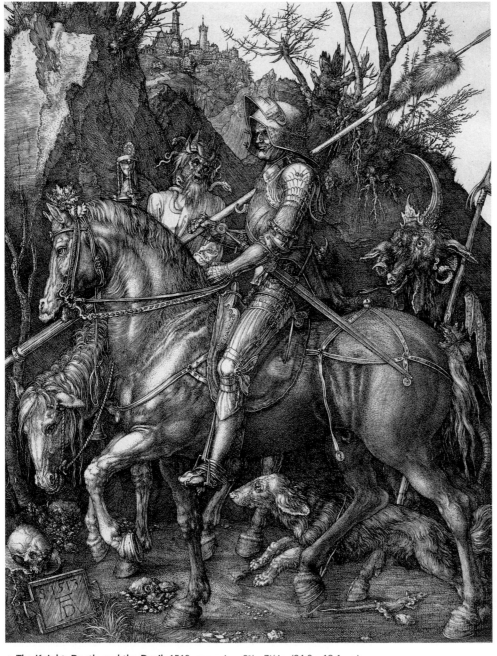

△ **The Knight, Death, and the Devil;** 1513; engraving; 9¾ x 7½ in. (24.8 x 19.1 cm)

> " Ask the art lovers of the world to vote on the greatest printmaker, and I think Rembrandt would win, but there would be a solid block of support— mine included— for Dürer. "

A sk the art lovers of the world to vote on the greatest printmaker, and I think Rembrandt would win, but there would be a solid block of support—mine included—for Dürer. There would be universal agreement, however, that among Dürer's greatest prints are *The Knight, Death, and the Devil* and *Melancholia I*.

Dürer was a complex man: proud, ambitious, and yet deeply religious. Luther's call to conscience stirred him. He saw Luther as the epitome of the Christian knight, riding out against corruption, as in the print of *The Knight, Death, and the Devil*. Dürer always referred to the print as "the Rider," because the horse was so important. He loved to understand proportions, and here he constructed the perfect horse: the supernatural, almost divine horse, bearing forward the knight of Christ. The knight looks neither to left nor right. He takes no notice of the bleak and rocky landscape, and the distance separating him from the safe city on the hill. By his side rides Death, on a very natural horse indeed—a dying horse—and he brandishes the hourglass that reminds the Christian how short a time he has left. Behind— ludicrous, futile, and ignored—trails the Devil. This was what Dürer wanted to be: a Christian knight, riding actively forward.

What he felt to be the reality was *Melancholia I*. In the 15th century, it was thought that the highest form of

melancholy was genius. This is how Dürer sees himself: a genius but inert; winged but weighted; vast but passive. Genius is the inhabitant of a magical world, where there are comets and rainbows; all forms of mathematics and science; a world of art in which living creatures run the gamut from animal (the sad dog) to angel (the little scribbling cherub). It is all too overwhelming. Genius thinks but cannot act—it is paralyzed by its own gifts.

These prints are objectively wonderful, yet they draw their power, I think, from their subjectivity, from Dürer's longing for the simplicity of the active Christian life and his sad consciousness of the complexity of his own intellectual life. His work gives us the privilege of contact with one of the greatest masters the world has known.

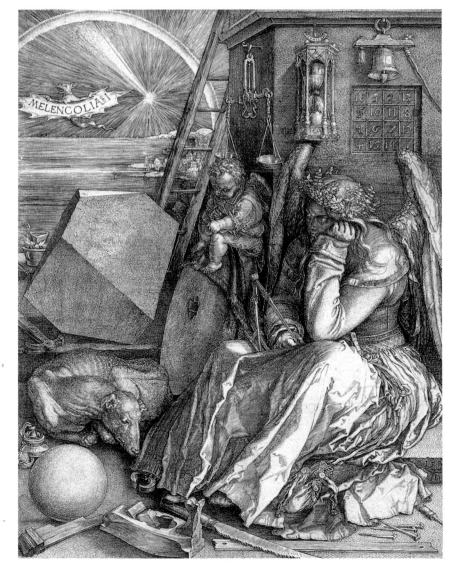

△ **Melancholia I;** 1514; engraving; 15¼ x 10½ in. (38.7 x 26.7 cm)

BIOGRAPHY

Albrecht Dürer
German, 1471–1528

• One of the greatest artists of the northern Renaissance, Dürer was a superb painter, engraver, and woodcut designer, and was instrumental in bringing the techniques and philosophies of Italian Renaissance art to northern European painting.

• He was concerned with proportion and perspective—classic occupations of the Renaissance artist—and published a number of treatises on this subject. He also published several volumes of his woodcut designs.

• Dürer's meticulous nature was ideal for producing engravings, upon which his reputation primarily rests. He revolutionized the art form by using crosshatching to create a wide range of tones and textures.

Mulholland Drive:
The Road to the Studio

HOCKNEY

△ **Mulholland Drive: The Road to the Studio;** 1980; acrylic on canvas; 86 x 243 in. (218.4 x 617.2 cm)

Hockney's painting is a feast of colors. The greens of the tree in the foreground (above left) seem to writhe over the canvas, as do the vibrant reds and opaque pinks of the plants growing in the fields (above right).

Artists can say daft things about art—their talent is in their fingers—but not David Hockney. One of Hockney's wisest remarks was that all art comes from love, and even on the surface you can see that in his huge *Mulholland Drive: The Road to the Studio* Hockney loves the United States. For a young man in austere postwar Britain, America was the magic country—and when he came here, and the farther west he came, the more at home he felt: golden sunshine, swimming pools, beautiful people. Every morning he drove down from his house in the hills to his studio in Santa Monica. In a three-week period, from memory, he painted this picture of that drive. He based it loosely on the approach of the Chinese handscroll, in which you unwind a little portion at a time, and the perspective and view is constantly changing.

Hockney structured his painting like a Chinese handscroll, which is unrolled section by section, so that the viewer is given the impression of moving through a constantly changing landscape. Hockney's road passes by eucalyptus groves, swimming pools, and tennis courts (left); travels across the length of the canvas alongside the grids of streets of Studio City and Burbank (above); before finally coming toward the viewer.

BIOGRAPHY

David Hockney
English, 1937–

• After completing his postgraduate studies at the Royal College of Art in London, the English painter and printmaker David Hockney traveled extensively in the United States. He relished his new surroundings, the glorious sunshine, and the beautiful people he met there, particularly in the west of the country, and began to use them as subject matter for his art.

• At around the same time he switched from oils to acrylics, using the new medium's intense, clear colors to produce paintings with flat, hard-edged planes of rich pigment.

• Prominent among his subject matter are figure studies and swimming pools. He has also designed stage sets and illustrated books.

You move through the landscape rather than remaining static and observing it.

Here, in typically Californian fashion, all is exposed—and the viewer does not, like the Chinese scholar, stroll. Instead, we whiz along in a fast car: this is Mulholland Drive. As we sweep over the hills with great velocity, we catch stray glimpses out of the corner of an eye: swimming pools, tennis courts, houses, groves of eucalyptus. On the other side of the road, the grid pattern of Burbank and Studio City are spread out in their conceptual outlines; from high up, I am told, this is very much what they look like. Everything glows with rich, flaring color, exuberant with Californian sunshine. It is a playful picture, and playfulness is something Hockney takes very earnestly. "If a picture isn't playful," he says, "it isn't alive. And if it isn't alive, it isn't real." So what we have here is serious play: a living reality, suffused with love.

> One of Hockney's wisest remarks was that all art comes from love, and even on the surface you can see that in his huge *Mulholland Drive: The Road to the Studio* Hockney loves the United States.

Ocean Park Series #49

DIEBENKORN

△ **Ocean Park Series #49;** 1972; oil on canvas; 93 x 81 in. (236.2 x 205.7 cm)

When it comes to abstract art, my spirits sink. It is often so beautiful and yet so difficult to talk about. In the case of Diebenkorn's *Ocean Park Series #49*, my spirits both rise and sink (a not inappropriate wave effect), because I think this series is the greatest of the 20th century—and it was painted locally, in the Ocean Park district of Santa Monica. It is not actually about Ocean Park, though many have claimed to see hints of landscape here: the light and spaciousness of California. Also, Diebenkorn is on record as saying that he is by temperament a landscape artist. However, I think we find these suggestions of landscape because we know his painting history: how he started as an abstract artist and then found he was becoming too slick, too vacant and self-centered. He needed the constraints, he felt, of the figure. He became a major figurative artist, and then dismayed his admirers by complaining that his work was "dingy."

I think he finally found the perfect compromise in the Ocean Park: the ocean, with its simplicities and immensities and changing colors; and the park, with its human constructs and its delimitations. Together they make a perfect whole, in which he is both held and set free. They are part of a series of over 140, and each is different, both in tone and in construction. There is always a scaffolding of the geometric, and an architecture; but

The juxtaposition of blocks of color helps to imbue the painting with dramatic tension.

beyond that he plays with abandon. We can often see his creative working: *pentimento*, not covered up but exposed as a kind of subtext. He was asked about this: "When I arrive at the idea," he said, "the pictures are done, and it seems a little immoral to go touching up an idea." Of course, it is more than that. These radiant subcolors give the work a sense of mystery, a feel of the unfathomability of the ocean. When I am distressed about contemporary art, I think of a work like this—so noble, so absolute in its beauty—and it is both a joy and a reassurance.

Man-Jaguar
MEXICAN

This crouching figure of a shaman-king is a were-jaguar. In Europe we have the fable of the werewolf, who looks like a man but is really a wolf, and shows his true nature in times of crisis. This shaman-king, however, had a much more lofty purpose. He is just rising into the position where he is tensed to combat evil. His skin is peeled away from his head to show his real nature: he is no longer mere man. The Olmecs had a distinctive style of sculpture: often very large, but even when small like this, always weighty and full of dignity. This figure is of dark serpentine, and would have had sparkling pyrites for eyes. They were lost—but what was not lost were the marks of cinnabar in the feline creases of the face, which show that this figure was prepared for ceremonial burial. Long, long ago, some shaman-king took this figure with him to the grave: a proof of his true nature and an eternally valid passport to the other world of the jaguar.

> " His skin is peeled away from his head to show his real nature: he is no longer mere man. "

THE SHAMAN-KINGS

For the Olmec people of early pre-Columbian America—nearly 3,000 years ago—the supreme deity was the jaguar. It was, they thought, lord of the world: strong, beautiful, agile, single-minded; living in caves that led to the other world; roaming the night with luminous eyes. A human ruler could only validate his claim to power by contact with that divine animal, which meant he had to become a shaman: a mystical figure who is in touch with the supernatural. The ruler would retreat into seclusion, fast, pray, and take mind-altering drugs, until he was lifted out of himself to encounter the jaguar god and to be transformed into a jaguar by the encounter.

◁ **Man-Jaguar;** c. 1000–600 B.C., Olmec culture; black serpentine with traces of cinnabar; 4¼ x 3⅛ in. (10.8 x 7.9 cm)

Ballgame Yoke
MEXICAN

The ballgame played a central role in pre-Columbian society, and yokes were used to protect the center of the body during play. I need hardly tell you that no one ever pranced out to play using a yoke of solid stone; these were perhaps the molds on which leather for the practical yokes was tooled. Or, wonderfully carved as they are, they could have been ritual objects. I am afraid, dear sports lovers, that I must now undermine your sense of solidarity, because ritual is the key word here. The ballgame in ancient America was not what a game is to us. It was sacred: a religious ritual, in which life fought death, light fought darkness, and the king defeated his enemies. By definition, then, the losing team were dark and deadly; they were the king's enemies—and what could their fate be but death? The captain was decapitated immediately.

The form of the yoke imitated the sacred caves that led to the underworld—to tell the players that they were entering an other-worldly state. You can see on this yoke the features of the toad, the earth-mother goddess. Her features were carved with keen-eyed reverence, because she

△ **Ballgame Yoke;** c. 600–900; rhyolite; 16½ in. (41.9 cm)

was a transforming deity. Not only was an hallucinogenic drug made from her venom, but she split her skin every two months and swallowed it, transforming herself. Anyone who played this ominous game had to be transformed into a mystic warrior: the representative of the king, in arms against the nation's foes. As you can see, there are more ways than one to play ball!

The form of the yoke imitated the sacred caves leading to the underworld, and reflects the spiritual significance of the game in pre-Columbian society.

THE SACRED BALLGAME

Of all the ancient civilizations, the pre-Columbian (Olmec, Aztec, and Maya) can seem the least emotionally accessible— they thought that to empower the sun to travel into darkness and rise again the next day, they must shed blood; and they waged war to gain victims for the sacrifice. It can seem a relief, therefore, to discover the central position in their culture of the ballgame. From Arizona to Nicaragua archeologists have found over 700 ballgame courts. The ball they used was very heavy (over 8 lb./3.6 kg), and it could only be hit with the hips and lower back, with an "assist" from elbows and knees. The center of the body therefore needed to be protected, and for this, they used yokes.

" The ballgame in ancient America was not what a game is to us. It was sacred: a religious ritual. "

Siva as Lord of the Dance

INDIAN

The first time I saw illustrations of the Indian art at LACMA, I could not remain seated—I was too moved. I had to walk off my emotion. I still struggle for breath when I contemplate Siva, Lord of the Dance: the Hindu god of destruction and creation and preservation. He is primal cosmic energy—absolute truth. He dances the world into being, and he holds it in being; one gesture from him and all that is would fly apart into nothingness. He is haloed by flames: the flames of illusion, held at a distance, because what is illusory cannot come near existential truth. In one hand he holds the real fire: the wild, purifying flame that only Siva can control. His second hand points down with infinite grace toward his feet, where he tramples the dwarf of ignorance; and even that hideous creature looks up at Siva with adoration. His third hand makes the

gesture of reassurance; and round his wrist is coiled a deadly cobra, sent against him by his enemies, but swept up into the god's dynamism. His fourth hand shakes the drum of time, which takes its beat from Siva's dance.

The figure seems so still, so eternally poised; yet the flying hair—the matted hair of an ascetic—demonstrates wild motion. There is a small goddess seated in that hair, representing the Ganges, which originally flowed in the Milky Way. When summoned to Earth, she begged Siva to break her fall, so that she would not drown the world with her flood, but separate into seven rivers.

It is said that the gods—and even the demons—sometimes catch a vision of Siva dancing, and at the sight they become revitalized. Even as mere human beings, looking at what is only a simulacrum of that dance, we can understand this.

> " The figure seems so still, so eternally poised; yet the flying hair— the matted hair of an ascetic—demonstrates wild motion. "

The goddess in Siva's hair represents the Ganges. Siva divided the mighty river into seven smaller ones when the goddess came to earth, so that she would not drown the world.

▷ **Siva as Lord of the Dance (Nataraja);** c. 950–1000; copper alloy; 30 x 22½ x 7 in. (76.2 x 57.2 x 17.8 cm)

Buddha Calling the Earth to Witness

TIBETAN

This Buddha is a rare 11th-century masterwork from Tibet. It was buried for centuries in a ruined monastery, and conservators found the marks of melted snow and rain on the body. It shows the moment when the Buddha achieved enlightenment. He had sat all night under a Bo tree, his hands folded in prayer. Then, in a moment, he saw: he understood. The powers of darkness, in the person of Mara, god of death and sensual pleasure and illusion, rose up to bar him. Buddha simply touched the earth with one hand, calling it to witness, and the earth thundered and reverberated its acclaim. Then Buddha rose from his prayer, and began his career as a preacher.

He preached the eightfold path: right intention, right opinion, right words, right concentration, right mindfulness, right action, right effort, a right way of living. This all comes down to total goodness: never hurting, never using, always being unselfish. He preached friendliness—a loving interest in others; he preached forgiveness—never minding what injuries were done him; he preached compassion; and best of all for me, he preached joy—an innocent delight in the world. Most statues of Buddha have a sweet, remote smile, but the Tibetan Buddha glints with joy. There is a sparkle here (an almost impish twinkle), as if Buddha looks upon reality—and laughs. Technically the Buddha is not divine, but I never saw a religious image that speaks to me more powerfully of the love, the strength, and the sheer joy that is of the essence of God.

> 66 Most statues of Buddha have a sweet, remote smile, but the Tibetan Buddha glints with joy. 99

BUDDHA'S SEARCH FOR TRUTH

Buddha was born roughly 500 years before Christ, an Indian prince of a warrior clan, whose father was determined that his son would never know unhappiness. Not until his late twenties did he encounter suffering, in the form of an old man, a sick man, a corpse, and a monk. He at once grasped the implication that life is hard and painful. The only one to escape the misery of life was the monk, whose happiness rested upon eternal truth. The prince left the palace, stripped himself of everything, put on a monk's habit, and set out to seek that truth. This Tibetan image shows the moment when he attained it and entered the state of pure enlightenment.

Picture Credits

HarperCollins Publishers and Rose Publishing would like to thank the following for their kind permission to reproduce images in this book. Please note that the six museums featured in the book are listed in chapter order; additional picture sources are listed at the end. Unless stated otherwise, the page references indicate reproductions of the images in full, not details.

CHAPTER 1: COPYRIGHT © THE METROPOLITAN MUSEUM OF ART. ALL RIGHTS RESERVED.

p7 (below) & p35: Fragmentary Head of a Queen; 1352–1336 B.C., 18th dynasty, reign of Amenhotep IV/Akhenaten; Egyptian, New Kingdom; yellow jasper; height 5½ in. (14 cm); purchase, Edward S. Harkness Gift, 1926 (26.7.1396); photograph by Bruce White

pp10–11 (detail), p36 (in full) & p37 (three details): The Harvesters; 1565; Pieter Bruegel the Elder, Netherlandish (c. 1530–69); oil on wood; 46½ x 63¼ in. (118 x 160.7 cm); Rogers Fund, 1919 (19.164)

p12 (above): Exterior view of the southeast entrance to the Metropolitan Museum of Art, New York

p12 (below): Amphora, Side A: Kithara Player; c. 490 B.C.; Greek, Attic, attributed to the Berlin Painter; terracotta; height 16⅜ in. (41.6 cm); Fletcher Fund, 1956 (56.171.38)

p13 (left): The Book of Hours of Jeanne d'Evreux, Folio 16r: The Annunciation; 1325–28; Jean Pucelle, French (c. 1300–c. 1355); grisaille and color on vellum; 3½ x 2½ in. (8.9 x 6.4 cm); The Cloisters Collection, 1954 (54.1.2)

p13 (right): Mary and Michael Jaharis Gallery for Greek Art of the 6th–4th centuries B.C.

pp14 (in full) & p15 (detail): Juan de Pareja; c. 1650; Diego Velázquez, Spanish (1599–1660); oil on canvas; 32 x 27½ in. (81.3 x 69.9 cm); Fletcher Fund, Rogers Fund, and Bequest of Miss Adelaide Milton de Groot (1876–1967), by exchange, supplemented by gifts

from friends of the Museum, 1971 (1971.86)

pp16 (in full) & p17 (detail): Aristotle with a Bust of Homer; 1653; Rembrandt van Rijn, Dutch (1606–69); oil on canvas; 56½ x 53¾ in. (143.5 x 136.5 cm); purchase, special contributions and funds given or bequeathed by friends of the Museum, 1961 (61.198)

p18 (in full plus detail): Seated Gudea; c. 2150–2100 B.C., Neo-Sumerian period; south Mesopotamian, probably Tello (ancient Girsu); diorite; height 17⅜ in. (44.1 cm); Harris Brisbane Dick Fund, 1959 (59.2)

p19 (in full plus detail): Standing Male Figure; c. 2750–2600 B.C., Early Dynastic II period; south Mesopotamian, Tell Asmar, Square Temple, Shrine II; white gypsum; height 11⅝ in. (29.5 cm); Fletcher Fund, by exchange, 1940 (40.156)

p20: Hatshepsut Enthroned; c. 1503–1482 B.C., 18th dynasty; Egyptian, Thebes, Deir el Bahri, Temple of Hatshepsut; painted indurated limestone; height 76¾ in. (194.9 cm); Rogers Fund and contribution from Edward S. Harkness, 1929 (29.3.2)

p21 (below left): Sphinx of Hatshepsut; c. 1503–1482 B.C., 18th dynasty; Egyptian, Thebes; red granite; height 64½ in. (164 cm), length as restored 135 in. (343 cm); Rogers Fund, 1931 (31.3.166)

p21 (above right): Osiride Head of Hatshepsut (originally from a statue); c. 1503–1482 B.C., 18th dynasty; Egyptian, Thebes, Deir el Bahri; painted limestone; height with crown 49 in. (124.5 cm); Rogers Fund, 1931 (31.3.157)

p22: Aquamanile: Aristotle and Phyllis; c. 1400; French, Meuse valley; Mosan metalwork; bronze; height 13¼ in. (33.5 cm); Robert Lehman Collection, 1975 (1975.1.1416)

p23: Kneeling Bull Holding Vessel; c. 2900 B.C., Proto-Elamite period;

southwest Iranian; silver; height 6⅜ in. (16.3 cm), width 2½ in. (6.3 cm); purchase, Joseph Pulitzer Bequest, 1966 (66.173)

p24 (two details) & p25 (in full): Ugolino and His Sons; 1865–67; Jean-Baptiste Carpeaux, French (1827–75); Saint-Béat marble; height 77 in. (195.6 cm); purchase, the Josephine Bay Paul and C. Michael Paul Foundation, Inc., and the Charles Ulrich and Josephine Bay Foundation, Inc., gifts, 1967 (67.250)

p26 (in full plus detail) & p27 (detail): The Rape of Persephone; c. 1750; Gaspero Bruschi, Italian (c. 1701–80), for Doccia porcelain factory, Florence, Italy, after a model by Giovanni Battista Foggini, Italian (1652–1725); hard-paste porcelain; height 19⅜ in. (49.2 cm); purchase, gift of Irwin Untermyer, by exchange, 1997 (1997.377)

p28 (left and center figures): Harlequin and Columbine; c. 1760; Franz Anton Bustelli, German (1723–63), for Nymphenburg porcelain factory, Germany; hard-paste porcelain; height 8 in. (20.3 cm) and 7⅞ in. (20 cm); the Lesley and Emma Sheafer Collection, Bequest of Emma A. Sheafer, 1973 (1974.356.524-.525)

p28 (right): Columbine; c. 1757; Franz Anton Bustelli, German (1723–63), for Nymphenburg porcelain factory, Germany; hard-paste porcelain; height 8⅝ in. (21.9 cm); gift of R. Thornton Wilson, in memory of Florence Ellsworth Wilson, 1950 (50.211.251)

p29: Donna Martina (left), Pantaloon (center), and Lucinda (right); c. 1760; Franz Anton Bustelli, German (1723–63), for Nymphenburg porcelain factory, Germany; hard-paste porcelain; height 7½ in. (19.1 cm), 6¾ in. (17.1 cm), and 8⅛ in. (20.6 cm) respectively; the Lesley and Emma Sheafer Collection, Bequest of Emma A. Sheafer, 1973 (1974.356.521, .526, .802)

p30 (in full) & p31 (two details): Mezzetin; 1717–19; Jean-Antoine Watteau, French (1684–1721); oil on canvas; 21¾ x 17 in. (55.2 x 43.2 cm); Munsey Fund, 1934 (34.138)

p32: Bis Poles; 20th century, Asmat people; Oceanic, Irian Jaya (New Guinea), between the Asewetsj and Sirotsj rivers; wood, lime, charcoal, ocher, and fiber; the Michael C. Rockefeller Memorial Collection, Bequest of Nelson A. Rockefeller, 1979 (1979.206.1611)

p33: Head of an Iyoba (Head of a Queen Mother); 18th–19th century, Court of Benin; African, Nigeria, Edo; brass and iron; height 21 in. (53.3 cm); Gift of Mr. and Mrs. Klaus G. Perls, 1991 (1991.17.146)

p34: Head of a Dignitary; c. 2000 B.C.; Iranian; arsenical copper; height 13½ in. (34.3 cm); Rogers Fund, 1947 (47.100.80)

p38 (in full) & p39 (detail): The Mountain; 1937; Balthus, French (1908–); oil on canvas; 98 x 144 in. (248.9 x 365.8 cm); purchase, Gifts of Mr. and Mrs. Nate B. Spingold and Nathan Cummings, Rogers Fund and the Alfred N. Punnett Endowment Fund, by exchange, and Harris Brisbane Dick Fund, 1982 (1982.530); © ADAGP, Paris and DACS, London 2000

p40 (in full) & pp42–43 (three details): Triptych with the Annunciation; c. 1425; Robert Campin, Netherlandish (c. 1373–1444); oil on wood; central panel 25¼ x 24⅞ in. (64.1 x 63.2 cm), each wing 25⅜ x 10¾ in. (64.5 x 27.3 cm); The Cloisters Collection, 1956 (56.70)

p41 (in full plus two details): The Cloisters Cross; 12th century; English, probably made in Bury St. Edmunds; walrus ivory with traces of polychromy; 22⅝ x 14¼ in. (57.5 x 36.2 cm); The Cloisters Collection, 1963 (63.12); details photographed by Malcolm Varon

p44 (two details) & p45 (in full): Mihrab; c. 1354; Iranian; composite body, glazed, sawed to shape, and

assembled in mosaic; 11 ft. 3 in. x 7 ft. 6 in. (3.4 x 2.9 meters); Harris Brisbane Dick Fund, 1939 (39.20)

p46: Page from the Koran, in Maghribi script; c. 1300; north African, Islamic; ink, colors, and gold on parchment; 21 x 22 in. (53.3 x 55.9 cm); Rogers Fund, 1942 (42.63)

p47: Tughra (calligraphic emblem) of Suleyman the Magnificent, Sultan of Turkey (reigned 1520–66), from an imperial edict; mid-16th century, Ottoman period; Turkish, Istanbul; gouache and gold leaf on paper; 20½ x 25⅜ in. (52.1 x 64.5 cm); Rogers Fund, 1938 (38.149.1)

pp48–49 (in full, below) & p49 (two details, above): The Horse Fair; 1852–55; Rosa Bonheur, French (1822–99); oil on canvas; 96¼ x 199½ in. (244.5 x 506.7 cm); Gift of Cornelius Vanderbilt, 1887 (87.25)

p50 (in full) & p51 (two details, above): Young Woman Drawing; 1801; Marie-Denise Villers, French (1774–1821); oil on canvas; 63½ x 50⅜ in. (161.3 x 128.6 cm); Mr. and Mrs. Isaac D. Fletcher Collection, Bequest of Isaac D. Fletcher, 1917 (17.120.204)

p51 (below): Atelier of a Painter, probably Madame Vigée Le Brun (1755–1842), and Her Pupil; c. 1796; Marie Victoire Lemoine, French (1754–1820); oil on canvas; 45⅜ x 35 in. (116.5 x 88.9 cm); Gift of Mrs. Thorneycroft Ryle, 1957 (57.103)

p52 (in full plus detail): Kouros (Statue of a Youth); c. 590–580 B.C.; Archaic Greek, Attic; Naxian marble; height without plinth 76 in. (193 cm); Fletcher Fund, 1932 (32.11.1)

p53 (in full plus detail): Grave Stele, of a youth and a little girl with a finial in the form of a sphinx; c. 530 B.C.; Archaic Greek, Attic; marble; 13 ft. 11 in. (4.2 meters); Frederick C. Hewitt Fund, 1911, Rogers Fund, 1921, Munsey Funds, 1936, 1938, and Anonymous Gift, 1951 (11.185a–d,f,g,x)

p54 (in full) & p55 (two details): Allegory of the Faith; c. 1670; Johannes Vermeer, Dutch (1632–75); oil on canvas; 45 x 35 in. (114.3 x 88.9 cm); the Friedsam Collection, Bequest of Michael

Friedsam, 1931 (32.100.18)

p56: A Maid Asleep; 1656–57; Johannes Vermeer, Dutch (1632–75); oil on canvas; 34½ x 30⅛ in. (87.6 x 76.5 cm); Bequest of Benjamin Altman, 1913 (14.40.611)

p57: Young Woman with a Water Jug; c. 1660–67; Johannes Vermeer, Dutch (1632–75); oil on canvas; 18 x 16 in. (45.7 x 40.6 cm); Gift of Henry G. Marquand, 1889, Marquand Collection (89.15.21)

p58: Woman with a Lute; early 1660s; Johannes Vermeer, Dutch (1632–75); oil on canvas; 20¼ x 18 in. (51.4 x 45.7 cm); Bequest of Collis P. Huntington, 1900 (25.110.24)

p59: Portrait of a Young Woman; c. 1665–67; Johannes Vermeer, Dutch (1632–75); oil on canvas; 17½ x 15¾ in. (44.5 x 40 cm); Gift of Mr. and Mrs. Charles Wrightsman, in memory of Theodore Rousseau, Jr., 1979 (1979.396.1)

CHAPTER 2: COPYRIGHT © THE MUSEUM OF FINE ARTS, BOSTON. ALL RIGHTS RESERVED.

p7 (center) & p83 (both sides): Sons of Liberty Bowl; 1768; Paul Revere II, American (1735–1818); silver; height 5½ in. (14 cm), diameter of lip 11 in. (27.9 cm); Gift by Subscription and Francis Bartlett Fund (49.45)

pp60–61 (detail), p74 (in full) & p75 (two details): The Daughters of Edward Darley Boit; 1882; John Singer Sargent, American (1856–1925); oil on canvas; 87⅜ x 87⅜ in. (221.9 x 222.6 cm); Gift of Mary Louisa Boit, Julia Overing Boit, Jane Hubbard Boit, and Florence D. Boit in memory of their father, Edward Darley Boit (19.124)

p62 (above): Exterior view of the entrance to the Museum of Fine Arts, Boston

p62 (below left): Standing Figure; 1969–84; Willem de Kooning, American (1904–97); bronze, edition 4 of 7; 148 x 252 x 80 in. (375.9 x 640.1 x 203.2 cm); The Gund Art Foundation (0229.1996); © ARS, NY and DACS, London 2001

p62 (below right): Appeal to the Great Spirit; 1909; Cyrus Edwin

Dallin, American (1861–1944); bronze, green patina, lost cast wax; 122 x 102½ x 43¾ in. (309.9 x 260.3 x 111.1 cm); Gift of Peter C. Brooks and Others (13.380)

p63 (left): Madonna of the Clouds; c. 1425–35; Donatello, Italian (c. 1386–1466); marble; 13 x 12⅝ in. (33.1 x 32 cm); Gift of Quincy Adams Shaw through Quincy A. Shaw, Jr., and Mrs. Marian Shaw Haughton (17.1470)

p63 (right): Pair Statue of Mycerinus and Queen Kha-merer-nebty II; c. 2548–2530 B.C., 4th dynasty; Egyptian, Giza, Valley Temple of Mycerinus; graywacke; height 54½ in. (139 cm), base 22½ x 21¼ in. (57 x 54 cm); Harvard-Museum Expedition (11.1738)

pp64–5 (in full) & p65 (detail of upper door jamb, right): The Oak Hill Rooms, Elizabeth Derby West's home in Danvers, Massachusetts, U.S.; 1800–01

p65 (detail, inset): Cornice in the Oak Hill Rooms, Elizabeth Derby West's home in Danvers, Massachusetts, U.S.; early 19th century; American; wood and gilt; Gift of Miss Martha C. Codman (22.811)

p66 (above): The Oak Hill Parlor; Elizabeth Derby West's home in Danvers, Massachusetts, U.S.; 1800–01

p65 (detail): Neoclassical Side Chair in the Oak Hill Rooms, Elizabeth Derby West's home in Danvers, Massachusetts, U.S.; 1790–1800; design and carving attributed to Samuel McIntire, American (1757–1811); mahogany; M. and M. Karolik Collection (23.27)

p67 (in full plus detail): Chest-on-Chest; 1782; John Cogswell, American (1738–1818); mahogany and white pine; 89½ x 43½ x 23½ in. (227.3 x 110.5 x 59.7 cm); William Francis Warden Fund (1973.289)

p68 (above): Scholar's Table Screen with the Image of a Rock; 18th century, Qing dynasty; Chinese; Dali marble with wood stand; on loan from Richard Rosenblum (270.1997)

p68 (below left): "Rock" Album; 1893; Hankei, Japanese; ink on paper; Private Collection (255.1997)

p68 (below right): Spirit Rock; 18th–19th century, Qing dynasty; Chinese; white-veined lingbi rock with wood stand; Private Collection (255.1997)

p69 (above): Water Dropper in the Shape of a Peach with a Parrot; 13th century, Southern Song dynasty; Chinese; Qingbai ware, porcelain with "white" glaze and molded decoration; Edward S. Morse Memorial Collection, 1976 (1976.25)

p69 (below): Brush Holder; 1723–35, Qing dynasty, Yonghzhen period; Chinese; carved glass with auspicious symbols in red; 4¾ x 4⅝ in. (12 x 11.9 cm); Gift of Paul and Helen Bernat (1986.643)

p70 (above): Snuff Bottle; 19th century, Qing dynasty; Chinese; jade with gold-rimmed jade stopper; 2⅜ x 1⅞ in. (6.2 x 4.9 cm); Bequest of Dudley Leavitt Pickman (39.717)

p70 (below): Jade in the Shape of Mountains Brush Rest; Chinese; pale green nephrite with wood stand; Private Collection (272.1997)

p71: Bowl; late 6th century, Northern Qi dynasty; Chinese; stoneware with light yellow glaze over white slip; height 5⅜ in. (13.5 cm), diameter of mouth 5⅛ in. (13 cm); Helen S. Coolidge Fund (1990.120)

p72: Jar; 700–750, Tang dynasty; Chinese; glazed earthenware with geometric decoration in cobalt blue and copper green; height 11 (28.2 cm), diameter 10¼ in. (26.9 cm); Chalres B. Hoyt Collection (50.879)

p73 (interior and exterior): Tea Bowl; late 12th century, Southern Song dynasty; Chinese; Jizhou stoneware with mottled black and brown glazes, and reserved decoration of bird and flower; diameter of mouth: 5⅞ in. (14.9 cm); William Sturgis Bigelow Collection (98.12)

p76 (above): Mimbres Bowl; 1000–1150, Mogollon culture; American, southwestern New Mexico, Mimbres River Valley; Mimbres classic black-on-white style II, painted earthenware; height 4¾ in. (12.1 cm), diameter 11¼ in. (28.6 cm); Seth K. Sweetser Fund No. 1 and Gift of the Supporters of

the Department of American Decorative Arts and Sculpture (1990.248)

p76 (below): Mimbres Pot; 1985; Pablita Concho, American, (c. 1900–c. 1990); Acoma Pueblo, New Mexico; painted earthenware; height 6 in. (15.2 cm), diameter 7 in (17.8 cm); Gift of a Friend of the Department of American Decorative Arts and Sculpture (1985.449)

p77 (above): Basket with Lid; 1992; Mary A. Jackson, American (1945–); plant fiber/grass; height 17 in. (43.2 cm), diameter 18 in. (45.7 cm); Gift of Charles Devens, Mrs. Frances W. Lawrence, and The Seminarians (1992.523)

p77 (below): Jar; 1857; Dave the Potter, for Lewis Miles Pottery; stoneware with alkaline glaze; height 19 in. (48.3 cm), diameter 17¾ in. (45.1 cm); Otis Norcross Fund and Harriet Otis Cruft Fund (1997.10)

p78 (two details) & p79 (in full): St. Francis; c. 1640–45; Francisco de Zurbarán, Spanish (1598–1664); oil on canvas; 81½ x 42 in. (207 x 106.7 cm); Herbert James Pratt Fund (38.1617)

p80 (in full) & p81 (two details): Fray Hortensio Félix Paravicino; 1609; El Greco, Greek (1541–1614); oil on canvas; 44⅛ x 33⅞ in. (112 x 86.1 cm); Isaac Sweetser Fund (04.234)

p82 (in full plus detail of medallion): Grand Piano; 1796; case decoration designed by Thomas Sheraton, English (1751–1806), for John Broadwood & Son, London; veneered case of satinwood, tulipwood, and purpleheart with Wedgwood cameos and medallions; piano 97⅛ x 43⅞ x 35⅞ in. (248.7 x 111.5 x 91.2 cm); detail of lilac Wedgewood medallion c. 3 in. (7.6 cm) across; George Alfred Cluett Collection, given by Florence Cluett Chambers (1985.924)

p84 (in full) & p 85 (two details): Paul Revere; 1768; John Singleton Copley, American (1738–1815); oil on canvas; 85⅛ x 28½ in. (89.2 x 72.4 cm); Gift of Joseh W. Revere, William B. Revere, and Edward H. R. Revere (80.781)

p86 (in full) & p87 (two details): The Mystic Marriage of St. Catherine; c. 1340; Barna da Siena, Italian (active mid-14th century); tempera on panel; panel 54⅝ x 43¾ in. (138.9 x 111 cm), design 53⅛ x 42⅛ in. (134.8 x 107.1 cm); Sarah Wyman Whitman Fund (15.1145)

pp88–9 (in full) & pp90–1 (three details): Where Do We Come From? What Are We? Where Are We Going? (D'où venons-nous? Que sommes-nous? Où allons-nous?); 1897; Paul Gauguin, French (1848–1903); oil on canvas; 54¾ x 147½ in. (139.1 x 374.6 cm); Tompkins Collection (36.270)

p92: Yakshi (Torso of a Fertility Goddess); c. 25 B.C.–A.D. 25; central Indian, Madya Pradesh, Sanchi, from a gateway of the Great Stupa (Stupa 1); sandstone; height 28⅜ in. (72 cm); Denman Waldo Ross Collection (29.999)

p93 (in full plus detail): Architecture; late 16th century; Giambologna, Flemish (1529–1608); bronze; height 14¼ in. (36.2 cm); The Maria Antoinette Evans Fund and 1931 Purchase Fund (40.23)

p94: A Portrait—Georgia O'Keeffe; 1918; Alfred Stieglitz, American (1864–1946); palladium print; 9⅛ x 7½ in. (23.3 x 19.1 cm); Gift of Alfred Stieglitz (24.1724)

p95: White Rose with Larkspur No. 2; 1927; Georgia O'Keeffe, American (1887–1986); oil on canvas; 40 x 30 in. (101.6 x 76.2 cm); Henry H. and Zoë Oliver Sherman Fund (1980.207); © ARS, NY and DACS, London 2001

pp96–7 (in full) & p97 (two details): Approaching Storm: Beach Near Newport; 1867; Martin Johnson Heade, American (1819–1904); oil on canvas; 28 x 58¼ in. (71.1 x 148 cm); Gift of Mrs. Maxim Karolik for the M. and M. Karolik Collection of American Paintings, 1815–65 (45.889)

p98–9 (two views): The Garden Tenshin-en (The Garden of the Heart of Heaven); dedicated on October 24, 1988, to the memory of Okakura Kakuzo; Donated by the Nippon Television Network Corporation, Chairman of the Board, Mr. Yosoji Kobayashi (89.23)

pp100–1: Seven Forms; 1982; Dale Chihuly, American (1941–); glass; Basket Form (p100 below left) 2 x 7 in. (5.1 x 17.8 cm); Four Basket Forms (p100 above), large basket: 6⅛ x 23 x 24½ in. (15.5 x 58.4 x 62.2 cm), three baskets within: 8 x 4 x 3⅜ in. (20.3 x 10.1 x 14.3 cm), 8½ x 14 x 10 in. (21.6 x 35.5 x 25.4 cm), 7 x 14 x 10½ in. (17.8 x 35.5 x 26.6 cm); Pouch Form (p101 above) 6 x 5½ x 4½ in. (15.2 x 14 x 11.4 cm); Sea Urchin Form 2 x 7 in. (5.1 x 17.8 cm); Gift of Michael J. Bove III (1983.518-24)

p102: Glass V; 1978, Roy Lichtenstein, American (1923–97); painted and patinated bronze; 69¾ x 26½ x 17¾ in. (177.2 x 67.3 x 45.1 cm); Private Collection (0188.1986); © Estate of Roy Lichtenstein/DACS 2001

p103 (above): Settee; 1979; Wendell Castle, American (1932–); cherry; 58 x 36 x 24 in. (147.3 x 91.4 x 61 cm); Purchased through funds provided by the National Endowment for the Arts and the Deborah M. Noonan Foundation (1979. 266)

p103 (below): Settee; 1975; Sam Maloof, American (1916–); walnut; 30¼ x 42½ in. (76.8 x 108 cm); Purchased through funds provided by the National Endowment for the Arts and the Gillette Corporation (1976.113)

CHAPTER 3: COPYRIGHT © ART INSTITUTE OF CHICAGO. ALL RIGHTS RESERVED.

p7 (above) & pp112–13 (in full above, plus detail below left): A Sunday on La Grande Jatte—1884; 1884–86; Georges Pierre Seurat, French (1859–91); oil on canvas; 81¾ x 121¼ in. (207.6 x 308 cm); Helen Birch Bartlett Memorial Collection (1926.224)

pp104–5 (detail), p136 (detail, below) & pp136–7 (in full, above): Nighthawks; 1942; Edward Hopper, American (1882–1967); oil on canvas; 33⅛ x 60 in. (84.1 x 152.4 cm); Friends of American Art Collection (1942.51)

p106: Exterior view of the Michigan Avenue entrance to the Art Institute of Chicago; photographed August 1990 by Thomas Cinoman

p107 (above): The Assumption of the Virgin; 1577; El Greco, Greek (1541–1614); oil on canvas; 158 x 90 in. (401.4 x 228.7 cm); Gift of Nancy Atwood Sprague in memory of Albert Arnold Sprague (1906.99)

p107 (below): Teardrop I; 1996; Magdalene Odundo, Kenyan (1950–); ceramic; 23⅝ x 19⅞ in. (60 x 48 cm); Harriott A. Fox Endowment (1997.63)

p108 (two details) & p109 (in full): Lady Sarah Bunbury Sacrificing to the Graces; 1763–65; Sir Joshua Reynolds, English (1723–92); oil on canvas; 95¼ x 59⅝ in. (242.6 x 151.5 cm); Mr. and Mrs. W. W. Kimball Collection (1922.4468)

p110 (in full) & p111 (two details, above center and below left): Acrobats at the Cirque Fernando (Francisca and Angelina Wartenberg); 1879; Pierre Auguste Renoir, French (1841–1919); oil on canvas; 51¾ x 39½ in. (131.5 x 99.5 cm); Potter Palmer Collection (1922.440)

p113 (below right): Seated Woman with a Parasol; 1884; Georges Pierre Seurat, French (1859–91); study for A Sunday on La Grande Jatte in black conté crayon on ivory laid paper; sheet 18¾ x 12⅜ in. (47.7 x 31.5 cm); Bequest of Abby Aldrich Rockefeller (1999.7)

p114 (in full plus detail) & p115 (two details): The Mocking of Christ; 1865; Édouard Manet, French (1832–83); oil on canvas; 74⅞ x 58⅜ in. (190.8 x 148.3 cm); Gift of James Deering (1925.703)

p116: Rinaldo Enchanted by Armida; 1742–45; Giovanni Battista Tiepolo, Italian (1696–1770); oil on canvas; 73⅜ x 85⅜ in. (187.5 x 216.8 cm); Bequest of James Deering (1925.700)

p117 (above): Rinaldo and Armida in Her Garden; 1742–45; Giovanni Battista Tiepolo, Italian (1696–1770); oil on canvas; 73⅜ x 102⅛ in. (186.9 x 259.5 cm); Bequest of James Deering (1925.699)

p117 (below): Armida Abandoned by Rinaldo; 1742–45; oil Giovanni Battista Tiepolo, Italian (1696–1770); on canvas; 73⅜ x 102⅛ in. (186.9 x 259.5 cm); Bequest of James Deering (1925.701)

p118: Rinaldo and the Magus of Ascalon; 1742–45; Giovanni Battista Tiepolo, Italian (1696–1770); oil on canvas; 71⅞ x 72 in. (182.4 x 182.9 cm); Bequest of James Deering (1925.702)

p119: Sanctuary; 1982; Martin Puryear, American (1941–); wood and mixed materials; 126⅞ x 27½ x 18 in. (320 x 70 x 45.7 cm); Mr. and Mrs. Frank G. Logan Prize Fund (1982.1473)

p120 (in full) & p121 (two details): Salome with the Head of St. John the Baptist; 1639–40; Guido Reni, Italian (1575–1642); oil on canvas; 97¾ x 88½ in. (248.5 x 224.8 cm); Louise B. and Frank H. Woods Purchase Fund (1960.3)

p122 (in full) & p123 (two details): Madame de Pastoret and Her Son; 1791–92; Jacques Louis David, French (1748–1825); oil on canvas; 51⅛ x 38⅛ in. (129.8 x 96.6 cm); Clyde M. Carr Fund and Major Acquisitions Endowment (1967.228)

p124 (in full) & p125 (two details): Amédée-David, Marquis de Pastoret; 1823–26; Jean Auguste Dominique Ingres, French (1780–1867); oil on canvas; 40½ x 32¾ in. (103 x 83.5 cm); Estate of Dorothy Eckhart Williams; Robert Allerton, Bertha E. Brown, and Major Acquisitions Endowments (1971.452)

p126 (two details) & p127 (in full): Cupid Chastised; 1605–10; Bartolomeo Manfredi, Italian (c. 1580–c. 1620); oil on canvas; 69 x 51⅜ in. (175.3 x 130.6 cm); Charles H. and Mary F. S. Worcester Collection (1947.58)

p128: Entertainer; 6th century, Northern dynasties; Chinese tomb figure; buff earthenware with pigment, 10⅝ x 10 in. (27 x 25.4 cm); Gift of Stanley Herzman in memory of Gladys Wolfson Herzman (1997.369)

p129: Equestrienne; 700–50, Tang dynasty; Chinese tomb figure; buff earthenware with traces of polychromy; 22⅛ x 19 in. (56.2 x 48.2 cm); Gift of Mrs. pauline Palmer Wood (1970.1073)

p130: Celadon Ewer; 12th century, Koryo dynasty; Korean; stoneware with celadon glaze and incised decoration; 8⅜ x 7 x 5¼ in. (21.4 x 17.7 x 13.2 cm); Bequest of Russell Tyson (1964.1213)

p131 (both sides): Carved Flask; 15th century, Choson dynasty; Korean; Punch'ong ware, stoneware with carved slip decoration; 8¾ x 7⅞ x 5⅛ in. (22.3 x 20.2 x 13.1 cm); Bequest of Russell Tyson (1964.936)

p132: Tea Ceremony Jar; late 16th century, Momoyama period; Japanese; Iga ware, natural glazed stoneware; height 13 in. (33 cm), diameter 9⅝ in. (24.5 cm); Gifts of Josephine P. Albright in memory of Alice Higinbothem Patterson, Mrs. Tiffany Black, John Carlson, Mrs. Kent S. Clow, Edith Farnsworth, Alfred E. Hamill, and Mrs. Charles S. Potter and Mrs. Hunnewell in memory of Mrs. Freeman Hinkley, through exchange (1987.146)

p133: Ceremonial Knife (Tumi); 1200–1470, Chimu culture; Peruvian, north coast; gold and turquoise, 13⅜ x 5 in. (34 x 12.7 cm); Ada Turnbull Hertle Fund (1963.841)

p134 (in full) & p135 (detail): City Landscape; 1955; Joan Mitchell, American (1926–92); oil on canvas; 80 x 80 in. (203.2 x 203.2 cm); Gift of The Society for Contemporary American Art (1958.193)

p138 (in full) & p139 (three details): American Gothic; 1930; Grant Wood, American (1891–1942); oil on beaverboard; 29¼ x 24⅝ in. (74.3 x 62.4 cm); Friends of American Art Collection, All rights reserved by The Art Institute of Chicago and VAGA, New York, NY (1930.934)

p141 (right): Woman Descending the Staircase; 1965; Gerhard Richter, German (1932–); oil on canvas; 79 x 51 in. (200.7 x 129.5 cm); Roy J. And Frances R. Friedman Endowment; Gift of Lannan Foundation (1997.176)

p142 (left): Ice (1); 1989; Gerhard Richter, German (1932–); oil on canvas; 80 x 64 in. (203.2 x 162.6 cm); Through prior gift of Joseph Winterbotham; Gift of Lannan Foundation (1997.167); photograph by Susan Einstein

p142–3 (center): Ice (2); 1989; Gerhard Richter, German (1932–); oil on canvas; 80 x 64 in. (203.2 x 162.6 cm); Through prior gift of Joseph Winterbotham; Gift of Lannan Foundation (1997.168); photograph by Susan Einstein

p143 (above right): Ice (3); 1989; Gerhard Richter, German (1932–); oil on canvas; 80 x 64 in. (203.2 x 162.6 cm); Through prior gift of Joseph Winterbotham; Gift of Lannan Foundation (1997.169); photograph by Susan Einstein

p143 (below right): Ice (4); 1989; Gerhard Richter, German (1932–); oil on canvas; 80 x 64 in. (203.2 x 162.6 cm); Through prior gift of Joseph Winterbotham; Gift of Lannan Foundation (1997.170); photograph by Susan Einstein

p144: Meissen Tureen and Stand; 1737; modeled by Johann Joachim Kändler, German (1706–75), for the Meissen porcelain factory, Germany; hard-paste porcelain with polychrome enamels, gilding, and ormolu mounts; bowl 11 x 17½ x 10 in. (27.9 x 44.5 x 25.4 cm), stand 6 x 26 x 20 in. (15.2 x 66 x 50.8 cm); Decorative Arts Purchase Fund, Atlan Ceramic Fund, Buckingham Lustre Fund (1958.405a-f); group shot with 1984.1228a-b, 1984.1229a-b, and 1998.504a-b photographed by Robert Hashimoto

p145: Sugar Caster and Cover; 1737; modeled by Johann Joachim Kändler, German (1706–75), for the Meissen porcelain factory, Germany; hard-paste porcelain with enamel decoration and gilding; height 7⅞ in. (19.5 cm); Edward Byron Smith, Jr. Charitable Fund, Louise D. Smith, Robert Allerton, Mrs. Edward I. Rothschild, and R. T. Crane, Jr., Funds (1984.1228a-b); photographed by Robert Hashimoto

p146 (interior) & p147 (exterior): Du Paquier Gaming Set; c. 1735–40; produced by the Du Paquier porcelain factory (active 1718–44), Austria; hard-paste porcelain with polychrome enamels, gilded mounts, and diamonds; 6⅝ x 5⅞ in. (16.8 x 14.8 cm); Eloise W. Martin Fund, Richard T. Crane and Mrs. J. Ward Thorne endowments, through prior gift of The Antiquarian Society (1993.349)

p148: Monumental Seated Ancestor Figure; 250–550, Early Classic period; Mexican, Veracruz, Remojadas culture; terracotta; 34 x 26 in. (86.4 x 66 cm); Gift of Mr. and Mrs. Thomas H. Dittmer, Major Acquisitions Centennial Endowment (1995.429)

p149: Ceremonial Drum (Pinge); 1930–50, Senufo people; African, Ivory Coast; wood, hide, and applied color; 48⅜ x 19⅜ in. (122.9 x 49.2 cm); Robert J. Hall, Herbert R. Molner Discretionary, Curator's Discretionary, and the Africa, Oceania, and the Americas Purchase Funds, Arnold Crane, Mrs. Leonard Florsheim, O. Renard Goltra, Holly and David Ross, Africa, Oceania, and the Americas Acquisitions, Ada Turnbull Hertle, Marion and Samuel Klasstorner Endowments, through prior gifts of various donors (1990.137); photograph by Robert Hashimoto

p150 (two details) & pp150–1 (in full): The America Windows; 1977; Marc Chagall, Russian (1887–1985); stained glass; Gift of the City of Chicago and the Auxiliary Board of The Art Institute of Chicago commemorating the American Bicentennial in memory of Mayor Richard J. Daley (1977.938); © ADAGP, Paris and DACS, London 2000

CHAPTER 4: COPYRIGHT © THE CLEVELAND MUSEUM OF ART. ALL RIGHTS RESERVED.

p8 (above) & p191: Portrait of the Zen Master Hotto Kokushi; c. 1286, Kamakura period; Japanese; wood with hemp, cloth, black lacquer, and iron clamps; height 36 in. (91.4 cm); Leonard C. Hanna, Jr., Fund (1970.67)

pp152–3 (detail), p160 (in full) & p161 (three details): The Holy Family on the Steps; 1648; Nicolas Poussin, French (c. 1594–1665); oil on canvas; 28½ x 44 in. (72.4 x 111.7 cm); Leonard C. Hanna, Jr., Fund (1981.18)

p154 (above): Guelph Treasure: Medallion with the Bust of Christ; late 700s; German, Weserraum; cloisonné enamel on copper; height 2 in. (5 cm); Purchase from the J. H. Wade Fund (1930.504)

p154 (below): View of the south façade of the Cleveland Museum of Art, architects Hubbell and Benes, 1916, and the Fine Arts Garden with Fountain of the Waters by

Chester Beach, marble, 1928 (owned by the city of Cleveland)

p155 (far left): Guelph Treasure: Arm Reliquary of the Apostles; c. 1195; German, Lower Saxony, Hildesheim; silver, gilt, and champlevé enamel; height 20 in. (50.8 cm); Gift of the John Huntington Art and Polytechnic Trust (1930.739)

p155 (above, center left): Guelph Treasure: Ceremonial Cross of Count Ludolf Brunon; c. 1037; German, Lower Saxony, Hildesheim; gold, cloisonné enamel, gems, pearls, and mother-of-pearl on oak core; 9½ x 8½ in. (24.1 x 21.6 cm); Gift of the John Huntington Art and Polytechnic Trust (1931.461)

p155 (above, center right): Guelph Treasure: Portable Altar of Countess Gertrude; c. 1045; German, Lower Saxony, Hildesheim; red porphyry, gold, cloisonné enamel, gems, and pearls on oak core; 4 x 10½ x 8 in. (10.2 x 26.7 x 20.4 cm); Gift of the John Huntington Art and Polytechnic Trust (1931.462)

p155 (above, far right): Guelph Treasure: Ceremonial Cross of Countess Gertrude; c. 1038; German, Lower Saxony, Hildesheim; gold, cloisonné enamel, gems, pearls, and mother-of-pearl on oak core; 9½ x 8½ in. (24.2 x 21.6 cm); Purchase from the J. H. Wade Fund with the addition of a gift from Mrs. Edward B. Greene (1931.55)

p155 (below right): Table Fountain; 1300–50; French, Avignon; silver gilt and translucent enamel; height 12¼ in. (31.1 cm); Gift from J. H. Wade (1924.859)

p156 (left): Guelph Treasure: Reliquary in the Form of a Book; c. 1340; German (possibly Lotharingia or Liège), Master of the Registrum Gregorii; ivory plaque set within a frame of gilt silver; 12⅜ x 9½ x 2¾ in. (31.5 x 24.1 x 6.9 cm); Gift of the John Huntington Art and Polytechnic Trust (1930.741)

p156 (right): Guelph Treasure: Monstrance with the "Paten of St. Bernward"; c. 1185; German, Lower Saxony, Brunswick, St. Oswald Reliquary Workshop; paten: gilt silver and niello,

monstrance: gilt silver and rock crystal; height 5¼ in. (13.5 cm); Purchase from the J. H. Wade Fund with additional gift from Mrs. R. Henry Norweb (1930.505)

p157 (above right): Tureen; 1735–38; designed by Juste Aurèle Meissonier, French (1695–1750); silver; 14½ x 17¾ in. (36.9 x 45 cm); Leonard C. Hanna, Jr., Fund (1977.182)

p157 (below left): Guelph Treasure: Monstrance with a Relic of St. Sebastian; 14th century; German, Lower Saxony, Brunswick; gilt silver and rock crystal; height 18½ in. (47 cm); Gift of Julius F. Goldschmidt, Z. M. Hackenbroch, and J. Rosenbaum in memory of the Exhibition of the Museum of Art from 10 January to 1 February 1931 (1931.65)

p157 (below right): Guelph Treasure: Horn of St. Blaise; 12th century; Sicilian-Arabic, Palermo; ivory; width 4¾ in. (12 cm); Gift of the John Huntington Art and Polytechnic Trust (1930.740)

p158 (in full plus detail): Half-Armor for the Foot Tournament; c. 1590; Pompeo della Cesa, Italian (active 1572–93); etched and gilded steel, with brass rivets, and leather and velvet fittings; John L. Severance Fund (1996.299.a.-h)

p159 (in full plus detail): Eleven-Headed Guanyin; 700–25, Tang dynasty; gray sandstone; 51 x 25 x 10 in. (129.6 x 63.6 x 25.4 cm); Gift of Severance A. and Greta Millikin (1959.129)

pp162–3 (in full) & p163 (two details): Twilight in the Wilderness; 1860s; Frederic Edwin Church, American (1826–1900); oil on canvas; 40 x 64 in. (101.6 x 162.6 cm); Mr. and Mrs. William H. Marlatt Fund (1965.233)

p164 (two details) & p164–5 (in full): Yosemite Valley; 1866; Albert Bierstadt, American (1830–1902); oil on canvas; 38¼ x 56 in. (97 x 142.3 cm); Hinman B. Hurlbut Collection (221.1922)

p166 (in full) & p167 (two details): Don Juan Antonio Cuervo; 1819; Francisco de Goya, Spanish (1746–1828); oil on canvas; 47¼ x 34¼ in. (120 x 87 cm); Mr. and Mrs. William H. Marlatt Fund (1943.90)

p168 (in full) & p169 (two details): Gray and Gold; 1942; John Rogers Cox, American (1915–1990); oil on canvas; 35¾ x 49½ in. (90.8 x 125.7 cm); Mr. and Mrs. William H. Marlatt Fund (1943.60)

p170: Mat Weight in the Form of a Bear; 206 B.C.–A.D. 220, Western Han dynasty; Chinese; gilt bronze; height 6⅛ in. (15.7 cm); John L. Severance Fund (1994.203)

p171: Krishna Govardhana; 500–550, Pre-Angkor period; Cambodia, Phnom Da; gray limestone; height 46¾ in. (118.8 cm); John L. Severance Fund (1973.106)

p172 (in full) & p173 (two details): Stag at Sharkey's; 1909; George Wesley Bellows, American (1882–1925); oil on canvas; 36¼ x 48¼ in. (92 x 122.6 cm); Hinman B. Hurlbut Collection (1133.1922)

p174 (in full) & p175 (two details): The Biglin Brothers Turning the Stake-Boat; 1873; Thomas Eakins, American (1844–1916); oil on canvas; 39⅞ x 59⅜ in. (101.3 x 151.4 cm); Hinman B. Hurlbut Collection (1984.1927)

p176 (in full) & p177 (detail): The Fight of a Tiger and a Buffalo; 1908; Henri Rousseau, French (1844–1910); oil on canvas; 66⅞ x 74⅜ in. (170 x 189.5 cm); Gift of the Hanna Fund (1949.186)

p178 (in full) & p179 (two details): Still Life with Two Lemons; 1629; Pieter Claesz, Dutch (c. 1597–1661); oil on panel; 16⅞ x 23⅜ in. (42.7 x 59.3 cm); Anonymous Loan (665.1993)

pp180–1 (in full) & p182 (three details): Nome Gods Bearing Offerings; 1391–1353 B.C., 18th dynasty; Egyptian, reign of Amenhotep III; painted limestone; 26 x 51⅜ in. (66 x 133 cm); John L. Severance Fund (1961.205, 1976.51)

p183: Amenhotep III Wearing the Blue Crown; 1391–1353 B.C., 18th dynasty; Egyptian, reign of Amenhotep III; granodiorite; 15⅜ x 11⅞ x 10⅞ in. (39.1 x 30.3 x 27.7 cm); Gift of the Hanna Fund (1952.513)

p184: Jonah Swallowed; c. 270–80, early Christian; eastern

Mediterranean, probably Asia Minor; marble; 20⅜ x 6⅛ x 10⅜ in. (51.6 x 15.6 x 26.2 cm); John L. Severance Fund (1965.237)

p185 (left): Jonah Cast Up; c. 270–80, early Christian; eastern Mediterranean, probably Asia Minor; marble; 16 x 8½ x 14¾ in. (40.6 x 21.6 x 37.6 cm); John L. Severance Fund (1965.238)

p185 (right): Jonah Praying; c. 270–80, early Christian; eastern Mediterranean, probably Asia Minor; marble; 18½ x 5½ x 8⅛ in. (47 x 14 x 20.6 cm); John L. Severance Fund (1965.240)

p186 (above): The Good Shepherd; c. 270–80, early Christian; eastern Mediterranean, probably Asia Minor; marble; 19¾ x 10⅛ x 6¼ in. (50.2 x 25.7 x 15.9 cm); John L. Severance Fund (1965.241)

p186 (below): Jonah Under the Gourd Vine; c. 270–80, early Christian; eastern Mediterranean, probably Asia Minor; marble; 12⅝ x 18¼ x 6⅞ in. (32.1 x 46.3 x 17.5 cm); John L. Severance Fund (1965.239)

p187 (in full plus detail): Christ and St. John the Evangelist; early 14th century; German, South Swabia, near Bodansee; polychromed wood; 36½ x 25½ x 11¾ in. (92.7 x 64.8 x 29.8 cm); Purchase from the J. H. Wade Fund (1928.753)

p188 (in full plus detail): Cista Handle: Sleep and Death Carrying Off the Slain Sarpedon; early 4th century B.C.; Etruscan; bronze; 6⅞ x 7¼ in. (17.4 x 18.3 cm); Purchase from the J. H. Wade Fund (1945.13)

p189 (in full plus detail): Raft Cup; 1345; Zhu Bishan, Chinese (c. 1300–c. 1362); hammered silver pieces soldered together with chased decoration; 6¼ x 8⅛ in. (16 x 20.5 cm); John L. Severance Fund (1977.7)

p190: The Thinker; c. 1904; Auguste Rodin, French (1840–1917); bronze; height 28½ in. (72.3 cm); Gift of Alexandre P. Rosenberg (1979.138)

p192 (in full) & p193 (detail): Vaulting; 1986–87; Susan Rothenberg, American (1945–); oil on canvas; 90⅛ x 132½ in. (229 x 336.5 cm); Leonard C. Hanna, Jr., Fund (1988.12); © ADAGP, Paris

and DACS, London 2000

p194 (left): The Hours of Queen Isabella the Catholic, Folio 146v: The Massacre of the Innocents and the Flight into Egypt; c. 1497–1500; Flemish, produced by the Master of the Old Prayerbook of Maximilian I and Associates, Ghent; ink, tempera, and gold on vellum; 8⅞ x 6 in. (22.5 x 15.2 cm); Leonard C. Hanna, Jr., Fund (1963.256)

p194 (detail, right) & p195 (in full): The Hours of Queen Isabella the Catholic, Folio 167v: St. Michael the Archangel; c. 1497–1500; Flemish, produced by the Master of the Old Prayerbook of Maximilian I and Associates, Ghent; ink, tempera, and gold on vellum; 8⅞ x 6 in. (22.5 x 15.2 cm); Leonard C. Hanna, Jr., Fund (1963.256)

pp196–7 (in full, above) & p197 (two details, below): Streams and Mountains Without End; early 12th century, Northern Song dynasty; Chinese; handscroll, ink with slight color on silk; 13⅞ x 83⅞ in. (35.1 x 213 cm); Gift of the Hanna Fund (1953.126)

**CHAPTER 5: COPYRIGHT ©
KIMBELL ART MUSEUM, FORT
WORTH. ALL RIGHTS RESERVED.**

All of the Kimbell photographs are by Michael Bodycomb.

p8 (below left) & p222: Composition No. 8; 1939–42; Piet Mondrian, Dutch (1872–1944); oil on canvas; 29½ x 26¾ in. (74.9 x 67.9 cm); AP 1994.05; © Mondrian/Hotzman Trust, c/o Beeldrecht, Amsterdam, Holland/Dacs 2000

pp198–9 (detail), p212 (in full) & p213 (detail): Maison Maria with a View of Château Noir; c. 1895–98; Paul Cézanne, French (1839–1906); oil on canvas; 25⅝ x 31⅞ in. (65 x 81 cm); AP 1982.05

p200: View of the southwest portico of the Kimbell Art Museum, with reflecting pool; constructed 1969–72; architect Louis I. Kahn, American (1901–74)

p201 (left): L'Asie (Asia); 1946; Henri Matisse, French (1869–1954); oil on canvas; 45¾ x 32 in. (116.2 x 81.3 cm); AP 1993.01; ©

Succession H. Matisse/DACS 2000

p201 (right): Constellation: Awakening in the Early Morning; 1941; Joan Miró, Spanish (1893–1983); gouache and oil wash on paper; 18⅛ x 15 in. (46 x 38 cm); acquired with the generous assistance of a grant from Mr. and Mrs. Perry R. Bass; APg 1993.05; © ADAGP, Paris and DACS, London 2000

p202 (two views): Portrait Head of a King (Oni); 12–14th century, Ife culture; African, southwestern Nigeria; terracotta; height 9 in. (22.9 cm); AP 1994.04

p203 (in full plus detail): Idealized Head of a Woman; c. 1817; Antonio Canova, Italian (1757–1822); marble; height 22¼ in. (56.3 cm); AP 1981.13

p204 (in full) & p205 (two details): The Cardsharps (I Bari); c. 1594; Caravaggio, Italian (1571–1610); oil on canvas; 37⅛ x 51½ in. (94.2 x 130.9 cm); AP 1987.06

p206 (detail) & p206–7 (in full): The Cheat with the Ace of Clubs; late 1620s; Georges de La Tour, French (1593–1652); oil on canvas; 38½ x 61½ in. (97.8 x 156.2 cm); AP 1981.06

p208 (in full) & p209 (two details): Four Figures on a Step; c. 1655–60; Bartolomé Esteban Murillo, Spanish (1617–82); oil on canvas; 43¼ x 56½ in. (109.9 x 143.5 cm); AP 1984.18

p210 (in full) & p211 (two details): Girls on a Jetty; c. 1904; Edvard Munch, Norwegian (1863–1944); oil on canvas; 31¾ x 27¼ in. (80.5 x 69.3 cm); AP 1966.06; © Munch Museum/Munch-Ellingsen Group/Dacs, London 2000

p214 (in full) & p215 (two details): Man in a Blue Smock; c. 1892–97; Paul Cézanne, French (1839–1906); oil on canvas; 32⅛ x 25½ in. (81.5 x 64.8 cm); APg 1980.03

p216 (in full) & p217 (two details): A Mountain Peak with Drifting Clouds; c. 1835; Caspar David Friedrich, German (1774–1840); oil on canvas; 9⅞ x 12 in. (25.1 x 30.6 cm); AP 1984.08

p218: Aymard-Jean de Nicolay, Premier Président de la Chambre des Comptes; 1779; Jean-Antoine Houdon, French (1741–1828);

marble half-length bust on original pedestal; 35½ x 29⅛ in. (90 x 74 cm); AP 1991.01

p219 (in full plus detail): Chibinda (The Hunter) Ilunga Katele; mid 19th century, Chokwe people; African, northeastern Angola; wood, hair, and hide; height 16 in. (40.6 cm); AP 1978.05

p220 (in full plus detail): Cylindrical Tripod Vase with Effigy Cover; 300–400, Early Classic period, Mayan culture; Guatemala, central lowlands; ceramic with stucco and polychrome decoration; height 11 in. (27.9 cm), diameter 6¼ in. (15.9 cm); AP 1997.01

p221 (in full plus detail): Wine Flask; late 16th or early 17th century, Momoyama period (1573–1615) or early Edo period (1615–1868); Japanese; Negoro ware, lacquered wood; height 11¾ in. (29.9 cm); AP 1981.16

p223: Composition No. 7 (Façade); 1914; Piet Mondrian, Dutch (1872–1944); oil on canvas; 47½ x 39⅝ in. (120.6 x 101.3 cm); Gift of The Burnett Foundation of Fort Worth in memory of Anne Burnett Tandy, 1983; AP 1983.03; © Mondrian/Hotzman Trust, c/o Beeldrecht, Amsterdam, Holland/Dacs 2000

pp224–5 (in full above, plus two details below): An Exiled Emperor on Okinoshima; c. 1600, Momoyama period (1573–1615); attributed to Mitsushige, Japanese, of the Tosa school; six-fold screen, ink, mineral pigments, and silver on paper; 58¼ x 237 in. (148 x 348 cm); AP 1971.11

p226 (in full) & p227 (detail): Interior of the Buurkerk, Utrecht; 1645; Pieter Jansz. Saenredam, Dutch (1597–1665); oil on panel; 22⅞ x 20 in. (58.1 x 50.8 cm); AP 1986.09

p228 (in full) & p229 (two details): The Apostle St. James Freeing the Magician Hermogenes; c. 1428–30; Fra Angelico, Italian (c. 1395/1400–1455); tempera and gold on wood; 10½ x 9⅜ in. (26.8 x 23.8 cm); AP 1986.03

p230 (two details) & p231 (in full): Brutus and Portia; c. 1490; Ercole de' Roberti, Italian (c. 1456–96);

egg tempera and shell gold on wood; 19⅛ x 13½ in. (48.7 x 34.3 cm); AP 1986.05

p232 (in full) & p233 (two details): A Country Road by a House; 1620s; Goffredo Wals, German (c. 1595–1638); oil on copper; diameter 9½ in. (24.1 cm); AP 1991.02

p 234 (in full plus detail): Standing Maitreya Bodhisattva; c. late 8th–early 9th century, Pre-Angkor period (550–802); Thailand, Prakhon Chai; bronze; height 48¼ in. (122.5 cm); AP 1965.01

p235 (in full plus detail): Standing Bodhisattva; 1st–2nd century, Kushan period (1st–3rd century); Pakistan, Gandhara region; gray schist; height 59⅛ in. (150.2 cm); AP 1997.04

p236: L'Air; designed 1938, cast 1962; Aristide Maillol, French (1861–1944); bronze, fifth cast in an edition of six; 60½ x 94 x 58 in. (153.6 x 239.9 x 96.5 cm) including plinth; AP 1967.06; © ADAGP, Paris and DACS, London 2000

p 237 (in full plus detail): Hari Hara: The Supreme Hindu Deity; c. 675–700, Pre-Angkor period (550–802); Cambodia, Prasat Andet; stone; height 45½ in. (115.6 cm); acquired with the assistance of a generous grant from the Sid W. Richardson Foundation of Fort Worth, AP 1988.01

**CHAPTER 6: COPYRIGHT ©
MUSEUM ASSOCIATES/LOS
ANGELES COUNTY MUSEUM
OF ART. ALL RIGHTS RESERVED.**

p8 (below right) & p249 (in full plus detail): Rooster, Hen, and Hydrangeas; 18th century, Edo period; Ito Jakuchu, Japanese (1716–1800); hanging scroll, color and ink on silk; 54⅞ x 33½ in. (139.4 x 85.1 cm); Etsuko and Joe Price Collection, Los Angeles County Museum of Art (L.83.50.1)

pp238–9, pp270–1 (in full), p271 (two details), p272 (detail) & p273 (detail): Mulholland Drive: The Road to the Studio; 1980; David Hockney, English (1937–); acrylic on canvas; 86 x 243 in. (218.4 x 617.2 cm); Purchased with funds provided by the F. Patrick Burns Bequest (M.83.35); © 1980 David Hockney

p240 (above): Exterior view of the Los Angeles County Museum of Art from Wilshire Boulevard

p240 (below): Beaker with a Theatrical Scene; late 2nd–3rd century; Egyptian or Syrian; free-blown, painted, and gilded glass; height 5¾ in. (14.6 cm), diameter 3½ in. (8.7 cm); Gift of Hans Cohn (M.87.113)

p241: Buddhist Altarpiece with the Goddess Chunda Flanked by Tara and Bhrikuti? (center), and the Transcendental Buddha Amitabha Flanked by the Bodhisattvas Vajrapani and Avalokiteshvara (top); c. 800; Indian, Madya Pradesh, Sirpur; copper alloy, silver, and copper; 15 x 10¼ x 7 in. (38.1 x 25.7 x 17.8 cm); from the Nasli and Alice Heeramaneck Collection, Museum Associates Purchase (M.84.32.1a-d)

p242 (in full) & p243 (two details): A Musical Party; c. 1626; Valentin de Boulogne, French (c. 1591–1632); oil on canvas; 44 x 57¾ in. (111.8 x 146.7 cm); Gift of The Ahmanson Foundation (AC1998.58.1)

p244 (in full) & p245 (two details): The Death of Lucretia; c. 1730; Ludovico Mazzanti, Italian (1686–1775); oil on canvas; 71 x 56 in. (180.3 x 142.2 cm); Gift of The Ahmanson Foundation (M.82.75)

p246 (detail) & p247 (in full): The Martyrdom of St. Cecilia; c. 1610; Carlo Saraceni, Italian (c. 1580–1620); oil on canvas; 53½ x 38¾ in. (135.9 x 98.4 cm); Gift of The Ahmanson Foundation (AC1996.37.1)

p248 (back view plus detail): Emperor's Twelve-Symbol Dragon Robe (Long Pao); 1821–50, Qing dynasty, Daoguang period; Chinese; silk and metallic foil-wrapped yarn in tapestry weave (kesi); center back 60¼in. (153 cm); Purchased with funds provided by Mr. and Mrs. William M. Carpenter, Helena and Boyd Krout, Mrs. Harry Lenart, Terry and Lionel Bell, John and Leslie Dorman, Beverly J. and Herbert M. Gelfand, Elyse and Stanley Grinstein, Diana Jonsson, Tally and Bill Mingst, Mr. and Mrs. R. Paul Toeppen, Diane Keith, Mr. and Mrs. Jeremy Fair, Leona Palmer, and Dr. and Mrs. Richard A. Simms through the 1997 Collectors Committee,

and the Costume Council (AC1997.89.1); © Joe Dorsey

p250 (in full plus detail): Woman's Evening Dress; 1987; Christian Lacroix, French (1951–); printed silk taffeta; center back 26 in. (66 cm); Costumes and Textiles Special Purpose Fund (AC1997.53.3); © Christian Lacroix

p251 (in full plus detail): Dress from the "Staircase" Series, Winter 1994; Issey Miyake, Japanese (1938–); metallic polyester, pleated; center back 45½ in. (115.6 cm); width approximately 84 In. (213.4 cm), Costume Council Fund (AC1996.158.1)

p252 (in full plus two details): Jizo Bosatsu; late 11th–early 12th century, late Heian period; Japanese; carved wood; height 57⅞ in. (146.5 cm); Gift of Anna Bing Arnold (M.74.117)

p253 (below left): Inro; early 19th century; Kajikawa Bunryusai, Japanese; Shibuichi metal bead ojime and wood netsuke; 3⅞ x 2 in. (9.9 x 5.1 cm); Gift of Miss Bella Mabury (M.59.35.1)

p253 (above right): Dragon Standing on Clouds; 18th century; attributed to Yoshimura Shuzan, Japanese; painted soft wood; 3⅝ x 1⅛ x 1¼ in. (9.1 x 3.1 x 3 cm); Raymond and Frances Bushell Collection (M.87.263.92)

p253 (center): Baku, Monster who Eats Nightmares; 18th century; attributed to Gechu, Japanese; ivory; 3¾ x 1⅛ x 1¼ in. (9.5 x 3.1 x 4 cm); Raymond and Frances Bushell Collection (AC1998.249.63)

p254 (detail) & p255 (in full): Triptych with Scenes from the Life of St. George; c. 1425–50; Spanish school; tempera on panel; 98 x 74 in. (248.9 x 187.9 cm); William Randolph Hearst Collection (50.28.8)

p256 (in full) & p257 (detail): The Flight of Europa; 1925; Paul Manship, American (1885–1966); bronze with parcel-gilt patina on original onyx base; 25¼ x 30 x 9 in. (64.1 x 76.2 x 22.9 cm); Purchased with funds provided by the American Art Council and its memers and the Shirley Filiatrault Trust (AC1998.63.1); courtesy of John Manship

p258 (two details) & p259 (in full): Mother About to Wash Her Sleepy Child; 1880; Mary Cassatt, American (1844–1926); oil on canvas; 39½ x 25⅞ in. (100.3 x 65.8 cm); Mrs. Fred Hathaway Bixby Bequest (M.62.8.14)

p260 (in full) & p261 (two details): Allegory of Salvation with the Virgin and Child, St. Elizabeth, the Young St. John the Baptist, and Two Angels; c. 1521; Rosso Fiorentino, Italian (1494–1540); oil on panel; 82 x 72 in. (208.3 x 182.9 cm); Gift of Dr. and Mrs. Herbert T. Kalmus (51.6)

p262 (in full) & p263 (two details): The Raising of Lazarus; c. 1630; Rembrandt van Rijn, Dutch (1606–69); oil on panel; 37⅞ x 32 in. (96.3 x 81.3 cm); Gift of H. F. Ahmanson and Company in memory of Howard F. Ahmanson (M.72.67.2)

p264–5 (in full) & p265 (detail): Plague in an Ancient City; c. 1652–54; Michael Sweerts, Flemish (1618–64); oil on canvas; 46¾ x 67¼ in. (118.7 x 170.8 cm); Gift of The Ahmanson Foundation (AC1997.10.1)

p266 (in full) & p267 (two details): After the Hunt; 1892; Winslow Homer, American (1836–1910); watercolor, gouache, and graphite underdrawing on off-white paper; 13¾ x 19⅞ in. (35.3 x 50.5 cm); Paul Rodman Mabury Collection (39.12.11)

p268: The Knight, Death, and the Devil; 1513; Albrecht Dürer, German (1471–1528); engraving; 9¾ x 7½ in. (24.8 x 19.1 cm); Graphic Arts Council and Los Angeles County Fund (70.1)

p269 (in full plus detail): Melancholia I; 1514; Albrecht Dürer, German (1471–1528); engraving; 15¼ x 10½ in. (38.7 x 26.7 cm); Gift of Bella Mabury (M.49.9.10)

p274 (in full) & p275 (detail): Ocean Park Series #49; 1972; Richard Diebenkorn, American (1922–93); oil on canvas; 93 x 81 in. (236.2 x 205.7 cm); Purchased with funds provided by Paul Rosenberg and Company, Mrs. Lita Hazen, and David E. Bright Bequest (M.73.96); © Diebenkorn Estate

p276 (in full plus detail): Man-Jaguar; c. 1000–600 B.C., Olmec culture; Mexican, Gulf Coast, Tabasco; black serpentine with traces of cinnabar; 4¼ x 3⅛ in. (10.8 x 7.9 cm); Gift of Mrs. Constance McCormick Fearing (M.86.311.6)

p277 (two views): Ballgame Yoke; c. 600–900; Mexican, Gulf Coast, central Veracruz; rhyolite; 16½ in. (41.9 cm); Gift of Constance McCormick Fearing (AC1992.134.25)

p278 (in full plus detail): Siva as Lord of the Dance (Nataraja); c. 950–1000; Indian, Tamil Nadu; copper alloy; 30 x 22½ x 7 in. (76.2 x 57.2 x 17.8 cm); Given anonymously (M.75.1)

p279: Buddha Calling the Earth to Witness; 11th century; central Tibetan; copper alloy with pigment and gilding; 18¼ x 13¼ x 10¾ in. (46.4 x 33.7 x 27.3 cm); Gift of the 1996 Collectors Committee (AC1996.26.1)

ADDITIONAL PICTURE SOURCES:

COPYRIGHT © ART GALLERY OF ONTARIO/MUSÉE DES BEAUX-ARTS DE L'ONTARIO. ALL RIGHTS RESERVED.

p31 (in full): The Rape of Proserpine by Pluto; 1702; Giovanni Battista Foggini, Italian (1652–1725); bronze; height 21½in. (54.5 cm); purchased from the collection of Margaret and Ian Ross with assistance from the Volunteer Committee Fund, 1982 (82/70); photographed by Brenda Dereniuk, AGO

COPYRIGHT © JACK STRECKFUS, SAN RAFAEL, CALIFORNIA U.S.A. ALL RIGHTS RESERVED.

p111 (above right): Family of Francisca Wartenberg, San Francisco, c. 1910

COPYRIGHT © PHILADELPHIA MUSEUM OF ART. ALL RIGHTS RESERVED.

p141 (left): Nude Descending a Staircase No. 2; 1912; Marcel Duchamp, French (1887–1968); oil on canvas; 58 x 35 in. (147.3 x 88.9 cm); The Louise and Walter Arensberg Collection (50.134.59); © Succession Marcel Duchamp/DACS, 2001

Index

Page numbers in *italics* refer to
 illustrations

d following page number indicates
 picture details

A

Alexander the Great 17, 22, 235
Altarpiece: Buddhist *241*
Amenhotep III 180–1
*Amenhotep III Wearing the Blue
 Crown 183, 183*
Ancestor Figure: Mexican 148, *148*
Angelico, Fra: *The Apostle
 St. James Freeing the Magician
 Hermogenes* 228, *229, 229d*
aquamanile: French 22, *22*
Aristotle and Phyllis 22, *22*
Asmat 32
Aztecs 277

B

*Baku, Monster who Eats
 Nightmares* 253, *253*
Ballgame Yoke 277, *277*
Balthus (Count Balthasar
 Klossowski de Rola):
 The Mountain 38, *39, 39d*
Barna da Siena: *The Mystic
 Marriage of St. Catherine* 86,
 87, 87d
Basket with Lid 77, *77*
Beaker with a Theatrical Scene *240*
bears 170
Bellows, George Wesley: *Stag at
 Sharkey's* 172–3, *172, 173d*
Benin 33
Bierstadt, Albert: *Yosemite Valley*
 164, *164–5, 164d*
Bis Poles 32, *32*
Boit, Edward Darley 75
Bonheur, Rosa: *The Horse Fair* 48,
 48–9, 49d
Book of Hours of Jeanne d'Evreux
 13
Books of Hours 195
Boston: Museum of Fine Arts 62–3,
 62
Brown, Richard 215, 236
Bruegel, Pieter, the Elder:
 The Harvesters 10–11d, 36,
 37, 37d
Bruschi, Gaspero: *The Rape of
 Persephone* 26–7, *26, 26d, 27d*
Brush Holder 69, *69*
Brush Rest 69, *70*
*Buddha Calling the Earth to
 Witness* 279, *279*
Buddhism 92, 159, 234–5
Buddhist Altarpiece *241*
Bunbury, Lady Sarah: portrait 108,
 108d, 109
Bustelli, Franz Anton:
 Nymphenburg Figures from the
 Commedia dell'Arte 28–9, *28–9*

C

Campin, Robert: Triptych with
 the Annunciation 40, *40,
 42–3d*
Canova, Antonio: *Idealized Head of
 a Woman* 203, *203, 203d*
Caravaggio 126
 The Cardsharps 204–5, *204,
 205d*
Carpeaux, Jean-Baptiste: *Ugolino
 and His Sons* 24–5, *24d, 25*
Cassatt, Mary: *Mother About to
 Wash Her Sleepy Child* 258,
 258d, 259
Castle, Wendell: Settee 103, *103*
Cecilia, St. 246, *247*
Celadon Ewer 130, *130*
Cézanne, Paul:
 *Maison Maria with a View of
 Château Noir 198–9d, 212,
 213, 213*
 Man in a Blue Smock 214, *215,
 215d*
Chagall, Marc: *The America
 Windows* 150–1, *150–1,
 150d*
Chest-on-chest 67, *67, 67d*
Chibinda (The Hunter) Ilunga Katele
 219, *219, 219d*
Chicago: Art Institute *106*, 107
Chihuly, Dale: *Seven Forms* 100,
 101, 101
Chimu 133
Chokwe 219
Christ and St. John the Evangelist
 187, *187, 187d*
Church, Frederick Edwin: *Twilight
 in the Wilderness* 162, *163d,
 164*
Cista Handle 188, *188, 188d*
Claesz, Pieter: *Still Life with Two
 Lemons* 178–9, *178, 179d*
Claude 233
Cleveland Museum of Art 154–6,
 154
Cloisters Cross 40–1, *41, 41d*
Cogswell, John: Chest-on-chest 67,
 67, 67d
Commedia dell'Arte Figures:
 Nymphenburg 28–9, *28–9*
Copley, John Singleton: *Paul Revere*
 84, *85, 85d*
Corne, Michele 65
Cox, John Rogers: *Gray and Gold*
 168–9, *168, 169d*
cubism 213
Cuervo, Don Juan Antonio: portrait
 of *166, 167, 167d*
Cylindrical Tripod Vase with Effigy
 Cover 220, *220, 220d*

D

Dallin, Cyrus Edwin: *Appeal to the
 Great Spirit* 62, *63*
Dave the Potter: Jar 77, *77*

David, Jacques Louis: *Madame de
 Pastoret and Her Son* 122, *123,
 123d*
de Kooning, Willem: *Standing
 Figure* 62, *63*
della Cesa, Pompeo: Half-Armor for
 the Foot Tournament 158, *158,
 158d*
Derby, Elias Hasket 67
Diebenkorn, Richard: *Ocean Park
 Series #49* 274, *275, 275d*
Donatello: *Madonna of the Clouds*
 63
Dragon Standing on Clouds 253,
 253
dresses 250, *250–1, 250–1d*
Drum: Ceremonial 149, *149*
Du Paquier: Gaming Set 146–7,
 146–7
Duchamp, Marcel: *Nude
 Descending a Staircase No.2*
 140, *141*
Dürer, Albrecht:
 The Knight, Death, and the Devil
 268, *269*
 Melancholia I 269, *269*

E

Eakins, Thomas: *The Biglin
 Brothers Turning the Stake-Boat*
 174–5, *174, 175d*
Eleanor of Aragon 230
Eleven-Headed Guanyin 159, *159,
 159d*
Emperor's Twelve-Symbol Dragon
 Robe 248, *248, 248d*
Entertainer 128, *128*
Equestrienne 129, *129, 129d*
Eugénie, Empress of France 48
Exiled Emperor on Okinoshima
 224, *224–5, 224–5d*

F

Flask:
 carved 131, *131*
 Wine 221, *221, 221d*
Foggini, Giovanni Battista: *The
 Rape of Proserpine by Pluto* 27,
 27
Fragmentary Head of a Queen 7,
 35, 35
Friedrich, Caspar David:
 *A Mountain Peak with Drifting
 Clouds* 216, *217, 217d*

G

Gainsborough, Thomas 81
Gaming Set: Austrian 146–7, *146–7*
*Garden of Tenshin-en (The Garden
 at the Heart of Heaven)* 98, *98,
 99*
Gauguin, Paul: *Where Do We Come
 From? What Are We? Where
 Are We Going?* 88–9, *89–90,
 90–1d*

David, Jacques Louis
George, St. 254, *254d, 255*
Giambologna (Jean Boulogne):
 Architecture 93, *93, 93d*
Good Shepherd 186, *186*
Goya, Francisco de 125
 Don Juan Antonio Cuervo 166,
 167, 167d
Grave Stele 53, *53, 53d*
El Greco:
 The Assumption of the Virgin 107
 Fray Hortensio Félix Paravicino
 80, *81, 81d*
Guanyin: Eleven-Headed 159, *159,
 159d*
Gudea 18–19, *18, 18d*
Guelph Treasure 155–6, *156, 157–8*

H

*Hari Hari: The Supreme Hindu
 Deity* 237, *237, 237d*
Hatshepsut Enthroned 20, *21*
Head of an Iyoba 33, *33*
Head of a Dignitary 34, *34*
Head of a Queen, Fragmentary
 35, *35*
Heade, Martin Johnson:
 *Approaching Storm: Beach Near
 Newport* 96–7, *96–7, 97d*
Hermogenes 228, *229, 229d*
Hinduism 92, 171, 237, 278
Hockney, David: *Mulholland Drive:
 The Road to the Studio* 238–9,
 270–1, 271–3, 272d, 273d
Homer 188
Homer, Winslow: *After the Hunt*
 266–7, *266, 267d*
Hopper, Edward: *Nighthawks*
 104–5d, 136, *136–7, 136d*
Hopper, Jo 136, 137
Hotto Kokushi: statue of 8, 191,
 191
Houdon, Jean-Antoine: *Aymard-
 Jean de Nicolay* 218, *218*
*Hours of Queen Isabella the
 Catholic* 194, *194d, 195, 195*
Housman, A. E. 136

I

Ilunga Katele 219, *219, 219d*
Incas 133
Indian sculpture 92, *92*, 278, *278,
 278d*
Indra 171
Ingres, Jean Auguste Dominique 81
 *Amédée-David, Marquis de
 Pastoret* 124, *125, 125d*
Inro 253, *253*
Isabella, Queen: Book of Hours 194,
 194d, 195, 195
Iyoba: Head 33, *33*

J

Jackson, Mary: Basket with Lid 77,
 77
jade 70

Jakuchu, Ito: *Rooster, Hen and Hydrangeas* 8, 249, 249, 249d
James, St. 228, 229, 229d
Jizo Bosatsu 252, 252, 252d
Jonah Cast Up 184, 185
Jonah Praying 185, 185
Jonah Swallowed 184, 184
Jonah Under the Gourd Vine 186, 186

K

Kahn, Louis 200, 236
Kändler, Johann Joachim: Meissen porcelain 144, 145, 145
Kimbell Art Museum, Fort Worth 204–5, 204
Kneeling Bull Holding a Vessel 23, 23
Knife: Ceremonial 133, 133
Koran: page from 46, 46
Kouros (Statue of a Youth) 52, 52, 52d
Krishna Govardhana 171, 171
Kuralik, Maxim 96–7

L

La Tour, Georges de: *The Cheat with the Ace of Clubs* 206, 206–7, 206d
lacquer work 221, 221, 221d
Lacroix, Christian: Woman's Evening Dress 250, 250, 250d
Lazarus 262, 263, 263d
Lee, Sherman 156
Lemoine, Marie-Victoire: *Atelier of a Painter* 51, 51
Lichtenstein, Roy: *Glass V* 102, 102
Long, Charles 203
Los Angeles County Museum of Art (LACMA) 240–1, 240

M

Maillol, Aristide: *L'Air* 236, 236
Maitreya Bodhisattva 234–5, 234, 234d, 235, 235d
Maloof, Sam: Settee 103, 103
Man-Jaguar 276, 276, 276d
Manet, Edouard: *The Mocking of Christ* 114, 114d, 115, 115d
Manfredi, Bartolomeo: *Cupid Chastised* 126, 126d, 127
Manship, Paul: *The Flight of Europa* 256, 257, 257d
Massacre of the Innocents and the Flight into Egypt 194, 195
Mat Weight in the Form of a Bear 170, 170
Matisse, Henri: *L'Asie (Asia)* 201
Maya 220, 277
Mazzanti, Ludovico: *The Death of Lucretia* 244, 245, 245d
Meissen:
 Sugar Caster and Cover 145, 145
 Tureen and Stand 144, 145
Metropolitan Museum of Art 12–13, 12, 13
Mihrab 44, 44d, 45
Milliken, William 156
Mimbres Bowl 76, 76

Miró, Joan: *Constellation: Awakening in the Early Morning* 201
Mitchell, Joan: *City Landscape* 134, 135, 135d
Miyake, Issey: Dress, from the "Staircase" Series 250, 251, 251d
Mogollons 76
Mondrian, Piet:
 Composition No.7 223, 223
 Composition No.8 8, 222–3, 222
Monumental Seated Ancestor Figure 148, 148
Munch, Edvard: *Girls on a Jetty* 210, 211, 211d
Murillo, Bartolomé Esteban: *Four Figures on a Step* 208–9, 208, 209d
Mycerinus and Queen Kha-merer-nebty II 63

N

Netsuke 253, 253
New York: Metropolitan Museum of Art 12–13, 12, 13
Nicolay, Aymard-Jean de: bust of 218, 218
Nome Gods Bearing offerings 180–2, 180–1, 182d
Nymphenburg Figures from the Commedia dell'Arte 28–9, 28–9

O

Oak Hill Rooms 64–5, 65–6, 65d, 66
Odundo, Magdalene: *Teardrop I* 107
O'Keeffe, Georgia:
 portrait of 94, 94
 White Rose with Larkspur No.2 94, 95
Olmecs 276, 277
Osiride Head of Hatshepsut 21

P

Palmer, Mrs. Potter 111
Paravicino, Fray Hortensio Félix 80, 81, 81d
Pastoret, Adelaide, Madame de: portrait 122, 123, 123d
Pastoret, Amédée-David, Marquis de: portrait 124, 125, 125d
Pauahtuns 220
Pearl Harbor 137
Persephone 26–7
piano: Sheraton 82, 82, 82d
Picasso, Pablo 145, 177, 213
Pluto 26–7
Portrait Head of a King 202, 202
Portrait of the Zen Master Hotto Kokushi 8, 191, 191
Poussin, Nicolas: *Holy Family on the Steps* 152–3d, 160–1, 160, 161d
Pucelle, Jean: *Book of Hours of Jeanne d'Evreux* 13
Puryear, Martin: *Sanctuary* 119, 119

Q

qi 68, 69

R

Rembrandt van Rijn:
 Aristotle with a Bust of Homer 16, 17, 17d
 The Raising of Lazarus 262, 263, 263d
Reni, Guido: *Salome with the Head of St. John the Baptist* 120, 121, 121d
Renoir, Pierre Auguste: *Acrobats at the Cirque Fernando* 110, 111, 111d
Revere, Paul:
 portrait of 84, 85, 85d
 Sons of Liberty Bowl 7, 83, 83
Reynolds, Sir Joshua: *Lady Sarah Bunbury Sacrificing to the Graces* 108, 108d, 109
Richter, Gerhard:
 Ice 1–4 142, 142–3
 Woman Descending the Staircase 140, 141
Roberti, Ercole de': *Brutus and Portia* 230, 230d, 231
"Rock" Album 68, 70
Rodin, Auguste 257
 The Thinker 190, 190
Rosso Fiorentino: *Allegory of Salvation with the Virgin and Child, St. Elizabeth, the Young St. John the Baptist, and Two Angels* 260, 261, 261d
Rothenberg, Susan: *Vaulting* 192–3, 192, 193d
Rousseau, Henri: *The Fight of a Tiger and a Buffalo* 176, 177, 177d

S

Saenredam, Pieter Jansz: *Interior of the Buurkerk, Utrecht* 226, 227, 227d
St. Michael the Archangel 194d, 195, 195
Saraceni, Carlo: *The Martyrdom of St. Cecilia* 246, 246d, 247
Sargent, John Singer 81, 266
 The Daughters of Edward Darley Boit 60–1d, 74, 75, 75d
Sarpedon 188, 188, 188d
Scholar's desk objects 68–70, 68–70
Senufo 149
Seurat, Georges Pierre:
 Seated Woman with a Parasol 113
 A Sunday on La Grande Jatte—1884 7, 112, 112–13, 113d
shaman-kings 276
Sheraton, Thomas: grand piano 82, 82, 82d
Siva as Lord of the Dance (Nataraja) 278, 278, 289d
Sleep and Death Carrying Off the Slain Sarpedon 188, 188, 188d
Snuff Bottle 70, 70
Sphinx 53, 53
Sphinx of Hatshepsut 20–1
Spirit Rock 68, 68, 70
Standing Bodhisattva 235, 235, 235d
Standing Maitreya Bodhisattva 234, 234, 234d

Standing Male Figure 19, 19d
Stieglitz, Alfred: *A Portrait—Georgia O'Keeffe* 94, 94
Streams and Mountains Without End 196, 196–7, 197d
Suleyman the Magnificent: Tughra 47, 47
Sweerts, Michael: *Plague in an Ancient City* 254–5, 255

T

Tarquinus Superbus 245
Tasso, Torquato: *Gerusalemme Liberata*, illustrations to 116–18, 116–18
Tea Ceremony Jar 132, 132
Tiepolo, Giovanni Battista: *Gerusalemme Liberata* illustrations 116–18, 116–18
Tomb figures: Chinese 128–9, 128, 129, 129d
Triptych with Scenes from the Life of St. George 254, 254d, 255
Triptych with the Annunciation 40, 40, 42–3d
Tughra of Suleyman the Magnificent 47, 47

V

Valentin de Boulogne, Moïse: *A Musical Party* 242–3, 242, 243d
Velázquez, Diego: *Juan de Pareja* 14, 15, 15d
Veracruz: artists of 148
Vermeer, Johannes:
 Allegory of the Faith 54, 55, 55d
 A Maid Asleep 56
 Portrait of a Young Woman 59
 Woman with a Lute 58
 Young Woman with a Water Jug 57
Victoria, Queen 48
Villers, Marie-Denise: *Young Woman Drawing* 50, 51, 51d

W

Wals, Goffredo: *A Country Road by a House* 232, 233, 233d
Water Dropper in the Shape of a Peach with a Parrot 69, 69
Watteau, Jean-Antoine: *Mezzetin* 30–1, 30, 31d
West, Elizabeth Derby 65–6
Wilkes, John 83
Wine Flask 221, 221, 221d
Wood, Grant: *American Gothic* 138, 139, 139d

Y

Yakshi (Torso of a Fertility Goddess) 92, 92

Z

Zen garden 98, 98, 99
Zhu Bishan: Raft Cup 189, 189, 189d
Zola, Emile 215
Zurbarán, Francisco de: *St. Francis* 78, 78d, 79